KU-216-161

EILEEN ALEXANDER was born in Cairo and grew up in a cosmopolitan Jewish family before moving to Cambridge as a student. She graduated from Girton College with a first-class degree in English in 1939, and worked during the Second World War for the civil service in the Air Ministry. Eileen went on to be a teacher, writer and translator, notably translating works by Georges Simenon. Her letters were discovered through a chance eBay purchase, and serve now as the best testament to Eileen's extraordinary literary talent, which might otherwise have been forgotten.

Praise for *Love in the Blitz*:

'Once in a while, just at the right moment, a truly gorgeous real-life love story appears out of the blue, or in this case out of a chance purchase on eBay. Some of wartime's funniest, most unexpected and possibly unintentionally sexiest letters. Eileen has an insatiable eye for funny stories amid the strange circumstances of war. There are echoes of intimate, Mitfordian shorthand and a touch of the self-deprecating, self-doubting Bridget Jones about her'
The Spectator

'It has been a long time since I enjoyed a book as much ... Of the hundreds of books about World War II that I've read, this is one of the best. Imagine how [Austen] might have witnessed the Blitz, and you have a sense of this wonderful book' *New York Times*

'Eileen emerges as a force of nature, and her voice is one of the real joys in these remarkable letters. She was clever and caustic, without being cruel; intellectually brilliant and revelling in that fact ... a memoir of hope and resilience, as much as of love' *The Times*

'A trove of dazzlingly literary love letters. These are as [Oswyn] Murray rightly concludes, 'some of the most beautiful and vivid' love letters of the Second World War' *Daily Telegraph*

'The great value of Eileen's book is that it takes you out of our present troubles into a world even more dangerous and destructive, which people nevertheless survived' *Sunday Times*

'This remarkable treasure trove of letters gives a unique insight into home-front life and romance' *Mail on Sunday*

'Superbly entertaining ... on almost every page there is a gleaming little starburst of life ... She is immensely clever and her literary judgements are delicious. Her writing is a diary-like outpouring, a stream of consciousness in which she relives her days in the glorifying imagined gaze of her recipient; it is a mass of aperçus, jokes, observations and confessions' *TLS*

'A unique and vivid account of both love and war ... The book reminds us of the lost art of letter-writing, which first was replaced by email and now by the even hastier and more forgettable text. Alexander is a master of the art, and her letters are a treasure – artful, eloquent, deeply informed, emotionally alive and full of life' *Jewish Journal*

'Deftly edited by McGowan and with informative chapter introductions by Crane, the letters offer a moving, sharply etched chronicle of wartime London ... Alexander's wit and intelligence shine through reports of her work, their friends' romantic entanglements, her reflections on religion, her sexual longing, and tidbits of gossip ... A rare, vivid perspective on the impact of war' *Kirkus Reviews*

'Remarkable ... Any reader with an interest in cultural history or a love of romance will find this a book to savour' *Publishers Weekly*, starred review

'A treasure trove of love letters, cultural history, and memoir ... Alexander's adoration for Gershon shines through in every letter, and so do her observations on the opinions and foibles of the people around her. You'll laugh out loud at unbuttoned descriptions of friends, family, and coworkers while learning more than you'd expect about life in London leading up and during to World War II' *Library Journal*

Love in the Blitz

A Woman in a World Turned Upside Down

Eileen Alexander

Edited by David McGowan and David Crane

Foreword by Oswyn Murray

WILLIAM COLLINS

William Collins
An imprint of HarperCollins*Publishers*
1 London Bridge Street
London SE1 9GF

WilliamCollinsBooks.com

HarperCollins*Publishers*
1st Floor, Watermarque Building, Ringsend Road
Dublin 4, Ireland

First published in Great Britain in 2020 by William Collins
This William Collins paperback edition published in 2021

1

A catalogue record for this book is
available from the British Library

ISBN 978-0-00-831124-7

Printed and bound in Great Britain
by CPI Group (UK) Ltd, Croydon

MIX
Paper from
responsible sources
FSC™ C007454

This book is produced from independently certified FSC™ paper
to ensure responsible forest management.

For more information visit: www.harpercollins.co.uk/green

Contents

Foreword
by Oswyn Murray

In the autumn of 2017 I received an email from an unknown correspondent:

> Dear Mr Murray,
> I hope you will forgive the intrusion, but I recently purchased a large quantity of wartime correspondence, via eBay, written by Eileen Alexander (soon to be Ellenbogen) in which I have found many references to your father, as Eileen worked with him in S9 at the Air Ministry during World War Two. I attach details of a weekend she spent with your family in Summer 1943. I have considered long and hard whether this is the right thing to do, and am basing my decision on the fact that if there were written details of my own family from over 70 years ago I would very much like to read them. Eileen held your father in the very highest regard and her letters are bejewelled with words like kind, intellectual, understanding, humanist regarding him. Although it is only just over 70 years ago – the idyllic weekend she describes seems to certainly belong to a lost era ...
>
> With very best wishes,
> David McGowan

I replied enthusiastically:

> I have often blessed my parents for giving me a name (my grandfather's) that is unique on the world wide web, but never more so than on receiving your email at the age of 80. Yes I still remember Corners vividly, our home from before my birth in 1937 to 1945, the doodlebugs, the air raid shelter, the 1945 election (when we were the HQ of the local Liberals), the garden and its wood. Your extracts are however the only written record I know of that period, and they are lovely. I do remember vaguely the name of Eileen Alexander, who sent Christmas cards every year, and I can locate most of the places and people she mentions.
>
> It seems my father was still in the Air Ministry in 1943; but in that year he moved to be civil service head of SOE under General Gubbins, an experience he claimed had been expunged from his memory by concussion at the end of the war; but my first suitcase was one designed to hold a radio transmitter to be parachuted into France ... Subsequently Patrick went on to the Ministry of Power, where he headed the electricity division, being responsible for the nationalisation of electricity and its denationalisation twenty years later, and for the creation of a nuclear power industry. He retired in 1965, and went to live in the south of France and Weybridge.

Thus began an unexpected friendship during which David and I researched his find. For thirteen years he had been the sole carer of his aged mother and confined to the house much of the time; to occupy himself he decided to buy letters on eBay and perhaps make a book out of them. By pure chance he bought a small bundle of letters from Eileen Alexander, and realised that these were truly remarkable; so he contacted the seller and offered to purchase the rest. A year passed, and he had given up hope, when finally the seller offered him the remaining letters for the original auction price.

Eileen Alexander graduated in 1939 with a brilliant first-class degree in English from Girton College, Cambridge; her subsequent accident in a car driven by her future husband,

Gershon Ellenbogen, begins the correspondence and their love affair. There were approximately fourteen hundred of these letters, written almost daily, covering the years 1939 to 1947. David began transcribing them; he sent me a first volume and then three further ones, over sixteen hundred pages covering roughly half of the correspondence. I began to quail at the thought of a book as long as Proust, and suggested that he try to edit it down to a single volume with the idea of publication. Within ten days that volume arrived, covering the years of courtship up to Eileen's reunion with Gershon and marriage. We christened it *Love in the Blitz*, and I introduced him to a family friend, the literary agent Felicity Bryan. She read it while confined with flu on her sick bed, and the next day phoned David and offered to be his agent. Together the three of us began to research the history of the correspondence.

The letters appear to have been first auctioned at Bridport Auction House in a bundle of miscellaneous papers shortly after Gershon's death in 2003; presumably they had been part of his house clearance. The lot did not sell, and was taken away by an employee, who sorted the letters out from the rest of the papers and identified the writer, but found the task of transcription too difficult. A decade later, in January 2015, she put them back into the auction house as a separate lot:

> Large quantity of correspondence (1939–1947) written by
> Eileen Ellenbogen (née Alexander) to Gershon Ellenbogen.
> Eileen Ellenbogen, a graduate of Girton College, was a
> noted teacher, writer and translator – especially of George
> Simenon's *Maigret* books. In WWII Gershon Ellenbogen,
> who was in the RAF, worked for British Military
> Intelligence in Cairo.

The letters were bought for £250 by the dealer who subsequently began offering them on eBay until David's intervention. Meanwhile David researched the family and friends of the couple, and Felicity tracked down Eileen's grandchildren, who gave their assent for the letters to be published.

So these letters, surely some of the most beautiful and vivid love letters ever to be written during the Second World War,

have survived through a series of chances, to be rescued from oblivion by David McGowan, their devoted transcriber and editor.

We plunge into the correspondence and follow the young writer's experiences day by day with little knowledge of what lies ahead, as she lives through the war years. Slowly we learn to know her idiosyncrasies, her growing love, her relations with her rather 'odd' – as she describes them – family, her experience of the Blitz in London. We learn to trust her judgements on her circle of friends and acquaintances and we find them increasingly hilarious. Everything is seen through her eyes: even her beloved is only dimly reflected in her comments. We are amazed at her naivety and her ignorance of sex. We may admire her independent stance on Judaism and some of her progressive views on politics.

We begin, too, to appreciate that Eileen is involved in a new literary genre with a multiple purpose. The first is to enmesh her beloved in her life, to keep him engaged with herself and prevent him straying during their long separation – the sort of narrative letters that Ovid imagines Penelope writing to Ulysses. She wants to display all her talents, her knowledge, her first-class degree, her ability to find a quotation in Elizabethan literature for every eventuality. There is also much about her friends' liaisons – perhaps in order to warn Gershon to keep faith with her.

The second is to create an intensely personal narrative, a type of *Bildungsroman*, so rich that it holds us as we follow the daily experience of a young woman setting out on life, with all its uncertainties, exploring her environment and learning from the mistakes of those around her.

The third is perhaps inadvertent; without knowing it, she is fashioning a feminist vision of war, a description of war as it is seen by women, not men – a time of absence and waiting, of hoping and doubting, of being caught between tradition and modernity, desire and faithfulness. That makes the narrative almost unique, the outside world impinges, disasters hit her, but she never acts, only reacts: and yet life goes on apparently normally. Elias Canetti's famous description of contemporary London, *Party in the Blitz*, seems mean-spirited and randomly vicious beside Eileen's instantaneous, daily, witty and loveable take on the undisturbed rhythms of Cambridge and London Jewish life in wartime Britain.

Did she ever think of publishing? She knew she had a talent for 'the Art of letter-writing', but publishing was never part of her plan. In September 1943 she wrote: 'Pan has just come in to say: "Really, the care you take over your letters to Gershon – one would think that you were writing for future publication." I looked at him Sternly, my dear love, & said: "Oh! no, I'm writing for a far more important reason than that." But one day, he'll learn, my love. Pan is the sort of person who will love a woman as I love you.'

Rather, her letters and her love for Gershon were her life: 'I once thought that I had a genius for writing,' she told him, 'but I find instead I have a genius for love.'

> As far as I'm concerned all my creative energies, all my critical & social faculties, all my moods and thoughts, and, above all, all the boundless sea of my love for you go into my letters to you ... My letters are only a translation of my love, my darling. I can only give you my love itself when I'm with you, when I'm lying back in your arms – then, darling, I can give you my love with my voice & my eyes & my body. I am tired of being a translator, my darling. I want to be a creative genius again. If I have any creative genius, my dear love, it is in my love & not in my writing, which is insignificant & meaningless beside my love. What would the outside world know of my love for you, darling, if they were to read my letters? They would know what I know of the Odyssey when I read it in translation – but you are the only person, my darling, who has read the story of my love in the original and you are the only person who understands it fully & truly. That's good, darling. It was a story which was written for you & only for you. I don't want anyone else to understand it. It is not their story – it is only our story. I'm as arrogant & exclusive about our love as Ouspensky is about his Esoteric Knowledge.

This was ultimately the point: 'I wonder what anyone would think if they suddenly came across my letters to you & started reading them in chronological order? I think they'd say "This girl never lived till she loved" – and it would be true, darling. Until I loved

you, I was in the process of undergoing intellectual and emotional dry-rot. If I'd never known you – people, in later years, would have looked at me as though they'd taken a mouthful of vinegar – with the corners of their mouths screwed up, & said "Wormwood! Wormwood!" – but now they'll say "While she lived she was a true lover & therefore she had a good end."'

As she wrote these letters Eileen was surely thinking of the portrayal of courtly love in her favourite book by C. S. Lewis, *The Allegory of Love*, published in 1936, which she described as 'the finest piece of Medieval literary criticism of our time & perhaps of all time'. She seems to see herself half 'in the precarious dream-world of medieval love poetry', as the faithful damsel of troubadour tradition in her chastity belt, creating a romance as she writes to her beloved lord away on the Crusades about the strange deeds at home in their feudal castle. She moves between 'the allegory of the Body and the Heart'. And she follows C. S. Lewis in believing in the continuity of courtly love into the English literary tradition of Shakespeare, Thomas Wyatt and John Donne. She is a supreme writer of modern literary prose, schooled by her love of English literature from Malory to Elizabethan and modern literature, yet with all the wickedness of a Stella Gibbons in her delight in 'mollocking'. Compared to these, Eileen seems scarcely aware of Jewish antecedents, such as the Song of Songs or the books of Ruth and Esther, let alone the Jewish and Arabic love poetry of medieval Spain, still to be discovered. Yet she has written a masterpiece worthy to stand with these earlier writings in the Jewish tradition, alongside Giorgio Bassani's *The Garden of the Finzi-Continis* (1962); and perhaps her insistence on the virtues of chastity and faithfulness, so at odds with her contemporaries, owes much to her Jewish upbringing.

The experience of love is both unique and universal, but it changes almost imperceptibly in each generation. Too often it is reflected in recollection, when, for whatever reason it is lost, its intensity dispersed or transformed by memory, as in Proust or the late poems of Thomas Hardy. There are many accounts of love from the two world wars, beginning with Vera Brittain's *Testament of Youth* (1933) and Helen Thomas's memoirs (1926 and 1931). Diana Athill – Eileen's exact contemporary, who graduated from Oxford

in the same year – may have experienced some of the same emotional highs and lows as Eileen as she corresponded with her fiancé, also in Egypt, but their relationship failed: he betrayed her (*Instead of a Letter*, 1963) and the letters themselves are lost. One of the nearest accounts in both time and place is Laurence Whistler's numinous *The Initials in the Heart* (1964) about his love for the actress Jill Furse in the early years of the war, her death and his subsequent grieving for the rest of his life. But that too is about loss, and, like Athill's account, is written twenty years after the event in an attempt to assuage his grief.

The one thing that such historical narratives lack, however personal they are, is ignorance of the future, and so they cannot capture the vividness of living in the present as this book does. This is what makes Eileen Alexander's letters such an immense literary discovery. It is a description of love as it unfolds, 'suspended between unborn tomorrow & dead yesterday', as she wrote in the middle of war, an emotion as it is experienced by a young woman day by day, existing in a moment of history, unique to its time but universal in its meaning.

Historical Introduction
by David Crane

On 19 July 1939, as Europe drifted towards war, a short report from the police courts under the mildly sardonic heading 'DIFFERENT TYPE OF STUDENT HAD SIMILAR SORT OF ACCIDENT' appeared in the inside pages of the *Cambridge Daily News*. 'When a research student at Cambridge University,' the piece began, 'was summoned at the Maidenhead Borough Police Court on Monday for alleged dangerous driving and for failing to conform to a "Halt" sign at Braywick cross-roads on June 29th, he said to the magistrates, "I want to persuade you that I am not one of those reckless undergraduates about whom you have heard from time to time. I have already spent four years at Cambridge University, having gained a State Scholarship and two other scholarships and am now beginning my fifth year of study as a research student. During the four years I have been there, I have held various positions of responsibility in the life of the university, and have never come into contact with the Cambridge police or other authorities at all. I am not just a reckless undergraduate, but a research student of four years."'

'It was an accident that might happen to anyone,' he told the court – the car roof was down, the sun was in his eyes, the road unfamiliar – but that was probably not a wise line to take. 'It was alleged in evidence,' the report went on, that he had driven over a major junction 'at colossal speed', smashed into a car coming from his right on the main Maidenhead to Windsor road, spinning his car over onto the far side of the road twenty-eight feet away and

hurling his 'lady passenger ... herself a Cambridge student' out of the passenger seat and onto the tarmac.

The 'lady passenger ... on her way to London to meet her parents who were coming home from Egypt the next day' was Eileen Alexander, and the driver – banned from driving for a year, fined £3 and ordered to pay costs – was the Liverpool-born son of devoutly Jewish parents, with a double-first in classics and psychology, called Gershon Ellenbogen, the recipient of these letters. At the time the case came to court Eileen was in Maidenhead hospital, slowly and painfully recovering from her injuries, her nose and collarbone broken, her teeth and left eye-socket damaged, her face bruised and swollen.

If there was one event in her life, however, that Eileen would not have seen undone it was that car crash. She had first met Gershon Ellenbogen in the summer of 1938 but it was the accident that changed their lives, turning a friendship that might have naturally ended with their Cambridge days into the all-consuming love affair celebrated in these letters.

Eileen's remarkably forgiving letter from her hospital bed, with which this volume opens, was just the first trickle in an unstoppable flood of words that passed between them over the long years of war. At some stage Gershon's letters to her were either lost or destroyed, but he preserved hers to the end of his life, more than a thousand of them in all, written from air-raid shelters and office desks, on buses and station platforms, in hotel foyers and under hair-dryers, in that minuscule hand of hers that could have damaged stronger eyesights than Gershon's.

Like the lovers in a poem of Donne's – a God in her pantheon second only to Shakespeare – Eileen lived through Gershon, happy only when she was writing to him or when a letter from him arrived to obliterate the space between them. In many ways the letters are closer to a diary than love letters, and closer still to an uninhibited and unstoppable stream of consciousness than either – a 'complete chronicle' of her life, waking and sleeping, as she put it – with that 'little room' of Donne's lovers that she inhabited, peopled with a wonderful array of characters and incident.

Even were these letters less brilliantly written they would still be of historical interest for the people Eileen knew, from

wartime cabinet ministers, financiers, soldiers, philanthropists and art collectors to some of the major figures in the Zionist movement and the future State of Israel. She was lucky to have been part of a very bright Cambridge set, and yet it is just as much the London beyond her friends and family, the London of chance meetings in cinema queues and Lyons Corner Houses, of overheard snatches of conversations in restaurants and shelters – the London of the Blitz – that gives her letters their life and their colour.

These letters – vibrant, intimate, joyous, dark, angry, obsessive, neurotic, generous, scurrilous and very, very funny by turns – can speak for themselves, but something needs to be said of the remarkable woman who wrote them.

Eileen Helen Alexander was born in Cairo on 13 April 1917, the oldest of three children of Vicky Mosseri and Alec Alexander, a much-loved and highly successful South African-born and Cambridge-educated Cairo barrister of impoverished Polish Jewish parents. While it was from her father that Eileen inherited her intellectual rigour and fierce attachment to Cambridge, her Italian Jewish mother's influence was equally marked. Each summer the Alexanders would escape the Cairo heat for the Highlands of Scotland and London's Mayfair Hotel, but it was as 'a poor little rich girl', surrounded by the uncles, aunts and cousins of her mother's sprawling, immensely wealthy, and interrelated Mosseri family that she spent her cosseted and unhappy childhood. 'I think I should inform you that she is a very brilliant daughter of a very brilliant father,' Eileen's headmaster at the Cairo English School began a letter in support of her application to Girton in the summer of 1934 – a reference that tellingly says more about her parents than it does Eileen:

> Mr Alexander is a Jew and Mrs Alexander is a member
> of the Mosseri family, one of the principal Jewish
> families in Central Europe and the Near East. She
> also is a woman of very great ability and the widest
> education ... Mrs Alexander is extremely particular, not
> to say old-fashioned, in the upbringing of her daughter
> and until the time comes for her to go to Cambridge

> she would, I know, hesitate to send her to England
> alone or leave her there after her own departure ...
> Eileen, herself ... hopes to be called to the Bar and it
> is her ambition eventually to enter Parliament.

If ever one heard the voice and ambitions of the parent rather than the child it is in that last sentence, but if Alec Alexander had already mapped out the future for his daughter, Eileen had other ideas. When 'I was about sixteen,' she wrote later,

> my father hauled me off to Cambridge to see the
> Mistress & the Director of Studies in Law (I knew I
> was going to read English but Dad refused to believe
> anything so revolutionary – so, in spite of my protests,
> he arranged that I should be interviewed as a
> prospective law-student). It was a grilling day in
> August, I remember. I dressed very carefully in my
> best clothes to give myself confidence. (I was very
> frightened) Dad took one look at me & said that he
> wasn't going to be a party to the prejudicing of my
> chances – by letting me appear before women of High
> Living & Thinking, with short-sleeves (it was, as I have
> said before, a grilling day in August) and looking as
> though I were an associate of the doubtful revels of
> Brighter Mayfair. He ransacked my wardrobe, while I
> stood by, crying – and drew forth a knitted jersey
> which I kept for fishing in Scotland – a very old skirt
> and a pair of hearty shoes – and said 'wear those'. I did
> – and cried all the way to Cambridge ... We had an
> uneventful interview with the Mistress – but I
> recovered my self-respect with the D of S in Law. She
> and Dad were obviously twin souls. They discussed
> highly technical points of International Law for a long
> time – while I sat languidly staring out of the window.
> Then she turned to me & asked where my particular
> interest in the Law lay ... I said – nowhere – I was going
> to read English. She drew herself up to her full height,
> turned a cold eye on my father & asked him why we

were seeing <u>her</u> if that was the position. He had
nothing to say in answer to that & we withdrew
hastily.

It would be another two years before Eileen finally escaped parents, siblings and a Cairo she had grown to hate, but in the October of 1936 she finally had her wish and left to study English at Cambridge. The official college photograph of the Girton entrants for that year shows the young woman whom Gershon would have first met, uncomfortably perched second from the right in the third row from the back, a nineteen-year-old who looks little more than half that age, a schoolgirl 'bent on celibacy', as she put it, and still recognisably the same physically awkward, emotionally uncertain adolescent her father had dragged to the Girton interview two years before.

If this is nothing like the whole story – in a college full of 'Amazonian clergyman's daughters with bulging, scrawny legs' she was happy enough to play the 'Mosseri card' when it suited – it is worth keeping in mind this Eileen because for all the brilliance and intellectual swagger of the letters this is the young woman who wrote them. She had come up to Cambridge, too, with every hope of emulating her father's dazzling record, but if a 'second' in 'Prelims' was not disgrace enough for an Alexander, she had spent the summer of 1938 – 'ill with anxiety' from her father's 'intellectual demands' – recovering in the Evelyn Nursing Home from a duodenal ulcer which had stopped her even sitting the Part I of her English Tripos.

It was a low period in her life, brightened only by her first meeting with Gershon, but a year later redemption had come. As she set off to meet her parents with Gershon driving her car, 'Semiramis', it was to give her father the news that she had gained one of only three firsts awarded that year to women in the English Tripos. She had also won a college prize, and with a place at Cambridge to begin research with the promise of some teaching, her academic future seemed assured. All she had ever wanted as she grew up, she said, was to be a Cambridge don, and now there seemed nothing to stop her.

*

We first meet Eileen in July 1939, recovering in hospital, her hopes for the future still alive in spite of a worsening situation in Europe. When she is well enough to travel she goes for the summer to the family's holiday house near Drumnadrochit, high above Loch Ness, and it is not until 23 August, the same day that the Nazi-Soviet non-aggression pact is signed, that the first half-fearful, half-comic references to the outside world break in on her letters. From this point, as it becomes clear that there is to be no second Munich, the fragile quiet that had held since Germany's annexation of Czechoslovakia in the spring unravels at frightening speed. On 24 August, Parliament passes an Emergency Powers (Defence) Act, giving the government control over virtually every aspect of national life. On the 25th, Britain and France reaffirm their commitment to Polish independence and territorial integrity and, six days later, in the early hours of 1 September, German troops cross the border into Poland. By 6 a.m. that same day Warsaw will be under air attack and Britain and France left facing the consequences of their Polish alliance.

Love in the Blitz

Love in the Blitz

Drumnadrochit, summer 1939

Gershon – what everyone seems to have forgotten is that if I hadn't asked you to drive me to London that Tuesday, you would never have had your arm broken & your life thoroughly disorganized for a considerable period of time – Furthermore if I had directed you rightly we'd never have got into that damned death trap of a side-road.

I have been brooding on this for a very long time Gershon, and at nights I have lain trying & trying to recall something about the accident but I simply can't remember a word, so I shall not even be able to help you by corroborating your evidence.

Whichever way the verdict goes, please remember that I feel, absolutely certainly and sincerely, that the accident was not down to your carelessness but to pure chance, and that I owe you nothing but profound gratitude for the friendship and loyalty you have shown me during all these weeks of illness.

The very best of luck Gershon – I am looking forward to seeing you after this irksome business is all over, today.

WEDNESDAY 19 JULY Talking of my appearance – assuming (rather dangerously – for I never can tell with you whether what you say is what you mean & vice versa – as I think I've said before) that you were serious when you asked me to give you a photograph of me – I asked my mother whether we had any copies of the Family Features still in our possession – but, no, it seems that all 24 are scattered among Alexander's and Mosseri's over an area stretching

from Cape Town to Vancouver – so, alas, I cannot send you one of those, but must wait until my transitory (as opposed to permanent) blemishes have gone, & then have one done especially for you at one of those kind <u>misty</u> photographers who define one's eyelash, a shoulder curve, & the tip of an ear, and have the rest enveloped in a kindly greyish haze. (I <u>mean</u> that you shall have a photograph of me if, though I can hardly credit it, you really want such a useless commodity.)

<u>FRIDAY 21 JULY</u> My face is now fully exposed to the world & it looks like the rear elevation of a baboon. This is very disconcerting, as it gets no better & I am going to be driven very slowly to London on Monday for X-ray treatment. I'm so glad I didn't show it to you on Monday – it is perfectly horrible & I don't want anyone to see me while it's like this. I do hope they'll find something to cure it – it looks like bright pink – and – yellow leprosy to me but the Doctors will never listen to a lay-diagnosis.

<u>FRIDAY 28 JULY</u> Yesterday my parents went to Cambridge to choose lodgings for me, and I had a <u>lovely</u> evening when they came back, listening to their accounts of all the people they met, (while calling on Miss Bradbrook in Girton) who told them how clever I was – D'you think I shall ever get used to the idea of being clever, Gershon, or believe that I really am? (The odd thing is that though I don't feel in the least convinced of it myself, I <u>love</u> other people thinking it.) Apparently they have found magnificent rooms for me – and quite near the Evelyn too, just in case!

Aubrey sent me the *Cambridge Daily News* with its beastly little mean-spirited lead-line & account of the accident. I think it would be a good idea if you had a Medieval Shivering of Lances with the Editor while I hid beneath a bush – prodding him in the behind with a two-handed sword – but this is as you please, of course.

Dicky is in our midst once more. At present he is concealing his fiendlike personality beneath a well-bred and charm-dripping exterior, for some reason known only to his Machiavellian self. My parents have swelled several inches with pride in his 'reformed' self. He has further won their hearts by being second in his form for the term – which is an improvement on a steady

record of last place. Personally I feel he is brewing something <u>perfectly awful</u> & is waiting to get to Drumnadrochit to spring it on us all. However, perhaps I am wrong after all – I hope so. If an explosion occurs in Scotland I'll send you an expurgated account of it. Dicky's language, on the occasions when his brow is blackened with wrath, is not repeatable.

<u>WEDNESDAY 2 AUGUST</u> The train journey from Edinburgh to Inverness (180 miles) took longer than the journey from London to Edinburgh (410 miles) & we arrived an hour late. And the jolting was phenomenal, even for a branch line Scottish train.

But all this was nothing to the 15-mile drive from Inverness to Drumnadrochit. We have an old Ford 8 here which Dad uses for fishing & which has no springs at all, to mention. The road from Inverness to the village of Drumnadrochit is very good, but no surface can soothe the vibrations of our old Ford – and as for the last three miles – from the village to our house – Christina Rossetti's poem, 'Does the Road wind uphill all the way?' was inspired by this very stretch of squelching mud – to call it a road would be forever to debase the word.

So I arrived thinking my head was cracked in two & I looked around at the familiar drawing-room furniture with a jaundiced eye – & thought with loathing of five weeks here without electric light – the shrill voices of my family converging on me from every angle – and the eternal gurglings of drain-pipes in the bathroom next door. This is a squat, grey little house – & <u>looks</u> solid enough – but it must be built of twigs because every sound made <u>anywhere</u> in the house can be heard <u>everywhere</u> else. It reminds me of Chaucer's House of Rumour.

But, for all this, I feel better this morning – & I look better too.

<u>THURSDAY 3 AUGUST</u> Oh! dear, Gershon, (observe the comma – I am <u>not</u> being forward!) I wish you weren't so much cleverer than I am. When I first knew you, I was always in a state of waiting breathlessly for you to find out that I wasn't clever, & erase me from the tables of your brain for ever – then I thought oh: well you must have found out by this time & were kindly overlooking it – but the

more I saw of you, the more things I discovered you could do that I couldn't – you could understand music, and pass your driving test at the second attempt, and play games, & follow the Hebrew in the prayer book without using your finger, & be forward without being impertinent, & sing in the street without being foolish – & all kinds of other things too – but this last display of versatility is too much – you can type as well – and in two colours – and two different sizes! What can I do but say humbly that it's been an honour to know you?

Are you going to be at Ismay's wedding or will you be travelling home on that day? (Surely if you wait until the 13th you will be using a public conveyance on the New Year which would be horribly un-kosher of you and put you out of Beth Din* spitting range for ever!) I shall have a new tooth for that day – (my dentist has promised me most solemnly to have it ready) & it will be my first public appearance since the accident. So if you aren't there I shall probably cry – but no matter! I was very perturbed to hear that Ismay had chosen a Rabbi not labelled by Beth Din either – How awful! But I feel sure that she'll give such an air of respectability to her life of sin, that we'll all be shaking our heads and declaring, in about a year's time, that we must have made a mistake, after all.

<u>TUESDAY 8 AUGUST</u> It is charming of you to look forward to my letters with 'unreasonable impatience' – that is exactly how I look forward to yours – though I'd never have been able to express it so aptly myself – nor so prettily! There is nothing more to tell you about my collar bone. You knew it was dislocated, didn't you? If not I can't think how I forgot to tell you – you must have distracted my attention!

Your suggestion about our being seen together at Ismay's wedding did not surprise me much, after your startling revelations about Mr Zeigler, D. Machonochie <u>and</u> the Prosecuting Solicitor – but I was mildly shocked to realize that things had gone so far, that we wouldn't be able to go to a huge reception – and there nod to one another in friendly greeting & perhaps exchange a casual

* Beth Din or 'house of judgement' is a rabbinical court of Judaism.

word, without giving rise to whisperings & head-waggings of the kind you suggest. I see that it is going to take us a long time to Live This Down! This is, in its way, a pity, but I think we'll survive it, don't you?

I was relieved to read your delicately worded confession that you would be in Cambridge next year – (this is an understatement – but I feel I must learn to be a little more <u>formal</u> and less <u>forward</u> with you, before we meet at Ismay's wedding, in view of all the inquisitive eyes that will be upon us there).

<u>SATURDAY 12 AUGUST</u> On Monday the family circle will be widened by the inclusion of my cousin Jean & Aunt Teddy, & from then, onwards, we shall have visitors the whole time, which will break the monotony of purely rural occupations a little, I hope. We expect to be in London on September 6th – & on the 15th my parents are going to Paris. <u>They</u> are trying to <u>persuade me</u> to go with them – but I loathe the Channel – hateful, bulging, oily, green horror – and feel disinclined for the French, at present – so <u>I</u> hope to be able to <u>persuade them</u> to let me go & stay in the country with friends until the beginning of term. Pray for me. I am <u>so</u> tired of la vie de famille.

Please write and laugh at me for thinking you are cross with me, Gershon – (if you <u>are</u> angry you can laugh satirically, or sardonically if you prefer it – and if you are not, you can laugh comfortingly – but <u>please</u> laugh!).

<u>MONDAY 14 AUGUST</u> You know, it is a strange thing, but everyone has suddenly started to say kind things about my appearance since the accident. It is rather like the kind of thing which is raked up about the character of the deceased in an obituary notice. Joan Aubertin was in Girton the other day, & she met Maureen Stack & Jo Manton – (d'you know either of them? No? Neither do I – but we know one another by sight). They gossiped about this & that & apparently my injuries were mentioned – and they said they <u>hoped</u> my face wasn't spoilt. It was such a lovely <u>serene</u> face & reminded them of the Monna Lisa!!! (No, Gershon, they were <u>not</u> mistaking me for someone else – they know me <u>very well</u> by sight.) Joan retailed this in a letter to my father with a sardonic chuckle behind

every word – but he lapped it all up & was simply delighted, & came & waved the letter at me.

Because I feel full of the milk of human kindness, I'll concur in your judgement of Nachman. He bores me & always will – but that, as I think I told you, is because he never laughs at me – it casts no slur upon his character or intelligence. Lois is another matter altogether.

SATURDAY 19 AUGUST It was nice of you not to be sceptical about the Monna Lisa comparison. (Monna was a 13thC. Florentine abbreviation for Madonna – in fact an exact translation of m'lady – and so although I know all about how the vulgar herd spell this (conjectural) name for Leonardo's *Gioconda*, I stick to Monna which is pedantic but Right.)

TUESDAY 22 AUGUST Hamish came to see me on Sunday – (Charlotte is back in Edinburgh). I told him politely, but with a subtle inflection of enquiry in my voice, that Charlotte had written to me. He gave me a long and involved explanation of this phenomenon – (his story is that she got so tired of the sound of my name (!) that she got quite nasty about me. Hamish explained to her, with dignity, that he and I were on a Higher Plane – and finally brought her to see me – whereupon she was immediately reassured – one look at me was enough to convince her that here was no rival for her charms – and her letter was a subtle (?) tribute to her restored faith in Hamish – and her Absolute Confidence in me). It was a good story, told in Hamish's inimitable voice & enlivened by Hamish's inimitable mannerisms but I doubt if we've got to the core of the matter, even now.

WEDNESDAY 23 AUGUST I wish I were a Cabinet Minister, Gershon – I'd have been so clever – nothing like this could ever have happened.* When Italy attacked Abyssinia, I'd have put two nasty, bristling battle cruisers across the Suez Canal (strictly illegal, of course –

* In 1935 Mussolini had brutally invaded Abyssinia in defiance of the League of Nations, driven the Emperor Haile Selassie into exile and proclaimed a new Roman Empire. Fearful of war with Italy at a time of the growing German threat, Britain, like France, had shied away from effective sanctions and allowed Italian warships unhindered access to the Suez Canal.

but oh! what a gesture) and then I'd have cocked a snook at Mussolini (I never liked his face anyway) and I'd have written a rude note to Hitler saying that I knew all about why he was holding Mussolini's hand – so as to keep his mind off Austria.

And <u>now</u> look what a nasty mess we're in – all because no-one thought of including me in the Cabinet. It gives rise to 'thoughts that do often lie too deep for tears'. Ah! well, let's eat, drink & be merry for tomorrow we die – tis a maxim tremendous but trite.

As a matter of fact, I'm frightened. I just wanted to tell someone I was. Let's not mention it again. You're not thinking of sprouting into a handsome territorial, or anything, are you? don't – darling – (not that I really think you would – but I'm being Forward and, (I hope) appealing, just in case you <u>had</u> considered it).

My aunt is clucking helplessly. Jean keeps on expecting a wire announcing her instant mobilization. My father prophecies a cataclysmic collapse in Germany, after which everything will be All Right. (He believes the Russo-German pact to be a wild clutch at a swirling-away straw by a drowning Fuhrer.) I go out & stir up rabbits – I prefer rabbits to political arguments. What's done is done. She wept because she had no more to say.

Dear me, this is a very unsatisfactory letter. The truth is that I want to be comforted.

<u>FRIDAY 25 AUGUST</u> In case of war I think my mother and the children will stay here. Dad will go to London to see in what way he can be of use, and I have written to Leslie HB's* secretary asking her advice as to what kind of job I'm fitted for. Don't worry, I don't intend to offend the aesthetic sensibilities of my friends or the nation by blossoming forth as a WAT Or a WREN Or a WAAF or even a land-worker.

My father doesn't think there'll be a war. He bases his belief on that old saw about right triumphing in the end – and also on a conviction that the Führer is played out.

* Leslie Hore-Belisha, Secretary of State for War. An old friend of the Alexanders, he had holidayed with them at Drumnadrochit.

Dicky is getting more and more insufferably insolent. I'd like to beat him hard. I wish you were here to do it for me – as a matter of fact I wish you were here – (but that is a forward admission, & quite by the way). There's a sort of heat-vapour of suppressed hysteria in the house – which makes me feel I want to scream & scream. It is no-body's fault – but it's Hellish. Your letters are the only things that happen, to make me smile.

I blush, Gershon, I really do, to think of the number of letters from me which will await you on your return from Liverpool. (Though I am forward, I am not brazen – yet.)

MONDAY 28 AUGUST I had an agitated letter from Joyce by the same post as your two. If there is a rent in the clouds – she is coming up here at once – otherwise she will be evacuating school-children for her Country.

I liked the fatherly touch about 'one oughtn't really to worry about individual skins'. Of course one oughtn't, *mon cher*, but one does – and the more shocked one is by the unethicalness of worrying, the more one worries, because in addition to worrying, one worries about one's own shortcomings which make one worry – if you see what I mean – and I shouldn't blame you if you didn't. Anyway, (and I say this defiantly, though firmly) I'm glad you're not a Territorial – though I don't suppose that will prevent the War Office (damn it lustily) from sending you off to prod Germans in the rear from the Maginot Line, while they are busy trying to squeeze into the corridor, if & when war breaks out.

Of course, I was saddened to hear that you had had my blood cleaned off your suit – but I do see the position. It would have been a fine gesture to arrive at Ismay's wedding all spattered with it – but it might have caused Comment or even Gossip – and then – Reputation, Reputation, we'd have lost our Reputation – which would have been a pity – but it was uncommonly civil of you to say you wouldn't let anyone else bleed on it. If anyone tries, just push her onto the ground, and let her bleed on that!

WEDNESDAY 29 AUGUST If there is no war, we leave here next Tuesday evening and hope to arrive in London on Wednesday morning – (bless we the Lord. Let's praise & magnify him for ever, if we are

able to proceed according to plan). Excavations on my tooth are scheduled to begin on Thursday 7th – but I don't think my chin will be quite itself again in time for Ismay's wedding. It is getting paler – but slowly. Eventually I think it will disappear altogether (I mean the redness – not (I hope) the chin!) but not for some time, yet.

FRIDAY 31 AUGUST Your letter has just arrived, Gershon. Your reprimand was more than justified and, in the circumstances most kindly expressed. From now onward, the expression 'I shall never be the same again' will be wiped from my epistolary slate for ever, though it is only fair to warn you that, after taking this drastic step, I shall never be quite the same again! And there is a condition attached. 'Sweet-darling' must be immediately erased from your vocabulary. It does not suit you – or me – and it is not funny.

I thought, like you, that we had the Führer in a corner – but now I don't know. I don't understand anything, & I want to say – I'm glad you only feel a healthy glow. My inside is now minced as well as mashed. Thank you for your solicitous advice about what I should do in the event of war – (in this, you and my parents are at one – we have established an armed neutrality on the subject – there's no point in arguing with them until I hear from Miss Sloane). I could not possibly stay here more than a week or two if there was a war. I am perfectly healthy now – but in a very dangerous state of restlessness because I have nothing to do. When I say dangerous, I mean that I haven't forgotten that nine weeks ago I was sure I was going mad, (this state of mind was only indirectly due to the accident – ever since I was eleven or twelve, at all times when my mind was not fully occupied with work which was tough & impersonal, I have watched myself fearfully for signs of a lack of mental equilibrium – I don't know why – I just did) and unless I have some very definite and absorbing work to do, soon – I shall get worse.

I had a letter from Jean this morning. She has been mobilized – at which she is not amused – nor am I, for that matter. As a member of the auxiliary air force, she will spend the entire duration of any war training recruits at humming aerodromes all over the country. She is the only one of my 52 first cousins (except

Victor, whose face I slapped, but with whom I am very friendly for all that – which, on the whole is magnanimous of him) of whom I am really fond.

Now that Ismay's wedding is post-poned, (sorry – wrong word – I mean now that it is a 'fait accompli') I presume that we shall not leave Clunemore on the 5th, unless something absolutely definite happens one way or another before then – but I don't know. If the status quo is maintained, during the next few days, perhaps you would very graciously go on writing to this address – also, if war breaks out. If anything unexpected happens in the way of a Peace conference or the like – then I expect my address as from Tuesday, 5th will be 'The Mayfair Hotel, Berkeley Square, London W1' (Note the forward manner in which I now just take it for granted that you are going to write to me! Oh! Indubitably, I am not what I was! Hubris again, Eileen – oh! Nemesis is close at hand – beware).

Oh! by the way, to revert to this photograph question. When we last met, you asked me for a photograph of my counte-nance, if and when it returned to its old 'chubby' symmetry. (Ill as I was, I was touched at your choosing the word 'chubby' in prefer-ence to 'fat'. These are actions that a king might show.) On the strength of this request, I bullied you into having your photograph taken for me. Now I feel in duty bound to 'fulfil my obligations' if you wish to hold me to them. (It most certainly is not too late to withdraw – negotiations have hardly started. I can't even have proofs taken, until my broken tooth is restored – but let me know, and I shall, in all my best, obey you, sir.)

September 1939–April 1940

With the German invasion of Poland, war had become all but inevitable. On the same day that German planes bombed Warsaw, Britain's army was mobilised, and as the evacuation of mothers and children from major cities began, and London sank into the darkness of the first blackout, the country waited every hour for the declaration of war that still did not come.

At 9 a.m. on Sunday 3 September, after another two days prevaricating, Chamberlain finally bowed to Cabinet and parliamentary pressure, and an ultimatum was delivered to the German government. At 11 a.m. it expired unanswered, and the country finally, and unheroically, stumbled into war. Six hours later, an even tardier France followed suit. The long 'half-time' of peace was over.

This would be the last summer the whole Alexander family would spend together at Drumnadrochit. That Sunday morning they sat around the wireless and listened to the prime minister's broadcast to the nation, and as their holiday neighbour, Mrs Ironmonger – an aspiring Lady Novelist who had tormented Eileen with her unpublished manuscript – hurried back to Liverpool and ambulance duties, and her son to his Territorial unit, a frustrated Eileen was left in her Highlands limbo, with her parents, brothers, family nurse and the Alexanders' customary gaggle of hangers-on, wondering what she was going to do.

In these first weeks of the 'Phoney War', when no German bombers came, and the RAF dropped leaflets on Germany, and city evacuees drifted back to their homes, a curious sense of anti-climax settled over Britain. On 4 September the first advance units of the British Expeditionary Force had

sailed for France, but the only real fighting was taking place a thousand miles to the east, where a doomed Poland fought on alone.

When more than a month later Eileen finally returned with her mother to London, before going on to Cambridge to begin her research on Arthurian Romance, it was certainly the normality of home-front life rather than its strangeness, that would have struck her. The Emergency Powers Act (Defence) had given the government dictatorial powers over the whole gamut of national life, and yet while barrage balloons floated above London, air-raid wardens patrolled the blacked-out streets and everyone now carried ration books, identity cards and gas masks, the cinemas were again open, rationing – except for petrol – had not yet begun, the gas and bomb attacks had not materialised, and 'everything that was supposed to collapse', as Eileen's great friend Aubrey Eban recalled, 'went on exactly as before'.

It was the same when Eileen moved into her rooms at 'Girton Corner' in the middle of October, with Cambridge very much the Cambridge she knew and many of her old friends still up. On the outbreak of war, Parliament had brought in conscription for all men between the ages of eighteen and forty-one, but Gershon's age group had not yet been called up and he was back at King's, studying law, starring in union debates alongside Aubrey, and exchanging notes and letters with Eileen, just three miles down the road, as if the war did not exist.

War, however, was closing in. On the day that Eileen and her mother had left Drumnadrochit for the Mayfair Hotel in Berkeley Square, Poland finally succumbed, and German armies began their move from east to west. In December the Battle of the River Plate gave the British public a rare victory but the New Year brought little else to cheer. Abortive plans to help Finland and simultaneously deny Germany Sweden's iron ore would lead to the chaos and humiliation of the Norway campaign. Merchant losses at sea prefigured the long and desperate fight against the U-boat that lay ahead and by January the first food rationing – sugar, butter, bacon – was introduced. Before the New Year was a week old, too, the Alexanders' much-loved old friend, Leslie Hore-Belisha, the Secretary of State for War, bitterly at odds with his own generals, had been sacked.

As Eileen prepared to return to Cambridge after the Christmas vacation, across the Channel the BEF dug in along the Belgian border next to their French allies, and waited for an attack they were ill-equipped to resist.

'No time to sit on brood'

On hearing Hitler's 'peace' proposals over the wireless last night, I begin to feel a warm glow at the idea of punishing the insolent brute, as well! The beautiful impertinence of the suggestion that – (given twelve months for the dissemination of Nazi propaganda & terrorism in the Corridor) he would like another of those now-notorious cooked plebiscites – is really almost inspired! I don't think even our simple-minded Neville would fall for that one again, somehow. Do you?

I have now heard from Miss Sloane. There is nothing but clerical work at the War Office for the present – but she advises the Censorship. I should apply immediately, she says & I shall probably have to take an exam, soon. Thank God for that. Can't you see, Gershon, how I come to life again, at the very prospect of something to do?

I had a pathetic card from Ismay this morning. She is staying in Sussex with Charles. He can't be far away from London, as he expects to be called up any day.

I have written to the Censorship office, telling them how clever & useful I am, and how silly they'd be not to have me. I intended to write the letter myself, but I turned all bashful at the last minute & couldn't take the responsibility for such a lot of lies, on my own shoulder – so Dad dictated a gem of a document. If you only knew what a mine of precious ore you'd held, bleeding down the front of your suit, ten weeks ago – you'd never have sent the suit to the cleaners.

We have just been listening to Chamberlain's announcement that we are at war. There is nothing more to be said except God bless you and keep you, and everyone else who is going to help in blotting out slavery & brutality, from too much sorrow and pain. I'm afraid this sounds banal – but I mean it, Gershon.

Let me have news when you can – because I shall be worrying and wondering, at all times, about the whereabouts and safety of all my friends in vulnerable areas – but once again let me reiterate that a post-card will be enough if you haven't the time or the inclination for letter-writing.

You must be worrying a great deal about your parents. Has your younger brother been sent away to a place of safety?

Under the new Conscription Act* – I suppose you will soon have to start training for a commission.

This declaration of war has had an astonishingly Cathartic effect upon me. 'I have not youth nor age – but, as it were, an after dinner sleep, dreaming of both.' The rain is coming down in a thin drizzle and there are wisps of fog crossing the tops of the hills. It is very dark.

We are as safe here as we could hope to be anywhere. Don't worry about me, please. I am getting better astonishingly quickly, and soon, I hope – I shall be perfectly fit to do useful work wherever I can be of help.

I hope you are less thin & tired than when I saw you last. Forgive my clucking (nature will out) but do take a tonic if you're not – an army marches on its stomach, after all – & people with concave tummies have to crawl along on their ribs – which is uncomfortable.

Good luck, Gershon darling, and (as Miss Sloane said) may we soon meet again in Peace.

Don't be alarmed at the solemn, not to say sententious, tone of the last part of this letter. I can & shall smile still, but I did want to say just once, quite seriously, what I was thinking. It won't happen again.

* In May 1939 the government had introduced a very limited programme of conscription, and on the outbreak of war this was superseded by the National Service (Armed Forces) Act, under which all men between the ages of eighteen and forty-one, with numerous deferments and exemptions, became liable for conscription.

<u>WEDNESDAY 6 SEPTEMBER</u> I had another letter from Joyce this morning. She is definitely going back to Girton next term. I think she's wise. I would do the same, were it not that I feel compelled to try & be as useful as possible – and I shan't do that by digging myself deeper & deeper into the middle-ages. I simply <u>cannot</u> go on living on my parents any longer – though they would, not only willingly, but gladly, go on supporting me in luxury forever. I have, however, written to the Mistress of Girton,* asking her if there's any work I can usefully do in Cambridge – and to Miss Bradbrook. I'd be happier there, than in a strange sea-port, prying into other people's private letters. But if neither the Censorship nor Girton can make use of me, then I think I'll write to Dr Weizmann & see if he can include me in his scheme for organizing Jewish brain power!! The old boy is about as fond of me as the Chief Rabbi is (I have found it necessary at times to use the same methods of intimidation upon him – when he comes over the heavy leader and martinet) but surely he won't allow personal prejudice to interfere with the Public Weal – what d'you think?

Now about your air-raid adventure. How damnable! But I really don't see why you, and millions of other people (many of them a lot more uncontrolled than I am), should be submitted to this kind of experience, while I sit snugly in the North feeling safe. It simply <u>isn't</u> good enough, Gershon. I'm a physical coward of the first magnitude – but so are thousands of others – it is not customary to <u>pander</u> to fear. No doubt I, like everyone else, would soon get used to the sound of Air Raid Sirens, and the dazzle of incendiary bombs. If being a nice girl entails being regarded by one's friends as on a mental level with an evacuated schoolchild of tender years & snivelling habits – I wish I weren't a nice girl. I <u>know</u> I'm not 'self-composed in crises' – but it's about time I learnt to be, & this seems to me a good opportunity to begin.

* Helen Marion Wodehouse (1880–1964).

FRIDAY 8 SEPTEMBER It's funny that you should refer in your letter to the myriads of first cousins who have a claim on the Alexander hospitality – because only yesterday we had a wire from Jean's mother to say that we may expect her, (Aunt Teddy), Jean's sister & Jean's niece (aged two – Ye Gods!) on Sunday morning. So the family circle is due for expansion soon.

My future was the subject of much discussion yesterday between my parents and myself. They lean towards the suggestion that I should stay here until term begins & then go back to Cambridge for Research as long as they can afford to keep me there. The cultural work of the Nation, says my father with a wide arm-swing, must go on. How I wish my conscience would allow me to believe that they're right. Other suggestions were that we should all go back to Egypt together as soon as it's practicable – but I'd see myself dead before submitting to that.

I was very startled at your talking about conscription as though you thought a few months was the maximum length of time, you could hope to be left at liberty. I think it would be fantastic of the government to make a soldier of you – you'd be invaluable in all sorts of other ways – but unless you bring yourself to their notice – they'll never find out. *O mon dieu, quelle vie.*

I had a long letter from Ismay yesterday. She had five days of honeymoon – then Charles wrested from her. He's back again now, with ten days' leave – then he's due to go away again – she doesn't know where or for how long. Poor Ismay – her sang-froid has completely deserted her. She almost clucked (but not quite, because, like Joyce, she's too dignified ever to sink as low as that, even though she has just cause. I wish I were a little more like my friends).

THURSDAY 14 SEPTEMBER The war has brought solace to one person of our acquaintance, anyway. Joan Friedman. Raphael Loewe has written to tell her that his country calls, but that he's probably too short-sighted to be of much use. This, after a silence of several months (I suppose he had to work off his patriotic zeal on some-one). Dear Joan – though she doesn't know it, she's got a Jocasta complex about Raphael (is there such a thing?) You see, she loves him like a mother – but unfortunately she doesn't realize it – which, in its way, is a pity.

(By the way, darling, are you too short-sighted to be of much use to the British Army? It's a beautiful thought anyway.)

SATURDAY 16 SEPTEMBER I have just heard, from the mother of a friend of mine, who is a Cameron Highlander (one of the few regiments still to wear kilts, even in battle), that he has been issued with a pair of gas-proof pants to wear under his kilt. (The official army name is 'proofed nether garments'.) The legs unroll to make protective gaiters which are buttoned under the instep! Let it not be said that England doesn't look after her warrior sons.

MONDAY 18 SEPTEMBER My future seems to be taking shape – but (as I may have said once or twice before) no man should be declared happy until he is dead. The censorship doesn't want me at present – but if I'll fill in a form all about the colour of my hair & my mother's nationality and take their exam at my own convenience – they'll put me on their waiting list. The Mistress of Girton says – come to our arms my beamish girl – there are, at present, no specialized war jobs for girls under 25 – so stick to Research

Oh! Gershon, I want to Research in Cambridge – but there are grave difficulties. The college can't house me – and my mother sends feathers flying with her clucking at the thought of my living in lodgings with bombs banging about. (The beautiful rooms she'd chosen for me are now out of the question on financial grounds – and I'd have to live where the College sent me – and like it.) My parents and I are going to have a session to consider the problem, this afternoon. I'll let you know the results.

My parents and I have now sat down to this question of Cambridge or not Cambridge. It is damned difficult. My father says, 'We cannot commit ourselves,' (with term 2 weeks away!) My mother says, 'If they'd have you in College, you could leave tomorrow if you liked,' – and points out that I'd be as miserable as sin in strange lodgings – not being able to go out at night, and having to sit alone in a probably hideous room – going mad. Then she cries at having to oppose my dearest wish – at this point I cry too – at having to oppose her – and my father relents and says, 'Well, write to the college and ask them what sort of lodgings are available – and where – and then we'll see', – and then the wireless announces

the sinking of the air-craft carrier *Courageous** – and Dad says, 'Look at those poor people,' – and I do – and feel a cad, & cry a bit more.

Yesterday, I cured all my humours by cleaning my vinaigrettes.† I haven't had the heart to look at them since the war started. They are looking lovelier than ever – bless them. May they never be subjected to the ordeal of fire.

THURSDAY 21 SEPTEMBER Today or tomorrow I expect to hear from Girton whether they will allow me to live in the gardener's cottage in the grounds, until something more satisfactory can be arranged. I don't expect, for a moment, that this will seem to them a practicable suggestion. A month ago, I was their blue-eyed darling, & the trouble they took over me, one way or another, was phenomenal. Now their sense of proportion has undergone a violent readjustment. They think I ought to go back (for my own sake) but they don't care a damn if they never see me again – and the twitterings of me & my parents are a matter of superlative indifference to them (and I can't say I blame them).

I've cried so much during the last week that I really begin to feel, as Shelley would say, like a cloud that has outwept its rain!

Actually, of course, I am fussing disquietingly about very little – what on earth does it really matter whether I go back to Cambridge or not? At this moment I see it as a life or death question – but once a decision is made, I'll get used to it. Oh! I shall get used to it shan't I, Gershon? Instead of being secure & pampered, I might have been a Central European or German Jewess, mightn't I?? – and then I'd have had something to cluck about. This happy thought, instead of restoring my sense of balance, only adds humiliating self-disgust to my other discomforts. I wish you were here – and you could shake me until my toothless gums rattled together – it's the only fitting treatment for me.

* The sinking of HMS *Courageous* off the coast of Ireland by a U-boat with the loss of 519 lives. Hailed as a triumph in Germany, it came as an early blow to British pride in the Royal Navy.

† 'An unconsidered trifle of the goldsmith's art', the vinaigrette was a small ornamented container with a pierced grille containing a perfumed sponge. A lifelong passion of Eileen's, she would have the best collection in England and after the war write a book on the subject.

I had a letter from Miss Bradbrook. All the double sets of rooms are being converted into single bed sitting rooms (poor Joyce!) – and Miss Bradbrook says they're living like pigs. It must be pretty bad, for her to notice anything because, in the ordinary way, she has a Soul above Space – but there you are – the war has changed a lot of people.

I may say that this photograph business has caused a terrific stir in our ménage. 'Why do you want to have your photograph taken?' asks Aunt Teddy, rudely & inquisitively. 'What on earth do you want a photograph of yourself for?' says nurse – adding more kindly, 'It's not like you to want to be photographed.' 'Is this quite the moment to be photographed my dear?' says Pa. 'Of course you're looking more like yourself, and we haven't had one of you for some time – but ...'

My mother, who is the only one who knows why I had it taken, smiles kindly, although she thinks it forward, if not improper of me to give a photograph of myself to a MAN (other than Pa, of course). She might be less kindly if she knew the shocking spirit of barter in which the whole transaction has been carried out – but she doesn't. I tell my mother more than you tell yours, – but not everything.

SATURDAY 23 SEPTEMBER I lay in bed alternately musing and reading the book of Job. (I do not like the Day of Atonement service. I always read the Bible instead.) The only diversion which occurred during the morning was a letter from the Mistress (in reply to my letter to the College Secretary). She has investigated the matter of lodgings herself. I am to live at 130 Huntingdon Road, in a smallish single room (but who cares?) and she personally guarantees my comfort and safety – and Dad, purified by starvation, and intimidated by her august and brisk intervention, says, 'Yes'.

Oh! Gershon, I am so happy (always bearing in mind that no man should be declared happy until he is dead) that I'm even prepared to admit that (in a non-erotic way, of course) I love you better than my country. (Does it matter which country?)

I am sorry to have to tell you that Aubrey also seems to have noticed that I love you better than my country. (It pains me that my most intimate feelings, however non-erotic, should be so

patent to you both – but, no matter, I shall learn resignation in time.) I am led to this conclusion by the fact that in an eleven-page letter, yesterday, he devotes four lines of verse to the war and five pages to you.

He did not owe me a letter, Gershon, – he just caught sight of a reproduction of the Monna Lisa on his wall, (he spells his 'Mona') detected a facial resemblance between us – and so wrote me eleven pages of profuse strains of carefully pre-meditated art. (In a post-script he says delightedly: 'Something really wonderful has happened – Gershon came in while I was out, saw my Mona (sic) Lisa and stuck a label on saying "Eileen" I swear that we have never discussed it before. So you see how I am proved right by the highest authority available. Who better could distinguish a genuine Eileen from a fraudulent reproduction?')

MONDAY 25 SEPTEMBER My mother looked at the enclosed photograph, shuddered, and said, 'My dear', in a voice charged with meaning, and then handed it back to me in the manner of one lifting an earwig out of the soup. This was not encouraging, so I showed it to Gerta. She smiled and said, 'you do look a hap'. Aunt Teddy glanced at it and said, 'It's a good likeness – but not flattering', and if ever a voice implied that a good likeness of me was a painful sight, it was hers.

I think that, insofar as it doesn't show my scars, my pink chin, or the bump on the bridge of my nose, it's not too bad, considering the material upon which the unfortunate photographer had to work.

TUESDAY 26 SEPTEMBER There is now a further hitch in regard to my proposed return to Cambridge. The rooms which the Mistress so kindly offered me, have been let to somebody else – so chaos is come again. I've wired to Girton for advice, and I'm waiting to see what happens. Pa is seeing everyone in London, and has suddenly woken up to the fact that Drumnadrochit is a backwater. I think he will send for us soon.

WEDNESDAY 27 SEPTEMBER Nurse has come back from London – oh! dear, our peace is shattered again. Of course the first thing she did was to demand to see my photograph and, when I showed it to her, she giggled noisily – slapped me heartily on my sore shoulder and said, 'I think you'd better have another one taken – he photographed the uglier side of your face by mistake.' Nurse has taken the place of Lois as Hate No. 1 on my (at present) narrow horizon.

THURSDAY 28 SEPTEMBER No letter from you by the first post, Gershon! Only nine pages from Aubrey, who is now an Intelligence Officer in embryo. I quote a vital passage from his letter below, to show how interviews with the recruiting board should be managed. Please learn it by heart & say it over to yourself every day before breakfast. Here it is: '... then there was the moment when a decrepit doctor with creaking joints asked me to take off my spectacles and read the letters on the board. "What board?" I asked innocently staring straight at it. This disability disqualified me from a Commission in the Observer's Corps. Some capacity to distinguish an ally from an enemy is apparently regarded as an indispensable asset in war.' Be as blind as you possibly can, Gershon, when your time comes. Aubrey's account of his interview with the Recruiting Board has made me realize, (tardily perhaps) that there's a war on, and that you may be called upon to go forth and get yourself killed in a dirty dug-out in France. I don't mind telling you, that this is a possibility which I find singularly unpleasant to contemplate. It may be eccentric of me – but there it is.

Pa has just telephoned from London to say that he's been appointed to a job in the Treasury as an expert in International Law. I gather that he starts work at once – so he probably won't be coming back to fetch us after all. This means that he may be able to afford the rooms he and my mother originally chose for me in Cambridge – but everything is still very uncertain – he could give us no details over the phone as the appointment is still a secret – and I've no business to be telling you about it.

The three o'clock post has just come – with a letter from the Mistress saying that she's cycled all round Cambridge trying to find me a home! She hasn't succeeded yet – everyone is housing Bedford women & evacuees from the London School of Economics.

She is writing to me again tomorrow. She is, with sympathy, mine sincerely ... and I had the temerity to say that Girton wasn't bothering about me any more. Bless her lily-white head. I hope all her cycling expeditions aren't in vain!

FRIDAY 29 SEPTEMBER This morning I had a letter from Girton. They've taken rooms for me at Girton Corner. The main disadvantages are six children and high tea instead of dinner – but oh! if I could get back to Cambridge, I wouldn't care if it were six boa-constrictors and no food at all! (You're not the only one who's willing to go without your meals in a Higher Cause!) Owing to sundry obstacles like clinging parents, and dentists who <u>must</u> be seen, I shall not return to my Alma Mater (if I ever get there at all – and I'm afraid to believe I shall) until Thursday, October 12th.

We leave here, inshallah, on Sunday 8th, and if you are moved to write to me in the intervening four days, my address (unless you hear to the contrary) will be 'The Mayfair Hotel', Berkeley Square, London W1.

Dad has started work at the Treasury. (It is therefore no longer a secret – when an Alexander is anywhere, it is difficult to look as though he's not, and although all Government departments adore secrecy, and would have liked Pa to disguise himself as a puff of wind, they were reasonable, and saw his difficulty.)

SUNDAY 1 OCTOBER Your lyric outburst over my photograph was prettily written – but did you <u>really</u> like it? More and more people here seem to like it less & less – but, if it meets with your approval, I don't give a damn. (I'm getting very independent in my declining years.)

Y'know, Gershon, sometimes I get into a wild panic at the thought about how much you know about me. Your photographic picture of my defences, must be almost as complete as the Allies' picture of the troop concentrations on The Siegfried Line. T'aint 'ardly decent – and think of all the damage you could do, if you felt so inclined.

WEDNESDAY 4 OCTOBER This is my last night in my solitary Clunemore double-bed. (I use the word 'solitary' graphically – not regretfully.) We've been here two months – and a more unpleasant two months I've never spent in all my life. Thank God for the accident:

> a.) because it gave me an excuse for retiring to bed when I was tired of family life, which was often.
> b.) because it kept the children quieter.
> c.) (and by far the most important of all.) It amused you to write to me often. I have often wondered whether, if there hadn't been an accident, you'd ever have written to me at all. I have never made up my mind on this point.

I really am too tired to write any more, Gershon. My next letter will be from London. The first thing I shall do when I get there will be to write to you (G. No?) The next will be to go to the pictures – and the rest to have my tooth mended. What a busy girl I'm going to be!

FRIDAY 6 OCTOBER We had a loathly journey. I've never travelled at night on English trains before – and to think that once I used to grumble at Wagon Lits! I just didn't know when I was lucky.

In a moment I am going to see my dentist. I'm frightened out of my wits.

Evening: The dentist was foul. He gave me a cocaine injection, and drilled for two hours – long after the numbness had worn off – and now all I have the energy to do is to lie in bed and cry weakly.

Joyce and I pranced round the shops in a girlish way after lunch. I haven't been inside a shop since the accident, and I bought myself a beautiful gas-mask case as a gesture.

MONDAY 9 OCTOBER It is very strange to be back in London again. I have shopped – braved the black-out with my father to see *I Was a Captive of Nazi Germany* – which I thought lacked co-ordination, and was far too documentary – besides, Miss Steele is very plain, I think, which, aesthetically, makes a difference – besides which, I

25

don't like her voice – <u>and</u> I have met Prince Axel of Denmark at a lunch party. No! he was not Prince Hamlet, nor <u>anything</u> like his illustrious forbear – the only thing he has in common with Hamlet is the potentiality to say <u>with truth</u>: 'I'll teach you to drink deep ere you depart.' If example is a satisfactory method of instruction – he would. Never have I seen a man <u>shovel</u> down so large & miscellaneous an assortment of alcoholic liquors. It was all very instructive. Today, I am seeing Mr Back (the surgeon) and the eye specialist. If they give a satisfactory verdict – then it's Cambridge for me on Thursday afternoon.

It was unsubtle of you, dear, not to see that, if I have never been serious about anything else in all my life, I am serious about not wanting to be married. Mr Kean, who hardly knows me at all, realized that I was frightened of erotic love (of which, everyone tells me, there is a certain amount in every marriage) and <u>you</u>, who know more about me than is good for either of us, don't seem to realize that that is the most serious obstacle to marriage which could possibly exist – and it's not that I don't know anything about it either. <u>Practically</u> speaking, of course, I <u>don't</u> know anything about it – but otherwise I do. From the ages of 11–20 (inclusive) I brooded over a morbid and depressing infatuation for Gerta's cousin/young man. I did not like him – nor was I amused by him – but he was very attractive and exciting. It was not until I met him by accident in the theatre, at a performance of the *Three Sisters*, after which he took Jean & me out to coffee, that I realized that he'd bored me excruciatingly for years. (His comments on 'The Three Sisters' were as banal as they were insensitive. Silly ass.)

I shall not write to you again before we meet – (unless I owe you a letter before then). I don't like my mother's caustic comments – though she doesn't <u>mean</u> to offend me – besides, there's a lot in what she says (by implication). <u>You</u> think so too, don't you.

<u>MONDAY 16 OCTOBER</u> [Girton Corner, Cambridge] You'll be gratified to hear, darling, that Miss Bradbrook has told the Board of Research Studies (by letter) that my Literary Judgement is penetrating & accurate.

I'm feeling quite clever today – so if Mr Bennett gives me half a chance when I see him this afternoon, I'll ask him what he thinks about supervision. I dare do all that may become a girl, who dares do more is none.

SUNDAY 22 OCTOBER I'm very sorry I was so querulous this afternoon, darling. So sorry, in fact, that I'd probably have cried if Aubrey hadn't been here. (Poor Aubrey!) I was fantastically tired & I had a headache – but that was no excuse. It was an impossible way of returning your kindliness & hospitality – (pause for a semi-tearful brood on the whole thing).

You can come & see me any evening you like, if you like, provided you telephone and/or write and say you're coming. I now have no sherry, coffee, squashed-fly biscuits, nor any other form of sustenance to offer you, (except Sanatogen, of course, you can have lots of that) – only me, trying hard not to look like Lois – and probably not being able to think of anything to say – so if you'd rather stay at home or prowl about on your Quest for Her – you may. I shall understand.

MONDAY 6 NOVEMBER I skipped out of bed this morning just as though I'd never had a headache in my life. The red streaks of dawn (is dawn red? I've never seen it, so I wouldn't know – but popular fiction has a tradition to that effect) were just appearing in the sky. Clutching my dressing gown about me and pushing wisps of hair out of my eyes, I tottered downstairs and found your letter (in a carefully disguised hand – which I recognized at once) side by side with a very fat one from Sheila. I opened yours first – and, darling, the photograph is the concrete embodiment of the Platonic idea of a photograph of you. It is not flattering – it is ideally and trium-phantly Right. This morning (because nobody is coming to see me today), it is sitting on my dressing table. I don't think I'm going to be able to do any work – so perhaps there are advantages in *les convenances*, which dictate that I should keep it out of sight when I have visitors! Thank you for taking so much trouble over it – it was worth waiting for.

Sheila's letter was Beautiful, too. She lives in a welter of Air Raids and domesticity. She ascribes her engagement to Allan's

27

whirlwind courtship, when he spent a week in Edinburgh prior to being called up. There was nothing to do but court, she says, social life in Edinburgh being practically at a standstill. Not, mind you, but what they've often courted before – but, (in case you'd forgotten) there's a war on now – so everything is different. She is a little worried about Hamish & Charlotte who are now practically indistinguishable in looks, voice and ideas. They remind her of Paolo & Francesca,* she says. Their spirits have mingled and they are One. (Don't misunderstand me, Charlotte is, in every sense of the word, a nice girl and Hamish's intentions, though undefined, have been strictly honourable from the first.) This is the old Sheila – and I'm very happy at having re-established contact with her.

TUESDAY 5 DECEMBER My dear love, I have News for you. I am going to have a job at the War Office, in the vac, as assistant to Public Adorer No. 1, and so I shall be in direct contact with Leslie for a whole month. I shall come to London by train from Middleton every day. Isn't that Beautiful? Ma told me, all casual-like, on the telephone this morning. I was strook-aback.

And, darling, now that I'm such a Personage, you will come to tea at four on Thursday, won't you? After all, an hour one way or another won't affect your work much, will it? – but oh! the difference to me!

THURSDAY 14 DECEMBER I've had a most fantastic day, darling, which is a Good Thing, because there's been no time for my imagination to sit on brood (a lovely expression, I've always felt – and from one of my best-known plays too).

Miss Sloane introduced me to her underling – a Miss Fox, whose underling I am to be (and damn me if she isn't a fully fledged Public Adorer as well! This thing is becoming a cult – but I'm pledged to it now and there is no escape†).

* Characters based on the life of Francesca de Rimini (c.1255–85) from *The Divine Comedy* by Dante Alighieri (c.1265–1321).

† Eileen would be a little unfair to Hore-Belisha: on his death in 1957 he left two-thirds of his estate to Miss Sloane and the other third to Miss Fox.

Then Miss Sloane said, 'I think Mr Hore-Belisha wants to see you,' and she flung open the double doors – and there I was in his room. That was at three – at three-five he'd already found out why I love Malory – at 3.10 he was asking me what position the Jews held in Mediaeval Society (if any) and at 3.15 – I was giving him a lecture on Chivalric Love Poetry, and religious mania as exemplified in the 'Book of Margery Kempe'.* He just sat and nodded all the while – and then he sighed and said, 'My dear, you must come in and read me some of these things. I feel like the child in Robert Louis Stevenson's fable – everyone laughed at him for playing with toys – and so he put them away in a cupboard, saying that he'd play with them again when he was grown up and no-one would dare laugh at him, then – and then he forgot all about them. You have opened the cupboard for me, and I have caught a glimpse of the things I had forgotten. Please come and read to me sometimes.'

It was very beautiful, darling – and then the crash came. PA No. 1, who had been standing by chafing all this while, now bustled busily forward. 'Certainly, certainly,' she said briskly, more in anger than in sorrow, 'Eileen will be glad to read to you when we've got rid of this war – but you've got to see the Prime Minister in five minutes – and you put off Lady Dawson of Penn,' (Leslie here interjected irritably, 'Damn the woman' and PA No. 1 looked as shocked as a PA can permit herself to look) 'so as we could go through the points of your interview together' – (glowering at me) 'and we haven't.' Whereat she seized me by the shoulder and pushed me out – shutting the door with a determined click. Not So Beautiful.

However, my work is to consist of filing his letters from constituents (y'know – Mr X has rheumatism – and Mr Hore-Belisha did say at the last election that he'd be pleased to help and advise his constituents – and someone said horse-embrocation was a good thing – what did Mr H. B. think – and so on) and also to help Public Adorer to compile a War-File – of all his successes & failures and speeches, and all the nice comforting things we've

* Margery Kempe (c.1373–1438) was an English Christian mystic, known for dictating *The Book of Margery Kempe*, a work considered by some to be the first autobiography in the English language.

done for the troops – bein' an uncle to them and all that – you know.

I ought to be doing this now – but as this is my first afternoon, Miss Fox is being kind to me and letting me have an hour off to write a Very Important letter which <u>must</u> catch the evening mail.

Nor marble nor the gilded monuments of War Chiefs shall outshine this powerful claim, Darling.

SATURDAY 16 DECEMBER Leslie said good-morning with a sardonic chuckle, and said he hoped I was finding my work under Miss Sloane as inspiring as Mediaeval Literature – and turning to Miss Fox, he asked her, whether she had noticed that the office had definitely acquired Tone since they'd got a future University Don to do their odd jobs. He then grumbled at Miss Sloane for telling him he was dining at the Admiralty when he wasn't, and then wandered back into his own room, calling vociferously for his mid-morning pills, and some hot whisky and milk to wash them down with!

SUNDAY 24 DECEMBER It occurred to me on Friday, Gershon, that there was One Person in my life of whom you know nothing – namely Duncan. Now all my friends except you know about me and Duncan – and it is not Right that you should be kept in ignorance any longer. (Hamish knows, Victor knows – and of course Joyce & Jean & Sheila know – even the Outer Circle, like Ismay & Joan Pearce know – true Aubrey does not – but that is difficult, as you will readily understand when I tell you All.)

You see, when I say to any of my friends suddenly in the middle of a conversation, 'Excuse me, I must see Duncan', they know that in another idiom this would read 'Please teacher, may I be excused', and they smile kindly, for Duncan is beloved of them all – and they also are liable to desert me for him, at any moment of the day – and this is how he came by his name.

As I have often told you, in Drumnadrochit I live next door to the bathroom (and Duncan) and, when we have a house-full of people, there are often battering queues of devotees waiting outside his door (true, we have a Poor Relation established in the

garden – but few people care to venture out into the blast on cold mornings to see a mere lateral branch of the family) and one morning, when there were more banging than usual on the bathroom door, I found myself murmuring absently 'Wake Duncan with thy knocking', – and of course from that time forth Duncan it was and is and ever more shall be.

Merry Christmas (but don't tell your parents I said so) and Happy New Year, Darling.

<u>SATURDAY 30 DECEMBER</u> What you've had to put up with from your grandmother is just <u>nothing at all</u> compared with what I have had to suffer from my brothers. They want vociferously to know which I prefer, you or Aubrey. Lionel is sure I prefer you; Dicky thinks it's Aubrey. They asked me all sorts of personal questions about you both, to which I replied primly & non-committally. 'Which of them has nicer teeth?' Dicky asked. I said you both had mouths full of orient pearls. 'Which has most teeth?' Lionel wanted to know. I said that, as far as I could tell, you both had the same number. They obviously felt at this point that a deadlock had been reached – then Lionel brightened. 'Has either of them any gold fillings?' 'Yes,' I said. 'Gershon has two.' Lionel positively <u>glowed</u>. 'My dear,' he said (he has a paternal way about him). 'Mind you, I'm not urging you to marry money, but times are hard, and two gold fillings should be looked upon in the nature of an investment.' With that I left the room but I heard the two of them discussing you & Aubrey's chances from the next room. 'When I was in Cambridge at half-term,' Dicky said lyingly, 'I went into Aubrey's rooms and found him kissing Eileen's photograph.' Lionel gave a hollow laugh. 'When I was last in Cambridge,' he said, 'I went into Eileen's room and found Gershon kissing Eileen!' 'Good God!' said Dicky in awe, '<u>Did</u> you?' 'Certainly I did,' Lionel answered – and then there was a shuffling outside my door – and Dicky burst in to ask for confirmation!!! I was <u>very cryptic</u>, and he went away uncertainly scratching his head. Do your young brothers behave in this unseemly fashion, darling?

* * *

TUESDAY 2 JANUARY 1940 Good morning, darling. I'm in Disgrace! It is all very sad – because it's PA No. 1 I'm in Disgrace with – and it is, as you know, essential that Perfect and Beautiful Concord should prevail among the elaborate hierarchies of Public Adoration. Moreover it's all because of a Cona,* and although no-one realizes better than I what a vital spoke a Cona can be in the Wheel of Life, I sorrow at the thought of seeing Miss Sloane forever henceforth through a glass bulb darkly.

And this is the story. The prelude goes back to the Friday on which I had lunch with you – (oh! that there were more such Fridays in the vacation calendar, but that is beside the point). On that day in the afternoon my mother telephoned me in a state of extreme agitation (at about 3.30) not, as you might suppose, to find out whether I had got back from lunch or not, but to cluck about our Cona, which had inconsiderately fallen to pieces in her hand – funnel <u>and</u> bulb – at one fell swoop. Could I please ring up Fortnum & Mason and ask them to send me the requisite spare parts which I could then bring back to Middleton in the evening. I said I could and would. I duly telephoned that 'igh-class emporium, and asked them to send the Cona round to Miss Alexander at the War Office before 5 o'clock. They didn't – so I arrived home without it. My mother greeted me more in sorrow than in anger and suggested that I might collect the parcel on my way to the theatre with Lionel the next day. I said I would – but owing to the temperamental tendencies of the South Down motor-bus service, we missed the train we intended to catch, lunched on the next one & reached Victoria just in time to seize a taxi and get to HM's theatre as the curtain was going up. We came out of the theatre into an impenetrable fog, bleated impotently for a taxi, took refuge in the Carlton – and were only able to get a taxi in time to catch the 6.18 train back to Middleton (we had intended to get the 5.30). My mother observed the absence of Cona much more in Anger than in Sorrow this time – but I promised faithfully to bring it back on Thursday (which was to be my first day at the office after Christmas) if I died in the attempt. *Figures-toi donc mon chagrin* when I got to the office, to find, No Cona awaiting me. I immedi-

* A glass coffee machine.

ately set Wheels in Motion (not to say such wheels as were within wheels and therefore hardly worth mentioning), and telephones buzzing – and it finally transpired that F and M had delivered the parcel to the War Office – but that nobody seemed to know anything about it. It took me the whole day to get as far as this, (case histories got somewhat neglected in the process) and I left the office in the flappiest cluck of the century – and got back to Middleton – without the Cona. When my mother had recovered from her Swoon and decided not to cut me off with a jade cigarette holder, I explained the situation, and she was appeased. On Friday, as you already know, I did not go to the office – and yesterday was New Year's Day, with the result that the train was in a Holiday Humour and I got to work an hour late. However, I tripped happily up the marble steps at 11.15 and burst into Miss Sloane's room with 'Mikado' on my lips. 'A Happy New Year', I said convivially to Miss Sloane taking her hand warmly, and failing to notice the lack of response in her clasp. 'A Happy New Year', I added affectionately to Miss Fox – and I was just making my way to the Inner Doors to say the same thing to Leslie when a Frosty Silence hit me between the eyes, and trickled moistly down my nose. 'Oh! er – yes?' I said, retreating a step in acknowledgment and then my eye lighted upon a huge wooden crate addressed to 'Miss Alexander – The War Office'. This, I thought, misguidedly, was better. 'Aha,' I said. 'My Cona.' 'Yes,' said Miss Sloane. 'Your Cona,' and her words froze into sharp icicles in the air before her. Something was wrong. There was a significant pause. 'I was nearly court-marshalled* during the weekend on account of your Cona,' she added, and the vitriol dropped steaming and sizzling on to the desk. 'Oh! were you?' I muttered ineffectually. 'I am sorry' – and then the whole story poured out like wine out of the mouth of a narrow-necked bottle, which, as Rosalind knew, comes out not at all or all at once. It transpired that there was only one Miss Alexander on the permanent staff of the War Office and she (fate is unkind at times), works in MI5, which is the most Secret and Sinister branch of the Intelligence, and has a notice on the door of its department saying

* Gershon was always complaining about Eileen's spelling, and she happily confessed that she could not spell in any language, including in Hebrew.

'No Admission except by Special Pass'. (I have often quailed, in passing, before this notice.) She was sure it was a bomb, and sent it off to Wormwood Scrubs to be opened (this is True, darling, though I shouldn't blame you if you don't believe it – it <u>sounds</u> too fantastic even to happen to me). When they found (at Wormwood Scrubs) that it was only a Cona, they sent it back – and enquiries were set on foot to locate the owner. The entire War Office by this time knew about it and Miss Sloane happened to overhear it talked of in a corridor and said (poor soul, she knew not what she did!) that there was a Miss Alexander working in the S of S's department, thereby bringing the August and Collective wrath of MI5 on her innocent head for allowing Strange Parcels (which might easily be bombs) to be delivered at a Government Office. Furthermore, to add to her general sense of ill-being, F and M had spent the <u>whole</u> of Friday ringing me up about the Cona – thereby blocking the Official Line.

And that is the story of the Cona. It was the first that ever burst into that silent sea, and I think – & Miss Sloane hopes, that it will be the last.

I looked in the mirror this morning and was appalled at how plain I was. I'm so sorry, dear. I've known it for years but never so overwhelmingly as today. How Awful for you to have to look at me as often as you do. It is Very Beautiful of you.

SATURDAY 6 JANUARY Darling, I've just this minute-as-ever-is finished writing to Leslie. Of course, I Know Nothing about the reason for Leslie's resignation,* and I never suspected for an instant that it was coming. I'm sorry – not because I agreed with his politics but because he knew how to remain human in a clogged and sluggish machine. (I mean Neville and his Naughty Ninepins.) He was a man (and still is, bless him – (Dear Leslie).) Take him for all in all, I shall not look upon his like again.

* Hore-Belisha had been at odds with his generals since he first took office, and disagreements over the disposition and readiness of the BEF in France finally led to his dismissal. Public opinion was on his side but it was the effective end of his political career.

SUNDAY 7 JANUARY I am now unemployed. I had a cryptic telephone message from Miss Fox saying that, for reasons that I wotted of (or words to that effect) my services would not be required on Monday morning – or subsequently. Oh! darling, Leslie has been most notoriously abused (as Olivia said of Malvolio in a different connection). It is a Great Sorrow to me. I hope a nasty judgement descends on someone for this. I shall just go on Adoring – and Hope.

MONDAY 5 FEBRUARY I didn't sleep last night, Gershon. Not on account of the Warning – but because you are reproaching yourself on my account. Listen, my dear love. I have known, ever since there was anything to know, exactly what your attitude was – and because of this there has always seemed a touch of irony in the kindly advice of Mrs Turner, Joyce & Joan Friedman who (in that order) advised me to take stock of my intentions before I went Any Further with you.

I told Joyce (but not Mrs Turner or Joan) that I sincerely and honestly believed that in this matter I was not being unfair to you, because you knew and I knew that my Intentions would change according to your wishes. She said, yes, but I must consider the question of whether I would be prepared to make a drastic change in my attitude to marriage should the occasion arise. I said that it would be unfair to myself even to consider that question, unless the occasion arose – and I didn't believe that it ever would arise. She said that she thought I was deliberately evading the issue – but I maintained that since my whole plan of living was based on the assumption that I didn't want to marry, I dared not reconsider it, since I believed that you had shifted the basis of our relationship only because you thought I was safeguarded from being seriously hurt when it ended, by my views on marriage. And now you aren't sure, are you dear, whether I am safeguarded by them? And neither am I – but that is my fault and not yours. After all, you told me very seriously, quite a long time ago to hang onto my independence, and you've often told me that you'd never met the woman you wanted to marry. So, darling, please believe that you have nothing with which to reproach yourself – and all I want, is that our relationship should go on until you are tired of it – and it won't

be any more difficult for me later than sooner – since it is quite clear in my mind (I hope) that the break must come – and, as far as I'm concerned, the longer it is put off, the better.

As for my changed attitude to Forwardness, I haven't any regrets about that, either (though I'm glad I still think the same about Wantonness). I feel, rather arrogantly, that the nobleness of life is to do thus, when such a twain & such a mutual pair can do it.

I'm afraid all this sounds rather clumsy & solemn, darling – but I want to be faithful, even at the risk of expressing myself stupidly.

In conclusion, darling, please don't worry about me. 'I wonder, by my troth, what thou & I did till we loved' and now – 'you are all states and all princes I. Nothing else is, Princes do but play us.'

MONDAY 19 FEBRUARY Last night you were wondering about Aubrey, darling. Wonder no more – I had a letter from him this morning – written in a barracks room which he was sharing with twenty vociferous & newly-inoculated privates – all singing 'Kiss Me Goodnight, Sergeant Major'. He'd just had a meal consisting mainly of spinach. ('Dear Leslie,' he says in an embittered parenthesis – and I can't say I blame him in the circumstances.) You shall see the letter when we meet – but I'll keep it for the present so as to be able to answer it point by point – as is my way.

SUNDAY 25 FEBRUARY It really has been a very varied day. I had a terrific discussion with Jennifer about the way Men of Genius treat their wives (the particular instances in question were Shelley, Byron, Milton & Dickens). She said all the wives must have been Fools to Put Up With It. I said, with Infinite Wisdom born of Age & Experience that if they (the wives) were fond of them (the Geniuses) I expected they thought it was worth it. She snorted & said Tush, or something equally intolerant – & added that No Man was Worth Anything unless he knew how to treat his wife. Shelley & Co. were therefore all hypocrites – posing as social reformers indeed, when they'd have been better employed in reforming their own conjugal habits. (Further snort.) Women who married

Geniuses, she added, were fools. Love is not love which alters when it alteration finds, or bends with the remover to remove, I said mildly – but I'm afraid she thought it was a quotation from 'The Desert Blooms' – so it didn't carry much weight. Ah! me.

MONDAY 18 MARCH Oh! I'm so tired, darling. Mr Turner hammered on my door at seven, this morning – and it seemed such a short time since you'd left, that I thought you must have come back to collect something you'd forgotten! I <u>almost</u> said – 'Come in, darling', but fortunately I woke up, properly, <u>just in time</u>. Poor Mr Turner – he'd <u>never</u> have been the same again – and it would probably have disorganized the Administration of Justice at the Saffron Walden Courts (where he's appearing today) very seriously. Think what he was spared – if only he knew!

It's been a wearing day. Aubrey drove Semiramis* to London – just as if she were an Army lorry, darling. I shall never be the same again. Occasionally, he thought Semiramis was a motor-bicycle, and that was even worse. Outside the Blue Boar I met Raphael Loewe.† When I said I was on my way to collect Aubrey – he said intensely 'Ah! yes – he left me at eleven last night' just as though he were describing a Tender assignation which he felt to be Very Beautiful. Then he wished me a happy vac in an impassioned voice – & vanished – it was a Beautiful moment, in its way.

The Nester baby circumcision was Awful. As soon as I got to the hotel, I went to see Duncan – leaving Aubrey & Mrs Turner to drink coffee with my mother. I suddenly had a Horrible Thought and, parting hastily from Duncan, I rushed into the drawing room & asked my mother – *d'une voix mourante* – whether we'd actually have to <u>witness</u> the circumcision. (I'm frightened of shots in films & plays – my dear love – but it's all as nothing to the Terror I should feel at seeing a smallish, pinkish baby wriggling beneath

* Eileen's car, 'the most delicate shade of ivory imaginable', named after the legendary queen of King Ninus of Assyria.

† Jewish writer, translator, poet and decorated wartime soldier, Raphael Loewe came from a long tradition of Jewish scholarship. His father, Herbert, the Reader in Rabbinics at Cambridge, had written a letter of support for Eileen's application to Girton.

the surgeon's knife.) She said rather coldly that it would not be necessary – it was obvious that she thought that certain things should not be discussed in mixed company – and even more obvious that circumcision was among these things. I'm a Great Sorrow to my mother, Gershon – even on my first day in the Family Bosom and that is a Heartly Sorrow to me. Ah! well.

TUESDAY 19 MARCH Oh! darling – London is close and clammy & tomorrow is Wednesday and I shan't be having lunch with you – and I have a headache – & my mother saw a lad we know mollocking on a sofa in the Hotel lounge & said some harsh things about public mollockers – and Life is a Great Sorrow to me – but it has its Solaces too.

THURSDAY 21 MARCH Yesterday afternoon Basil & Nellie Ionides came to tea. Basil was in a new blue tweed country suit – his face all round & pink & sunlit – looking altogether more like a hand-printed smock than ever. Nellie was in black, and obviously on a Higher Plane, every inch of her. Soon after they'd gone Horace and his wife arrived. Horace was on the way to a Chess Tournament, and too preoccupied with his Next Move to say very much. When he'd gone his wife launched excitedly upon a series of Intimate Revelations about Flaubert's love-life. She'd just got to the point where he 'threw his whore out of the house – literally, my dear. But of course he was in love with his mother (wonderful woman!) all his life' – when my mother came in.

THURSDAY 28 MARCH Did I tell you, darling, about my urge for a Red Dress – a very bright red dress, preferably with white buttons. When Aubrey and I walked from the Mayfair to the New Gallery to see 'Pinocchio' – I kept darting away from him to flatten my nose avidly against window-panes in which red dresses were displayed, with cries of Rapture and Longing. (The cries of rapture and longing came from me, not the red dresses.) Aubrey was not only Alarmed – he was Appalled.

What shall I do about it, dear? If I don't have a red dress – I shall probably suffer from Repressions for the rest of my life – and if I do – you'll probably never speak to me again – and that

would be such a Sorrow to me that I can't contemplate it, even in jest.

SATURDAY 30 MARCH Yesterday, I had lunch with the Nathans – the most agonizingly well-regulated household in the world – each member of the family has a little saucer with the week's butter ration on it, and a little flag bearing his or her own initials – and they have competitions to see whose ration lasts longest!! Mrs Nathan billowed in, rather late for lunch – she was in black-and-white checks, from head to foot again. Why does she do it? After an excellent lunch which culminated in a Camembert as resilient as a spring mattress and as smooth as cream – Joyce and I went to see *Raffles* – undistinguished but pleasant.

In the evening Herman & I went to *The Beggar's Opera*. After the theatre we went to supper at the Landsdown Restaurant in Berkeley Square. There were some fantastic people dancing. There was one man in uniform with the tiniest hand I ever saw and little feet, and the most colossal massif centrale outside France. He was very tall and there was a little woman with him who was simply prancing about like an india-rubber ball, holding her two fore-fingers in the air and skipping from one foot to the other – occasionally pausing to prod him in the stomach. (Each time she did this Herman & I were certain that he was going to explode with a loud pop.) We hoped for her sake that she was tipsy – we feared she wasn't – particularly. But the most absurd thing of all was that the man, who looked like a General suffering from protracted adolescence – was in fact – a 2nd Lieutenant! Why this was so extraordinarily funny, I don't know – but it was. Perhaps because it was so incongruous.

SATURDAY 6 APRIL I had a Beautiful letter from Aubrey this morning. He says, of my letter: 'I read it between parades this morning & a Sergeant Major gazing at the blatantly feminine note-paper winked at me with misplaced lechery & enquired "What does she say?" (He said something else as well which my pen, schooled in moderation, cannot set down.)' His superior officers have set him problems in slogan-writing for the troops. His suggestion, he says, was received without enthusiasm. It was: 'Private soldiers are the

39

Braces of the High Command: not noticeable but <u>quite</u> indispensable.' I'll tell him what you say about writing to him. It <u>may</u> produce some effect – but I doubt it because <u>he</u> thinks you have far more to tell him than he has to tell you.

I had a letter from Ismay this morning by the same post as yours and Aubrey's. It was almost human, and it had a rosy glow of retrospective pleasure on its face when it described Charles's six days leave at Easter, which they spent at their London flat. (I gather they spent most of the time entertaining their relations to meals – but no doubt they had the evenings to themselves – in which to knit happily on either side of the hearth!) Even her clichés had a glimmer of life – like Lyons's pastry – if you warm it up in the oven.

MONDAY 8 APRIL Have you any wires you can pull, dear? If so <u>try</u> for your life – and mine – and don't forget that the Air Force and Navy have intelligence services too – and if you get into them you're not expected either to fly <u>or</u> run the Gauntlet of the U-boat pest. (I'm not suggesting that <u>you</u> would mind if you were – but <u>I</u> would.)

Oh! <u>why</u> didn't I cultivate the acquaintance of Sir Edward Grigg – permanent under-secretary for War – when I was at the War Office? My father wrote to me at the time, saying, 'Look up old Grigg, we were at John's together.' I told Leslie about this and asked who Grigg was. He said, 'Oh! Grigg,' as one would say 'Oh! <u>spinach</u>,' if one were Aubrey – and so I pursued the matter no further. What a <u>damned</u> fool I was, and am, & ever shall be.

THURSDAY 11 APRIL Darling, 'thoughts that do often lie too deep for tears' sounds nonsense until you suddenly & sickeningly apprehend its meaning in a kind of leaden stupor, as I did when I was confronted with an actual date – July. Then the vague and frightening notion of you in battle-dress and in a place where I am not, formulated itself into a dark reality. (Oh! apparently that thought didn't lie too deep for tears after all! It was really a delayed action of my tear ducts.) You are ten thousand times a properer man than I a woman, my dear love, and it's shallow and selfish of me to twit-

ter at you. But once this particular cloud has out-wept its rain, I promise you'll hear no more on't – but please don't be cruel only to be kind, and remind me of what is past and passing and to come. You treated me like a child in not telling me, until it was over, that you were going to see the Military authorities (bless you for it). Please go on treating me like a child – and only tell me things of that kind if and when you have to, for I am pigeon-livered and lack gall – and when I think of you as a cog in the military machine I am sick and sullen (though, as I once pointed out to Aubrey, I'm like Cleopatra in that alone).

May–September 1940

On 7 May, in the middle of the disastrous Norway campaign, Neville Chamberlain opened a two-day debate on the debacle in the House of Commons. The idea of the campaign had from the start been Winston Churchill's, but three days later it was Chamberlain who was gone, a scapegoat for Norway and belated judgement on the years of appeasement and moral failure, and Churchill was prime minister. It was not a moment too soon. On the same day, German armies swept into neutral Belgium, Luxembourg and Holland. The Phoney War was over.

The Battle of France, which began on 10 May 1940, was effectively all but over for the British by the end of the month. At that time, and since, the 'miracle of Dunkirk' masked the extent of the humiliation inflicted on the Allies, but the brutal truth was that within the space of three weeks, neutral Holland and Belgium had been overrun, France brought to her knees and almost 340,000 British and French troops, minus almost all their heavy equipment, transport vehicles, tanks and guns, left trapped in an ever-diminishing pocket on the French Channel coast. The campaign would limp on hopelessly through the early weeks of June, but by the 22nd, France had gone the way of Czechoslovakia, Poland, Denmark, Norway, Holland and Belgium and the invasion of Britain seemed only a matter of time.

To those returning from France to Britain in June 1940, however, London still seemed remarkably untouched by events across the Channel, and the 'terror bombing' it had expected in September 1939 no nearer than before. In many ways, in fact, the war had yet to affect Eileen directly, but when on 10 June Mussolini's Italy declared war on Britain and France, her mother, Vicky – married to a British citizen, and the mother of three British

children, but like so many Jews within the old Ottoman empire, the owner of an Italian passport – suddenly found herself categorised as an 'Enemy Alien'.

At a time when an invasion was expected at any moment 'Fifth Columnist Fever' was in the air – even Jewish refugees would find themselves interned on the Isle of Man – and while Vicky herself was at no risk her money was. The fear in the Alexander household was that with an Italian army threatening Egypt, and so many Egyptian Italians known to be fascist sympathisers, the family-owned Mosseri Bank, and with it all Vicky's capital and their only regular source of income, might be confiscated.

The news of the death of Vicky's brother, Eli, the head of the bank, only the day after Mussolini declared war, further darkened the future, and one of the first casualties was Eileen's academic career. The fears would eventually prove groundless, but with dire talk of what the Nazis would do to Jews when they invaded, and her father threatening to take the whole family to Canada, Eileen, like most of her Girton friends over the next eighteen months, gave up her dreams of Arthurian Romance and Cambridge to apply for war work in one of the government's rapidly expanding ministries.

The war had at last caught up with Gershon, too, who – after spending his final month of freedom walking in Wales, where he stayed on the farm owned by Eileen, and farm-labouring in the West Country with a Cambridge friend – was now '1310136 Aircraftman 2 G. Ellenbogen', the lowest rank in the RAF. For a man with his education and language skills his future lay in intelligence work, but in 1940 he was still too young for a commission into the intelligence branch, and for the next eighteen frustrating months his life would revolve around a succession of bases and camps across the country, punctuated only by the occasional snatched and uncertain leave in London.

This at least meant that he could see Eileen, because in the middle of May 1940 the Alexanders took a house in London's Swiss Cottage, and for the rest of the war 9 Harley Road, NW3, would be her home. The house was a comfortable, detached, red-brick building not far from the anti-aircraft battery on Primrose Hill, sandwiched between larger houses on either side, with a couple, Mr and Mrs Wright, to cook and generally 'do' for them, an Austrian refugee called Mrs Seidler as their first semi-permanent 'guest', and a big garden at the back, complete with its own concrete air-raid shelter.

The shelter's time would come, but over the long summer months of 1940, as Beaverbrook's factories worked heroically to keep up with fighter losses, and RAF pilots were thrown into the fight with only a handful of hours of air time behind them, the battle between Goering's Luftwaffe and Dowding's Fighter Command – the 'Battle of Britain' – raged largely over the villages and fields of south-east England. While there were continuous attacks on airfields, ports and shipping, it was only at the beginning of September 1940, when the Luftwaffe turned from the airfields, radar stations and strategic targets of the south-east to the capital, that London's volunteer army of wardens and fire-watchers – soon to include Eileen and her mother – found themselves on the war's front line alongside the city's firemen, gunners, barrage balloon teams, medics and bomb-disposal units. The Blitz – short for Blitzkrieg, Lightning War – had begun.

3

My Young Fellow

[Eileen's twenty-third birthday] Darling, when I wrote to you yesterday, I felt as though I should never smile again – but I was wrong. *This England** produced not a languid twitch at the corners of my mouth or anything like that – but a twinkle, and then a wide smile, and then a giggle, and then the loud laugh, which is such a source of surprise to you, dear.

The birthday atmosphere is somewhat marred by it's being Saturday, and the fact that I have a headache as though the flames of Hell were roaring in my skull.

Well, with all this, my gloom fell from my shoulders like a cloak – and now, I'm ready to laugh at anything – even at the merry absurdity of my ever casting you into the limbo of Men I have Known & Forgotten. As a matter of fact, I never forget anybody, not even the young man of Jewish Lineage and Parisian up-bringing who, for some reason known only to himself, wanted to impress me – and set about it by telling me that he'd had his first Mistress at the age of 12½, and that she was the mother of his best friend at school. He hastened to add that the suggestion came from her – and that Love (by which he meant Lust) was Very Beautiful. All this happened by moonlight on a Messageries Maritimes Liner in the middle of the Mediterranean – and was intensely funny. I listened solemnly to his catalogue of wantonness – and then laughed and laughed and laughed –

* A 1940 propaganda historical drama about a village defying tyranny.

47

and said 'Goodnight'. I don't suppose he's ever been the same since.

THURSDAY 23 MAY I bore my Mother away to the West End to see *Gone With the Wind*, which, darling, is <u>unendurably</u> long (3h 58m). The acting is good (but no better than that). Some of the photography is lovely – and you know what I think of the plot – and all its shoddy melodrama stands out far more glaringly on the screen than in the pages of the book. <u>No</u>, my comfort, it is <u>not</u> worth all the publicity which has been lavished on it – it is not worth getting pins and needles in the rear elevation for, either – and, <u>above all</u>, it is not worth Titanic feats of Endurance in connection with Duncan.

Horace is <u>so</u> bracing. He came to see me yesterday evening & solemnly urged my mother and myself to evacuate ourselves to my farm in Wales, so that when the Nazis smash us, we can make a 'quick getaway' via some northerly port. <u>Dear</u> Horace.

Oh! darling. I haven't seen you since Newton started Taking an Interest in Apples – and <u>that</u> was hundreds of years ago.

MONDAY 10 JUNE Aubrey came into the drawing room, stiff and correct and every-inch-an-officer – and the bridge-players (including my mother & father, darling – what a Sorrow) just looked at him with a glazed eye &, as he said afterwards, made him feel like the Shrinking Man in every Bateman cartoon. My father then bore Aubrey & me off to the Front Parlour & told us All, with vague & gloomy expansiveness. All he said could be condensed into one poignant & succinct phrase. 'What a sorrow.' Aubrey called him Sir, and put his case – in the Pauses for Breath – and my father said he'd do what he could for him with Colonel Kisch & Lord Lloyd. He then said A Few Words on the subject of Glorious Evacuations & went back to his bridge. Aubrey seemed to think he might be helpful – but he (Aubrey) was tired & nervy & stilted – and when I told him about the Importance of Shoes in marking the distinction between Forwardness and Wantonness, he was only able to manage a wan smile – and it was obvious that his Mind was elsewhere.

I felt suddenly & frighteningly out of touch with Aubrey tonight. Perhaps because I'd hung on to the thought of his coming

as a kind of indirect link with you – and he was completely detached from us and our idiom and our Solaces & Sorrows.

Of course, it's not surprising. It looks as though MI* is off – but he hopes with the help of Dr Weizmann, Major Cazalet & perhaps Pa, to get to Egypt & Palestine, and do the kind of work that interests him – once he gets there. Everyone in Whitehall disclaimed all knowledge or responsibility in the matter or expressed Great Sorrow – Oh! I hope All will be Well with him.

TUESDAY 11 JUNE When sorrows come, they come not single spies but in battalions, darling – as I may have said before.

This morning Lord Inverforth† telephoned & my mother picked up the receiver. He asked if he could speak to Dad and then urged him to go into another room – alone. Something in his voice must have frightened my mother because she turned dreadfully pale – and I, rather foolishly, advised her to pick up the receiver & listen in. She did – and oh! darling, she just lay back in bed gasping & choking with dry, coughing sobs. Lord I had had a wire from her sisters asking him to tell her that Uncle Elie had died suddenly (acute appendicitis with complications). She has this rather frightening & very Jewish bond with all her relations – & in this case there was no warning or preparation of any kind. Dad came into the room & sat down – his face was quite grey & blank & he kept muttering 'She doesn't deserve it' over & over again – & nurse danced around squeaking with maddening ineffectualness. *Mon dieu, quel cauchemare*! (I can't spell, darling, even in an emergency. I don't know whether there's an 'e' in *cauchemare* or nor.) Now, there'll be another year of black and apathy & withdrawal for my mother.

Yesterday she was worried because all her money is in her brothers' bank & may be confiscated by the Egyptian Government – and that would mean that our only steady income would be cut off completely – & now there's this. I'm glad I'm here today, my dear love – not but what I'm completely useless & ineffectual – but she seems to be pleased that I'm back in London.

* Military Intelligence.

† Andrew Weir, 1st Baron Inverforth (1865–1955) created and headed the firm of shipowners in Glasgow.

This isn't a letter – just thoughts of a dry brain in a dry season. (Eliot is a great poet, dear.) Oh! I am out of suits with fortune!

It's been a wearing day – my father has suggested that a Good Way to end Italian intervention would be to dress the Pope up in Full Regalia & send him between the French & Italian armies saying 'Shoot if you dare!' (A Beautiful Thought in its way.)

WEDNESDAY 12 JUNE Yesterday evening my father & I walked to Primrose Hill for air. He was peering over fences at potato-patches in an ecstasy of dig-for-victory enthusiasm – but I was looking wistfully at the mollockers in the long grass & thinking that the nobleness of life would be to do thus if you & I could do it. Oh! my God, the Dragon School has just notified us of a violent epidemic of measles & Dicky is coming home on Saturday for a fortnight! where's that kindly & protective providence you told me about?

FRIDAY 14 JUNE I've just fled upstairs to escape the 1 o'clock news. Cowardly, dear? – but the tension here is growing & growing, & I'm so terrified of my father's deciding suddenly that we are to go away – to Canada or God knows where. If that happened, then that dream I'm always having about not being able to get to you would be real, darling. Oh! God. I'm bereft of all words at that thought.

My mother is eating off a low stool with a slit in her petti-coat – a gloomy business – & my father sits & speculates upon our chances of survival when the Germans occupy London. Tomorrow Dicky will be here to give us a taste of Nazism in the Home. Tired of all these, for restful death I cry ... as I said in one of my best sonnets – adding hastily however – save that to die I leave my love alone.

SATURDAY 15 JUNE I've been keeping out of my father's way – & last night he commented on it – acidly – & then took on a martyred air, & today he keeps coming into my room & asking me to go downstairs & talk to him. It's exactly as I told you, darling. I can't escape – and every time I'm with him, I simply quiver with fury – because he took me away from Cambridge, darling – and I can't

bear it. Dicky has come home today, doubtless to spread measles & havoc. There is no light ... no light.

We had a diversion yesterday in the shape of a fat little refugee rabbi who came to instruct my mother in the Art of Mourning. (She ought to Know All by now – she's had enough practice, poor woman, but she's so frightened of Leaving Anything Out, that she always likes to have a Spiritual Guide to Hold her Hand.) He was small & round and his features were richly curved – & he thought up a perfectly incredible number of things which my mother ought to be doing – & then when he got home he remembered yet Another – & he telephoned to tell my mother that she must on no account wear leather on her feet (Give me a shoe that is not leather soled! – or a bedroom slipper, for that matter) lest we should all Perish or be Cast into Hell. It was obviously a matter about which he felt strongly.

I've done nothing since I left Cambridge but let my melancholy sit on brood – and read crime-stories – the bloodier the better. I'm suffering from an infinite prolongation of the feeling I have in Cambridge when you're an hour or two late. I haven't smiled since I left you standing on the station in your white shirt & blue jacket which I could see for such a long time after the train had started moving.

FRIDAY 21 JUNE Oh! darling, it was fantastically selfish of me to suggest that you should come to London on Saturday – but when it's a matter of keeping you with me or having you back again soon, I have no morals – I've always felt in complete affinity with Cleopatra when she turned her ship round – knowing Antony would follow her – although it meant shame – shame – ever for ever – and she knew it.

MONDAY 24 JUNE I went to Kilburn with my mother this morning to buy vegetables (vegetables are cheaper in Kilburn, darling!) & now I Know All. You burst open pea-pods & taste the peas & unless they're a Solace in the Raw, you Reject them – you squeeze cabbages & unless they squeak, you say in a voice of withering scorn, that they Have no Heart – and cast them from you – a lettuce that you can't stub your finger on is No Good – & when

strawberries are two shillings a pound, you lose Heart & decide that you might as well have done your shopping at Swiss Cottage & saved a 2d bus fare.

TUESDAY 25 JUNE Oh! darling, things that love night love not such things as these. The sirens started screaming at 1.15. (Sirens are louder here than at Girton Corner.) I got up to see what my parents were doing – and Pa took such exception to my suggestion that we should all stay in bed, that I put on my new dressing-gown, wrapped my eiderdown round me & followed him to our outside shelter. It was a clear, still night and the stars couldn't have been more sharply focussed if there had been a frost – half a moon & little greyish clouds. We packed into the shelter like chocolate stick-biscuits in a round tin. We sat in deck-chairs – large deck-chairs – & my feet didn't reach the ground – but Stanley chivalrously stretched out his legs & let me rest my feet on his slippers. We sat quite silently for the most part – the only sound was the rumbling of poor old Wright's recalcitrant digestion – & occasional bursts of impromptu & heavy jests from Pa. At about 2.30 (the shelter is distempered concrete & as bare as a picked bone, and I was getting colder & colder), I was suddenly doubled up with cramp – (Nurse said nastily that it was due to my being out in the rain on Sunday. I pointed out tartly that there hadn't been a drop of rain anywhere except on the pavement by the time we got out of the house!). Anyway, I quaffed a sherry glass full of brandy & warm water in one nose-wrinkling gulp & went to bed. The All-Clear sounded at four – but I never heard it – the brandy having done its work – but that was only the beginning of things for my parents & Stanley – because poor old Wright had a heart-attack & they had to summon a doctor & send him off in Mrs Wright's care, to hospital. So this morning everyone here is a little blear-eyed & vague.

WEDNESDAY 26 JUNE Darling, I'm almost angry with you. Here are the papers all buzzing with vague & terrifying reports of continuous raids on the SW – and no letter of reassurance from you this morning.

I spent a fantastic afternoon with Joan at her crazy school yesterday. The children wear purple shorts and white shirts – the

garden is a carefully cultivated wilderness – the school-building, rambling, beautifully furnished, with a touch of arty-craftiness here & there. The staff sits about on tree-stumps Musing upon Life in rather uninhibited clothes. (Joan tells me that the Headmistress, who is nearly 83, and of titanic dimensions, appeared in the air-raid shelter on Monday night in a pair of trousers all tied together with safety-pins – declaring that her zip fasteners had been sabotaged either by one of the children or the staff – and after seeing the school, I can well believe it.)

Joan told me, more in sorrow than in anger, that she had met Joy Blackaby at her interview with the Cambridge County School, & the first thing Joy had said to her was that she'd seen me one day mollocking abandonedly in KP!* Joan said that in Cambridge of all places there was no excuse for Public Mollocking, because the facilities for kissing & clipping at home were unlimited. I agreed in principle – but I pointed out that in my case, there was a factor which had never entered into her relationship with Ian – Time fear. I said that taking a short-view, she too had often heard time's winged chariot hurrying near – but that against this – she had a confident feeling of permanence which made it unnecessary for her to hang on to the reassurance of physical contact. Because she has a sense of having all life before her, darling, she never has that terrifying 'Is he really here?' doubt – nor the crushing fear that every moment of Solace may be the last. She couldn't see why I should assume that you'd stop wanting me as a Solace one day. She said that, from what she had seen of us together, our regard for one another was unhurried & restful & built on more permanent foundations than most people's. I said that mine was – but that you had warned me from the very beginning that yours might not be – but I hoped to God she was right – whereupon she withdrew her censure of my public behaviour, & added that she was sure that, ultimately, All Would be Well.

THURSDAY 27 JUNE I have been to Kilburn again for vegetables. Cauliflowers have risen in price, whereas beans have Gone Down. The situation on the Asparagus Market remains unchanged.

* King's Parade, a street in the centre of Cambridge.

I'm seeing the Secretary of the Appointments Board tomorrow to Tell her All. I liked the sound of her voice over the telephone – which is encouraging – voices make a lot of difference. Did you hear the Princess Royal asking us to join the ATS on the Wireless? 'Over your dead body!' I replied sullenly. 'If it's the last thing I do.' (Aren't everybody's idioms but ours silly, dear?)

Then Aubrey rang up to ask if we could meet for tea instead of lunch, as his cousin Charles had decided to get married. I said oh! wasn't that rather surprising? – to which he replied Yes <u>and</u> No. Charles, it seems has been Walking Out for eighteen years – but, Aubrey says, after you have been Walking Out for eighteen years, people just assume that you have Got into a Rut, and stop wondering about Intentions – (what a Solace, darling, we've only got seventeen years to go!) & when you have an over-night whirlwind courtship with your wench of eighteen years standing, and get married the next day – it <u>is</u>, on <u>one</u> plane, surprising, although, on another, you've really been expecting it all along. This is the gist of what Aubrey said, though perhaps he didn't say it quite in those words.

<u>Later</u>: Aubrey arrived at the Cumberland rather late. He was delayed by the wedding. It's a Beautiful story, darling. It seems that Charles and his lady would have gone on Walking Out quite happily for another eighteen years, had it not been for his parents & the lady's. She is a Palestinian &, as such, subject to the Alien curfew. 'Poor Shulamite,' said her parents, in sorrow (Shulamite, believe it or not, is her name.) 'How inconvenient' – and they called on Charles' parents, who forthwith sent a wire to Charles saying, 'Be a man Charles – marry her – or she'll have to go to bed every night at 10.15.' So Charles called on her & said 'What are you doing on Thursday, sweet chuck?' & she said she had a short-hand exam in the morning but that she was free in the afternoon. 'All Right,' said Charles, 'we'll get married in the afternoon.' And they did – in the presence of Aubrey & his mother. The ceremony lasted 15 minutes & then Charles went over to the cash desk & handed over £2. 4. 6½d (Aubrey says you can do it for 7/6d if you really try – but Charles decided to do the Big Thing for once in his life. Aubrey says he is disgustingly rich – and incredibly parsimonious in the normal way). Aubrey arrived for tea looking harassed & a

little disillusioned. He says he now knows why so many people prefer to Live in Sin. Registry Office Marriages – culminating in a sordid little transaction at the cash desk are, he assures me, no solace at all. What an anti-climax, dear, after Walking Out on a Higher Plane for 18 years!

FRIDAY 28 JUNE I have had an eventful day, darling. I arrived at Bedford College much too early for my interview – so I went into the Botanical Gardens to smoke and muse. Then I went in to see Mrs Woodcock who was wearing a beautiful emerald ring – & was efficient & soignée and altogether quite a solace. She said the Higher Grades of the Civil Service were obviously The Thing. The Civil Service, she went on, loves Classicists & Economists & distrusted English Specialists but, she added consolingly, they were very partial to firsts. Then I told her about my mother being an Enemy Alien & she was in Great Sorrow & went into muse – out of which she emerged suddenly to ask briskly whether I knew anyone with Influence. I said, without enthusiasm, that I knew Lord Lloyd. 'Ask him to write a covering letter to your application – saying that your family is well known to him and is All Right.' She finished up by suggesting a teaching job in a boy's school, if Lord Lloyd couldn't help.

SUNDAY 30 JUNE Darling, following my newly learnt lesson of telling you All, I want you to listen to me tolerantly & patiently now. I'm so frightened that my hand is shaking – but because, you are, after all, my friend as well as my Young Fellow, I don't believe you'll be angry with me. (Please don't be angry with me, my dear love.)

Do you remember, when we were walking from Grantchester one afternoon, you said 'If your father were to ask me my Intentions, I know what I'd say to him'? Well, I wanted to ask you then, what you would say, not because I didn't think I knew the answer, but because I hoped I might be wrong – but I didn't ask because I felt then that indecision was better than crushing certainty. Now, however, I want to tell you what I believe to be the reasons for your Absence of Intentions, and to ask you if I'm right, & if, as far as you can judge at present, these obstacles will always be insurmountable. And here they are.

a.) My inadequacy as a Solace – the fact that you're afraid that if you were with me always, you'd be made restless & irritated by my clucking & possessiveness & would become obsessed with the idea of breaking free.
b.) You are in no position financially to have any Intentions. (Note – the present war-situation might over-ride that consideration, if your Intended-as-might-have-been were economical, practical and useful-about-the-house. It's a Heartly Sorrow to you, (though perhaps not for this reason) that I am none of these things.)
c.) You have a very strong feeling that I wouldn't be a success with your family. I am not Orthodox enough – or useful enough – or adaptable enough.
d.) As circumstances make it possible only for us to meet sporadically, you may at any time meet another & more adequate Solace.

That is how I interpret your attitude to the situation, darling. Am I right? Whatever you say will make no difference. I am yours now and hereafter and for ever, on any plane you will – but I feel it's cowardly of me not to ask you what you really think – & I know that whatever you say will be generous & kind, as everything you have said to me has always been.

Do you remember, as well, that when I told you about my recurring dream about our being separated by a room-full of people, you said that it was because I realized, as you did, that there was something standing in our way? Did you mean any of the things I've mentioned, dear – or something else – and, if so, what? I believe, you know, that I could make a success of being a permanent Solace to you – because I'd put every ounce of energy I had into trying to be what you wanted me to be – but if you don't, darling, it's no matter. I haven't any will but yours.

I'm so exhausted by this avowal, Gershon, that I feel as if I'd had a baby – limp & wan & panting! I am, I mean – not the Baby!

In the evening Norman Bentwich came to sherry. He has a job in the Ministry of Information. In the event of London's

becoming a besieged city, his job is to Keep the Population calm with Soothing News-bulletins. Horace, if he knew of this, would Snort and call him an Eye-wash-monger – I feel. Horace & Norman were at St Paul's together – they are no Solace to one another on any plane whatever. Norman Wilts visibly at the mention of Horace's name – Horace Seethes at the mention of Norman's – it is all very Intense & Concentrated.

This morning Mrs Seidler suddenly arrived here – she is coming to live in London. My parents are thinking of offering her a home with us, (She wants to live with a family as her husband is likely to be interned any day, and she has no friends in London) but Pa wants to think over the position before actually suggesting it to her.

Please write to me more often, darling. On the days when I don't get a letter from you, I feel like a Gothic Ruin in an 18th century landscape – an empty shell, overgrown with the tangled ivy of Desolation – which <u>sounds</u> very picturesque – but as a matter of fact it isn't.

MONDAY 1 JULY Darling, I'm in Solace – so please don't answer my questions in yesterday's letter – because I don't want to be in sorrow all over again. Thank you.

WEDNESDAY 3 JULY Oh! please let's get this Intentions question settled in your next letter, darling. It's no good being stern about 'troubled sleep'. Last night I didn't sleep at all, because I thought I was going to hear the Awful All this morning.

I had rather a Harrowing afternoon, yesterday. Joan & Ian came to lunch. It was their last day together before Ian left for Nyasaland* – and during & after lunch, we all Glittered with Synthetic Gaiety – then after coffee, Ian said he'd have to leave at 4.30 for Croydon where his people are staying – and Joan went upstairs to put on her hat & she sat down & cried & cried & cried. Then she went into the bathroom to wash her face – & remarked that she'd better see Duncan while she was there – when we

* Ian Nance joined the Colonial Service in Africa, before serving in the Abyssinia campaign with the King's Own African Rifles.

suddenly became Aware of a Strange Man on the Windowsill. (We found out afterwards that it was the Gardener trimming the hedge.) It was so fantastic that it broke the Tension & we laughed hysterically for at least ten minutes.

Then they went off to the Portuguese Embassy to get a visa for Ian for Mozambique – & at 4.30 I met Joan at the Cumberland. (She asked me to have tea with her somewhere detached & noisy – & it seemed the ideal place.) She behaved, darling, with marvellous dignity & courage. I have the most tremendous respect for her – perhaps more than for any of my other college friends. I wish I were more like her – & I know that, at the end of three years, she & Ian will resume their relationship as though he'd never been away. Their love is Serious, Complete & of a Certain Magnitude – and after Sorrow there will be Regeneration.

Nurse is a <u>fool</u>. I was trying to make Joan & Ian laugh at lunch (<u>and</u> succeeding, darling) by telling them how Sheila explained to me the other day that Allan failed in his Tripos because he <u>would insist</u> on sticking too close to the point. (I'd stick to it too, if I only had one point – I'd cling to it as a drowning man clings to a straw – wouldn't you?) & Nurse, to whom none of my remarks were addressed, snorted & said: 'I think you spend your whole life saying nasty things about the people you call your friends.' Joan & Ian just stared at her coldly & my mother said 'Well, I'd rather see her laugh than cry.' Nurse gave us all a Comprehensive Dirty Look – and subsided. My idiom is so much Bessarabian to Nurse (<u>Is</u> there a Bessarabian language, darling? It doesn't really matter – but I thought I'd like to know).

SATURDAY 6 JULY Joan doesn't know what to do this vac. She wants some kind of job, I think. We are considering trying to find something to do together, as soon as I hear from Lord Lloyd & find out what my position is with regard to the Civil Service.

Yesterday, I was able to collect quite a considerable parcel of jewellery to send to the Red Cross. I found I had a lot of gold bangles and lockets & trinkets which could be melted down for their metal value & I sent, as well, a diamond & sapphire bar brooch – a brilliant brooch and a seed pearl & lapis lazuli necklace.

In the afternoon my parents took me to Christie's to see the things that people had sent. The jewellery was rather staggering – colossal diamond necklaces – and superb single-stone rings – as well as smaller things running the whole aesthetic gamut from Horrified Sorrow to Extreme Solace.

MONDAY 8 JULY Good morning, my dear love. Thank you for your letter. You're right, you know – my mother in her twenties was very much the sort of girl you describe. Leslie H. B. realized this when he said 'If I could meet a girl who was what you must have been at twenty, Vic, I'd marry like a shot' (His idiom – not mine). And the look he gave me as he said this – spoke volumes for my inadequacy.

I'm more grateful than I can say, darling, for your just and generous summing-up of the situation. It seems to me that if I make up my mind to be a little less inadequate as a Solace – it will be something to keep me busy – & I think that, in future, if I'm busy, I shall be well, and that will be a Solace to you, won't it? You see, now there's nothing organically wrong with me. It's just that my mind is being pounded down ceaselessly with the fear of not seeing you – & the endless hammering tires me so much – that by the end of the day, I do feel ill. The Victorians called it a decline, dear, but stronger women than the milk & water heroines of Victorian fiction have suffered from the same thing. After all, Lady Macbeth's madness dated from the time when 'my lord went into the field'.

I'm going to learn to be useful. (You're right, darling, I can be useful – but it bores me.) Furthermore, if, at any time you want me to dance with you, I shall. (But you wouldn't really like to dance with me, would you, darling? No? Thank you.)

Nevertheless, my dear love, although, now, I know exactly what you want from a Real Solace, I shall try to be more like the girl you want. (Not as an affectation, dear. (Heaven forbid!) What I want to do is simply to make use of certain characteristics 'that I have of my own', which aren't developed at all because I wasn't interested in them – but they are there.)

Strangely enough, Gershon, one of the things that I value most highly in you is the fact that your affection for me does not

59

blind you to my shortcomings ... (Incidentally, dear, 'In love' is not my idiom – because its opposite is 'out of love' – whereas the opposite of 'to love' is 'not to love' which is less frighteningly consecutive!) That is why you are incontestably my friend as well as my Young Fellow – because, though my feelings are a sorrow to you on one plane, you are able to meet them with wonderful sympathy and understanding on another – whereas, if your regard for me were uncritical – you'd be so shattered when you found me out, that you'd cast me off at one fell swoop.

I often feel that you think that my affection for you is blind & undiscriminating – but, as a matter of fact, darling, it isn't. The things for which I love you are real – your tolerance & understanding – your infinite patience with me – your unswerving sense of honour – which has led you scrupulously to keep me abreast of what you were feeling from the very beginning of our friendship – the subtlety and delicacy of your mind – the broad sweep of your humour – and your charm, of which other women must have been aware before me. Besides these things, what do the qualities in you which frighten me, or which I don't understand, matter?

For instance, we'll never agree in our estimates of the significance of physical love. I am not able to understand, but I have learnt to accept, that you would not regard kissing another girl as an irrevocable act of infidelity on every plane. If I were to kiss anyone but you, it would be an irreparable betrayal – because, to me, a kiss is a symbol of complete surrender. It is something so personal & intimate, that to kiss anyone I didn't love would be nothing less than obscene. (It makes me feel ill to think of it!) But, darling, I do realize that you feel differently about this – just as lots of people feel differently about the actual presence of the body & blood of Christ in the bread & wine of Christian communion – & I'm not less fond of you for that.

I had a letter from Aubrey this morning. He's being moved, Mess & all – and he was all-of-a-flutter because his CO had asked him to go to the pictures with him. It is all Very Beautiful.

Lord Lloyd wrote this morning to say that he'd be glad to give me the letter of recommendation I need – so I'll be able to

send my Comic Form to the Central Register* within a few days – and then I really shall feel that I've taken the first step towards economic independence. (What a Solace!)

WEDNESDAY 10 JULY Ismay's dear little Charles has at last been transferred from an OCTU† darling, stripes and all. She's asked me to have lunch with her one day to celebrate his Rise.

Darling – there is one point arising out of your last letter which I want to make clear. You say that you would like your perfect Solace to be the kind of woman who would not allow her own personality to be submerged if it ran counter to yours at any point – & I don't think it's just a fancy of mine to suppose that you believe that my personality would be so submerged. Well, dear, I should always want, with you, to put your wishes before my personal inclination (as in the instance when you were so angry with me because I went to the theatre, in accordance with your spoken wish, instead of going for a walk as I wanted to – it's a trivial instance but 'twill serve) though often (as on the occasion when I wouldn't let you leave me – to write vitally important letters) my own selfish wants might overrule this – but, darling, if an ethical principle were involved in our conflicting wishes, then I should not want to give way to you – but, because I have absolute confidence in your moral dependability – I don't believe such a conflict could ever arise between us – if I thought it could, I couldn't love you.

Looking back on everything I've said to you in the last few months it occurs to me that I haven't a shred of dignity left in the world. (You know, I think I did once have a kind of dignity, in spite of being dumpy & silly-looking.) I wish I still had a little.

FRIDAY 12 JULY Darling, you should see Nurse's Air Force Hanger-On standing sentinel at the gate while she's pinning the last curl in place – (Tides – Seasons – Armies must wait while Nurse pins her curls into place. She has no Uncertain Opinion about her looks.

* At the beginning of the war the government had set up the Central Register to process the thousands of temporary civil servants that Whitehall was going to need.

† Officer Cadet Training Unit.

She bought a new cotton dress the other day & came into my room to show it to me. I was wearing my blue & white checked dress at the time, & I remarked that hers was very much more attractive than mine. 'It all depends on who wears a dress,' she said, tossing her head. 'Now you might look very silly in this dress, while I think I'd look rather nice in yours' & she left me gasping. Darling, I know I'm plain, but there are kinder ways of saying it, don't you think?)

Mrs Seidler has just arrived dear. She asked after you, and said such nice things about you that I think I'll find her a Solace for the rest of my life.

SATURDAY 13 JULY Some of the characteristics that I have of my own, darling, are the following:-

a.) The ability to talk vaguely to strangers about anything, as though I were interested in them and it. (As it is, I only talk to people who interest me on subjects that amuse – but I do know how to be universally 'sociable'.) In future I shall try & put this into practice.

b.) A real joy in household usefulness, efficiency & neatness – countered by a dislike of doing these things myself – but rather than see a room or a house messy & ill-managed, I would do it – and now I shall do it – in spite of the fact that if I left my room in a mess someone would come in & clean it up.

Bombshell of the Year – Sheila has just rung up to say that Hamish has announced his engagement to Charlotte – & Joan & I were congratulating one another on Tuesday on his Impending Happy Release – and now this has Happened. Oh! woe – how are the mighty fallen. Mr & Mrs Falconer are Numb – Sheila is Shattered – so is Allan – so am I – so, doubtless, is Joan. Charlotte arrived in London with him & her mother – All Dewy & Clinging – then she went to Devonshire & sent Sheila a pot of cream. This, says S, tragically is The End – & she rang off in Sorrow & Anger.

What a Beautiful Picture, darling, – you in the Air Raid Shelter trying to make your mother & Raymond & Alice aware of the Consummation of the Marriage of Literature & Life.

No – I'm not <u>surprised</u> about Hamish & Charlotte – only in sorrow. She's such a dam' silly, prim, <u>kittenish</u> little thing. I don't know why Allan is shattered – <u>probably</u> because Sheila is. I've never known him to have any reasons of his own for anything yet – but Charlotte is enough to make <u>anyone</u> come out in a rash of sheer irritation – & Allan, like the rest of us, is very fond of Hamish.

Darling, I <u>do</u> blame my school-fellows for being unkind about my appearance. You don't know what it's like to be fat & ungainly & acutely conscious of your supreme unattractiveness – & while I didn't want anyone to try & soothe me with mendacious flattery – I was grateful to the people who made no comment at all. I'm still very self-conscious about being plain – (Joyce says that what I lack is showmanship – the power to make the best of my appearance & to make an impression on people by physical self-confidence. Look at Ursula, she says, 50% of her charm is good showmanship. No-one stops to remember that she has nobbly features & is too thin – because she's vivacious & assured & she dresses & carries herself strikingly – perhaps she's right) and Nurse's constant jibes are a real Sorrow.

Joan Aubertin was in London today. She came to lunch and told me (in the <u>strictest</u> confidence, of course – I wasn't to tell <u>anyone</u> – not even you) that Sheila had told her (in the <u>strictest</u> confidence – she wasn't to tell <u>anyone</u> – and <u>particularly</u> <u>not</u> <u>me</u>) that Hamish had bought a Wedding-ring & was hoping that Charlotte would join him in S. Africa on the cargo-boat of an Uncle of a lady-friend of one of his colleagues in the Air Force.

You know, your mother is not the only harbourer of half-witted maids. Lady Nathan's parlour-maid leaves Alice stand-ing. The other night, Lord N, in his Hospitable way, fell-a-snoring before the coffee had been poured out – so Buxom Nellie told the maid to leave the Cona in the Library. 'Shall I leave the cups too?' the girl wanted to know. Lady Nathan thought it would be helpful if she <u>did</u> leave the cups. Then, at dinner, we had some difficulty in mopping up our cream with our raspberries – so Joyce called for

spoons. The maid took away our fruit knives & forks and laid pudding-spoons & forks beside our plates. She obviously took the view that, if we looked upon the raspberries as Dessert, then all we needed were dessert knives & forks – but, as we were going to be eccentric & regard them as Sweet – there was to be No Compromise. Pudding-implements were what we needed, and Pudding-implements were what we were going to get, willy-nilly. A Young Woman of Character – the Nathan's parlour-maid. Joyce has a theory that whenever she introduces Mr Mosley into the Library, she feels as though she were in a conspiracy, and gives Joyce a Lecherous & Understanding Leer – It's a Great Sorrow to Joyce.

MONDAY 22 JULY Joan and I have a Beautiful Scheme, darling. You know that it was announced on the wireless recently that if the town in which you happen to be living is declared a prohibited area, you are allowed to leave it with your debts unpaid for the duration. Well, we thought we'd tap every available Well-Informed Quarter, and find out what the next prohibited area was likely to be – then we'd take a beautiful house there, fill it with lovely furniture, pictures & ornaments, and live there in the Grand Manner, entertaining our friends in Voluptuous tea-gowns, & becoming Centres of Intellectual & Social Life. When our home was declared a prohibited area, we would Move On – to the next potential PA – and so on. Joan has sixteen pounds and I have five – and our only expenses would be train-fares & Removal Vans – so we ought to be able to do very nicely.

WEDNESDAY 24 JULY Darling, my remark about your last letter being 'distant' wasn't a rebuke. There's no need to apologize. All your letters are a Solace, whether you have any news or not. The tone of patient exasperation in this letter (I mean your letter, which I've just received) is more than justified. I try not to cluck, darling – but it's no good. I know that I'm adding to your irritation at a time when you're already restless & irritated. I know that you'd come & see me if you could – That's the real reason why I'm such a hopelessly inadequate Solace. What you want is sympathy & amusement – and all you get is cluck. Damn you, Eileen, you'd be much better dead. (I'm not suggesting that you think this, though you

well might – but I do. I'm sickeningly angry with Eileen Alexander. She hasn't any balance or any control. She professes to love you & all she can do is worry you. She's egocentric and a fool – and oh! so ludicrously inept. Tell her once & for all time, to let you alone, darling, and find a Solace worthy of you – a solace who will make you laugh & feel light-hearted & young when you see her, who has life & colour & charm, not one who can only cry & clamour and look pale, not one who would see you ill rather than away from her.)

MONDAY 29 JULY I had a letter from Aubrey on Saturday. He goes around the countryside in a car (with or without Attendant Sergeant – It All Depends) ostensibly engaged upon Detailed Reconnaissance – but really drinking Gallons of tea beside the Wye. He's in Great Solace. Pte Nightingale is sure he (Aubrey) is winning the War – Aubrey is not so sure – but he finds Pte Nightingale's devotion & loyalty (In Spite of All) Very Beautiful. (All this is, of course, my idiom – not Aubrey's.)

I hope you'll find the work interesting in the Air Force, my dear love. It isn't dangerous, is it? Oh! please God don't let it be dangerous. Darling, it would be so humiliating to be in Grade II (feet) that I'm almost glad you're ineligible for Special Duties. Grade II (eyes) is an Intellectual Grade – All the Best People are in it – It's an honour to be in Grade II (eyes). But Grade II (feet). Oh! no, dear.

TUESDAY 6 AUGUST I had a long letter from Joan Aubertin this morning. She says her sister, Alice, solemnly assures her that Chamberlain may not recover from his operation – which was an attempt to put guts into him! (Alice's idiom – not mine.) She hasn't heard from Ian again – and she's had her eyebrows plucked. She says the effect is a Terrific Solace – but I can only say, what a sorrow. She was knitting me a square for my blanket – but the dog got hold of it – it's Alice's dog, she says defensively, as though this was enough to exempt her from All Responsibility – but, on the other hand, it was her knitting – ah! Well.

I'm lunching with Pa & Mr Gisborne at the 'Cheshire Cheese' today. I gather the food is good but Beefy – but it was a favourite haunt of Dr Johnson – and I'm going there in search of Resolution – the Resolution to Write – a quality which the Great

Cham of Literature had, above all others. (A wonderful man, Dr Johnson – the greatest prose stylist of all time.)

Pa & Mr Gisborne talked war across the table & I just sat steeping myself in the Atmosphere. Of course, the place has been exploited – The menus are distinctly Ye Olde ... in Gothic lettering with deckle-edging – and there's an iron grid sentimentally protecting the step worn down by Dr Johnson, Charles Dickens & others. The café was rebuilt in 1667 & hasn't been touched since. It's down a tiny alley off Chancery Lane in the city & it has a wrought iron sign over the door. The fact that the shop opposite assures all comers in heavy white enamelling that it sells All Birth Control Appliances, illustrates the profundity that Time Marches On – but otherwise you'd never suspect it. The rooms are low and square with flagged floors covered in saw-dust – and heavy oak panelling & benches – leaded glass, old pewter, and framed playbills, 18th century newspapers, and great mugs of clay pipes everywhere.

WEDNESDAY 7 AUGUST I'm very tired, dear, – I've done nothing all day but go with my mother to the butchers to help her buy several miles of miscellaneous sausages – and take my shoes to be repaired. I woke up this morning with a great Longing upon me for tripe & lemon sauce – I mentioned this to my mother who said hesitantly that she wasn't sure that it was Kosher. We rang up Mrs Greenberg to find out what she had to say about it – but she wasn't very helpful – she said it wasn't on her Forbidden List – but that she'd never seen it in a Kosher butcher's shop. We approached Mr Rubenstein in some trepidation, and timidly put the question to him – He emerged from an Outsize in Bowler Hats, and stood for a moment bemused and blinking in the sunlight. He murmured something about having to get a Certificate for it – and any way they weren't issuing it since the war – but the major problem still remains unsolved – and to whom should I turn in my bewilderment but my solace? Tell me, darling, is tripe Kosher or is it not? Everybody Hedges so, when confronted with this seeming-simple question that I begin to believe that it must have some Awful Mystic Significance – like the Question in the Fertility Rites of Antiquity. If it has any such Significance, you will know it. (After all we know Everything between us, don't we, dear?) So Tell Me All.

<u>THURSDAY 8 AUGUST</u> Miss Sloane rang up this morning to ask me if I'd like to become PA No. 2 again for a time – if I had nothing better to do – I said I had nothing better to do (and I said it more in Sorrow than in Anger, darling) and promised to call at Leslie's Office on Monday & do what I could.

Oh! and one other news item before I go to sleep. Lord Lloyd's secretary phoned Pa to ask whether I'd got a Civil Service job yet. Lord Lloyd, he said, was particularly anxious to be kept informed. This may mean nothing or it may mean a great deal. I'm not banking on it as a Great Hope, but it's encouraging, isn't it, dear? I'll never say another word about Lord L. He's really been extraordinarily kind in the matter.

<u>SATURDAY 10 AUGUST</u> Pa & I had Words this morning – because neither of us were smoking. He said I did nothing but sit in my room & write letters – He hoped I was proud of my War Effort, he added acidly. I said that I only stayed in my room to Keep Out of the way of his Incivilities. My mother intervened soothingly and there the matter ended.

Darling, please don't start your letters 'Dear Eileen' – I always feel as though you're about to Congratulate me on the birth of my third son, or ask me to dinner to meet your deceased wife's sister – such an interesting woman, you'd have so much in common – or offer me a ticket in the House to hear your Budget speech – or ask me to return that book I borrowed from you in '86 – and I always miss the Solace of the first page, because I'm busy adjusting my mind to the queer convention which moves you to start a letter to me in the same terms as you would start a letter to your grocer – ordering a pound of tooth-picks. Plunge straight into your letter, darling, please, and then I won't have the disconcerting feeling that you're writing 'Dear Eileen' to gain time – & thinking 'What on earth shall I say to her today?'

<u>MONDAY 12 AUGUST</u> Think of me in the next few days, recording applications for the abolition of Rats & other Vermin (unspecified) in tenements, in a 'neat, round, complacent hand' – which reminds me of an authentic remark made by one of my father's Egyptian Students in the days when Pa was Professor of English Law at the

University of Cairo. The young man had been absent from his class for several days, & my father went up to him after the lecture and asked whether he'd been ill or anything. The young man looked woeful & said no, that he hadn't been ill – but that his wife had died – but it was the idiom in which he announced this unhappy event which was so remarkable – because, darling, believe-it-or-not, he said – 'The hand that rocked the cradle has kicked the bucket.' My father has never really been the same since.

Listen, my love, (talk about trembling fingers) has it occurred to you that if you should become hurt or anything, on active service – I could only find out about it by reading the casualty lists in *The Times* or by casual report? I'm not being morbid – just provident – D'you think you could ask Basil to write to me, if your family were to hear that anything had happened to you?

What's the good of saying to me that the question of your going abroad 'probably won't arise for months'. What are months? – Darling, I have resources of love to last me till eternity – and then there shall be new reserves in store – and you talk to me about months. If you spent every second of your time with me for the next seventy years, I should still be clucking at the end of it because you were going to leave me for an hour – and you talk to me about months. Oh! darling, don't go overseas – at the thought my heart is turned to stone – I strike it & it hurts my hand.

SATURDAY 17 AUGUST Yesterday was quite Adventurous. I was just coming back from Haverstock Hill with Lionel – I'd been there to have a piece fitted onto the end of my gas-mask at the Town Hall – when the sirens went. We walked into a shelter in a leisurely way, sat down on one of the benches – and I did my knitting until the All Clear sounded an hour later. There was one girl in the shelter besides Lionel & me. Most people took no notice of the warning at all. I arrived very late for lunch with Jean – but she was quite happy, contemplating a heavy gold signet ring which one of her Air Commodores has just given her.

I was on my way home to change for dinner with Joyce, when the second warning went. I took shelter at Hyde Park Corner

– and knitted again. When I got to the point when I had to measure what I'd done – I enlisted the help of four old charladies (all girls together, y'know) and they rewarded themselves for their assistance by Telling me All – inveighing darkly against 'Them' the while. 'They' are the bloated plutocrats who own offices, carpeted in rich Persian carpets which have to be swept and cleaned without so much as a 'oover – O' course it's the 'ousekeeper – <u>She</u> takes the money. Very Sinister, darling.

Dinner at the Nathans was uneventful – except that the Col. asked Pa & me to one of his Wednesday lunches at the Dorchester, which ought to be interesting. Joyce sends greetings.

I went in to call on my parents this morning – and Pa greeted me with the words 'And what does Lord Nathan think about the war?' & suddenly, darling, my patience snapped. I've heard nothing but war from Pa for months – a handful of clichés – an alternation between that gloomy optimism which Victor used to find so trying, and the 'if we have to take refuge in Canada ...' strain.

I said nastily: 'I never discuss the war with anyone.' Then he gave me a dirty look & said 'No, I suppose you prefer to discuss your love affairs with the Nathans.' I was so angry that I felt as if someone were sewing up the corners of my mouth with a needle and thread. I didn't answer though, and he said that he was 'fed up' with my behaviour and he never wanted to speak to me again. I said – thank God for that & would he kindly stop bellowing at me now – whereat he leapt out of bed & left the room – & I haven't seen him since. The whole thing is so damned sordid that I'm sickened by it, darling. – *N'en parlons plus.*

SUNDAY 18 AUGUST Lionel & my mother were hovering around me all morning – palpably sent on a mission of Reconnaissance – and, if necessary, of Appeasement by Pa. The Actual Peace Negotiations started while I was in my bath. My mother sat on the marble edge Appealing to my Better Nature. Lionel stood at the door – declaring that he had been authorized to say that Pa had Meant no Offence – and had Spoken in Anger – and was Very Sorry. I decided that you'd want me to Come Off It, darling – so I did – and it was really just as well – because it's difficult to register Unflinching

69

Aloofness in the confined space of an Air-Raid Shelter – and Pa was Genuinely in Great Sorrow for what he had said.

TUESDAY 20 AUGUST Good morning, my dear love. Nurse is going to be married – her intended is an RAF Sergeant – She's welcome to him – I only know his voice & the back of his head – and neither are a solace to me on any plane whatever. She expects to be married in three weeks' time – to go away for a week's holiday & then come back to us. She's in Great Solace and all Dewy. It was all Decided in an Air Raid Shelter and is Obviously Very Beautiful.

I went reluctantly to Leslie's office yesterday & when I got there Miss Fox told me that He was coming in to work that afternoon. When he came in, he asked Miss Fox whether Miss Sloane had arrived yet. 'Yes,' she said. 'And Miss Alexander is here too.' 'Oh!' he said, with what seemed to my sensitive ear a marked absence of enthusiasm – but a few minutes later he came in and looked over my shoulder at photographs of himself – and fulsome press accounts of 'Our Popular War Minister' and, simulating confusion very prettily said: 'I've never seen any of these – but this kind of work isn't quite in your line is it, my dear?' Then he left me – but in an instant he was back. The office is really a small residential flat & the room where I work must have been the bedroom, because there's a washbasin in one corner and a bathroom within. Now as the bath is crammed to the brim with press-cuttings, darling, the only reason anyone ever has for going into it is to commune with Duncan, as the vociferous plug stridently testifies. It is impossible to be Bashful about Duncan in that office – so Leslie decided to Brazen It Out. 'The lavatory,' he said with Elaborate Unconcern, 'is in There. Do you mind if I use it?' 'Not at all,' I said Graciously. I wonder what would have happened if I'd said it would be a Great Sorrow to me? I shall Never Know, now.

Later in the day, I heard him rating Miss Fox soundly for only providing dry biscuits for my tea. She came in all chastened to ask if I'd like a doughnut. 'No, thank you,' I said mendaciously – and – when she went back to report – he positively exploded – 'Of course, she'd say "no thank you" – what else could the poor girl say in the circumstances. She's good enough to come all this way to help and all you can give her is a handful of water-biscuits. I

never heard such nonsense – Don't let it happen again.' And when I left, he expressed Great Sorrow at my not yet having a job: 'Tell 'em all to go to Hell – and go back to your books where you're appreciated,' he said. So you see, darling – I'm not In Disgrace with him any more.

WEDNESDAY 21 AUGUST Lionel & Dicky, on hearing of Nurse's engagement, asked wistfully when I intended to Follow Suit. Lionel thought Antony Ellenbogen would be a nice name for my first-born. Dicky favoured Winston S. Eban! Lionel said oh! no, the country would be Overrun with Winstons in the Coming Generation – besides, I was, after all a literary specialist though, of course, Dicky couldn't be expected to know All the implications of 'Antony' – Dicky (who had thought Lionel had chosen Antony as a compliment to him – Dicky's name is Anthony) shrunk from his F. H. to normal & withdrew from the Discussion. Lionel added that Eban was a trivial little name. He, for his part, preferred the Rich Resonance of Ellenbogen. (What then would he say of Kazen Ellenbogen if he Knew All, dear? One day, I must Tell him.)

Darling, while I was in my bath the other day a Great Sorrow Swept Over me – sorrow that you & I had never mollocked on your sofa at King's. What a waste, as my Grandmother said when she was sick as a result of over-eating at Dicky's circumcision party. (He was circumcised on the Day of Atonement.) 'What a waste' was a favourite expression of my grandmother's.

Joy Blackaby has just written to me saying, 'Whether it's love or the motor accident you're certainly a pleasanter person than you were'! Look what you've done for me, dear.

THURSDAY 22 AUGUST Thank you for your letter in Morse, darling – but don't do it again. It has a stultifying effect on your style. Lord Nathan did Pa & me much honour at the Dorchester Lunch.* We

* The Dorchester lunches, organised by Lord Nathan in support of Army Welfare. Sir John Anderson, the guest speaker at this lunch, was effectively the home front supremo in the wartime government, but best known now for the 'Anderson Shelter' named after him, a curved, galvanised corrugated steel air-raid shelter, 6 ft high by 4.5 ft wide and 6.5 ft long, that could be sunk into the ground or covered in soil and sandbags. Issued free to all householders with an income under £5 per week, over 2.5 million were erected before and during the war.

were at the same table as his mother & brother & Mr Oppenheimer. I was sandwiched between Pa & Mr Oppenheimer – who was all Gracious Civility. He said he couldn't see a trace of the accident – and told me coyly & In Confidence that he was dining with Fanny that evening. I will encounter Darkness like a bride, his look seemed to say – and hug it in my arms. Sir John Anderson was dull to yawning point, but he told one nice story about an Anderson shelter. He was investigating the damage at Croydon last Friday & he came to an enormous bomb crater in a working-man's back garden. The man pointed to a few scraps of shattered metal at the bottom of the crater and said rather shyly 'That was my Anderson Shelter'. 'Oh!' said Sir John – rather fatuously, as he admitted, himself – 'You weren't in it then?' 'No,' said the man, 'The warning sounded too late for me to be able to get there.' He also told of a mother who turned angrily to her fifteen-year-old daughter who was quietly reading in the shelter and said: 'Shut that book, Mary & pay attention to the air-raid.'

Allan unexpectedly got his calling-up papers for September 12th and he & Sheila are getting married by special licence tomorrow week.

Lord N. has asked us to the lunch on the anniversary of the outbreak of war (Sept 3rd, in case you've forgotten, darling) to hear Eden.* It should be interesting – only if you're in London then, I shan't dare to tell my parents I'm not going. Oh! Damn – I'm clucking already at the very thought.

SATURDAY 24 AUGUST Darling, If I sound querulous (and I am going to sound querulous) you may deduct 20% for Saturday – but the rest is real. Your twopenny snap is damned awful – and I wish you'd never sent it to me – (especially as you're wearing a jersey under your tunic which wasn't knitted by me. Yes, I do notice everything) because now I know you're in the Fighting Forces – and I've been crying ever since I had your letter – it makes me feel ill – and the thought that you are only going to write to me twice a week – because you're too busy being convivial with your fellow Air-Craftsmen isn't much of

* Anthony Eden, Conservative MP and enemy of appeasement, was Foreign Secretary from 1935–38 and after being Secretary of State for War returned to the Foreign Office at the end of 1940.

a Solace. Oh! darling, please don't be angry with me for saying this – but do you remember how often at the end of last year & the beginning of this, I used to be in Great Sorrow at some of the things you used to say in jest – and you used to explain that you were just absent-minded and that most of the girls you knew didn't mind flippant remarks in that strain. You won't be likely, will you, my dear love, to get into the way of making that kind of remark, through casual contact with girls who don't mind them? I'm frightened, darling, frightened that the new idioms & new values of military life will make you impatient and bored with mine. Please don't be bored with me, dear. (Pause – for more crying.)

I'm afraid this is a very Great Sorrow, darling. I've had three cigarettes in rapid succession & they've had no effect whatsoever. What has actually happened is that the solace of our time together while you were in London has lasted until today – and it's only worn off now because I've suddenly realized that you're in a new environment – among new people – and wearing new clothes. (Perhaps I'll feel a little better when you're dressed in my pullover, dear.) These strange men with whom you live and play cards & go to dances frighten me, darling. You're starting a new life in which I have no part. What do you talk about? Oh! darling, is all this going to 'iron wedges drive and always crowd itself betwixt'?* Please, dear, let me have a long letter on Tuesday and another on Saturday, and a little reassuring one on Thursday. You're so far away and I can't do without you – Indeed I don't want to. Does anyone want to go on living without a heart or lungs?

Pa has read & approved my letter to Lord Lloyd's secretary. Something ought to happen soon. Bernard Waley Cohen told me yesterday evening that he'd got a high administrative Civil Service job – and he hasn't even got a degree.

Miss Fox is away on holiday and I'm going to Answer the Telephone & Be Efficient for Miss Sloane all next week.

I met Nurse's YF† last night. A wisp of straw, darling, but quite inoffensive – though he's neither here nor there.

* 'The Definition of Love', by Andrew Marvell (1621–78).

† Young Fellow.

I wish you were here to mollock with me in Air Raids. I don't mind Air Raids if I can mollock while they're in progress. As it is I just Brood Savagely – & knit.

This is an unsatisfactory letter, dear. But if I were to have to do without you – why then let Rome in Tiber melt & the wide arch of the ranged Empire fall – oh! God, I hope they give you leave soon.

SUNDAY 25 AUGUST There's no place in the world where one is so suffocated by Family as in an Air Raid Shelter. I pretended to go to sleep in an endeavour to Escape – but there they were – Everywhere. Nurse, who hadn't bothered to see that the children had rugs – lay back on pillows – enveloped in an eiderdown – and Relaxed. (She'd obviously been reading the Women's Papers which tell you to Lie Back, Drop your Lids, and Relax completely whenever you can, or you'll get Wrinkles – I have wrinkles.) I'm getting a very severe attack of Emotional Claustrophobia, darling. It's not pleasant.

TUESDAY 27 AUGUST God! darling, what a night. Hell has no terrors for me anymore. As the sirens shrieked, I called on Duncan & went, quite good-humouredly into the shelter, thinking that having a warning at 9.15 might mean an undisturbed night. I knitted quite happily for about an hour and a half – and at quarter to eleven, Mrs Seidler turned out the shelter light & I tried to sleep, dear. We could hear the dull thud of AA* fire and the spattering of machine-gun bullets – and close overhead the thick chugging of aeroplane engines. It was an oppressively hot night and the only sound apart from war-noises, was Pa's ear-splitting snore. By midnight, darling, I felt that I'd rather die slowly of wounds than live in a room with Pa and Dicky. It wasn't a reasoned loathing, darling, it was just intense & hysterical & suffocating – the spiritual equivalent of the stale and thick air of the shelter. Then Pa said something nasty about Nurse, who had been caught in the raid – & his tone implied that no-one should stir from the house in these times – and I got up & said quite quietly that I was going to bed. Then, darling, the trouble started. Pa said that if I moved he'd go out into the night

* Ack-ack or Anti-Aircraft fire.

– (I knew it was only histrionics but I dared not take the risk of its being genuine for my mother's sake). I said he was a damned bully – and stood in the doorway, watching columns of sparks scattering outwards in the sky – and after that, I sat on a cane chair by the door until the All Clear sounded at four. I didn't get to sleep till about five – and now I feel infinitely old & tired – & so bitterly resentful of my father that I feel it would make me physically sick to be in the same room with him. Oh! darling, I wish you were with me – though even if you were here I can't see that we would have anything but Sorrow under this new martial law notion of Pa's. Darling, I'm sick & sullen – & I've only had two hours sleep – I'll write more later. Oh! I'd trade a kingdom for a laundry basket, if only I could get away from my father for ever.

Oh! darling, I could have done with a letter from you today – but I expect the mails have been delayed by the air-raids. It isn't that you're angry with me for the letter I sent you on Sunday is it, my dear love? Oh! please don't be angry with me. Your affection is the only thing of worth that I have in this turmoil – Don't take it away from me.

Later: Darling, I've just come home to find a letter from Lord Lloyd's secretary, saying that Lord L. is going to write to the Central Register asking them 'what exactly has happened to your application'. This is heartening news and a step towards achievement.

WEDNESDAY 28 AUGUST Darling, I had a very queer experience last night. We had a small dinner party which I hadn't even bothered to mention to you because I'd no reason to suppose that it would be anything but dull – and anyway I expected to be too tired to take any interest in anything. Our guests were Col. & Mrs Fred Samuel, Joyce, Herman and a Captain & Mrs Wingate,* whom I'd never met before. My parents met them a few nights ago when they were dining with Mrs Gestetner & had liked them so much that they'd asked them to dinner. He has rather a nobbly face, with a strikingly intellectual forehead and a sullen mouth – she is twenty-two

* Orde Wingate met his future wife, Lorna, on a sea voyage from Egypt when he was thirty and she sixteen, and they married two years later. They were both committed Zionists.

(she married when she was seventeen) and her eyes and face are alive with light and intelligence.

During the early part of the dinner, everything went as I'd expected. I was sitting between Herman & Capt. Wingate and I exchanged a few desultory & apathetic remarks with them – but mostly, I just sat back in a coma.

Then, darling, the Sirens went – and the thought that I need not go out into the shelter sent me almost crazy with relief. I laughed hysterically and said 'This is an Air Raid de Luxe' and I suppose my face must have come alive because Captain Wingate suddenly realized that I was there, and turned to me & started asking questions about Cambridge & what I'd been doing there. I knew I was talking well, dear, though I sez it as obviously shouldn't, and I told him that my major interest in Cambridge had been the study of love in Arthurian Romance. He asked me a lot of very searching questions – paused over the problem of reconciling the attitude of the church and the nobility to sexual love in the Middle Ages, and then asked me if my research had led me to consider the nature of sexual love – through its manifestations in different ages! I said not very seriously – and he said that he thought the essential pleasure of physical love and emotional love lay in pressure. (Yes, I thought, the pressure of Gershon's arms and mouth and head and hands – but I didn't say anything about that, darling!) He said that in the final act of love there was the joy of violation – of breaking down a barrier – but in all the less primitive manifestations of love, (he didn't use primitive in any censorious way, of course) pressure existed in two ways – actual physical pressure – and the pressure of repressing the normal biological urge – or rather pressing it into new shapes. If the pressure is too hard it becomes painful – but gentle repression can give very great pleasure. (That's why you and I are on the Highest Plane of All, darling.) He also put forward the theory that all civilized trends were, in their early stages, an attempt to enhance the sexual market-value of the individual. The accumulation of wealth, for instance, in the days of barter, made the owner of fine wares more alluring – and so on. We argued and danced around one another and side-stepped – and then the women went into the drawing-room – and I discovered that Mrs Wingate was a student of Malory – and a girl of very great charm

and acute judgement. What a Solace, darling. I talked too fast and too loudly, but I was alive again after a day of hellish weariness – and when they left – intoxicated with the exuberance of my own verbosity, I told my parents I was going to bed and I stuck to it.

Later; Oh! darling, I'm crying – Please don't be angry with me – I've been regretting that letter ever since I wrote it – I'm sorry about the photograph – Please may I keep it? – it's got a message on the back. In it, my dear love, you are most notoriously abused – you look like one of the Comic Characters from *Follow The Fleet* – but it's faintly like you and I'd like to have it. I was ungracious – but I'm so sorry, that it's inexpressible. The remark about the pullover was meant to be in jest – tearful jest, because I was (and am) in Sorrow – but I'm not surprised it didn't come across in the right spirit.

Of course you got full marks for Morse – I don't need to draw myself up to MFH* for that – I knew you would.

Thank you for not letting your new life drive a wedge between us, darling – I'm only frightened because I love you so much – It's not really surprising, is it? (I mean that I'm frightened! It would hardly be modest of you not to think the other surprising.)

Thank you for telling me that you were 'rather irritated by (my) clucking' at the beginning of your letter – but I had noticed – but please, darling, don't be irritated with me again. – I can't help clucking – and my clucks never mean anything. Please say in your next letter that you're not irritated any more – I knew you were going to be angry – and when I came in from Miss Sloane's office, I sat with your letter on my knee for well over ten minutes not daring to open it.

THURSDAY 29 AUGUST Hell was let loose in the sky last night darling – and I slept through most of it. The Sirens went at nine and, because I thought it would be uncivil to go to bed so early I sat in the shelter until ten, knitting – and then went up to bed. When I said goodnight to them, my parents were sullenly silent – but I undressed, and in a few minutes I was asleep. Mrs Seidler woke me

* My Full Height.

at two and said 'Listen' – and I did and I could hear the bombs crashing quite close at hand – she told me that my mother had spent the whole evening crying piteously – so I went down to the shelter as a Gesture. There were red patches in the sky from fires – and the searchlights criss-crossed like basket weave. I sat in the shelter for half-an-hour & we could still hear bombs and AA Fire – after that things quietened down – and I couldn't stand the shelter any more – I could feel that suffocating hysteria welling up inside me as it did the other night – and I went back to bed and I slept till morning, neither hearing the All Clear or anything.

You know, darling, I don't think women discuss the 'unmentionable' topics, which all men talk of when they're among themselves. Some of the dirty-minded little perverts at school used to stand in corners and smack their lips over pornographic talks – but they always stopped when I came into the room. Doris collected & retailed stories of hair-raising obscenity – but they didn't offend – because she was so objective about them. Jean is different – Her conversation isn't frankly & healthy bawdy in the Chaucerian manner, as I imagine that kind of conversation is among the nicest men, it is unpleasant & suggestive – and I should think hers is the idiom, verbal & atmospheric, of women who do discuss these things – jest – but I think it's the exception rather than the rule.

Please forgive me for clucking & snapping, darling – but suppose you suddenly found yourself in possession of the Kohinoor diamond, wouldn't your nerves be a bit frayed at the thought that the whole world was striving to take it from you by fair means or foul? I think you would – but I'll try not to cluck again – I only want to please you.

September–December 1940

For fifty-six out of the next fifty-seven days and nights, beginning on 7 September, London would be bombed. The shift in German tactics from the airfields to the cities might have been a tacit admission of failure, but if it arguably put paid to Hitler's invasion plan, that would be of precious little comfort to the capital, where in the East End and the docks, more than four hundred were killed and sixteen hundred wounded in that first massive raid alone.

It was typical of Britain's pre-war planning – too little and too late – that in crucial ways London, and particularly the poorest and most crowded areas, was hopelessly unprepared. The Luftwaffe might not have had the planes or accuracy to inflict the kind of casualties feared, but until Londoners took matters into their own hands and occupied the underground stations, a government wary of nurturing a defeatist 'deep shelter mentality' had left the capital criminally short of the kind of shelters that would have saved so many East End lives.

While it was of no help to the thousands already left homeless, however, with each passing September day the threat of invasion was receding. On the same Saturday that the Blitz began, the codeword 'Cromwell' – the warning of an imminent invasion – had been issued, but for all the false alarms and rumours of German parachutists, no invasion came and by the 17th, with the 'weather window' closing and Britain's Fighter Command still defiantly intact, German invasion plans were indefinitely postponed.

But if the Battle of Britain was won, there was no let-up in the bombing, and with Britain's night fighters as yet ineffective, and the capital's anti-aircraft guns as much a danger to Londoners as Germans, the

nights ahead would belong to the Luftwaffe's bombers. In the early days of the Blitz the raids had generated a good deal of class hostility, but as the attacks spread from the East End across the whole of London, and the king and queen found themselves as likely to be bombed out of their home as was a bank clerk, 'Britain', as J. B. Priestley memorably put it, found itself 'being bombed and burned into democracy'.

Something of this new democratic feeling – and with it a more richly varied cast of characters – finds its way into Eileen's letters. For the first year of the war her view had not stretched much beyond her family and Cambridge circles, but with the beginning of the Blitz the letters broaden out to embrace a world and a London of bus drivers, chars, wardens, police-men, secretaries, cinema queues and – most fertile of all – work.

She had, of course, helped out in Leslie Hore-Belisha's constitu-ency office, but her first real job was at the War Office's newly formed Welfare Department. The Army Welfare Service, to give it its proper title, was the brainchild of a distinguished veteran of Gallipoli and the Somme, the London-born and St Paul's-educated solicitor, Liberal MP, newly minted Labour peer, Zionist and 'Vociferous Clatter', Harry Nathan. At the beginning of the war Nathan had realised that there was nothing in place to help soldiers with the myriad problems of long separations, and after consultations with service chiefs had come up with the Welfare Service, a voluntary organisation, dependent on unpaid workers and charitable donations – Nathan's 'Dorchester Lunches' were a rich source of supply – and aimed at relieving 'as much as possible the anxieties of a soldier about his family, his job, his home'.

As there was no Treasury money available for this, Nathan had persuaded his law partners in Finsbury Square to partition off fifteen rooms of the firm's offices, and it was here, at the end of October, after the best part of a month humming and hawing over the offer of a job at Bletchley, that Eileen reported for her first paid work. It was an hour for her on the tube from Swiss Cottage to Moorgate and for the next two months, until the offices were badly bombed and their records destroyed in the terrible raid of 29 December, Finsbury Square and the bizarre antics of bigamist soldiers and unfaithful wives would provide Eileen and her letters with much of their copy.

The strategic bombing of Britain's major cities and ports would continue deep into 1941, but Britain, under Churchill, was in it for the dura-tion. By day, across the length and breadth of the city, Londoners like Eileen

were finding their way to work, cramming into overcrowded and fetid tubes, sitting on diverted buses, picking their way through streets lined by the smoking ruins of shattered buildings, and heavy with the smell of broken sewage pipes and death. By night, too, London was coming to terms with life under the Blitz. In underground stations, in commandeered and improvised shelters, in 'Andersons' and 'Morrisons', in cellars, surface shelters, church halls and under railway arches, in whole sections of the tube network, equipped at last with bunks by authorities badgered and shamed into action, London sat, dozed, talked and grumbled its way through the raids. But, then, as Eileen wondered, what else was it to do? 'When the papers say that people in London are behaving normally, they're telling the truth,' she wrote to Gershon, 'everyone is pretending as hard as possible that nothing is happening ... I don't think Hitler will destroy London, because London, if its legs are blown away, is prepared to hobble on crutches.'

4

Blitz

FRIDAY 30 AUGUST 1940 Thank God you're in Blackpool, darling. Even if you have leave soon, I begin to feel that perhaps you'd better go home. Here you will have disturbed nights and disturbed days – and no rest at all – & you'll hear the thudding of the war machine without intermission. I think you know what it costs me to say this, but I feel that I owe it to you and your parents not to let you walk straight into a barrage of gun-fire on my account. Yesterday the sirens sounded during Sheila's wedding (The all-clear went as they were signing the register) and again at the reception. Kirby was held up all along the road and was only able to get Joan to London at 5.30, just in time to whirl feverishly into Claridge's and see Sheila & Allan for an instant before they left. She had to spend the night here – because there was no train to Peterborough after 5.30 – but she was in the air-raid shelter from 9 till 4. We were able to show her a lively slice of death-in-action – The AA guns on Primrose Hill were firing for the first time – and there were two screaming bombs close at hand – (they didn't sound as bad as we'd been led to expect.) I went to bed at 10.30, to the usual accompaniment of bitter protest – but the noise was so terrific I couldn't sleep – and when the windows rattled and the floor shook after an explosion which sounded as though it were actually in my left ear, I went down to the shelter until things quietened down a little.

3.10 Three raids this morning, darling – and terrific Scenes over the third because I was sick of going to the shelter. Pa says he & I can't live together – Either I must leave the house or he will. Vociferous histrionics all round. I think I am nearly mad at the moment, darling – I have no control – and nothing to hold on to. It's terrifying.

There's nothing like Air Raids, darling, for Drawing People Out. Did I tell you about the old woman on the 'bus the other day – who, on the sounding of the sirens, was given the choice by the conductor, (like the rest of us) of alighting or carrying on with her journey – said 'Go on – They don't allow no dumb animals in them shelters – and what ain't good enough for my cat – fair 'uman 'e is – ain't good enough for me.'

TUESDAY 3 SEPTEMBER Lord Nathan's lunch was quite interesting. Eden spoke with Fervour and said nice things about the oppressed peoples & the ATS. He also referred to the Brief Lives of Secretaries of State for War (as such). Every time he signed a letter to the king recommending anyone for a DSO he said, the following qualifying words were always typed underneath 'His Majesty's Secretary of State for War – for the time being'!!!!

THURSDAY 5 SEPTEMBER Nurse is getting married this afternoon – She's charging up & down the stairs in a welter of diaphanous garments – My mother and Mrs Seidler are up to their ears in food for the reception – Pa is writing his lecture in the shelter, whence I can hear the thin strains of Mendelssohn's wedding march – played as a duet on violins by Lionel and Dicky – It's all quite fantastic and too Ruritarian for words. Have you ever seen an Ivor Novello musical play? – well, this is it! – even unto the Hint of Tragedy, when her brother Refused to Give Her Away, because he is a Welsh Methodist, and she is to become a Catholic – but it All Came Right in the end – and he is now Yapping Obligingly at Her Heels.

FRIDAY 6 SEPTEMBER While you were having a ten-minute raid, we were having a ten-hour one. Last night the explosions were so terrific that I took my pillows downstairs and slept on the drawing-room sofa. The fantastic thing was that the worst explosion occurred

about five minutes after the All Clear – and the LCC* was so Put Out by this, that no sooner had the bomb-reverberations died away, than the sirens went again – Another Warning!

Tell me All about the Commission, darling. Was your remark an Inspired Statement or just a Hope? Incidentally, your photograph grows on me. It really looks like you and furthermore, (and this is a Terrific Solace) it looks at me and not beyond me, like your more Beautiful Civilian Portrait.

Nurse's wedding was quite pleasant. She looked really lovely – but the service was gabbled & there was no music & no flowers in the Church. We had the reception here with froths & froths of champagne – and all the culinary delicacies that my mother, Mrs Seidler & Lyons could devise – and the last iced wedding-cake on the market – two tiers of it, and little silver wotnots everywhere. My father made a really charming little speech – and Nurse's mother-in-law and I Found One Another.

SUNDAY 8 SEPTEMBER Another disturbed night on the drawing-room sofa, darling. The raid began at 8.15 and lasted until 5. During an afternoon raid, Bernard, Jean & I were nearly blown out of the window by gun-fire from Primrose Hill – but we had a pleasant afternoon in Spite of All – and they stayed to dinner. We drew up a list of parental dont's to guide them in the upbringing of their twins – (They want twins – so as to Get It All Over at Once). They are going to make a fair copy of the document – sign it & date it – and then, put it safely away for future reference.

After dinner, we all went up to Mrs Seidler's room and watched the glow from the fires at the docks. The houses were chocolate-coloured, darling, against a translucent sky, the colour of vin rosé, and there were bulges of smoke welling up, feathered at the edges – and occasionally the dazzling comet-fall of a flare and the light of an anti-aircraft shell – as though an electric switch had been flashed on and off. It was beautiful, darling.

* London County Council.

Darling. Lionel & I thought we'd shake off our war-weariness by going to see 'Busman's Honeymoon' at Leicester Square. I don't know if you've read 'Busman's Honeymoon' but in it Lord Peter Wimsey mollocks with his wife in the idiom of Donne – so naturally it's a terrific Solace to me.

However, we found Leicester Square & Piccadilly Circus completely roped off – to safeguard the public from the effects of four delayed-action bombs which they are harbouring.

We were just walking sadly back to the tube-station when the sirens went and we took shelter in a basement, dimly lit by four hurricane lamps – so that knitting was out of the question – though, of course, I had your scarf with me, darling. Somebody said – inevitably – 'What do you think of it all?' which provoked a violent outburst from a tight-lipped, desiccated, decayed genteel old woman sitting beside me. 'If you'd been in the East End,' she said bitterly, 'you'd know what to think of it all. "The spirit of the people is fine" the papers say – I've seen 'em – I <u>know</u> – It's all very well for people like <u>you</u> –' She turned angrily to me – (I had asked her if it would be alright to smoke – and she obviously thought I was a flibberty chip of a Mayfair block). 'If one of your houses gets blown down you can go to another – but the poor folk lose their homes & their families, and then they're left to shift for themselves. Ask <u>them</u> if they want peace. They're crying out for it – craving for it – They want to <u>live</u>.' Here a rather attractive slow-voiced girl – I think she probably worked in a shop – interposed & asked why the 'Cosmo' shelter had been closed down – and a motherly charlady replied that the public had made an awful muck of the carpets – fair tore 'em up – Then she turned to me and said, 'Are you comfortable on that box, dearie? Come & sir 'ere – you'll spoil your pretty dress.' (I was wearing my rill red dress, dear) I said thank you very much but I thought I'd like to stand for a little while – and then a nice old man advised Lionel to move away from the window: 'We don't want nothing to happen to you' – and the All Clear went. So you see, darling, as things are it's almost impossible to move from home. It's depressing and exhausting but if I were asked to choose between death and a shameful peace – I would choose death – Wouldn't you? The only price I <u>couldn't</u> pay would be your life.

It was no good staying in splendid isolation in the house last night. The Primrose Hill AA batteries, which, as you know, are less than a quarter of a mile from our house, were firing every three minutes from 8.15 till 5.30. We could even hear the whirr of the reverberating steel after the guns had fired – and occasionally pieces of shrapnel clanked onto the stone path in the garden. When I left the house for the shelter there was a huge fire in the East, and a bomb exploded about five hundred yards away from me, lighting the sky as though a triangular sheet of magnesium had been ignited – and at the edges, showers of molten earth were thrown up.

Darling, in all my life I've never heard such terrible, heart-rending noise. We really are in the front line here. Sleep was, of course, out of the question. Lionel & I amused ourselves by wondering how our various friends in London were reacting to the havoc outside. The Sassoons, we decided, would be praying hard – in the cellar – you know, trusting in God & keeping their Anderson shelter dry. Aunt Teddy (who has reduced Parsimoniousness to a Fine Art), would probably be saying querulously that Gerta & Malcolm ought really not to keep up a town house and a shelter, when they only lived in the shelter. Jean, I suspected, would be slapping her thigh and telling one of her Air Commodores that she thanked God she was in this war – God! and in it up to the neck, too – and so on.

I've had a letter from the Air Ministry at Bletchley asking me if I'd like a job as a Computer Clerk in the Intelligence at £3. 10/- a week. I might be asked to go abroad and then my pay would be doubled. I'd have to pay 21/- a week for board & lodgings out of my earnings. I may go to the interview & say I'd do the work, provided I didn't have to leave England. It is translating Italian documents – and might be interesting & useful – even though it is not munificently paid – and after all I'm living on £1 a week now – that pays for my cigarettes, having my hair washed – 'bus & train fares – wool for your accessories – stamps and sundries – so really I'd be rich on £2. 9/- a week, wouldn't I, darling? – especially if I sent my washing home – but I'm not going to hurry over any decision.

FRIDAY 13 SEPTEMBER Last night was an exact repetition of the night before, except that I couldn't stand the shelter for long stretches and I had to keep going in and out of the house for a change of atmosphere. I did half-sleep during the night this time – but I feel heavy-headed and dim – and I woke up, darling, in a state of intense receptivity to mollocking! – now I know how you feel in the morning – I never did before.

Darling, did I tell you that Ismay's new house at Kings Langley leads on to 'Lover's Lane'? Could anything be more inappropriate – Ismay, who had to teach Charles to knit because she didn't know what else to do with him in the evenings! Ye Gods!

SATURDAY 14 SEPTEMBER I missed a terrific Drama last night because I was in the house, seeing Duncan. I was just on my way downstairs when I remembered that my mother had asked me to fetch her bag, and I went up again to get it from her bedroom. While I was upstairs I heard the whoosh of a bomb – then an explosion & the tinkle of shattered glass – immediately afterwards one of the Guns on Primrose Hill answered back in no uncertain terms. When there was a lull I went back to the shelter to find Nurse, (who has just come back from her honeymoon), in hysterics – because she'd seen the flash of the AA Gun reflected on the wall and she was vowing (in her own idiom, which is rather different from mine) that she'd Never be the Same Again. Then there was another scene with Pa – but I won't weary you with that.

I've just had a letter from Ismay (yesterday evening.) Charles has got his commission & is having a week's leave. Hurry up, darling, I don't like being outstripped by Ismay. What Charles can do in a year, you surely can do in a month.

TUESDAY 17 SEPTEMBER Darling I forgot to tell you Jean's latest & most supreme example of tact – 'Gershon is a Wireless Operator, isn't he?' she said. I told her that you were. 'Oh!' she said, 'I heard a very comic story about a wireless operator the other day. He was a boy scout and a protégé of the Director of Intelligence – and he wrote to the D of I as follows: "Dear Sir, The pay Sergeant says I get 21/- per day – I asked him how much this was per week and he answered,

'Don't be a fool, no wireless operator has ever been known to live a week.' Please, sir, will you confirm this.'"

THURSDAY 19 SEPTEMBER Darling, I had visions of the Inverforth's camping out on the ground floor with nothing but a longish tarpaulin between them & the rude blasts of Autumn – Actually, it isn't quite like that. Only one wing of the house is really badly damaged through all the floors. In the rest of the building the roof of the attic rooms is badly burnt – but the damage has not gone through to the other floors. We had our first war-wound last night, when the kitchen window was shattered by a jagged lump of shrapnel – There were no casualties. Lionel & Dicky have a new game. They hunt for shrapnel in the garden and then pore ghoulishly over the kitchen scales, Weighing their Catch!

Your letter did come, darling, and by the same post I heard from a Lieutenant Colonel at Bletchley, asking me to go for an interview on Monday.

I think I spoke a little too soon about the wreckage of the Inverforth home. Nita has just wrung up to say they've had another high explosive bomb in the garden & all the windows in the other wing (frames and all) have been ripped out. Lady Inverforth, who is a chronic invalid and 73 years old, was lying in her bed when her windows crashed to the ground. When her husband and daughter rushed in to see how she was she said, with the charming Scots accent that she's never lost, 'Och! Ye know – it's a wee bit draughty – but I'm thinking I'll stay where I am.' I don't think Hitler is going to win this war, dear.

Oh! darling, you're not serious about saluting Charles? – I'm sure he's a rotten hugger – he must be a silly mollocker altogether – he always reminds me, when he's with Ismay, of a bantam prancing round a chicken.

SATURDAY 21 SEPTEMBER My parents say that if Pa & I don't get jobs soon, we ought to leave London after Lionel has gone back to school – (His term begins next Friday) I don't know what to say. We've got a circle of ruined buildings within a radius of half-a-mile, and I haven't slept for three weeks, except very fitfully. Oh! Darling, what do you think? The thought of running away makes me feel ill – but

we're not much use here, really, unless we have something specific to do. I'll write more tomorrow – I'm too tired to think now.

The Inverforth's have a time-bomb & a Messerschmidt in the garden! They've roped off the bomb, and are exhibiting the bomber at threepence a time for the Hampstead Hurricane fund. Even a war has its comic side.

MONDAY 23 SEPTEMBER Good morning, darling. (I'd no sooner written that than the car arrived to take me to Bletchley – and here I am in the Labour Exchange waiting to be Looked Over.) This is a sordid place, darling, and seething with the most awful down-at-heel Girtonians – (They're not down-at-heel because they can't help it – most of them are like that because they make a cult of it. They did – even as Undergraduates – their dun-coloured wispiness was an acute disease then – now it's become chronic – some of them are working here already – some are here for interviews – but one and all have amalgamated into a girlish gaggle – oh! my dear love, if I get this job, you'll have to spend every moment of all your leaves being a Solace.)

I've had a glimpse of the Colonel – He's bent in the middle – and anaemic and he has nicotine all over his white moustache. The girl who is being interviewed before me gave him a Bold Look – and he wilted. When my turn comes he will give me a Bold Look – and I'll wilt. Life is like that.

Darling, as usual you were right. The work of a Computer Clerk has something to do with computation. When I got into the interviewing room – a shaggy man in corduroy's asked me if aeroplanes were 'my line of country'. I said not exactly, & was tempted to add that Launcelet usually got from place to place on a horse. However, I didn't – which was perhaps just as well. He then showed me a passage from an Italian newspaper – It was a detailed and technical description of the Heinkel No. 113 – but as words like 'fuselage' and 'retractive' etc. are much the same in every language, it wasn't difficult – & when I'd finished, the shaggy man said 'Excellent' and Col. Makin coughed approvingly – and then we went on to other matters. I was made to write my name in block capitals as small as I comfortably could. (Don't ask me why, darling – I shall probably Never Know.) This was All Right, too –

but then the Blow Fell. 'Now we come to the figures tests,' said the Man in Corduroys – and the words struck chill against my ear. 'Repeat these after me,' he said, pattering off a string of figures. Well, I could do that too – but, darling, when he made me write a string of nine figures in each corner of the page and then said 'Add those up' – That was my end. 'May I put them together?' I asked tremulously. 'You may not,' he snapped. So, thoroughly rattled and terrified by this time, I did my best – but it was all wrong – and he said 'I'm sorry – but that's a vital test for a Computer Clerk. It's a pity because your Italian is very good – but I'll send your name into another department, where no mathematical qualifications are needed – and if they have a vacancy, they'll communicate with you. I hope it wasn't because we were rather rushed for time that you couldn't manage those figures.' I assured him that it wasn't – I couldn't have done the addition if I'd had all afternoon. So, my dear love, I'm still unemployed. Oh! It makes me feel ill to think that fool of a Barbara Parker, who looks like a wilted leek and got a sweated third in Modern Languages, should have been computing for two months. She must have been able to deal with those damned figures. Oh! What a Sorrow.

TUESDAY 24 SEPTEMBER Oh! darling, they must have been very impressed with my Italian – because, in spite of the fact that I couldn't add sideways, I've had a letter from Col. Makin to say that I've been enrolled as a Computer Clerk, and that I'll hear from the Air Ministry in ten days or a fortnight! I'm in a glow of Solace – what with your long letter and this news.

THURSDAY 26 SEPTEMBER Did you hear Lord N on the wireless last night? 'You can't write too often,' he said – bless his heart. My mother & I exchanged Significant Glances when he said this. Talk about Little Father.

Darling, I'm feeling Uneasy in my Conscience about exceeding my smoking ration – because you never really released me from my promise, did you? Oh! Dear – I'd never make a success-ful sinner, would I?

I don't remember what the figures were, darling – but it's obviously not material, since they say they'll have me in spite of

All. And talking of jobs – Lord Nathan has just offered me one – but, alas, too late. My work would have been to go and see the families of Worried Soldiers imploring them to Write more often, and to call on the Mayors of Boroughs, begging them to look after the wives of men in the Forces while their husbands are away. I'm going to do the work temporarily – and voluntarily, until Bletchley Calls.

<u>MONDAY 30 SEPTEMBER</u> I'm going to help Lord Nathan from tomorrow and it's an all-day job – so I may not have time to do more than scribble a note during the day – though I'll do my best to manage more than that – if I have to get it done in the lunch-hour with a beef sandwich in one hand – and a cup of Camp coffee spilling all over everything.

<u>TUESDAY 1 OCTOBER</u> Oh! Darling, any job which involves reading other people's letters is my delight. I had some very choice ones to deal with today. There was Mrs X who wanted her daughter back from the mental home where she'd been detained for 15 years – all because, when she was 17 she had a baby – not, mind you, that she was a One for the Men – but the man Wot Done It had a spite against 'er (sic) father – and then she was shut up – but there was nothing wrong with her except she couldn't read nor write – and Lord Nathan's talk on the wireless was that friendly – could he do something about it, please? – and there was Lance-Corporal Y. who wanted compensation for his bombed house in London 'Luckily my wife and baby were saved – so was my mother-in-law.'

I work for a man named General Buchanan – I classified letters under various headings today – tomorrow I've been promised something more constructive.

Darling, it's sad to see the tube-stations full of people settling down for the night with rugs and children & thermos flasks at 3.30 in the afternoon. There isn't room at Swiss Cottage to move.

<u>WEDNESDAY 2 OCTOBER</u> Lord Nathan looked at me in puzzled bewilderment & said he hadn't recognized me because he'd never seen me wearing anything but black. (I've got my red woollen dress & grey jacket on this morning.) I <u>love</u> working here, darling – I have an office to myself & two telephones (but alas! they're both black – my Greatest Ambition is to have an office with two telephones – one red and one white – and a private radio-telephone to you – a green one – <u>jade</u>-green. When that happens, my dear love, I shall have Arrived) and writing letters is what I was Born for. General Buchanan apologized for not having a spare short-hand typist to take things down to my dictation! It was a Very Beautiful moment.

<u>THURSDAY 3 OCTOBER</u> Lady Nathan was in here all morning dealing with cases that can get help under the Ministry of Health Evacuation Scheme. I will say this for Lady N – she's astonishingly efficient.

You're wrong about the work here, darling. It's responsible and interesting. Lord N said this morning that he was extremely sorry I couldn't work here permanently – 'There are a thousand things you could do,' he said, 'and you'd be very well paid.'

Lord Inverforth's time-bomb (he's had two since then – one never went off) exploded on the Front lawn – there isn't much left of the Front lawn. Mr Gestetner's was harmlessly removed.

Darling, whenever you want to kiss me, tell me, and I'll stop smoking and suck peppermints instead – In fact, when you have leave, I won't smoke a <u>single</u> cigarette without your permission.

<u>MONDAY 7 OCTOBER</u> Shakespeare is my Greatest Solace after you, darling. I feel quite light-headed after hearing *Hamlet* last night. My mother is in Great Sorrow at the thought of Pa's imminent departure for the Isle of Man – (Oh! my dear love, he'll be within 46 miles of you on his way there). She isn't going with him because she feels she ought not to leave the children & me. We went past Gray's Inn* on our way back from Finsbury Square. 'That's your Young Man's inn,' said Pa reluctantly, and I Saluted it Reverently.

* Inns of Court. Gershon was a member of Gray's Inn.

He then went on to tell me that all that was left of Inner Temple Hall was the walls – and he said it <u>almost</u> as though it were your fault, darling!

TUESDAY 8 OCTOBER Lord Nathan was Displeased with me, darling, because I had filed letters under 'Compensation' which referred back to letters in the possession of The General – whereas I <u>ought</u> to have Tracked Down the first letter of the correspondence, before I filed the second one. Oh! dear. Now, I'm so terrified of making another mistake that I feel I'll never do anything right again.

THURSDAY 10 OCTOBER Darling, I had a remarkable experience last night. My mother has a dreadful cold, so she slept on the sofa in the drawing-room – and I slept on the floor – (I thought that, if the house was bombed, I should not much enjoy living à deux with Pa, afterwards) and Pa stood in the garden acting as unofficial 'spotter'. At about ten, he rushed in, terrifically excited, and said that there was a shower of parachute flares in the sky and that it was one of the loveliest sights he's ever seen. I went with him into the garden, and, darling, the sky was full of outsize stars the size of cricket balls dropping very slowly towards the ground. It was incredibly beautiful.

FRIDAY 11 OCTOBER Darling, today I'm so lonely for Cambridge that it's a <u>physical</u> ache. I had a letter from Mr Turner to say that he had four Girton Research students living in the house. Helen Brown (Zoology – my year – well-cut tweeds and Repression – Good human material – but unexploited – She hasn't decided yet what her values are, so she's a bit hoydenish – She's on rather a High Plane with Lord Rothschild, with whom she works). Rosa Morris (Maths – Welsh – Clever (capital 'C') Self-made (capital 'S') Religious (very large 'R') Worthy (Almost an Illuminated 'W') and painfully, <u>agonizingly</u> dull). Jeanne Fisher (Anthropology – kitten-ish – suburban – with a mind as Constricted as I always imagine the Polish Corridor to be) and Alison Dewar (Classics – one of Joan Friedman's clique – a mean-spirited, pedantic, unprepossessing creature if ever there was one).

Oh! darling – it scratches at the sensitive lining of my stomach to think of those four at Girton Corner – our home – yours & mine and the Turners'. Mr Turner's only comment is that they all seem fond of music and play all their gramophones at once. They're the sort of girls who would use one half of the chaise-longue for balancing their midnight cocoa & biscuits on – our chaise-longue!

I also got a letter from Mrs Woodcock saying that she'd heard from Col. Makin 'That you were accepted & were joining them shortly!' so I suppose I'll hear from the Air Ministry on Monday. Oh! darling, I see duty as a desiccated, wispy, mouse-coloured non-conformist Missionary – rather like some of the Girtonians working at Bletchley in fact. I'll do this job – and I hope I'll do it well – but I was born for other things – and now I wish I'd stood up to my parents and gone on with research. To investigate why a beautiful thing is beautiful is a very Great Solace – to find out why a Heinkel is Efficient may be of use to the War Effort – but on a Lower Plane. Never mind, dear, when you are with me again, I shan't care whether I'm in Cambridge, Bletchley or Bermuda – The mind is its own place, and in itself can make a heaven of hell, a hell of heaven.

Darling, how the monuments and symbols of our stability have been bruised in the past week – St Paul's with a bomb through its head – and Mr Loewe, dead. Mr Loewe was my first link with Cambridge – and, subconsciously, I must have been convinced of his immortality, because I was so outraged to hear that he had died. I think that what made Mr Loewe the only nice member of his family, was a touch of Puckishness – of naif fun – in spite of all his ponderous scholarship and bigotry. Darling, I'm frightened that we'll go back to a new and strange Cambridge, which refuses to acknowledge us. I suppose these are the things which make adults of us.

Joan writes that Sheila was bombed out of Earl's Court, and had to take refuge with her mother-in-law, which is asking for trouble, & the sparks will most certainly fly upwards.

WEDNESDAY 16 OCTOBER Darling, I intervened in what was really a Fight to the Death between two women on the Moorgate platform this

afternoon. Both had been bombed out of their homes and both were trying (illegally and pathetically) to reserve a place for the night against the wall.

They hated one another, and they were nervy and disconsolate within themselves – I went and talked to them, and told each of them that the other was tired and disturbed – and liable to say things she didn't mean because of her overwrought condition. I said we all felt the same at the moment – and at this point another Grand Old Woman marched up and croaked, 'Look at me – Six bombs I 'ad outside my front door – I never want to see my flat no more – Never I don't. Lost me voice wi' fright – I did – so everyday nah I comes to the choob at eleven in the mornin' and chooses me place – Nothink else for it –' – and then the other woman edged nearer to hear more – and I left the three of them exchanging pleasantries as to the manner born.

Lord Nathan asked me to sit in the Client's Chair in his Office this morning – and repeated his suggestion that I should stay on here – (Did I tell you, darling, that I had a letter from Mrs Woodcock yesterday, or it may have been the day before saying that I was under no obligation to go to Bletchley unless I liked?) But the more I think about it the more certain I become that I'd be better and happier at Bletchley.

I had a Beautiful letter to answer today – It was from a woman, who said it was all-very-well saying that wives ought to write more often to their husbands in the forces – but what about husbands in the Forces who refused to write to their wives? She implored us to Look at Her Daughter, whose husband never wrote and spent all his Leaves with Another Woman in York – (Please don't spend your leave with Another Woman, darling, in York or elsewhere).

FRIDAY 18 OCTOBER I had a letter from Col. Makin this morning, telling me to Hold Myself in Readiness and that I'll hear from the Air Ministry soon.

You know, in many ways Pa is the most objectionable man I've ever met. His first letter to Ma arrived tonight packed with honeyed phrases. He adds that he misses us all & 'even Eileen with her idiosyncrasies which she will lose when she's met a few more

young men'. After hearing that, darling, I felt so mud-spattered that I had to go and decontaminate myself in a bath. Darling, I'm <u>sick</u> with rage. Please may I cry about it on your shoulder? Thank you.

<u>SATURDAY 19 OCTOBER</u> Darling, I've just had a letter from Joan Friedman which drastically alters my attitude to the Bletchley job.

Here is the relevant passage and it is derived from Barbara Parker, who can be regarded as an Authoritative Source since she's been working there for three months: 'They work in 8 hour shifts, you know – So you would have a week of nights every three weeks – And Barbara says she is more concerned with figures than with Italian ... They expect the most astonishing versatility for the meagre salary they offer.' I read this to my mother and she said immediately that I'd never be able to stand night-work – and I'm dreadfully afraid she's right. I think you have to be <u>uncommonly</u> robust for that kind of thing, and while I'm better in health now than I have been for years and years, I do feel that night-shifts every three weeks would be a bit of a strain. I said 'What about Gershon's leave?' so my mother said (entirely without prompting, darling) 'We'd be pleased to have him here, if he'd be willing to come – otherwise don't you think you'd like to meet him in Cambridge – the town you both love?' She suggests that I should work voluntarily for Lord Nathan until about a week until your leave is due, and that then I should go for a fortnight to Cambridge for a change and a rest – and come back to London after your leave is over – when I could go back to Finsbury Square as a whole-time paid employee. I think this is a lovely idea, darling – only it will need some arranging, and I've lost count of the weeks, so could you please tell me again, the approximate date on which you may expect your leave? Then I could write to Girton and ask them if they'd be willing to house me for a fortnight (and give me a key!) and put my case to Lord Nathan.

I've written to Lord Nathan, asking him if he's still willing to have me, and if so, whether he'll give me a fortnight's holiday before I begin. I've told him that I'll be wanting my holiday in about a fortnight or three weeks' time – That must be about right, darling – surely you've been very nearly twelve weeks in Blackpool

– (it seems like ten years or a hundred years or a thousand years).

It's rather cowardly of me to write to him instead of asking him in person, but I'm very nervous of him, darling, and when I stammer & hesitate, as I do when I'm frightened, he just raises his eyebrows & looks bored – which isn't very helpful really.

WEDNESDAY 23 OCTOBER Lord Nathan was very kind, and said he'd be glad for me to stay if I liked – that he thought I would soon learn to be useful, though at the moment it was glaringly obvious that I'd never had anything to do with Real Life at all. Of course I could have my holiday – you know, darling, I think I'm going to be hurt quite often here – but I'm afraid that would happen anywhere – and I am going to be able to have my holiday with you in Cambridge, which is what matters more than anything else in the world.

Lord Nathan said this morning 'I wish you wouldn't write me letters in a hand that I can't read with a magnifying glass, let alone ordinary spectacles' – obviously Lord Nathan is not one of my Following.

FRIDAY 25 OCTOBER I went straight into my mother's room, via the bathroom, with the blasts of autumn blowing about my bare body under my pyjamas – (In my agitation, I forgot to put on my dressing-gown) and said what about my going to Blackpool? My mother said that, as far as she was concerned I could go, only she Must Ask my Father – (I believe and trust, darling, that this is only a formality – but I shall know more when I've discussed it further with her this evening).

Evening. Darling, I've cried a lot since I started this letter – I'm sorry – Apparently the question of asking Pa was not a mere formality – Mum says she feels that to agree to my undertaking a long journey alone in these times, is a responsibility she can't face alone – So, at her suggestion, I have written to my father, asking him to wire his decision. He is coming back from Douglas on Tuesday for a few days – so, in a day or two, Opposition will be so to speak at the door. You see, darling, what is making me cry is that if Pa says No – I shan't be able to oppose him and come to you, in defiance – because of my mother – but if he says Yes – then, my

dear love, I'm ready to leave at any time – (My mother won't mind my being away for her birthday, as Pa is coming back specially to be with her.)

Oh! I <u>will</u> pull every string to go to Blackpool – but if Pa wires back 'no' I'm powerless.

<u>SATURDAY 26 OCTOBER</u>　You know, I would Defy Pa and come to Blackpool, whatever he said – except that it would hurt my mother so dreadfully – <u>she</u> seems to think that there's a reasonable hope of his agreeing – but <u>I</u> think it's a safeguard to err on the side of pessimism – I started being in Solace too soon at the thought of being with you again in Cambridge – and what I'm afraid of, is that I've done the same thing about Blackpool.

<u>TUESDAY 29 OCTOBER</u>　I've had a wire from Pa, my dear love. It says 'Your letter just received please await my arrival Wednesday for sympathetic family discussion love Dad.'

What he means, darling, is that he's going to oppose my going, tooth and nail – I had a letter from him this afternoon in which he says that he can't look forward with the same pleasure as I had expected, to my journey to Cambridge. He then goes on to talk about lack of balance, dignity & reserve – you know.

You see, darling, I <u>can't</u> be really angry with either of my parents for their attitude in this matter – (My mother isn't happy about it either, but she's willing to put my happiness before her Standards). They believe sincerely that it is wrong for me to stay with you in your lodgings, unchaperoned – They both reiterate their perfect confidence in me and (because I love you) in you – but in their world (as, doubtless, in your parent's world as well) such a step would not have been <u>contemplated</u> – let alone executed.

<u>FRIDAY 1 NOVEMBER</u>　I can expect no quarter from my father, darling. He feels that in coming to you I shall be committing a moral wrong – and he says he'll never speak to me again. He says that he <u>and</u> my mother (and this is true) feel that I shall be committing a terrible breach of principle in staying with you in your boarding-house. That if you had written to my mother asking her to bring me to Blackpool, he would have agreed – That he would have assented to

let me stay in your parent's house – but that, unlike my mother, he is not prepared to put my happiness before his principles.

I want to be with you more than anything else in the world – but if my father repudiates me publicly, (as he will do) it will put you in the position of a co-respondent in a divorce case. Perhaps you will say that he has no right to place you in such a position – but, darling, the more I think of it, the more I feel that it is I who have no right to put you in that position – simply for my own happiness.

I have told you none of the terribly cruel things my father has said to me in the last twelve hours, darling. Perhaps, one day I shall. When I said I was not angry with him, that was true – but I don't want to be with him or to see him. He's stifling me and killing my spirit. Do you remember saying once that you were thinking of writing to my father about his attitude to me over examinations? It was in the sands of Weirbank – just before the accident – (the day before, to be exact). And do you remember how alarmed I was at the suggestion – even in jest? Well, darling, I don't want you even to criticize my father openly, for my sake. I never want him to be able to speak a word of reproach in connection with you, which has a shadow of justification. I want always to be able to say, as I was able to say today 'Gershon has always behaved to you with the greatest courtesy and respect' – and to hear him say, as he said this afternoon: 'Yes – that's true.'

Later: Darling, I think the catharsis is over and regeneration is beginning – After all, you are worth waiting for, and my solace, when we do meet will be twice as great, because I have had to wait and be dreadfully hurt by waiting.

My father is going back to Douglas* on Tuesday, probably for two months at least. Until then, I shall be civil to him and avoid him when I can. I am going to be strong – for you. I weighed myself this morning as a matter of scientific interest, and the

* On the Isle of Man. On the declaration of war there had been about 70,000 Enemy Aliens in the country, and these were divided into three categories of threat by government tribunals, with 'Category A' aliens liable to internment. In May 1940, with the fear of invasion in the air and in a climate of mounting hysteria, the first internment camps were opened on the Isle of Man and it was there that Alec Alexander was involved with the work of tribunals and the release of those who posed no threat.

needle pointed to seven stone-twelve – so I've lost half a stone in four days – but I'll put it on again – & when you see me, my eyes will be bright for you and my bosom soft for your head to rest on. Why should I allow myself to be hurt, when I <u>know</u> my love for you is a strength and the most honest thing in my life?

SATURDAY 2 NOVEMBER My parents have talked of my greatest achievement (my love for you) as though it were a theme from a twopenny novel. You know me as well as a man <u>can</u> know a woman – (better, I should think, than Bernard Lewis <u>knows</u> his wife, for instance) you kissed me in the Hall at Girton Corner one night and said 'How <u>can</u> you think I'm not fond of you?' and on the top of a 'bus in Oxford St you put your arm around me and said, 'You're the only real solace I have, you know that, don't you?' – and when I said that I thought I did – now – you said I'd taken a long time to find it out. And, darling, the last time you were in London, I felt confident for the first time, that you loved me – that's why, when you went away, it was almost as though you had not gone – for days.

My father has surpassed himself in bitterness this morning. He says I've done nothing but bully & insult him for the last two years – and that he doesn't ever want to see me again.

Darling, if I do leave the house – it will be interesting to see which of the people I know are really my friends. My father threatens (though I doubt if he means it) to tell people that I left his home because I said I couldn't get on with him – and the reason why I could not get on with him was that he wouldn't agree to my living with a man in a Blackpool Boarding House. No, darling, I don't somehow think he <u>will</u> say that – but from a purely scientific point of view, it would be interesting to see how many people who know me, would believe him. Be thou as pure as ice, as chaste as snow (as Hamlet said in his bitterness) thou shalt not escape calumny. Darling, may I emend my suggestion that, if you so wish it, our friendship should stop here and now, to a plea that, unless you are <u>violently</u> opposed to it, we should go on as we are at least until we meet again. You've often said that, though you're sometimes irritated with me when we're separated, it thaws & resolves itself into a dew when we meet – so please, my dear love, don't take

my strongest weapons away from me unless you must. Am I being unscrupulous in this struggle for existence, darling? Tell me truly – I'm trying so hard not to be.

MONDAY 4 NOVEMBER Because Mrs Seidler said she could see no difference between our being alone together in my room at Girton Corner for hours together, and our meeting in Blackpool, my father struck an attitude & said, 'Your mother never received a man in her bedroom until she married me.' You see, darling, he is not 'bad-minded' – but he's wild with jealousy – and he wants to hurt me as much as he possibly can, because, through no fault of my own, I don't love him. The other day, he sat in a chair and sobbed most dreadfully. The whole situation is an immensely complex psychological one. We're a highly emotional family and, so help me God, we take no pleasure in torturing one another – but that's what we're doing. He's sorry for the things he's said – He's tried, clumsily and pathetically, to make amends – but I know that in the next crisis, the whole thing will break loose again. Honestly, darling, the clearest solution would be for me to take my life – You and my parents would be unhappy for a little while – and then you'd all start afresh – but I want to live to enjoy your love. I hope to be able to think the whole thing out in Cambridge and find some solution. I think perhaps it might help to talk to Mr Turner, or Miss Bradbrook – I find immense comfort in the sympathetic advice of friends.

TUESDAY 5 NOVEMBER When I read your argument to my father, he smiled and said: 'He's very much like you, I think – perhaps that is why you get on so well. He is sincere and fair-minded, and he knows the value of family ties – Won't you both please try and be guided by my greater experience of the world and its judgements?' Darling, I don't want to be guided by his judgement – but I do want him to be your ally and not your enemy – because you and I both know the value of influence in the building-up of a career (especially if you happen to be a Jew) – and he could help you so much in re-enforcing your already not inconsiderable Cambridge contacts, by putting you in touch with the leading members of your chosen profession – by saying to them, 'This man is well

known to me – He has earned my respect and liking – His academic and social record at Cambridge speaks for itself – It's up to you to keep him in any way you can.'

I'm going to Cambridge early tomorrow morning, and I hope I'll hear your voice before very long. I had a telegram from Mr Turner this afternoon saying 'Certainly expect you tomorrow' – and I hope that I'll find real comfort there.

<u>WEDNESDAY 6 NOVEMBER</u> Darling, I was afraid when I arrived here yesterday that I'd made a terrible emotional blunder in coming. I went into Girton and Portress received me exactly as though I'd never been away. Girton was the same but Girton Corner was different – but, darling, our chaise-longue has not been subjected to the sacrilege that I had imagined – Mr Turner has it in his study and I'm sitting on it now.

After lunch, I met Miss Bradbrook in St Edward's passage & she bore me off to coffee. She waved her beautiful hands helplessly (have you ever noticed what very lovely hands Miss Bradbrook has?) and told me of the spate of marriages among the dons – 'I've never known anything like it,' she said, 'There's No Knowing where it will End.' She told me of Dr Tillyard & Mr Henn religiously going from Pub to Pub with the joyous abandon of perennial youth – to celebrate Mr Henn's promotion from a Pilot Officer to a Flight Lieutenant – 'They did it as a duty,' she said, 'but they loved every minute of it.'

Then I had to leave her for Mr Loewe's Memorial Service – When I got to the Synagogue I was certain I ought not to have come to Cambridge. Mrs Greenburgh was there, billowing out of a new fur-coat. The Loewes, of course, were there – Mrs L. rather small and triumphant – Michael barely emerging from an outsize top-hat (he reminded me of an Embryonic Kosher Butcher). The Salamans were there – trying to look as though they were somewhere else. Margaret Richardson had a bit of red fish-net around the top of her hat (only she knows why). Peggy was kind & motherly – Raphael draped his prayer shawl so that his Lance-Corporal stripe could be Seen By All – and sternly broke in upon the Greeting of a Man by saying, 'Don't talk in here'. All the other soup-carriers seemed to be there, too – Everyone except you, my

dear love – and I was terribly & sickeningly lonely – Everyone asked after you – and I had to answer very low – so as not to cry.

When Aubrey came in, late and reassuring, I felt a little better – He took me to the Union after the Service – said casually that he'd never seen a more Eloquent Look in any eye than in Mrs Loewe's – it said, 'This is the best organized function I've ever been at,' and, darling, he was right – and then asked me to tell him All. I did, darling, stammering and laughing hysterically – and he punctuated our story with sane, witty comments & a note of underlying sympathy.

TUESDAY 12 NOVEMBER I'm back in London, darling, & I start being Economically Independent from tomorrow. I think I shall like that.

Darling, I'm infinitely tired and frightened of believing that we'll be together on Saturday – You'll wire me the time of your train, won't you, my dear love, so that I can be at the station (which station?) to meet you? I hope you'll be able to come early – then we'll be able to go to a Theatre – (I haven't been to a Theatre since you were last in London, darling – *Thunder Rock* was on at the Arts while I was in Cambridge).

So – darling – it looks as though we're going to be able to sleep under the same roof after all. It won't be much of a solace spending Saturday evening *à quatre* with my mother & Mrs Seidler – but I'm determined <u>not</u> to cluck – but to savour every <u>instant</u> of Solace & make it a morsel for the Gods – & perhaps our next weekend will be in Cambridge.

Darling – shall I have to learn how to mollock all over again – or is it an art which once learnt is Never Forgotten – like swimming?

Hitler niggled at us All Night – we thought our End Had Come – twice – very disconcerting.

THURSDAY 14 NOVEMBER Oh! My darling, I feel quite faint at the thought of seeing you on Sunday. If anything happens to prevent our meeting – I think I shall be very ill.

Darling, I hope when Lord Nathan gives me my new work, he'll give me a room to myself to do it in – because Miss Hojgaard's Eternal Chatterings are No Solace to Speak Of. Today, she wanted to know whether it would be advisable for her father to Marry Again. He Had His Eye on a Fellow-Officer in the SA* – but he didn't know her very well – Was she worth Cultivating with a View to Matrimony? Darling. What could I say? – I murmured something about it being Difficult to Advise – or words to that effect – Oh! dear.

Darling, I have never told you of the Scandalous conduct of Mrs Bacon – because I was not aware that it was Scandalous – but Miss Hojgaard assures me that it is – so you shall Know All.

Mrs Bacon is a typist – she is tall & scraggy – with a hint of a dewlap and a promise of Scrawny middle age – she must be forty but she's Battling Bravely with the years – Her face has a Synthetic Bloom and her hair a Synthetic orange-golden sheen – In short, dear, she's a not-so-ravishing elderly blonde, who does her best with a paint-pot & Emphatic Velvet tights (that is the only word which really describes her Overgarments) and Large Tin jewellery everywhere.

Every morning, darling, she is Escorted to the Office by a little fat man – rather prosperous looking, in City Clothes & an umbrella – and every morning they kiss fervently on the steps of Finsbury Sq – I have always assumed that the little man was Mr Bacon (though I've never really thought much about it) and it all seemed Very Beautiful. But Miss Hojgaard has a theory that he is not Mr Bacon. She says that if he were Mr Bacon, she would not rest her head on his shoulder every lunch hour, between courses in the ABC – all of which leads me to the conclusion that either Miss Hojgaard has gleaned a warped & sordid impression of Marriage in the Salvation Army (She is in the Salvation Army – on Sundays) or she's right. I wonder if we'll Ever Know. Miss Burrows takes the Charitable View (as I do). She said timidly that her Douglas always held her arm – She hoped he wouldn't stop after they were married – and I said that my parents always

* Salvation Army.

held hands in taxis – to which Miss Hojgaard replied: (in her own rather limited idiom) Ah! different – What do you think, darling?

Miss Hojgaard (helped by the Military Censors in the Orkneys) is Learning to Forget – but (heavy sigh) she 'doesn't know any boys' in Lewisham – At least, she does know one – and she asked him to tea, but it is Not Bearing Fruit – and she Will Not Stoop to Chasing Men – like her sister.

I just let her burble trickle over me, darling – sometimes I Turn it into Copy for you – otherwise I just forget it.

WEDNESDAY 20 NOVEMBER Darling, He is not Mr Bacon – but 'a Friend' – She told Miss Carlyon All – and She's only working in the City because He works nearby – Somewhere, in Obscurity. Miss Carlyon has Gathered that there is a Mr Bacon – but Nobody Quite Knows Where – or Why.

Darling, it would be interesting, wouldn't it, to know what Lord Nathan is going to pay me? – but he has shown a Marked Reserve on this subject – but I do hope it will be enough to enable me to meet you in Oxford every Sunday – I think it will. (It had better be – or I'll Resign Willy Nilly.) Lord Nathan does not set my Worth at a Pin's Fee, darling – but he likes to be thought Generous.

THURSDAY 21 NOVEMBER Mrs Bacon is Leaving, darling – because one of the men at the Office Put his Hand over Her's, while it was Resting on the Keys of the Typewriter. She drew herself up to her FH, Declaring that This Would Never Do – Mr Bacon Would Not Like it – Nor would her Gallant – She Was Not That Kind of a Girl – (Girl!) Talk about Human Interest.

MONDAY 25 NOVEMBER Darling. Lord Nathan said, 'Good morning – I suppose you want to be paid,' which set me back a bit. I said timidly that I wouldn't mind, whereat he asked me to Name my Figure. I said I didn't know what I was Worth – and he said neither did he, but he'd pay me £3 to start with – and Raise or Lower it according to my Rate of Output. A brief and ungracious interview, darling – but I have become a Wage-Earner All at Once – and I have to fill

in Insurance cards and Render myself Eligible for the Dole. It's all rather frightening.

I'm very tired, darling – I worked at tremendous pressure all day – (with twenty minutes' respite for coffee after lunch) and Miss Burrows told me that I was the lowest paid minion in the Office, except the girl who types the filing-cards – which hurt me a little, darling, as I didn't realize I was as useless as all that. You asked me whether I was Superior or Inferior to the Secretaries and typists, dear. Now you know.

Darling, it isn't <u>any</u> wonder at all that I haven't a very high opinion of my capabilities – since everyone except you rates them so low. Never mind, I'll work very very hard – and perhaps he'll think I'm quite useful after all. (He'll never know whether I'm <u>clever</u> or not – because he won't give me anything to do which requires cleverness.)

<u>TUESDAY 2 DECEMBER</u> Oh! darling, in between Solace, I've been brooding with a kind of stifled, drowsy, unimpassioned grief upon the thought of your being sent abroad. I see it as a vast calamity – rather as Blake saw Hell, with streaks of reddish storm in the background. You see, my dear love, all the time you're away I'll be wondering if you'll still be mine when you come back – I'll be like Hans Anderson's little mermaid, who had to walk on knife edges all her life as a Penalty for giving up her tail for feet. She did it for love, darling, if you remember – and I think she felt it was worth it – never having been <u>alive</u> before – and I know that whatever happens it will have been worthwhile to have been alive for you – even if it kills me.

While I was waiting for you in the Randolf on that first Sunday – I very nearly came back to London without seeing you – because the fear that you might be disappointed in me when you did see me was so dreadful. You see, darling, you're so completely independent of me – I'm not <u>necessary</u> to you in any way at all. Perhaps it's because you're so sure of me that you never have to worry about what it would be like to have to do without my love – Oh! God! I don't know – but I don't want you to go away, darling. I don't want you to go away.

Darling, I'm going to have an <u>egg</u> for supper – a <u>rill egg</u>. Mrs Seidler brought a <u>whole dozen</u> back from Cambridge. But

don't Tell Anyone, <u>please</u>, or they'll all be Swooping on us like Kites on Carrion.*

<u>FRIDAY 6 DECEMBER</u> Oh! darling, we're going to Win this War – The Successes of the Greeks and your promotion are only a Foreshadowing of things to come. The first Symptom is that we have Found an Ally at Last. The Second is that there is now <u>one</u> Great Man at least in a Position of Authority – Oh! darling, I'm so glad – and I like the things they think about you too – but why aren't you paid, dear?

Aunt Teddy wrote today to say that Jean had got her commission – You'll outshine her yet, my dear love.

I shall <u>love</u> Walking Out with two stripes, darling – I shall like mollocking with them even better.

<u>MONDAY 9 DECEMBER</u> Darling, I'm writing to you in Miss Dyce's & Miss Watson's room – sitting in a very hard chair and leaning on a folder marked Importantly 'E. Alexander'. I can't do any work because we've been Bombed – There isn't a window left in the front of the building – and all our electric light & heating is off – and our room (though the windows are intact) is enveloped in the Blanket of the Dark – and, until Mr Hawes brings me some candles I am of necessity Unemployed.

It took me an hour and a half in a choking tube to get from Chalk Farm to Moorgate this morning – and now all I can do is shiver and write to my dear love.

Cold! Cold! My girl ... (Oh! Mr Hawes has just brought my candles in – I shall have to leave you in a moment – and work).

Darling, what I didn't tell you on the platform yesterday was something along these lines – When you talked about your family's Impending Sorrow, at not seeing you when you had a weekend's leave, <u>then</u> you made me wish that I were an Officially Recognized Solace – because, if I were, no-one could <u>expect</u> you to be with anyone but me – when you had time to spare. I <u>didn't</u> say

* Food rationing was brought in at different stages of the war, beginning in January 1940 with bacon, butter and sugar, with eggs (one egg per week per adult and dried eggs, one packet per month) first rationed in June 1941.

it, darling, because I'm <u>not</u> Impatient – but you <u>do</u> see what I mean, don't you, dear?

<u>MONDAY 9 DECEMBER</u> Darling, Aubrey's maid is Going to Have a Baby. (Tell your mother to keep a Wary Eye on Alice – forewarned is forearmed. <u>No</u>! Darling – Aubrey didn't think <u>his</u> maid Had it In Her either.) He thinks it was a Chance Encounter in an Air Raid Shelter, and he's thinking of Appealing to Welfare – because they Know it was a Soldier – though that is <u>All</u> they have to go upon.

Aubrey and I had a hearty lunch at the Cheshire Cheese – and Aubrey looked as though he'd Grown There – with his feet among the sawdust and the shadow of Dr Johnson falling across his plate.

<u>MONDAY 16 DECEMBER</u> Darling – I had lunch with Horace today at the Great Eastern Hotel – (and an excellent lunch it was, too.) and he exhibited a new & astonishing facet of his nature. In the taxi, he said please excuse him if he was being impertinent but had I been in Sorrow about anything the last time we'd met, because he'd never seen me so painfully flat & listless – whereas, today, I seemed unusually buoyant? Well, darling, the last time I saw Horace was on the Sunday when I ought to have been in Blackpool with you – & I hesitated for a moment before saying anything – because, fond as I am of Horace – I'm on a <u>very</u> impersonal plane with him – then I remembered that he'd walked 27 miles to see me in Maidenhead Hospital, and that, because I was tired, he had said 'Don't bother to talk, I'll be quite happy just to sit with you' and it seemed to me that he might not react as ruthlessly as his incisive manner suggests, so I told him All – And, darling, this Arch-Debunker, this chronic Anti-Cantite Came Over all Human – & said that Alec was a Good Chap but a bit Archaic – and he was overcome with paroxysms of helpless & noisy mirth at the thought of me as a Wanton – then he ordered dry sherry for me & beer for himself, and asked me to Drink with him to Our Happy & Undefined Relationship.

This morning Lord Nathan came into my Office &, looking pointedly and Censoriously at my cigarette, urged me not to

set the office on fire. I said I'd do my best not to – then he looked at my lists and asked me how far I'd got. I said I was getting on to the 700th folder – to which he replied repressively that there were 4,000, weren't there? – and I said sadly that there were – and we Parted.

Oh! my darling, thank you for our weekend. I'm sorry I cried – but, in a way, I'm glad this particular Anxiety Emerged – because it's been rubbing my Spiritual Stomach into an Ulcer for months – and I feel a little better about it now – though you weren't able to kiss it right out of existence – Otherwise, darling, it was all Solace. I'll try not to be so retrospectively inquisitive in future, darling, but you see, I so much want to know how your mind works in relation to me – and you're not very communicative, are you, my dear love?

TUESDAY 17 DECEMBER I do love the balloon barrage at dawn. This morning when I went out, there was a very bright, round moon, and a smoky pink sky – and the balloons were almost as bright as the moon – big sluggish ones in the foreground – like something out of a Fun Fair – and beyond – little ones, no bigger than cough drops, speckling the sky. I stood & watched them while I was waiting for my bus, and I was rather sorry when it arrived.

WEDNESDAY 18 DECEMBER A most alarming thing happened last night, as I was coming Home from Work. I was just about to cross Harley Rd., when suddenly it seemed as though all the traffic had speeded up to very much faster than life-size. The cars simply <u>reeled</u> towards me out of the dimness – and then, to make the illusion complete, a pedal-bicycle with a motor chugged across my path. At first I couldn't see the motor – and I thought this was a Forecast of Insanity – but when I did, my Balance was restored & I was able to cross the Road <u>almost</u> with sang-froid (but not quite.) A Sinister Experience, darling.

Miss Hojgaard told me a New & Revealing Piece of All today, dear. She said she'd once jilted a man because he took her to Blackpool for a Holiday – and then made her buy All Her Own Food – Also, there had Been a Time when he Did Not Behave like a Gentleman – (She did not Jilt him until Some Time after this,

however) and later she Discovered that he'd only taken her to Blackpool for a bet. Darling, Miss Hojgaard does accumulate a sordid collection of Experiences, doesn't she?

<u>TUESDAY 24 DECEMBER</u> A year ago today, my dear love, Lionel and I were taking shelter from the fog at the Carlton after *Julius Caesar* and I telephoned Aubrey, hoping you'd be there – and you weren't – a year ago today, the Drama of the War Office Cona was simmering and just about to come to the Boil – a year ago today – you'd just come back to me – from Bertha – in a black beard so that you wouldn't feel out of place among the foreign diplomats in Whitehall – (only that was the day before.) And, darling, a year ago today, I thought I loved you – but actually I'd Hardly <u>Begun</u>. Do you mind the reminiscent vein? – what Aubrey would call 'Dangerous Nostalgia'?

 Incidentally, talking of Aubrey, did I ever tell you his comment in the Union on the Blackpool Incident? He was wondering whether it wouldn't have been worthwhile to have risked Parental Displeasure for the sake of Solace – I said I couldn't do that, because it might have made you feel that if I meant that it might 'Precipitate Intentions'. I said yes, I supposed that was what I <u>had</u> meant – and he said, 'Well, I don't think Intentions <u>would</u> be Precipitate at this stage'!! I was very much amused, but rather shy of telling you at the time – you see, darling, at the end of the Easter term I said something in a letter to Aubrey which I very much regretted. (I remember telling you at the time that I had, but I didn't say what it was – and you didn't press me to Reveal All, for which I was very grateful.) It was just before I went down, and, at that time, it seemed to me that you couldn't fail to use the opportunity offered by chance, of severing your connection with me. I think you knew how desperately frightened I was – because you were so infinitely kind & gentle with me when I cried in your arms after dinner at Victoria Road. I wrote to Aubrey that night and said: 'Oh! Aubrey, I wish Gershon were more Intentions-Conscious.' Ever since that day, darling, Aubrey has been Unobtrusively Sponsoring my Intentions! I remember that, when he came to Cambridge during our last week-end together, you asked him what an Officer's pay amounted to. He told you, and added, quite gratu-

itously, that, of course, it was more if you were married. Darling, in the midst of all my Sorrow, I was terribly tempted to laugh – because Aubrey is so incredibly self-contained and Impersonal – and when he tries to descend to a more intimate plane, he's <u>exactly</u> like a Peer, dancing the Polka in full Coronation Robes. That's a jest, I've always wanted to share with you, but it's only in the last few weeks that I've <u>really</u> been able to tell you All, without <u>any</u> reserves at all. In the Union, his final comment on Blackpool was: 'Well, I really don't know what to say, because, though it may sound fantastic, I don't know what Gershon thinks on that – or any other <u>personal</u> subject.'

WEDNESDAY 25 DECEMBER Darling, at about eleven I got tired of staying in bed. (Not that I was wasting time, dear, I was turning out thank you letters five to the minute.) I had lovely presents – three vinai-grettes – a gold one & a silver-gilt one from my mother – and a little plain humped one, like a tiny pepper pot from Mrs Ionides – and my mother gave me a hand-bag suspended from a belt as well – quite absurd, darling – but a Great Solace. Mrs Seidler gave me pigskin gloves & Joan Aubertin *The Shropshire Lad* with Streamlined woodcuts – Mrs Low (who always does the Right Thing) gave me *The Bedside Book* which I've often had before – but I always lose it, so it doesn't matter. I had enough lavender water to last me for a year of Sundays – & a wonderful assortment of nice smells for my bath – Next time you see me, darling, I shall be perfumed like a milliner – as the Shakespearean phrase is.

MONDAY 30 DECEMBER Darling, today has been a bewildering and unreal day – Eliot called London an unreal city under the brown fog of a winter dawn, how much more unreal then, in a stinging curtain of black smoke.

At Chalk Farm Station this morning, they told me that I couldn't get out of the train at Moorgate – I should have to go to the Bank. I came out of the underground into a blinding mist – I could see people dimly, colliding on the pavements and in the roadway and threading their way among the thick white hoses of numberless grey fire-engines which were blocking all normal traf-fic completely. My shoes squelched soggily in the wet street, and

tiny jets of water from the joints in the hoses sprayed my legs. All the women in the street were splashed with mud-freckles all up their stockings – hundreds of fire-men in tin hats, and anachronistic Asbestos Helmets (they looked like cruel parodies of Roman Warriors, darling) were pushing their way through the crowds – flakes of charred paper were floating down from buildings everywhere and brushing against our smudged faces – and on the dry patches on the road they were crumbled by passers-by into tiny fragments – like blackened lice. I walked dazedly to the top of Moorgate – but I couldn't get down it – fireman's ladders crisscrossed in the dimness like monstrous darning needles – and I could see great yellow patches of flame through the empty window frames in the street. On some of the nearer ladders, the tiny firemen looked like flies on lumps of sugar, with their spindly legs outlined against the smoke-clouds. Even in the midst of my horror, darling, I was immediately excited by the perspectives of the firemen's ladders, disappearing into the fog.

I walked vaguely through the back streets trying to find a way into Finsbury Square – & then Miss Hojgaard tapped me on the shoulder & we went on together – like rolling snowballs, darling, we gathered a mass of bewildered Welfarers as we went along – and, at last, we met Miss Burrows – coughing and streaming & pointing inarticulately to the roofless, blazing shell of what had been 1, 2 & 3 Finsbury Square.

Then we all went to Finsbury Barracks which were always to have been our Emergency Headquarters. The Sentry challenged us – but we Forgot All & simply said 'Welfare' – He didn't shoot us, darling, he just saluted & let us through – & we all stood about Forlornly in a huge & barren room, until the General arrived & told us all to report again on Wednesday morning. Then Miss Burrows & I went to The Great Eastern, lathered ourselves thickly with Antiseptic Soap – and the dirt rolled off in flakes that were the reverse of Hoary.

I brought Miss Burrows home to tea – but I was too saddened to eat any. Oh! my darling, I've seen the second great fire – and there was nothing gigantic or elemental about it – it was just destructive and dirty. Of course all my Regimental lists and the office files – are burnt – I fancy there won't be any more work for

me in Welfare, but I shall doubtless Learn All on Wednesday morning.

Darling – shall I tell you something Fantastic? I didn't sleep all Saturday night – because I was terrified that I should walk up to your room in my sleep to see you – and that no one would ever believe either that I was asleep or that I'd just been to see you, because it was fantastic not to be with you when you & I were in the same house. I wouldn't blame anyone for not believing me – but it would have been true.

Thank you for coming to stay with us, my dear love. I hope you'll come again – often – but I'll never let you walk through an air-raid again – it was the worst half-hour I've ever had. D'you know, darling, that when I told you in the cinema that I was frightened of the whistle of bombs, it was the first time I'd told anyone – because, in this house, my mother & I have to preserve an elaborate indifference – because everyone else is in such a noisy cluck (Except Lionel, who is Vociferously Unconcerned.)

I'm too tired to write any more, dear. I'll let you know further developments soon.

January–March 1941

Nineteen forty-one will be remembered as the year a European conflict became truly global and Britain and her empire found themselves allies. Britain had never had to 'stand alone' in quite the way that propaganda and national myth suggests, and yet it was not until the war became a world war, with Germany's invasion of Russia in June and Japan's attack on Pearl Harbor on 7 December, that Britain could see a chink of light at the end of a very long tunnel.

If it would be hard after America's entry and German reversals in Russia to see how the war could be lost, it was just as difficult in these early months of 1941 to imagine how it might be won. On either side of the new year there were some facile and spectacular successes over the Italians, but with the Luftwaffe devastating Britain's western ports, and German U-boats and surface vessels wreaking havoc among Britain's vital Atlantic supply lines – almost 700,000 tons of shipping were lost in April alone – there would be no ringing of victory bells for another twenty-odd months.

Nor was the worst of the Blitz over – the heaviest raid on London would be the last, on a 'bomber's moon' night of 10/11 May 1941, when more than fourteen hundred people were killed and the Chamber of the House of Commons burned to the ground – and few major cities would escape. The attack that destroyed the Welfare Offices in Finsbury Square had also devastated much of the City, and at the start of the new year Eileen moved with Nathan's 'Welfare' to temporary offices in Buckingham Gate, and it is from her desk there that many of the letters from these next months were written, letters full, after the 'black hole' of the late autumn into which she

had sunk, of all the old signature mix of 'willy-nilly,' and 'cluck' and – hesitant at first, but increasingly insistent – 'Intentions'.

One of the main reasons for the shift of mood was that Gershon had also moved from his old camp near Blackpool to Calne, Wiltshire, though after seven months of RAF camps and courses a commission seemed as remote as ever. There seemed a glimmer of hope in February when his old Cambridge professor put him forward for a job psychologically evaluating aircrews, but the minimum age for a commission into the intelligence branch was twenty-five, and at twenty-four, a frustrated and often moody Gershon could do nothing but mark time and contemplate the grotesque thought of having to salute Charles Emanuel.

As a trained wireless operator working through the Blitz, however, Gershon would have been a small but vital cog in the intelligence war against the Luftwaffe. The popular story of British intelligence during the Second World War inevitably focuses on the codebreakers of Bletchley Park, and yet just as crucial were the men and women of the less-well-known 'Y Service', service personnel and civilian 'hams', based in listening stations across the country and the world, who were the 'ears' of 'Station X', as Bletchley was called, listening through their earphones around the clock to the cacophony of encrypted enemy signals and voices that filled the air and feeding them on to the Bletchley codebreakers.

How much of all this Eileen knew is impossible to say – her letters naturally give nothing away – but in February a letter arrived from the Air Ministry inviting her for an interview. If she could not be with Gershon she might at least be able to feel that they were working for the same 'firm'.

5

Intentions

THURSDAY 2 JANUARY Darling, Miss Burrows told us that when Lord N[athan] Heard All, he Paced Up and Down, muttering, '30 years' then Struck an Attitude and Bellowed 'We Must Have a Broadcast'.

She then told us the Sad Story of How She Lost her Underwear – You see, darling, the Thing is This ... Last week Miss Burrows bought a pair of lady's dustsheets – She left them at the Office – but in order to spare Mr Herbert any Embarrassment lest he should have to search her desk for an important document, she put them in a Foolscap envelope & marked them 'Personal' – and now they are Gone Forever – but a new word has been added to the language – because it's obvious that Henceforth, all lady's dustsheets must be known to Us and all our Intimates as 'Personals'. Take off your hat in the Presence of the Dead, darling, as Mr Corbel (he who caused Mrs Bacon to leave Welfare & go back to Commerce – because he imagined mistakenly (having Seen All that existed between Her and the Man who is not Mr Bacon) that she was a Multi-mollocker – and on that assumption kissed her hand – (It was the Velvet Tights and Golden Rinse that Got Him, I think)) said as he rushed with Another into the blazing wreckage on Monday morning, to Rescue his Compensation Cases and carry them out on a Tea Tray. (The results of his Heroic Action (all this is perfectly true, darling) were delivered at our new HQ this morning marked 'Salvaged from the ruins'.)

SUNDAY 5 JANUARY Darling, I have just Risen, much more like a boiled shrimp than Venus, from the foam of a scalding bath and, although my body is the colour of raspberry soufflé, I'm not warm yet.

Talking of Leslie (I did refer to him) I forgot to mention his comment on Churchill's Rallying Call to the Italians.* He said that that was not the way to Foster the Seeds of Dissatisfaction in Italian breasts. After all, he said, with an enquiring glance from one of my parents to the other, when a husband & wife were quarrelling, the one certain way of driving them back into one another's arms was for a third person to start abusing one of them. At this the other would Rally to the Abused One's side and Turn Fiercely upon the Abuser – That, he affirmed, was Human Nature. It's certainly true in respect of my parents, darling, and of most other married people I know as well as that; it remains to be seen how true it is of Mussolini and Italy, his Unmarried Wife.

The Nazis have started day raids on London again, darling – (We haven't had any for several weeks). It's very tiresome of them.

MONDAY 13 JANUARY Darling – I'm getting so tired of Welfare. The type-writers clatter all round me like teeth on a frosty night – (particularly my teeth) and everybody bickering with everybody else – and Miss Leonard, (whom I calls CIGS† Because she has a taste for pushing us about on a Chart as though we were Counters representing Army Units) putting her finger in every pie and then sucking all the plums off the end – (She never interferes with me, darling, so I don't mind her – but poor Miss Carlyon – and Miss Burrows and Miss Crook).

Have you heard anything from the Air Ministry? Darling, not the least frightening aspect of your going away is the thought of Pa's attitude which will be a What-are-you-clucking-about-he's-not-your-Intended-or-anything-what-you-need-is-to-meet-more-Young-Men-one.

* On 23 December, Churchill had addressed the people of Italy, stressing the old friendships between the countries and telling them that Mussolini's war was against everything the Italian Crown, the Vatican and the Italian people wanted.

† Chief of the Imperial General Staff.

WEDNESDAY 15 JANUARY I walked across the Green Park through the snow today – the tree-trunks were white all down one side and the branches lightly powdered with snow – Such lovely shading, darling – (Oh! I do love shape and shading & perspective – but I love colour too) and the Belisha Beacons* all had little white, furry caps – and the waste-paper bins had crisp little rims of snow round them – I don't know how I ever did without snow – before I'd seen it – I don't mean tracts of snow, such as I'd seen in Italy & Switzerland before I ever came to England for a winter – but intimate, domestic snow – which is much more of a Solace. I think that's why I hated Egypt so much – no snow – no Primroses – and no Gershon (Heaven's last, best Gift) – a barren country, darling.

THURSDAY 16 JANUARY A Beautiful thing happened today. A Stalwart Police Sergeant pushed his head Purposefully through the hatch and said: 'I want to see Colonel Lord Nathan of Churt.' 'Well, he isn't here,' I answered – 'Very well, I'll wait until he comes,' he said – obviously prepared to wait for the Duration if necessary. 'Well – er,' I went on timidly – (I could see he was the kind of man who would Wear Down a Stone until he got to the Blood) 'He never comes here.' 'No?' he said, Sceptically. 'Well this letter,' (he waved a type-written sheet of Paper at me) 'has this address at the top.' 'Oh! yes,' I explained. 'These are the Headquarters of Welfare – Eastern Command & London District – and he is the Director of Welfare, you know. Perhaps you'd better see General Buchanan – he'll tell you how to get in touch with Lord Nathan.' He gave me a Look at which a Strong Man would have Wilted – let alone your poor little Cluck. 'Lord Nathan,' he said slowly & ponderously, 'is going to be Seen by the Police – He needn't think he is not Going to Be Seen by the Police – It's a Case of Firearms.' This was becoming Exciting, and I said: 'Well, the only way you can get to Lord Nathan is by seeing General Buchanan first.' 'Very Well,' he said – Getting It at last, 'I Shall See General Buchanan.'

* It is an irony that the ablest Secretary of State for War Britain had had since Haldane should be best remembered for the Belisha Beacons, the amber globe added in 1934 to pedestrian crossings when he was Minister for Transport.

I went into the General, and between my gasps of merriment, told him that there was a Policeman outside who said that Lord Nathan was About to be Seen by the Police – willy nilly – Case of Firearms. The General said he'd see him – and I heard him say 'Come in Constable' before I shut the door on the pair of them. About ten minutes later he came out again. I was Palpitating to Know All – so I said: 'Are you satisfied now, Officer?' 'Yes <u>and</u> No –' he answered deliberately. 'Colonel or no Colonel – Lord or no Lord – he'll have to pay his half-crown for owning a Revolver – and unless he does, there's nothing for it – he'll Have to be Seen by the Police.' His Duty done – his Ultimatum delivered – I'm wondering whether Lord Nathan will Pawn his Butter-Ration to Honour his Debt. It's a Beautiful thought that he will sit down to meals every day for a week looking wistfully at Lady Nathan's & Roger's Flags – and Hoping.

<u>MONDAY 20 JANUARY</u> Darling, I shall have to Mend my Ways. I was just in the middle of stealing a House of Lords envelope for you, when Miss Carlyon asked kindly but in all seriousness what Lord Nathan's stationery bills would be like if the whole of Welfare Pilfered his notepaper & envelopes – 'Oh! but it's for Gershon,' I said, thinking this would Explain All – but there are none so blind as those who will not see, as the Old Saw has it, and it was obvious that Miss Carlyon was Oblivious of the Subtle Distinction between Pilfering for you and – Pilfering – so I just waited until her back was turned, darling, and then I stole it – but I mustn't do it too often.

<u>TUESDAY 21 JANUARY</u> Darling, I got a lift to Buckingham Gate from a Square-Jawed Naval Commander who was on his way to Admiralty Arch, A very Civil man – I <u>was</u> grateful because it was the nastiest morning I've seen for years – wet, blackish fog, dribbling all down my collar. As a rule I like fog, when it's grey and attenuated – because then the cars and 'buses start as a blur and grow sharper & sharper in outline as they get nearer – like Djinns taking shape out of a bottle.

It occurred to me last night that, in all my life, I've only really wanted two things – one of them was a First at Cambridge

and the other was you. The trouble with me, darling, is that I've got Exclusive Taste. I like the Genuine Warranted Best – or nothing.

And talking of Firsts, I never told you, did I, that, although actually, you were responsible for my getting a First (I did get a First, darling – d'you remember? You never remind me now) you were very nearly responsible for my not getting it – because during the last Paper, after I'd had lunch with you, I kept being held up to listen to your voice which kept cutting in across my train of thought – and which was so much more beautiful than my ideas on Restoration comedy & Bunyan. By that time, darling, I knew I loved you but I was pretending wildly to myself and everyone else that I didn't – and I mentioned this voice business to Elizabeth Knapp as an oddity at which she just looked Wise and said nothing.

THURSDAY 23 JANUARY The other day, darling, Lord Lloyd's Secretary rang up my mother (Lord Lloyd has German Measles, dear, but it's a State Secret – lest it should raise an undignified Snigger – as these things will – Oh! the small vanities of those who have Arrived!) and, inter alia, asked her what I was doing. She mentioned the Home Office interview and said I'd heard nothing further, whereat he said: 'Oh! we'd better jog their memory.' So perhaps Something Will Happen Soon, darling, and then again, perhaps not.

WEDNESDAY 29 JANUARY Darling, last night my mother said: 'You're not going to Reading this Sunday, are you?' and I said I was – and she Registered Displeasure and said: 'Can't you leave the poor boy alone – Have you ever thought that he might like a Sunday to himself – especially when he's been with you half the week?' Whereat I was in Great Sorrow, darling, but you don't want a Sunday to yourself, do you, my dear love?

THURSDAY 30 JANUARY Tomorrow, darling, half the Welfare staff (including me) is moving into the top storey of 22 Buckingham Gate – It's cold and cheerless – and terribly vulnerable to Air Attack – <u>and</u> the ceiling is on its last Joists – but there <u>is</u> a window – There is <u>also</u>

a lift – it doesn't work but it will at least give us <u>Class</u> – so we mustn't grumble.

<u>WEDNESDAY 5 FEBRUARY</u> Pa has just left for Liverpool – in Heartly Sorrow at Lord Lloyd's death.

Oh! darling, I'm sorry about your commission, but let's start hoping and hoping that your next application will be successful. Darling – once I loved you as an Academic Civilian – then I loved an A.C.2 and then an acting-Corporal – Perhaps Providence did not think it Seemly that I should transfer my Affections to a Pilot Officer too quickly.

<u>THURSDAY 6 FEBRUARY</u> It was Nancy Burrows's last day at the Office and she came back here to tea and to look at my vinaigrettes – and, darling, at lunch she asked my Advice about Birth-Control – as she & Douglas can't afford children yet – (<u>my</u> Advice!). I looked Very Wise and said I believed there were Clinics where she could Learn All – but I thought she'd be better advised to ask her Family Doctor first – but she said she couldn't do that, as he was an Old Friend of her mother's and would want to know if Mrs Burrows had been Told – & Mrs Burrows is Rigidly Anti-Contraception – <u>Well</u>, darling, what with Ruth Walker asking me What to Do about Living in Sin – and Miss Burrows asking me What to Do about Birth-Control, I begin to think that I must have a Worldly Air. Would you say I had a Worldly Air, my dear love? No – somehow, I <u>thought</u> not.

Darling, I don't know whether or not you're a 'born-letter-writer' but I doubt whether Keats's Fanny was as happy to get a letter from him as I am every time I get a letter from you – You know, dear, letter-writing is undoubtedly my medium – I'm not being vain, but I'm able to work off all my creative energies in my letters – because when I'm writing (and particularly when I'm writing to you, my dear love) I have the feeling that I'm living my experiences all over again – but living them more richly, because they're being shared with a friend – and are coloured by their outlook & idiom as well as my own. Every other literary form is less personal & intimate than the letter – and I'm a very personal little cluck, aren't I darling?

WEDNESDAY 12 FEBRUARY Oh! darling, Solace is bubbling up in me like a warm current through a soft bank of mud – I didn't understand a word of your letter but neither did Mary when Gabriel Announced that she was going to become the mother of Christ, but she was no less happy for that.

Am I to understand that Yatesbury* is to be your Headquarters for some time to come? – (but oh! my dear love, I see all those Waafs as a Vast Field of Wild Oats). And when are you getting your Commission? – and Bless the Air Marshal's heart for Knowing your Worth – although he couldn't do anything about it because of your age.

I've been so anxious and depressed about you, darling, in the last few days, that I still can't get used to the idea that All is well with you – but the Awakening will come.

MONDAY 17 FEBRUARY Darling, I came home crushed beneath a burden of boredom heavy as frost and deep almost as Life – to find a letter waiting for me. It was from the Ministry of Labour and this is what it said:

> Dear Madam, (It meant Me, darling)
> With reference to your enrolment on the Central Register, you have been selected, amongst others, for consideration for a post in the Air Ministry at a salary of about £260 per Annum. If you are available for consideration for this post, will you attend for interview at the Air Ministry, Ariel House, Room 204, Strand, WC 2 on Friday 21st February at 11.15 a.m.
>
> If you are in employment, you should ascertain from your employer whether he would be willing to release you, were you offered such a post.
>
> It would be appreciated if you would let me know immediately by telephone or wire whether you are keeping the appointment.

* In Wiltshire.

So, darling, perhaps I <u>shall</u> find myself in the same Branch of the Service as you after all – perhaps they'll send me to the Air Ministry at Harrogate – perhaps – but my fancy is Playing Havoc with my Good Sense, my dear love.

Darling, I've only got two cigarettes left of my ration, so I can't be <u>expected</u> to make the fullest use of my pen – After all, 'Kubla Khan' would never have been written but for an Opium Dream.

<u>TUESDAY 18 FEBRUARY</u> Darling, what a day! I went into the General this morning to ask him if I might be released on Friday morning for my interview at the Air Ministry – He looked at me severely and said 'If you go we Shall Have to Begin All Over Again' ... I said please could I go to the Interview, anyway – and he needn't worry as I probably wouldn't be leaving Welfare – He said 'Yes' and 'I hope not' and gave me a Courtly and Beautiful Smile.

Then I came upstairs to find Miss Page Launched on a Literary Discussion Class – She Worked Up from the novels of Mary Webb through *Anthony Adverse* and *Gone With the Wind* to Kipling. She assured me that Kipling would Go Down in History as a Great Writer, darling – I said, well if he did, it was a pretty poor lookout for History. This went on all morning – and I was just on the point of having a stroke when Jean came to fetch me for lunch – with a Chauffeur-driven car and one of her Air Commodores (only, actually he was a Squadron Leader, darling) In Tow – But we Shed him at his Club – and went on together to the Cafe Royal. (You can eat a four course lunch at the Cafe Royal for 3/6d darling – <u>and</u> see most of London's stage and Political Celebrities feeding there – free of charge – I mean you can see them free of charge – doubtless they have to pay their 3/6d like anyone else).

<u>THURSDAY 20 FEBRUARY</u> Darling, last night was full of Adventure, and when I tell you All, you will understand why, at the Instigation of my mother & Peggy Davies, I smoked three extra cigarettes.

It All began with the HE Bomb* – which Whistled Ostentatiously past our window at about 9.30, blowing the red

* High Explosive.

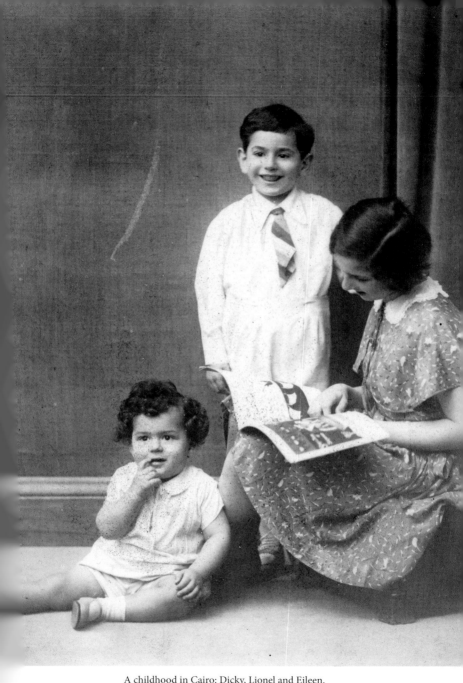

A childhood in Cairo: Dicky, Lionel and Eileen.

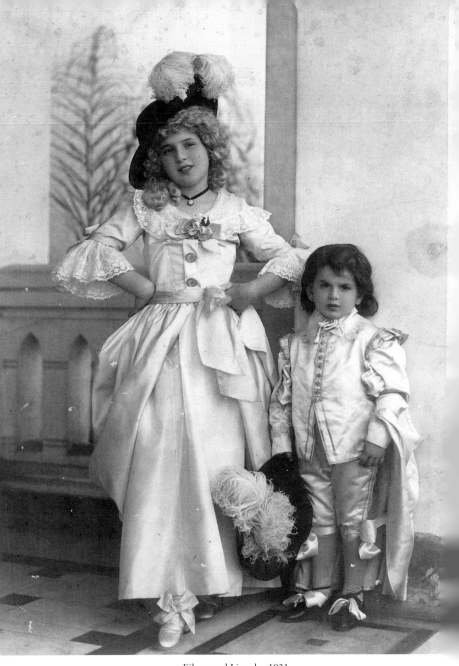

Eileen and Lionel, *c.*1931.

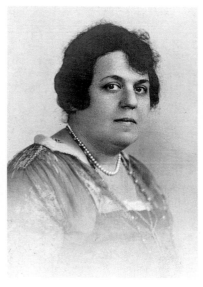

Victoria 'Vicky' Mosseri, mother
to Eileen, Lionel and Dicky, 1925.

Vicky holding Eileen, c.1919.

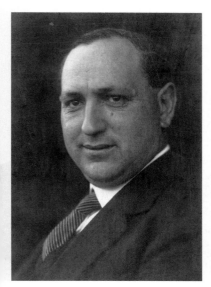

Alec Alexander, Eileen's father, 1935.

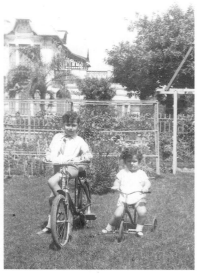

Lionel and Dicky playing in
the garden in Cairo.

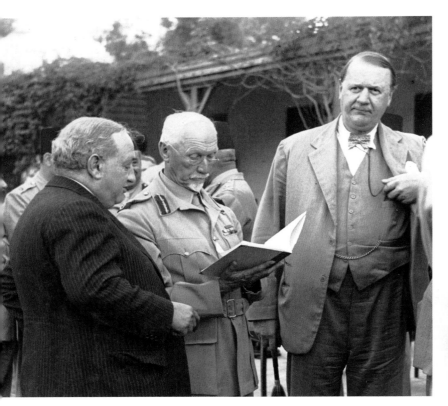

Alec Alexander, Field Marshal Jan Smuts, and Sir Miles Lampson, the British Ambassador to Egypt.

Félix Mosseri, Vicky's brother and Eileen's uncle, photographed in 1975.

Victor Kanter, Eileen's cousin.

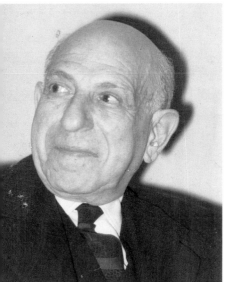

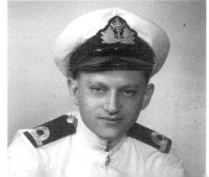

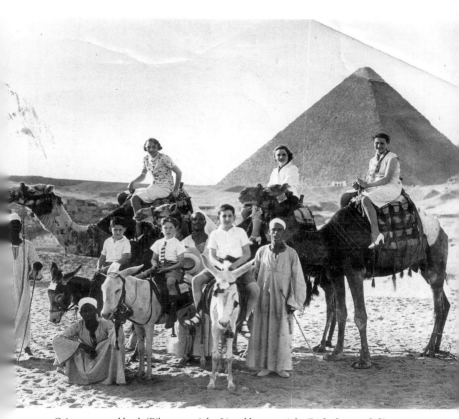

Cairo, on camel back (Eileen top right, Lionel bottom right, Dicky bottom left).

Lord and Lady Nathan.

Lord Lloyd, whose vast career ranged from serving as a deeply imperialist Governor of Bombay (and imprisoning Gandhi) to Leader of the House of Lords.

Muriel Bradbrook, a fellow of Girton College and Eileen's tutor, who after the war became Cambridge's first female Professor of English.

Nellie Ionides, an old friend of the Alexanders, was a major benefactor of Britain's museums and the daughter of the founder of Shell.

One of Eileen's constant correspondents, Aubrey 'Abba' Eban.

Eban went on to make a global reputation as a diplomat and 'Voice of Israel'. Pictured here with President Nixon.

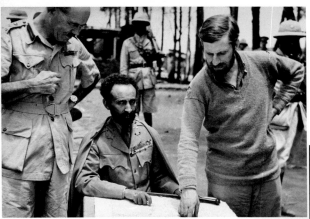

Orde Wingate (right) with a Brigadier of the British Army and the Emperor of Ethiopia.

Major General Orde Wingate was leader of the Chindits, the largest force of the Allied Special Forces in the Second World War.

Eileen outside the post office, 1933, Drumnadrochit, Scotland.

At 11 x 8¼ inches, an air letter demanded economical handwriting. Eileen regularly fitted 350 words to Gershon's 200.

curtains of the morning-room inwards – and landing with a dull thud about a mile away.

My mother and I went on with our knitting, being accustomed to that sort of noise – but Peggy, who had never spent an Air Raid outside her Shelter until she came to stay with us, tried to crawl under the sofa between the whistle and the thud – Then she sat down again, trembling violently and the effort of Reviving her was such that I had two extra cigarettes in rapid succession.

Then my mother and I went upstairs and looked out of the bathroom window to see What Was Going On. Well, darling – our Vigilance was Rewarded because in the Far Corner of the Garden, near the tomato-patch – there was a Red Glow. 'Incendiaries' announced my mother with Intense Satisfaction, 'Sand' I replied, (I have a neat turn for Repartee, darling) at which she, not to be outdone came back with 'Shovel' – and then, as a brilliant afterthought 'Coats'. No sooner Said than Done, darling. We put on heavy overcoats – armed ourselves with a bag of sand & a shovel each – rang up and asked the Police to Call when They had the time – and went out to Stalk the Incendiary. Peggy came to the dining-room window – watched the glow for a few moments, and then said that it didn't look much like an Incendiary to her – and if it was, it had burnt itself out.

Mrs Wright, hearing all this from the shelter – opened the door a crack, and asked what was the matter. 'Mrs Wright, Mrs Wright we've got an incendiary bomb in the garden,' carolled my mother in the voice of the Herald Angels announcing Mary's Happy Event to a Gaping World. 'Where?' said Mrs W. Sceptically – 'Over there,' my mother said, pointing to the Glow at the Bottom of the Garden, which was now very faint, owing to the impact of a heavy rainfall. 'Oh that,' Mrs Wright said, with a Hollow Laugh – 'That isn't an Incendiary – It's the Bonfire.' 'What Bonfire?' I asked angrily – 'The bonfire the gardener made this afternoon,' she said coolly, 'he must have forgotten to put it out.'

Well, darling … my mother and I walked boldly up to it with our sand and shovels and put it out. About ten minutes later the Police arrived – We Explained All – and the three Stalwarts Squelched across the lawn and emptied a can of water over the ashes.

'Thank you very much,' said my mother. 'Would you like a drink?' 'Yes,' they said – as one man – with heavenly harmony.

While they were having it, I smoked another cigarette – just to be matey, darling, and they went all Tender over us, and asked us if we were being Fire-Watched. 'If you get an Incendiary in the garden,' the head-man said affectionately, he was All Teeth, darling, with a Heart of Gold. 'Take no notice – If you get one on the Roof or in one of the Gutters – Creep up to it and empty a bag of sand over it – but I shouldn't wait to see what 'appens if I wos you.'

The second-in-command, a smallish wilted man, with a sparse sprinkling of golden hairs and a sunken chin, asked why we weren't in the shelter – We said we preferred to sleep in our beds & then he went All Intimate and told us that he did too.

Then the Third Man spoke. He was youngish and timid and teetotal (The others had whiskey-and-soda but he had lemonade) and asked us if we knew what to do in the event of Gas being used? We said no, because he was obviously <u>dying</u> to tell us – whereat he inflated his chest, breathed out hissingly and began.

'New-mown hay, Geranium, Garlic and Onions,' he said, 'If you smell those you'll know it's Gas.' (I didn't ask what would happen if it turned out to be just New-mown hay, Geranium, Garlic or Onions – It would have Hurt Him – although I <u>should</u> like to know – but I admit that it isn't <u>likely</u>, darling, that one would smell Onions, just willy nilly in these days.)

My mother looked mildly surprised & said she supposed we'd know anyway when we heard the Rattles. 'Oh! no,' said PC 3 kindly if Disillusioningly – 'not at all. You see, nobody knows the Gas is there until Someone happens to smell it and tell someone else. But you'll be alright,' he added consolingly 'if you have your Gas mask on.' My mother's mouth opened – obviously with the intention of asking why she <u>should</u> have her gas mask on, when there hadn't been a gas warning – but she Thought Better of It.

Then they went on to describe their experiences in the First Great fire at the Docks. 'We kept having to lie flat on our stummicks in the Road,' PC 1 said, 'And not a soul to offer us a drink of something to Hot us Up.' He rolled his Diminishing whiskey appreciatively round his palate.

At about five minutes to eleven he sighed and said: 'Well, boys, these ladies ought to be tucked up in their beds. We'd better be going' – and they shook hands Solemnly all round. Then he turned to my mother, 'I don't like to think of you ladies alone in this big house with only that sick old man in the shelter to look after you,' he said. 'You go along and have a Cosy Talk with the Chief Warden about Fire-Watchers, mum, but anyway, we'll keep an eye on you, so you don't fret – won't we boys?'

'Yes,' said PCs 2 and 3 Obediently – and they crunched out into the night.

I needn't tell you, need I, darling, how Very Beautiful it all was.

FRIDAY 21 FEBRUARY Darling, I caught my train by the scruff of its neck and leapt into the arms of a brace of Good solid British Workmen just as the wheels were starting to creak into action.

When I got home, I found my mother Anxious (because I was late) but Civil – and there was a message from the Air Ministry asking me to be there at 10.15 instead of 10.30. I had a Theory, darling, that this was because the Gas Attack was Due to begin at 10.30 and Mr Proper thought we'd probably be Matier out of our Respirators than in them – but actually it wasn't as Elementary as that, my dear Watson – It was because he had a Committee meeting at 10.30.

I sat for some moments with his typist in an Outer Office, and she (a Motherly, Woolly Soul in a Shawl, darling) said I needn't be nervous – as, after all, the Worst was Over.

Mr Proper (concave middle and bushy moustache) didn't keep me very long. He asked a few apparently driftless questions – but no doubt they had some Hidden Significance which I was too Mollock-dazed to see, darling – and then another man (also bushy-moustached and hollow-middled, I have a theory that The Head of the Civil Service Sends for a Vogue Pattern every five years or so and Cuts Out hundreds and hundreds of Higher Grade Civil Servants all exactly alike. These were about 1890 Vintage) asked me about Memoranda – and said he thought that abstracting a memorandum from a confused mass of documents would be rather like Research. Then Mr Proper said: 'Well, I suppose the Board said

something non-committal like "you'll hear from us in due course" – so I'll say the same,' and he gave me a pleasant smile, darling, and came to the door with me. That was really all, and I've no idea whether he liked me or not – so we'll just have to Wait and See.

Miss Page has been Giving a Lecture on the Mating of Animals, darling, all through this letter – It's simply been shattering my Concentration – I only heard odd snatches – 'Horses have to have a Gate between them so that the mare doesn't get damaged by his Hoofs ...' 'Then the jenny-robin hops on to a branch and he hops up beside her and he sidles after her – and then hops on to her back and nine times out of ten he falls off and has to start all over again ...' 'I get so dreadfully embarrassed when I find myself in the monkey-house, with someone I don't know very well ... It isn't only the baboons – It's some of the other monkeys – and their fronts ...' Here I looked up, darling, and remarked mildly that the trouble with her was that she was Inhibited – She started to get Irritated – and then Thought Better of it – and Miss Carlyon gave a wicked little smile and said when I got to her age, I'd learn the difference between Inhibitions and Maidenly Modesty. Then Miss Page went on to talk of Ducks who Mate in the Eternal Triangle – two Drakes and a Girl – and the Men fight it Out. Darling, no-one can say that I don't learn things in Welfare – Eastern Command & London District. Later she went on to Lovers I have Known – in the Animal World – Some of her stories were rather Beautiful – I'll keep the best ones till we meet.

THURSDAY 27 FEBRUARY Oh! my dear love, on Monday week, I shall be a rill Civil Servant. A man called D. A. Parry with a small cramped signature, has been Directed to Offer me an Appointment as a Temporary Administrative Assistant in the Air Ministry, subject to evidence of my medical fitness.

The appointment will be of a Temporary Character (and shan't I hare back to Cambridge and my dear love after the war?) The salary will be at the rate of £260 per annum. (Infinite Riches for a little girl.)

No additional salary will be paid in the event of my being required to go into the air in connection with my duties (at least, darling, I Know Where I stand – (or fly)).

Can you love a Temporary Administrative Assistant, my darling? Because, if not, I shall tell them that I'm afraid they'll have to find Another – because God Forbid that <u>you</u> should.

FRIDAY 28 FEBRUARY Lady Nathan turned rather Nasty on me this morning. I was discussing the Future with Miss Carlyon & Miss Page – and I asked them if they'd like to take over my lists after I'd gone – as they knew a good deal about them – (more than anyone else in Welfare at any rate) They both liked the idea as they feel they haven't nearly enough to do, as things are, and so I went into Lady Nathan and suggested that she should ask them about it. She looked annoyed and told me not to concern myself with what was going to happen after I'd gone – and said that a lot of trouble had been caused in Welfare by people delegating their work unofficially to other people. I said I was very sorry and that I wouldn't say any more about it – and left it at that – but I think she was being a bit Uncivil, darling – not to say Querulous.

WEDNESDAY 5 MARCH There's been an interruption in the form of Miss Carlyon muttering a line from *Coriolanus*. I looked up & remarked that I had <u>not</u> written Coriolanus, at which she Tore her Hair in a Worried Way, and said: 'Well, <u>who</u> did?' I said perhaps Bacon did – or Mrs Bacon (well – I <u>mean</u>) and then, darling, she made a Revolutionary Pronouncement – she said that for <u>all she</u> knew, <u>Shakespeare</u> might have written it! <u>Well</u>, darling, if she'd said Bombay Duck was a kind of Mallard found on the Ganges, it wouldn't have taken a heavier sandbag to knock me down.

Darling, you don't have to apologize to me for reading the papers when you're with me. My mother is talking nonsense – because she wouldn't be pleased <u>at all</u> if you were to show your affection for me by Mollocking in her presence. However, let's forget the whole thing and have our Solace in our own way – <u>please</u>.

I'm sorry I'm so often silent, darling – Sometimes it's because I'm completely at rest in your arms, and there's no need for idle chatter – and sometimes it's because a Roman thought hath struck me – but it's always because I love you – so please bear with it – after all, I'm often garrulous (particularly in letters) and

you're often very silent – which evens thing out somewhat, doesn't it?

<u>THURSDAY 6 MARCH</u> Joan rang me up a few minutes ago to tell me that she was leaving St Michael's in April, and was putting herself on the Central Register hopefully. She'd just had a letter from Sheila, announcing that Hamish had come back to England via Iceland and was now Commissioned and flying all over the place. Terrific Solace All Round.

Pa left today for Liverpool and Douglas. Oh! I <u>wish</u> you could be in London with me on Sunday – my mother is going to Oxford – and I shall be alone and Solaceless.

We're going to spend the day at King's Langley on Saturday with Ismay & her parents but if you were here for the weekend, you could come too – and make my duty-visit a pleasure.

March–September 1941

After the cosy world of Buckingham Gate, and Lord Nathan's Anxious Soldiers Department, the Air Ministry building on the Strand came as something of a shock. It would only be a matter of time before Eileen's new colleagues took their places alongside Miss Carlyon and Miss Sloane in her letters, but with the best will in the world she was simply not built to be an obscure cog in a ministerial machine the size of a largish town, a civil service drone somewhere at the bottom of an administrative hierarchy that stretched above her in a bewildering range of grades and initials from her own lowly position as TAA in S2b to the ultimate heights of the PUS to the S of S for Air.

While Eileen knuckled bravely down to her new work, in the world beyond Ariel House and S2b the war in North Africa was taking a turn for the worse. The early successes against the Italians had come back to bite Wavell, and the arrival of Rommel in North Africa was a prelude to a series of military disasters, first in the Libyan desert and then in Greece and Crete, where a wretchedly conceived campaign ended with a humiliating evacuation, serious naval losses and more than five and a half thousand British and Empire dead or wounded.

There was the odd success to lay against these reverses – the Bismarck was sunk in May – but the most comforting news was not from the battlefield but from America. At the end of 1940 President Roosevelt had proposed a system of 'Lend-Lease' that would enable Britain to buy American goods without payment, and in March 1941 this became US law, guaranteeing Britain could at least afford to fight the war.

If the deal was not as generous as it might first seem – in effect Britain was paying for survival with her future – it showed the same grim

resolution that was at last evident on the home front. At the beginning of the year, Herbert Morrison had introduced a compulsory adult register for fire-watchers, and from 1941 'compulsion' would become the watchword of the war, with food rations tightened and rationing extended to clothing, essential industries prioritised, income tax raised, prices controlled, 'reserved occupations' pared back, land put to plough, conscription for women introduced and the movement of labour – on the back of Ernest Bevin's Essential Work Order passed in March – controlled and directed to where it was most urgently needed.

 It was the personal rather than the public that Eileen preferred to share with Gershon and in the summer that Germany invaded Russia and changed the course of the war it is their old Cambridge world that fills her letters. In April, Joan Aubertin, the most vividly attractive of all Eileen's friends, came to live with her in Harley Road, and over the next months, as the two of them were joined in London by most of their old college friends and enemies – her old tutor Muriel Bradbrook at the Board of Trade, Mrs Crews at Postal Censorship, Elizabeth Clark with the Friends' Ambulance, Rosemary Allot at the BBC, Joan Friedman doing something noisily 'hush-hush' at Bletchley – Eileen's war began to look as much like an extended Girton reunion as anything else.

 Gershon, too, was now at West Drayton, and though that made it easier for them to meet, the small, almost imperceptible cloud that had hung over their relationship since at least Blackpool, was taking on a more definite shape.

6

A Rill Civil Servant

I arrived at Ariel House to find the entire staff in its Gas Masks. It's not so much having to put them on that we mind, a Home Guard spokesman said to me, (taking his off to make himself heard) it's putting them back in their satchels that is such a nuisance. I went (Escorted by the Home Guard) into Room 101 – The Establishment Secretary tried conversation à travers le respirateur and found it Wanting. He Took it Off – bade me a Civil Good-morning and gave me several hundred forms to fill in and sign – (Including the Official Secrets Act, which I read through carefully – He said that only one person in a thousand ever read it. I thought to myself, darling, that only one person in a thousand has such Urgent need to read it – but I forbore to say so). Then he gave me a Yellow Pass – and the Home Guard took me into a Large Bare Room where hundreds of Pilot Officers (mostly Old and Fat, darling) were sitting in a Row with numbers pinned on to them. A cosmetic-smeared Wild Oat of a Girl pinned a number on to me and I sat down next to the last Pilot Officer – then a photographer came in with a huge lamp & a very small camera and Moved down the line, snapping us all with the Wonderful impartiality of Complete Indifference – Then the Wild Oat took the number off me – and the Home Guard took me up six flights of stairs to see Mr Proper. Mr Proper handed me over to Another (same Vogue Pattern) and that was how I became a Temporary Administrative Assistant in the Meteorological and Educational department of the Air Ministry, darling. (This depart-

ment sees (a) that the Barrage Balloons go up when the weather is nice for Mollocking, and (b) that your Technical Instructors get Paid According to their deserts – What could be more fitting, darling? I wonder who told them All about me and Barrage Balloons.)

As for the work, it is mainly writing letters to the Treasury asking them if we can have more money for more staff. However, I've been promised that, in time, if I'm a Good Girl, I Shall See People and Get Things Done.

TUESDAY 11 MARCH Darling, Mr Crotch, who has only recently left the London School of Economics for the Air Ministry, sent for me and told me that, as he had to be away a great deal to sit on Selection Boards all over the country for Meteorological Assistants, he wanted 'an intelligent and Responsible person to keep an eye on the Recruitment Publicity and correspondence – and that's where you come in, Miss Alexander'. I looked up, Startled, darling, not having recognized myself from the description at the beginning of the sentence – and said I'd be glad to do the work – which I shall, darling. If I can make one Balloon more comfortable in the Stratosphere by my administrative efforts – then I shall have Served my Purpose in this war.

WEDNESDAY 12 MARCH Darling, I've had a very exhausting day, in the course of which I discovered, to my extreme embarrassment, that I am senior to everybody in the section of the department in which I am working – except Mr Crotch, who is a Temporary Administration Assistant like me. Thus old Greybeards come to me and ask my advice about Procedure in what they please to call 'Your Section' – and then I Tell them All I know, darling, which is practically nothing – in return for which they, haltingly and apol-ogetically tell me All they know, which to my bewildered ears sounds almost everything.

I tottered out of Ariel House at 5.30, completely spent, not having been able even to take ten minutes off for coffee after I'd eaten my sandwiches – and a voice said 'Can I take you anywhere, Miss?' It was Mr Gestetner's chauffeur, Richards, and, having Sworn me to Secrecy – (He's not allowed to Fritter away Mr

G's hard-won petrol ration) drove me home. What a comfort, darling.

THURSDAY 13 MARCH Oh! my dear love, there's far less to laugh at in the Civil Service than in Welfare – I feel strange and lonely – I miss Miss Carlyon – and her whimsies – I miss the fortnightly visits of the Field Security Police – I miss the People who Know All the Answers – I miss the Complex matrimonial tangles of my soldiers – but I shall forget them all, when I've got used to the Air Ministry, darling – so don't be concerned on my account.

Perhaps someone will say something human to me in the Department – and then, my darling, you shall have an Epic. (Mr Green, a permanent Assistant Principal, did tell me that he had two sons – but then he Recollected Himself – and was Covered in Confusion at the Electrical Intimacy of the Atmosphere – After that he could hardly Look Me in the Eye for Hours. The Civil Service is like that. People aren't Men or Women, they're Male or Female. Where Mr Herbert would have said 'Hurry Up, Girl', Mr Green would say 'Go to it, Female', – adding 'In Accordance with Section 85 of the Speeding-Up-of-Production Act.') Ah! me.

TUESDAY 18 MARCH Mr Crotch read English at London University, darling, and he wrote a Thesis on Caxton for his MA – so we have a Bond, because, after all, Caxton was Malory's first Editor (and, incidentally, his best in many ways) and, as such, is deservedly celebrated.

WEDNESDAY 19 MARCH Darling, I took Miss Smith out to lunch today, and, except that I had to borrow 2/6d from her to pay the bill, it was quite pleasant. Miss Smith is Young and Miss Smith is Earnest. She has the Fanatic Zeal of the Reformer – and she wants to build a new Leningrad in England's green & pleasant land. She is using the Civil Service as a stepping-stone into Parliament. She believes in Living in Sin (though obviously she's never tried it, darling) because Marriage is Restrictive, Artificial and often Impermanent – and Celibacy (though she didn't mention this) is obviously Repressive. Miss Smith, a young woman of Drive, does not like

being Repressed. She hates Escapism – I was immediately goaded into a State of Pantisocratic Vagueness far beyond my normal Attainments in this field, darling – I couldn't resist it. She reminds me a little of Ruth Walker (in her Pre-Feminine-Charm phase) except that she has a sense of humour and keeps primroses on her desk. In time she will grow up – but at present she has a touch of Mr Hobsbawm* about her, which is Disconcerting. She was writing an MA Thesis on Norman Legislation – but she's Put All that Behind Her – and now concentrates mainly on ARP.† (She stays in the Air Ministry at night, darling, to do First Aid – but she's going to ask to be transferred to fire-fighting because it's more Exciting.) I said mildly that it seemed a pity that she should abandon the Academic Life (her eyes Flashed Scorn) as, after all, Dons were the only people who had ever learnt the secret of Growing Old Gracefully – with Dons, by virtue of their constant contact with the young, Rigor Mortis only set in After Death. (I don't think I believe all of this, darling – at any rate it had never occurred to me before but I always turn enfant terrible when anyone goes Earnest on me, and There it is.)

Lionel has measles. My mother would have said, (had that been her idiom but it isn't – it's bad enough, darling, having two people in the same family who claim to have written Shakespeare) 'If Sorrows come, they come not single spies, but in Battalions ...' She wants to go and see him, but the Civil Service rules are Emphatic on the subject of Infectious diseases, and I'm trying to dissuade her.

MONDAY 24 MARCH My mother has just Announced in Triumph that Nurse is coming back to us during the children's holidays. (Dicky breaks up on Friday (sorrow noise) Lionel on the 10th) to Help in the House (More Woe). Nurse always was a Solace to my mother – I shall never know why.

* British historian and Marxist, Eric Hobsbawm (1917–2012).

† Air Raid Precautions.

WEDNESDAY 26 MARCH Darling, I wish I could do something about your boredom. You're very restless by temperament, darling, and there are only two ways of dealing with restlessness. It must either be lulled, or stimulated to the pitch where it becomes pleasurable – (horrible word, darling – Delete, as they say in the Civil Service, and read – a pleasure in itself). That's why I'm so certain (though personally I'm terrified of the prospect for obvious reasons) that Intelligence is the only solution – because that kind of work keys up the restless, enquiring mind and directs it into the right chan- nels. It exploits a quality of mind, which can become dangerous if it's allowed to rust, like Phosphorus when it's exposed to the air. The Narcotic method of treating restlessness is useful in small doses – but the effect wears off if it's used too often – That's why, darling, I am only a Good Influence in a very limited sort of way.

THURSDAY 27 MARCH Darling, I Put my Foot in it right up to my Chin today. I wanted to see Mr Crotch on a Trivial Matter, and when I went into his room, there was a very small old man sitting on his window-sill. He was rather a scrubby, insignificant little body, so I just ignored him, and asked Mr Crotch my question. Mr C. looked a little Put Out, and asked me to come back later, saying that he was Rather Busy now. When I went into him again, he said that I'd chipped in on Mr Gilbert (the head of the Education Section – a very Exalted Personage and a Civil Servant of centuries of Standing!). He said it didn't matter, and that Mr G. had just raised his eyebrows and made no comment – but he thought I ought to Know. Well ... I haven't been in the Civil Service long, darling, but I've been there long enough to know that the only person who can interrupt a Director with Impunity is another Director – or Something Higher-life Still – like a Permanent-Under-Secretary. Oh! dear, if I go on like this, darling, I shall find myself Unemployed before very long.

MONDAY 31 MARCH I've just telephoned Mr Lacey to have my teeth out tomorrow – I'm terrified, darling – My mother is coming with me as my Ersatz Courage – (I hope I don't say anything Indiscreet under Gas – I shall probably Explain that Beauty is in the eye of the Beholder, and that if you loved me you'd be Satisfied with my

Bosom – or lack of it – or else say: 'Of course my mouth opens when you kiss me, darling, it's all a Matter of <u>Pressure</u> – don't you remember what Major Wingate said about Love and Pressure?' or words to that effect).

Joyce rang up last night to ask me to a sherry party on Saturday after work. I said thank-you-very-much – I haven't been to a party since August, darling. I expect I shall eat my jelly with the wrong end of the spoon and ask my fellow guests to show me their Passes. Life today is either Work or Love – I've forgotten what Social Intercourse is like – on an impersonal Plane.

THURSDAY 3 APRIL Darling, this has been a stimulating day. I've just come home from work to find a wildly incoherent but intensely amusing letter from Sheila – who appears to be in Berkshire – apparently with Allan, though she doesn't make this very clear – but she says he was Battery Sergeant-Major this week – which indicates that they are at least in touch with one another! She says she leant over gates and is intensely Rural – she adds that Everybody is passionately interested in Ploughing – They plough up everything – and the inhabitants of her village have lost interest in her since they've discovered that she is not Arable! A Beautiful letter, darling – I must show it to you. We were a clever English year – though I sez it as shouldn't – but Sheila is the cleverest of us all. She says not a word of Hamish – I expect it's because he's so irrevocably Lost to all of us – for Prim, Dull, Middle-Class, Respectable Charlotte. Oh! darling, what a sorrow.

In the middle of the morning, Aubrey rang me up at the Air Ministry – and we lunched together. The Chief Instructress of the Mayfair Secretarial College for Gentlewomen turned out to be a Procuress – Seductive Perfume – Glints in the Hair – and Locked Doors – (according to Mrs Eban – according to Aubrey). Mrs Eban – a Seething Mass of Outraged Motherly Propriety (one gathers) snatched Carmel away from It All and arranged for her to attend a college, more Bourgeois, but less Exciting – They returned home Panting, but exulting, and having saved Carmel from what Aubrey described succinctly as WTD* we had lunch at the Strand Palace

* Worse Than Death.

– and we were Attended by an Aged Maidservant who had No Delicacy at All. 'Five Shillings' she said loudly, when we had eaten, slapping a pink bill on the table – and 'hurry up – someone is waiting for your table'. She was Wrinkled and Ugly and, in her limited way, rather Sordid.

Aubrey has a theory that when he rang up for my number, my mother Mistook him for you – because she went all Secretive and Guarded – until he told her who he was – when she sighed Gustily with Relief and Revealed All – But I expect this was just a Notion – Aubrey is given to Notions.

He sends his regards – I don't think there's anything else – oh! yes, I think he's a little tired of Joyce – he says that she's sunk into an Apathy of Negativity – which No one can Penetrate – (But to do her justice, darling, I expect it's because she went all the way to Cardiff to meet her Solace – and then he couldn't get leave – although I don't think she loves him very profoundly or irrevocably – In fact I'm sure she doesn't.)

MONDAY 7 APRIL You know Miss Waterworth and her Naval Commander? Well, darling, he's Married – not once but Twice in our Rough Island Story. His first wife Left Him and his second Misunderstands him so Dreadfully that he couldn't possibly live with her and his two-children-by-his-first-wife (wot left him). So he has dinner with Miss W., every night – and she rings him up at Woolwich and calls him 'darling'.

Joan Aubertin, after her first day in a Government Office, has learnt the same bitter lesson as I did – That No one has Anything for her to do. This is a Great Sorrow to her – but I've been able to assure her that, after 20 years in the Service, she will begin to Unlearn it. (Mr Green has been doing this for at least two years – if not three.) This is something of a Consolation to her.

Did I ever tell you about Joan and her Situations, darling? She is a One for Situations – They Cling about her like Lichens on a Rock. Two notable ones at Cambridge were the Mr Tanfield Situation (He threatened to Cut His Throat – but he was always doing that – He did the very same thing with Doreen Watson – but we didn't know, at the time, that it was just his Idiom – and we all waited Breathlessly while Joan Rent her Garments and Wrung

her hands). There was also the Mr Salingar Situation – Less Spectacular but of Longer Duration.

Now, darling, there is the Mr Sims situation, which is on the point of Bursting Into Flower. Mr Sims is a Canadian Officer – with a wife and child – in Canada. He is also a bit of a solace to Joan – on a non-Erotic plane, I'm afraid ('But,' she says plaintively, 'He has a Wife and child.' I say 'Yes – in Canada' – and I say it laconically – but I say it Often – and meaningly). Joan loves Ian – but she likes men – but men nearly always love Joan – Hence this Spate of Situations, over which we all Tear our Hair wildly and Helplessly. Joan is being Unwise over Mr Sims, darling – but one of her major charms is her unwisdom – and after all a Situation here and there does add zest to the life of a Civil Servant – (meaning Me, dear).

<u>WEDNESDAY 9 APRIL</u> Darling, as I was walking down Harley Road this evening, I saw a man disguised as a tree. He wasn't Aubrey – or any other Soldier, sailor or Airman (England's last, best force) but just a civilian – a civilian with his own ideas about ARP perhaps. At all events there he was disguised as a Laburnum in full flower – with almond-branches grafted on – a hybrid sort of tree, darling, and he looked me straight in the Eye and Defied me to Mistake him for a man. Perhaps he was a Surrealist Poet – putting his Soul into his Art – perhaps he was a Madman who thought he was Birnam Wood coming to Dunsinane – We Shall Never Know – but it was a Beautiful sight, darling, in this world where Normality has developed into a cult.

The Civil Service is a Hotbed of Normality. Today, the APS to the US of S* rang me up and told me of a man in the Met. Office who acted as a political agent to an MP. He wanted us to do something for him. I went in to consult Mr Green, whose hair literally stood on end at this Departure from the Normal – It flattened down a bit when he heard that the work was Unpaid – but he'll never be the same again. Everything in the Civil Service depends upon Precedent – and, darling, to see a Civil Servant Giving Birth to a Precedent, is far more vicariously painful than seeing a woman giving birth to a child – It's such an <u>Unnatural</u> Process.

* Assistant Private Secretary to the Under Secretary of State.

Joan comes home each evening with fantastic stories of the Trials of a Health Inspector. She says women are always ringing up to Demand Widows' Pensions – and when the Inspector Calls to Investigate the Case, nine times out of ten, she'll ask him (or her) in for a cup of tea, adding 'that is, if you don't mind The Corpse'. Darling, Joan has a Theory about why you are no longer employed on Psychological Investigations in the RAF. She believes that the RAF Has Lost Faith in Psychology – because they've heard this story:

There was a little boy who cared for nothing in the world but shooting at things with his catapult – and it was a Great Sorrow to his mother – she Brooded on it for a long time and then decided to consult a Psychologist. The psychologist told her not to worry – that it was probably due to some Sexual Peculiarity (the little boy was six) and if he could get the child to talk about it, he'd cure him and All Would Be Well. He sat the lad in a chair and said kindly: 'Now, Johnnie, tell me what you like doing best in the world?' 'Shooting with my catapult,' said Johnnie immediately. 'Ah! Yes! Quite' said the Psychologist, 'and what do you like doing best after that?' 'Collecting stones for my catapult,' said Johnnie stolidly. 'And after that what do you like best?' asked the Psychologist, refusing to be defeated. 'Finding the cats I've shot with my catapult,' answered Johnnie without hesitation. The Psychologist felt that this was Getting them Nowhere, but he was a patient man and Sure of his Ground so he said: 'Yes, Johnnie, but is there nothing else you like doing?' Johnnie paused rather doubtfully, and Then said slowly: 'I like putting my hands up little girls' skirts.' The psychologist's eyes lit up – This was His Moment. 'And why do you like doing that, Johnnie?' he said. Johnnie's answer came Laconically and Deliberately: 'To get the elastic out of their knickers for my catapult.'

Perhaps there's something in what Joan says, darling.

SUNDAY 13 APRIL [her birthday] I have nor youth nor age, darling, having had too much lunch and not caring whether it is I who have been Arrested in Adolescence or the rest of the world, which is Precocious.

Joan is writing letters too – Occasionally her mouth widens into a happy smile – that is when she has been able to capture an impression and bring it to life on paper – I wonder if I smile like that, darling, when I write letters?

Joan and I are full of resolves, darling. We are going (we say) to write at length to all our friends – we are going to share out our All – we are going to Get in Touch – and Keep in Touch – We are resolved. She's in a queer state, darling. She has an intuition that Ian has been hurt – and she talks wildly and brilliantly & frightenedly of everything but that. Oh! darling, what the Hell sort of use is anyone to a friend? One person can do nothing to help another. I never realized it so bitterly and sharply as that day in Queen's Hall – when I so wanted to be a comfort to you – and I could only be hand-wringingly and inarticulately useless. With Joan, I just go All Hearty and Impersonal and Aggressively larger than Life-Size. My mother said to me this morning that fundamentally I was generous minded and loveable – but superficially I was hardly nice at all – Is this true, darling? (Not a rhetorical question.)

MONDAY 14 APRIL Nurse's husband came from Liverpool for the weekend, darling – He's waiting to be shipped abroad – and he'd heard that if your wife is Certified in Danger of Her Life, (she's going to have a baby), you didn't have to go – He came to Look for a Doctor to Certify Nurse – However, he couldn't find one – The one he saw said she was Bursting With Health – which, I suppose, was Discouraging in its way.

THURSDAY 17 APRIL Darling, what I don't know about Hell this morning could be written on the thin end of a wedge. The sirens went at about 9 and after that, until five in the morning, the planes were whining overhead so that I thought I could feel them grazing my scalp, darling, and the sound they made gave me the impression that they were blackening the sky like locusts – wing-tip to wing-

tip. There wasn't a moment of silence all night – 'Look how the floor of heaven is deep inlaid with patens of bloody Huns' I kept saying querulously to myself, and I couldn't sleep. Then, darling, above the noise of planes there was another noise, suddenly. It was far more terrifying – It sounded as an oncoming train must sound to a suicide on a railway-line – it was like the whistle of a bomb and yet unlike it – it was like the hissing of a monstrous boiler – and yet it wasn't. My mother said it was a land-mine so we all got up and stood under the stairs in the hall. The air is cut away before and closes from behind, I murmured to myself. I always get quotation fever when I'm frightened, darling. It took 25 minutes to come down, darling, and then it crashed and splintered and we all went back to bed. (We discovered this morning that it had landed in West End Lane.)

The West End is a shambles of splintered glass this morning – Oxford Street, from Selfridges to Debenhams is roped off – and the Strand is still ablaze. Ariel House seems to have been missed, as the result of an Oversight. There doesn't seem any other possible explanation. Trafalgar Square was solid with Traffic – and a man was announcing irritably, in a voice fraught with pained refinement, that all Traffic to the City must turn back. It was uncanny – as though Nelson with his Celebrated Public-Spiritedness had decided to play his part in ARP and had had loud-speakers installed for that purpose.

I'm so tired, darling, that I can hardly see the page. I've been nervous in Air-Raids before, but last night I was Terrified.

I worked scrappily and desultorily, today – and then I couldn't get a 'bus or a taxi to come home in and I walked & walked and walked. I found a taxi in the end – but there was a lot of Talk and Acrimony and threats from Beefy Men to report the Driver to the Police (because he said he didn't want to drive me – he wanted to go home to his supper – I don't blame the poor devil).

Pa is getting all Shelter-conscious again, darling, and he's as Broody as an Expectant Hen – over the news – and Life – and Death – and talking of Death, I saw a dead man being brought out of a house on a stretcher on my way home. I've never seen anyone dead before. He just looked as though he were asleep – but I was terribly frightened, darling – I'm frightened now. I wonder if we'll

ever grow to forget the things we've seen and heard in this war, darling? Oh! thank God for you. The only thing that has made these last months <u>possible</u> is your love. When I'm with you, I don't believe in anything else – but when I'm away, my dear love, the clouds do hang on me – That's why it's of such <u>paramount</u> importance that I should be with you when I can. (Hold on to Sunday.) That's why I'm so <u>ruthlessly</u> selfish with my parents.

<u>MONDAY 21 APRIL</u> Darling, what made you suddenly ask me yesterday if I was sorry you ever kissed me? Of course I'm not, my dear love – Being close to you is the greatest happiness I have – and I like to be close to you physically as well as emotionally and intellectually – That's why, darling, I <u>know</u> (not by the light of nature but by the light of deductive reasoning) that I should be happy to be Wanton with you (but only if I were your wife, darling, otherwise the Social and Family and Emotional implications would set me a-cluck up to death!) because then I'd be closest of all to you.

Oh! darling, the birds' songs are filling the sky. It's damnable that their sweet jargoning should be battered out of existence by the guns in the night. You know I'm right in saying that there's no joy in modern poetry (except in Yeats). I don't think Eliot ever mentions birds – but Chaucer is <u>full</u> of *fowles* and *briddes* – and Shakespeare embodies all the desolation of winter in 'bare ruined choirs where <u>late</u> the sweet birds sang' – and all the joy of summer in 'hark, hark the lark at Heaven's gate sings'. Yeats believes that the sadness of old age lies in its turning away from birds in the trees to monuments of imaginary intellect – Bird-songs are youth and joy and love, darling. Hold on to bird-songs. (Damn! Pa has come in to talk about Him & Leslie – it looks like an all-evening session.)

Darling, it came over me in a Wave today, that I'm not really Efficient. Mr Crotch gave me something to do which was really childishly simple – To draft and address a letter to our education authority. The draft was alright, but I addressed it to the man who wrote the letter, and the man quite <u>plainly</u> and in words of one syllable asked us to write to someone else (He gave the proper address in Large Black Type). Mr Crotch was just amused – (He thinks it's a Huge Joke, darling, that they pay me a colossal

salary for doing things wrong) but I was distressed. Oh! God, I wish I weren't so stupid. It's because I'm so silly in a vague way, and so plain and so useless, darling, that I feel it's so monstrous that I should have any pretensions to being your Solace – but oh! my dear love, thank you for loving me.

Apart from this nothing happened today. I went to the dentist after work and he hurt me a little – but not much.

MONDAY 28 APRIL On Thursday, darling, I asked you if you'd ever heard of Rosemary Allott – and, of course, you said you never had? The whole point about Rosemary Allott, darling, is that no-one has ever heard of her – and nobody ever will. Well, I met her today in Charing Cross. She has a Gauntness about her that she hadn't got at Cambridge and her face is covered with yellowish down, like a new-born chicken (only it suits a new-born chicken) and instead of being burly and bumptious she's wiry and bumptious. She's working for the BBC in Bush House, a score of paces from our door. Oh! dear. She almost Folded Me in Her Arms – but not quite – and she said we Must Meet. I wilted and said, 'Yes, indeed' or words to that effect – and after she had Wrung my Telephone number from me, we parted.

TUESDAY 29 APRIL Rosemary's visit wasn't altogether appalling, dear. She had a wonderful tale to tell about Edna Browne. (Edna was very tall and fair, darling, and very Upright – as though she had a rod down the middle of her back instead of a spine – I think you met her once or twice. The night Porter at Girton always called her Miss Browne Withance.) Someone told Joan that Edna was friendly with a BBC Official in Bristol – which I naturally took to mean that she was Walking Out with Bruce Belfrage* – but apparently he is not Bruce Belfrage – his name is Horace – and All is Over, because to use Rosemary's Striking Phrase, he made Improper Proposals. He had a wife, darling, (his second) who, when she was at school was concerned about the Flatness of her Bosom – and a kindly school-mate told her that she'd heard that if you Bound a Brace of Cabbage Leaves round the place where your Bosom should have been – you

* Bruce Belfrage (1900–74) was an English actor, BBC newsreader and Liberal politician.

would, in the Fullness of Time, develop Comely Curves. I asked interestedly whether this ingenious cure had had the desired effect – but Rosemary didn't know and didn't care – She was more concerned with another aspect of the story. 'He told this to Edna the second time he met her – so you can just imagine the kind of man he was,' she said in a Pleasurably Scandalized voice.

She wanted to Know All – relating to Joan and me. When I said I hoped to go back to Cambridge after the war and finish my Thesis – she said, Coming Over All Girlish: 'Oh! but aren't you thinking of getting married?' I said something evasive about Having Forgotten How to Think – so she tried a New Tack – she wanted to know how you were – and where you were – and what you were doing. I told her – distantly – and then when Joan said absent-mindedly that it was no wonder I was suffering after a day in a roaring gale with you and your cold – she murmured something coy about 'My true love hath my cold and I have his' – at which Joan & I withered her with a Collective & Piercing Glance – and she went home – abashed – I hope. Furthermore, she was Astonished at Joan's and my Firsts and said so – without Inhibition. This did not please us – and we explained that, though others might have been surprised – we had known what to Expect all along. At this, she was more astonished than ever, and said that she'd always understood that Firsts were rare in English. We pointed out that they were rare, and that it was simply that she was Overwhelmed at seeing two of us at once – we didn't blame her – on the Contrary – we Understood – but she mustn't lose her sense of proportion all the same. We pointed out, too, that we were two-thirds of the Women Firsts in our year – and that this was her Great Moment. My father was rocking with mirth at our Impertinence – but I don't think Rosemary was amused.

MONDAY 19 MAY Darling, I'm coming to Cambridge on Saturday afternoon. I spoke to my mother about it while we were clearing the table after dinner last night, and she said she'd no objection if Pa agreed. Of course, Pa did not agree. He said he'd made no comment on the manner in which I was 'making myself cheap' by running after you on Sundays – and that he supposed I'd got enough sense and was old enough to look after myself – but since I'd asked for

his opinion, he was glad of the opportunity of Voicing his Displeasure – And then he reiterated (in a very watered-down and expurgated form, because Joan was there, Thank God) all the things he's said so often before. He said that I was not behaving in a way calculated to win your lasting affection and respect and that one day I'd be Sorry for It and would Remember his Words. It was all very Gentlemanly, darling, and I said that if Mr Turner would have me, I was going all the same, and he said very well, and the discussion was closed.

But I'm in a Damn Everything mood and furiously angry to boot – I am not going to Have a Scene – I'm tired of Scenes, darling – and if I've got to live with my father – my best course is to ignore his attitude as long as he doesn't refer to it – but oh! my dear love, I do think it's hard – and so does Joan. She says she wouldn't have believed that my father could be so unreasonable unless she'd heard it with her own ears – (and even so, darling, she only heard a very mild version of the Usual Spate of Rhetorical Tags).

MONDAY 26 MAY Jean has just come in, in a state of Morbid Preoccupation. She says she's been Wallowing in Confidential Reports about the Shipping situation. She says her only Consolation is that the man who wrote them is called Dismal Jimmie for short – and that, therefore, All is Not Lost – which, she feels, is Something – but not Much.

MONDAY 2 JUNE I had a dreadful time with Joan last night – all because of the Neutral tone of Ian's letters – She said she was Going Mad – that Ian had written to her for the past eleven months just as though she were his Maiden Aunt. (Oh! my darling, if you're sent abroad (Heaven Forfend) please don't write to me as though I were your maiden aunt) and she cried most painfully. In the meantime Pa has a theory that she's 'losing her head' over the Canadians – and, as usual, he's thinking the right thing for the wrong reason. She is losing her balance over Mr Sims – (She says herself that if he weren't married she'd probably marry him in sheer desperation and gratitude for his affection) but there's far more Complexity in the whole business than meets the eye.

Darling, the fact that when I try and help you off with your coat, it takes longer for you to shake yourself out of it, and the fact that I clear my throat nervously in concerts, and my hundred thousand other Ineptitudes may make you smile but they make me cry – and I think, with crushing fear, that when they cease to make you smile, they'll bore you and irritate you beyond endurance. Oh! God – so darling, I'm leaden-stomached and infinitely tired – I feel like a Temporary Clerk, Grade III, who has been cast for the role of Cleopatra by a fantastic producer and who can't manage it because she hasn't the intellectual breadth or emotional stature to play the Queen whom age could not wither and whose infinite variety custom could not stale.

I had a card from Sheila last night – packed with Matter for a going to be WAAF. Hamish & Charlotte were married in St Giles Cathedral – How Fantastic – but how typical of Hamish, darling – typical by its very incongruity. Why haven't I answered her letter, she asks Petulantly, she points out that it was a Beautiful letter, which undoubtedly it was. The Ministry of Shipping is seething with Girtonians. In addition to Joan & Susan and Aviva, there's Aileen Little, a pink-and-white creature with a Vacuous Eye and a First in Modern Languages. Joan is delighted.

Oh! darling, please write to me – and forgive me for being Possessive and querulous and intransigent. I love you, and it so often seems to me that you'd be better and freer and happier without me – and it screws my heart-strings to snapping point. Of course, a clever woman would either take what she could get and make no additional, unreasonable demands – or she'd say well, Hell! And let you go Graciously, while it was still possible – or she'd shift her love onto a lighter and more casual plane – but I can't do any of those things, my dear love – I can only go round and round at the centre of a smallish whirlpool.

Darling, am I mad – or only overwhelmed by a love which is so much greater than I am? I don't know.

We had rather a prim day in the sunshine with the Levys. I knitted ferociously at your sock and thought how much happier I'd be in your arms by the cool river at West Drayton. Dapper little Charles who had 48 hours leave, was twittering

about, being All Helpful – and being Quashed rudely by all the Levy's for his pains. Ismay regards him as a useful but rather inept household good and/or chattel – but I don't think she loves him much, though she holds his hand with polite connubiality when he feels so inclined, which is less often than yester-year. He's been made Messing Officer of his unit and he adores it. He has a wonderful time making Hot Chocolate Sauce out of Nothing for his Men – and spends most of his day In Camera with a sheaf of recipes. If you'd been there to smile with me, darling, I'd have had a happy day.

MONDAY 16 JUNE Darling, I had lunch with Aubrey. He'd been at the War Office Conference about Obstructing Landing Grounds – and he'd just Put Across a Scheme for Hacking up several Million Acres. He was Elated. You should have heard him on Charles Emmanuel in the role of Messing Officer: 'We are all misfits in this war,' he said wistfully, 'except Charles Emmanuel – He has found his Niche.' I said something about Ismay being a Static Personality – He said, more in Sorrow than in Anger, not Static – Stagnant.

MONDAY 30 JUNE Darling, gas-mask practice is at 10 and I've left my mask at home again. I daren't Face the wardens so in five minutes I'm going to have an Urgent Call from Duncan – and I shall go into Secret Session with him until the All Clear Bell rings! What else can I do? The Penalties for forgetting your gas-mask twice in succession are so Sinister that no-one knows what they are – but, as the *Mikado* says, the Punishment is something terribly amusing with Boiling Oil in it – yes, I'm sure there's Boiling Oil in it.

TUESDAY 1 JULY Darling, Donne's greatness is illimitable. I'm sure he's the greatest writer of all time – except Shakespeare. I've been reading his sermons – God, what it must have been to have heard him preach. He tears his text to pieces with the level-headed thoroughness of a Hebrew commentator – and yet all the time there's a pressing undercurrent of exulting sensual excitement – and it swells to a torrent as he gets to his peroration – I wanted to get up and shout with delight in the 'bus – but perhaps on the whole, darling, it's just as well that I Restrained myself.

Pa is sitting downstairs in his shirt-sleeves – a Lost Soul – because my mother has gone to spend the afternoon with Peggy Davies. He feels Ill-used – Rudderless – War-weary. His state of mind is Tchekovian to a degree – and the Free French News doesn't come on for two hours at least! Poor Pa.

MONDAY 7 JULY Darling, Pa is a Hero! There was something about his FH when he opened the door to me yesterday evening that made me suspect that something Untoward had Occurred – and when I went into the Dining-room my mother unfolded such a tale of Gallantry as never was!

They hired a punt at Oxford to take Dicky on the river, darling, and my mother stepped into it with one picnic basket while Pa followed with the other. Her weight tilted the nose of the punt downward and she fell forward and clutched at the tree on the bank to save herself. By doing this she pushed the punt into midstream and sploshed into the River. 'My God,' yelled Pa. 'She can't swim –' and, tossing the picnic basket aside with Fine Abandon, he leapt into the river after her with his hat on his head & his shoes on his feet. He seized my mother under the Arms and swam her ashore – and, as he keeps saying, looking Modestly down his nose the while, he's no swimmer – hasn't been in a river for 32 years. Darling, this is his Big Moment. He refuses to have the Honourable Mud cleaned off his shoes. He refuses to have the limp brown cigarettes taken out of his case. He refuses to throw the damp matches out of his pocket – and the Look in my mother's eye! I always said he was a Pearl among men, it says I always Knew. And he's enchanted with her for being enchanted with him – and their Love has taken on its Pristine Walking-Out Bloom again. And I'm no swimmer, he says and, she wouldn't be here now but for me, he says – and He was Wonderful, she says – and it's all Very Beautiful. Doubtless you will hear All at the Earliest Opportunity from Pa's own lips. He goes about with a Withdrawn Higher-Thoughts Look – He's wondering if there's any Medal for which he is eligible – He hopes there is.

MONDAY 14 JULY Darling, Nurse has had a son. So much for Joan and my theory that we knew it was going to be a girl – by her shape (It All Goes to Show.)

MONDAY 21 JULY Darling, I slept heavily and wastefully last night and I woke up as though I'd never slept at all. When I got home (at 9.30) my mother was Taking Mild Umbrage because she says she never sees me – and when Joan told me about it I snapped: 'Well, if we were living in lodgings we shouldn't have to spend any time with our landlady if we didn't want to.' I was very much ashamed, darling, and Joan was shocked and left me sitting Abashed with a mouthful of salad. Then I went into the sitting room & rebuked Ma for talking about me to Joan – and I asked her if you could spend Wednesday night with us, and she said certainly. And I told her that you were going away. Then I Took Umbrage at her having been annoyed at my coming home late and she said that wasn't why I was crying – she added that she wasn't born yesterday and I went to bed With Dignity. Both my parents are very pleased for your sake about Bodmin.* My father says it shows signs that your Worth has been Recognized.

THURSDAY 24 JULY Darling, Dan Green has been missing since the Crete evacuation. His elder brother died of pneumonia about three years ago (he was 24) and Mrs Green had a stroke soon after-wards from the shock. I expect when they tell her about this it will kill her. When people I know are killed and missing – I feel a dull sort of Sorrow – as though it were something very remote that I was seeing through the wrong end of a telescope – and then I set my teeth and exercise my will-power in respect of you, my dear love. The thane of Fife had a wife – so had Marcus Ruelf – and Dan was engaged to a very young, very pretty English Girl. Peter Grant was Walking Out – but oh! my darling, I don't believe that any of them were loved as you are loved.

* Gershon had been promoted to sergeant, and posted to a listening station in Bodmin, Cornwall.

FRIDAY 25 JULY I wish I could tell you a story, darling, but I can think of none. Mrs Elliott (whose Late Lamented Spouse wrote Lovely Music about Mimosa and Rose-petals and (doubtless) Effusions to the Moon in June in Pulsating tune (I can think of another rhyming word but Far Be it From Me to Muddy my Quink with it!)) is ill. I think it's Drink. The air about her, when she comes to work is so Charged with Alcoholic fumes, that you can almost see them Shimmering like steam from a car radiator on a hot day – But she's the essence of Archaic Gentility – and but for that No-one would Ever Know.

Darling, it's late at night & I can hardly see because I've cried so much. I've had a hellish scene with Dicky. He scratched all the skin off my wrist and I tugged and tugged at his hair – hating him, darling. Oh! God, I'm not a monster really but I'm so monstrously resentful of being here that I take quite a sadistic pleasure in making things as uncomfortable as possible for my family. Darling, all the time you were near London, I hadn't had a moments trouble with my father or Dicky – and now it's starting all over again – because I can't feel you near at hand – and I know you won't be within call for much longer. Darling, I don't think I'd ever dare to marry you – even if you wanted me to. Perhaps you'd grow to hate me for the vindictive side of my nature – Oh! God. I feel as if my brain were bursting through the bones of my skull. Please love me, darling, I think I'm nicer on the days when I'm sure that you love me.

THURSDAY 7 AUGUST Last night Joan suddenly said: 'You're just like Dorothy Sayers.' 'Oh! come,' I said querulously, with a picture of a huge white lump bulging out of a U-shaped Dip in a green chenille velvet sheath – 'She's like a Great White Whale'. 'Oh! I don't mean in appearance,' Joan said, 'I mean that your mind works exactly like hers. You might have written *Busman's Honeymoon*, The self-conscious & academic approach to love.' And she didn't mean it as a compliment, darling. Oh! dear.

I know what prompts Joan's attitude about Us, darling. In the first place, she's Paying Off Old Scores – and I don't blame her. In the second, because she's been Wary and Reserving Judgement right from the start, I have been nervous and on the defensive, and

whenever I've talked about you it's always been self-consciously and with embarrassment. It would have been better not to have talked about you at all, darling – but I haven't yet learned the Golden Art of Silence.

FRIDAY 8 AUGUST Darling, I had a gruelling time with Joan last night. Ian's letter was 3½ months old, and he said in it that he felt, from the tone of her letters, that she'd Thought Better of It – and she could consider herself as being under No Obligation to him – if she liked. Poor Joan didn't like – and it made my stomach contract to see her seeing the hopelessness of trying to be convincing in a letter. She wrote to him last night and today she wired to say that she'd be much happier if they were properly engaged. (Apropos of all this, darling, I asked her if she knew the difference between a Legal and an Illegal Intended – and she said, without hesitation, – oh! yes! an Illegal Intended couldn't sue for breach of promise! The question didn't seem to strike her as odd in any way.) Darling, if you were sent away and you loved me enough (and only if you loved me enough) I should like to be your Intended.

Last night Mr Crotch asked Joan & me if we ever made up quotations in exams to illustrate our points. I said, rather absent-mindedly, that I never had to – I always knew a real one – and, darling, everyone looked appalled – but it was true enough! No wonder Mr Crotch thinks I'm mightily pleased with I. It's extraordinary how I contrive to consolidate that impression.

Tomorrow I'm going to Margaret's wedding. I shall (of course) Tell You All, darling.

SATURDAY 9 AUGUST Darling, my mother and I had a Terrific Scene this morning before I left, and the astonishing thing was that I lost my temper completely with her because she was doing something which I should undoubtedly have done in similar circumstances. Pa said suddenly at breakfast that he ought go back to Cambridge and take the Chair of Constitutional Law – six months reading, and he'd be fully equipped. Well, darling, although he didn't mean it seriously and I could tell that by the tone of his voice that he was being half-humourously provocative – I took up the challenge

153

and said that I'd never heard such nonsense in my life and that the greatest brains in the country spent their whole lives in research and were yet unfitted to fill the chair of Constitutional Law.

My mother <u>bounced</u> with rage – that I should <u>presume</u>, in my immature arrogance, to suppose that anyone was better equipped intellectually for <u>anything</u> than her Solace. What, she Demanded Rhetorically, had ever come out of the Universities? I replied rudely that as she hadn't read a book for 30 years she naturally wouldn't know. She said that she'd been too busy making our lives as comfortable as possible to have time for reading (which is not <u>strictly</u> true, darling, because in Egypt she <u>could</u> have found time to read if she hadn't been too busy with a dozen Public-Spirited activities – However that was no excuse for me) and then we stormed and ranted – but, when I saw she was really hurt, I apologized – because I could see so well what she meant. If anyone <u>dared</u> to imply that there was any intellectual feat of which <u>you</u> were incapable, darling, I'd smoulder and spark just as explosively.

<u>SUNDAY 10 AUGUST</u> After the Parental Upheaval yesterday, I dashed to Euston, bought a ticket & a detective story and scurried on to the platform. I was walking towards the train gloomily studying my toes when a voice said 'Hello, Eileen, I thought you might be coming'. It was Joan Pearce. Darling, she looked like a blowsy barmaid – in a powder blue coat with tired grey fur on it – a pinkish-mauve silk dress with white sprigs on it and a black straw hat with yards of veiling and enormous mauvish blue buckram hyacinths bunched on the top and dotted along the band at the back – her hair had been gathered up into a meagre and wispy bun at the back with tiers of a-symmetric curls up each side of her face. *Un désastre.* Nevertheless I was delighted to see her, and we babbled merrily all the way to Rugby and all the way back.

Margaret was married by a Bishop in the most enchanting black gaiters, darling. Keith's face was more terraced and receding than ever and he wore RA Breeches & top boots which contrived to look more like a ballet-skirt than anything else. Margaret looked beautiful – a long train and cream veil with a tiny gold edging –

and a halo of her grandmother's lace – but she shouldn't have blossomed out into full dress, darling – It was an Anachronism.

Instead of icing, they had a cake-cover decorated with white flowers. Oh! darling, I should like a wedding-cake decorated with real flowers – but oh! you should have heard Keith's speech. Darling, I blushed for him. 'I don't want to say anything I shouldn't,' he said coyly, 'But I can't help feeling that if I'm ever able to give a future son-in-law of mine a daughter as Marvellous as Margaret, I'll consider myself a jolly fine parent.' Well! Pa was right, darling, when he said that it wasn't often you heard a Fine Piece of Oratory in these days. Margaret's pre-Cambridge tutor proposed their health. He said in a Hoarse Whisper (Laryngitis) that he felt he was responsible for It All. If Margaret had gone to Oxford she might have married an Oxford Man – He was proud to have averted a Major Disaster.

Talking of Laryngitis, darling, I never told you the story of Joan & Peter Edgson, did I? (Peter was Keith's Best Man.) He pursued Joan (Aubertin) with an Eye to Holy Matrimony throughout his Cambridge career – and one day he asked Ian to breakfast to have a May-the-Best-Man-Win talk with him. Ian was so intensely amused by the Man-to-Man tone of his letter of invitation that he decided to go – and when he arrived he found Peter completely inarticulate with acute Laryngitis. He whispered something inaudible – 'That's All Right, old Man,' said Ian heartily, eating his way happily through four courses – punctuated by agonized whispers of 'Joan' and 'talk' from Peter. When there was nothing left on the table but an array of glistening plates and cutlery, Ian got up, wrung Peter by the hand and left. After that Peter gave up the struggle as Unequal & Joan was never bothered by him again.

MONDAY 11 AUGUST Mr Crotch is a Monster, darling. He's passionately interested in biology, and he told me today that he once wanted to find out if there was any pattern in the rise and fall of a woman's emotional reactions – so he spent ten months seeing a girl every day and drawing a graph of her Responses. (He wasn't Living in Sin with her.) The results were extremely interesting, he said, but he never had the courage to publish them. He was delighted with the

Expression on my face as I Listened. I haven't been so Horror-struck since Mr Gestetner told me about his microphone.

WEDNESDAY 13 AUGUST Darling, Joan has had a letter from Ian which has caused her much Solace. You know Joan & Ian are cast in the same mould in the matter of Cluck.

I walked into the house today to find Jean in the sitting room – with two Broad Rings. A Flight-Officer forsooth. Oh! darling I sizzled with fury. Commissioned rank, Aubrey says is now apparently the preserve of cretins & all the intellectual powers seem to be between minelayers, & supervisors of sanitation – There, I think he Has Something – though I can't be sure what.

SATURDAY 16 AUGUST I'm tired of Mr Crotch's Gallantries. When he talks about women I really loathe him though I like to work with him and I respect his initiative and drive. Of course, it's my fault that he always talks to me as though we had some sort of Obscene Understanding because I have always talked to him rather as I talk to Aubrey – and he's the sort of man to whom it's impossible for a woman to talk, without his replying with a kind of Intellectual Mollocking.

Don't misunderstand me, darling, there's no thought of Mollocking or anything like that in his mind. It's simply his manner with all women. I didn't mind it while you were here, because I didn't mind anything much – but now I hate it – I hate it. Damn. Darling, I wish I weren't so painfully restless & on edge when you're away.

I've decided, my dear love, that the only people (with a few notable exceptions) who make a success of marriage are Jews. Joan came home yesterday, in great distress, with a sordid story of the Domestic Troubles of the Assistant Principal who shares her room. It's a queer thing, but all the really happy marriages I know (discounting those of less than 5 years standing) have Jewish blood in them – Stanley & Mary, my parents, the Bennetts, the Chesters – Horace & Estelle (on their own Peculiar Plane) & it obviously has nothing to do with the Family Tradition or anything like that because all the people I've mentioned, except my mother & father and Mary Levy haven't had any very important Jewish Family

Background. It must be that Jews just happen to have that particular kind of mind. Of course the Turners are happy & so were the Inverforths and the Worths seem to be – though one can't be sure – but they're in a minority. The Gestetners are happy too, because they laugh at his infidelities together. Henny Gestetner is an extraordinarily clever and strong-minded woman. As a matter of fact I think the root of the problem is that Jewish women think it worthwhile to sink everything in love. (All the women I've mentioned are Jewish, though some of the men are not.) Mrs Gestetner will never lose her husband's love and respect – because she accepts his limitations sanely and openly and makes it her business to know exactly where she stands. She doesn't try and change her husband – but she does make a most terrific effort to understand him. Christian women, for the most part, won't make the effort – and so their marriages are often failures – and I say this, darling, in spite of what I've seen in Egypt – because I believe that there, marriages are nothing but a convenient escape from the Galling restrictions of parental authority – for most women – any man with enough money and poor enough emotional eyesight will do.

Darling, I was All Wrong when I wrote 'Thus, conscience doth make cowards of us All.' It doesn't – Conscience gives one courage, I think. At any rate, lying is invariably the result of cowardice. Yesterday I had a cigarette before sunset and Pa came into my room & smelt the smoke & saw the stub. 'Have you been smoking?' he said – and I said no, darling, but I was so ashamed of myself that I admitted that I had, and then he looked so shocked that I added hastily that I'd forgotten it was Saturday. Ever since I've been writhing with Conscience and I shall have to Tell him All. Oh! darling, I wish I didn't lie so often because it's the easy way out. I do hate doing it.

MONDAY 18 AUGUST Joan's Canadians are back! They were all sent to the Northernmost point of Scotland with a view (I thought) to biting the Enemy in the rear – but No. They just went off in a Swirl of Fanfares and Regimental Balls – and within three weeks they were back. Very peculiar. Joan is delighted. She was furious when I replied to her triumphant Announcement by wondering what

Strategic Significance their return might have, She said that when you came back from Bodmin it would give her <u>great</u> pleasure to ask me whether your return meant that the Air Ministry had decided to dismantle all the wireless stations in Great Britain – I said coldly that I didn't regard the two situations as even faintly analogous and that if <u>Ian</u> came back suddenly – I should not ponder over Strategic Withdrawals and things of that sort. She retired – Worsted.

Darling, my mind is Stagnating – I'm so absurdly tired when I get home that I can't describe the incidents of the day to you with any sparkle at all. Fantastic things happen – like the Return of Mrs Elliott – (whom I've always suspected of Drinking). She suddenly stopped coming to work – and we assumed she'd Left Us – for which we were Fervently Grateful (Darling, she's Wronger than Marcus if possible, although on quite a different Plane) but as we were afraid it was Suicide – committed in an excess of Bibulous Self-Pity – I sent someone round to her address to Investigate. She was out – and, her landlady said, perfectly well. Well now she's back with a Medical Certificate calling it Nervous Debility – (Darling, the <u>number</u> of Civil Servants who have to stay away from work because of Nervous Debility – it may be Drink or an Aggregate of Darning or Shopping – or a Party – or a Film – but it's always called Nervous Debility – and if you meet your Principal in the cinema or the Pub – you just say that the doctor says you need Distraction and/or Stimulus. I'm due for six weeks' Nervous Debility with pay myself, darling – You couldn't get a long stretch of leave, could you, to Coincide with my Seizure?)

TUESDAY 19 AUGUST Darling, I've had a hell of a morning. When I was being flippant about Mrs Elliott in my letter yesterday I hadn't seen her – She'd just left her medical certificate and gone home. But today she came in to see me, darling – and she was trembling so violently that she could hardly stand. I asked her why she'd come back as she was obviously unfit for work and she hesitated a moment and said when she went to the Doctor, he said: 'Get back to your work, you've been drinking.' 'I suppose everyone can see I've been drinking,' she said. 'Do you think I've got DT?' Darling, I was so non-plussed that I said confusedly 'Have you been Seeing

Anything Peculiar?' 'Peculiar?' she said. 'Yes,' I said, 'Pink Elephants or anything?' Darling, if I hadn't been so unhappy on her account, I suppose it would have been funny. Then she told me that there had been a Man Following her Everywhere. 'Such a common Man,' she said. 'Labour – I told him I didn't like labour people.' Oh! darling, the poor old soul is entirely alone and half-crazy. I'm going to send her to Dr Minton who specializes in the human touch. Damn – why isn't something done to prevent lonely old women from being properly looked after? I shouldn't want to live if I was as old and as lonely as she is. And she has a kind of pathetic dignity, too.

FRIDAY 22 AUGUST Darling, I'm alone in the house and it's very quiet and restful. I can write on and on and on if I like & I needn't feel that I must stop because my parents will be wondering what I'm doing. I wish you were here with me, darling. (Interruption in the form of one of Joan's Canadians 'calling' to ask her to choose a fur cape for his 'girl'. He's the one who Wrecked the Spring Manoeuvres by failing to recognize the enemy, and when they got mixed up with his mechanized columns on the road, he nipped onto an island and Waved them by. A perfect piece of traffic control, darling, but not quite what was required at that particular moment.)

You don't write love-letters very easily, do you, my dear love? I think you've written me about three – and they all made me cry – I always want to cry when you suddenly say you love me in the middle of something quite different.

Do you remember a very wet day when you came back from Liverpool and we ate something in the Chicken Inn and went to a News Film. You suddenly bent down in the middle of the film and said, 'I love you, darling' – apropos of Nothing at All – I nearly cried then.

FRIDAY 29 AUGUST Darling. Mr Crotch has just been in to discuss the appalling pay conditions of Civil Service Typists. 'The poor girls hardly earn enough to keep body and camisole together,' he said, and added maliciously: 'And don't forget to tell Gershon that one.' I assured him that I wouldn't.

Darling, I was almost angry with you today – (but it didn't last for long – it never does). I waited at the Ministry until almost four & as there was still no letter, (it wasn't on that account I was almost angry with you, darling, even you cannot command the GPO) I left. When I got home there was a message from the Air Ministry to say a personal letter had arrived for me. So, darling, because I love you on the other side of idolatry, I went back to the Strand (an hour and a quarter each way) and got your letter – and it was such a very little letter, my dear love, that I almost cried – and I was so very tired with travelling and not smoking and clucking that I read the most Awful Things into your remark about jumping to conclusions. Oh! my darling, I hope I haven't been jumping to conclusions about your love for me. I've been diffident about it for so long that I feel I should really snap in two if I found that in this, as in so many other things, I had gone to the other extreme and become over-confident.

September–December 1941

On 22 June 1941 Hitler unleashed Operation Barbarossa against the Soviet Union, and for Jews across Europe the horror of the Holocaust had begun. The bureaucratic formulation of a 'Final Solution to the Jewish Question' did not come until the following January, but by then Nazi death squads, operating behind the line of the German advance across eastern Poland and over the border into Soviet territory, had already murdered over 444,000 Jews.

For any Jew, events in Europe brought home in the starkest form the question of what it meant to be Jewish, and as her letters show, Eileen was no exception. For her father's generation the Balfour Declaration had made it seem possible to be both a good Zionist and a 'good Englishman', but for men and women of Eileen's age, confronted on the one hand by a volte-face in British policy and on the other the imminent extermination of European Jewry, any such double allegiance was more and more problematic.

Over the next three years, as the full extent of Nazi persecution became known, these issues would rumble on below the surface of Eileen's letters, but in the summer of 1941 it was something else that gave the question of her Jewish identity a more sharply personal focus. If Eileen believed in a God it was certainly not the God of the Ellenbogen household, and between her proudly secular, intellectual and ethical sense of what it was to be Jewish and Gershon's parents' 'rigid observances' lay a gulf that a potential daughter-in-law could only look across with anxiety. First, though, there was the still unresolved question of Gershon's 'intentions'.

7

Your Intended

Darling, Joan said last night: 'If Gershon looks like coming over all marriage-conscious at any time – let me know, and I'll go away for a day or two – I don't want to be in the Family Circle when the Bomb Explodes.' I assured her that there would be no need for her to take her second week's holiday precipitately – but that we'd give her due warning! You do realize, don't you, darling, that, if and when you get Taken with an Attack of Intentions, Pa will probably go all Difficult? – but not, I suspect, for very long. When Lionel & Dicky make pointed remarks about Us, darling, he always says 'Nonsense' repressively, but with a hint of a smile nevertheless. He can never resist an opportunity of coming the Heavy Father. However, he also enjoys Gestures – There'll be a Struggle within him if you ever want to marry me, darling. He probably won't be able to resist the Truculent line at first – but after that, he'll evaporate in a cloud of Sentimental Good-nature. An odd man, Pa, and not as much like me as you think, darling. (Though there is a lot in what you say. There always is.)

Oh! darling – only three more days. I can hardly believe it. I bought some peppermints the other day, to Celebrate – I loathe the things – I never touch them except when I've been smoking and I think you're going to kiss me. Forward, aren't I, darling? I think, in fact, I'm sure, (because I remembered it afterwards & made a mental note that I must tell you sometime) that I forgot to tell you one of the things David said that night when we were

being so personal: 'It's very hard for a man to tell whether a woman loves him or is just being sympathetic – Particularly if she is not a Forward woman – which you, of course, are not.' He Little Knows, does he, darling?

Mr Crotch has just been in. He's in a state of acute nervous depression. I think he thinks his wife is getting tired of him – and he loves her, darling, though he tries to pretend to himself and the rest of the world that he doesn't. Poor Mr Crotch. I really like him, you know, though I get so irritated with him at times.

I'll tell you something, darling, if you promise never to refer to it either in conversation or in a letter to me. I've been holding on to my leave ... (oh! Dear, I don't want to tell you now, but having got this far, I'll have to or you'll think it even worse than it is) because I thought that perhaps before the end of February when my leave-year expires, you might want to take me to your home to meet your family – as your Intended. Darling, never mention this to me – I shall be quite ill if you do – It's the most shockingly Forward thought I ever had – I'm sorry, darling, but I want you to Know All – however Awful.

MONDAY 8 SEPTEMBER Darling, this is the first letter you've ever had from your Intended – and the first I've ever written to mine, so may I begin please by saying that I love you, which I always feel is a Useful piece of Information for one Intended to have about the other? I rang up Joyce this morning and Told her All. She said: 'I'm very pleased.' 'So am I,' I said, as one who is replying to a conversational remark about the weather. She laughed, darling – but I can't help it – I am so comfortable and safe and happy that I'm Bereft of all but rather simple, prosaic comment. But what a story I'm weaving in my mind for Aubrey, notwithstanding. (It's all right, my dear love, I won't be Too Imaginative.)

I'm writing in the little room where you asked me to marry you, darling, and I'm smoking through the holder which was your first present to your Intended. (I haven't given you a present yet, my darling. Please say what you would like – (Nothing is no answer at all – for as you know – Nothing will come of Nothing – speak again) I want to get you something which you will use constantly – (no, not a Toothbrush – think again) Something which you need

– you see, darling, I want to Begin as I mean to go on – and give you presents which are <u>useful</u> as well as Beautiful.)

Darling, I've just looked out of the window and Caught the Eye of the Woman in the Building opposite – You know, the one who saw you kiss me. She looked at me Coldly – but she's Inhibited, darling, because she hasn't got a Solace – poor old Soul – fancy having to work in a Government Department with no Solace. I shudder to think what it must be like.

Darling, Mrs Elliott arrived this morning – a positive <u>triumph</u> of Mind Over Matter. I took her down to SI and now she's Off My Hands forever, my dear love. Poor Mrs Elliott – It was Nostalgia for the Mimosa-scented snows of yesteryear wot done it. I'm glad you don't compose dear little melodies about flowers, my love, or Moonlit Raptures.

Nothing has happened since you left me, darling (which is not surprising as it was only 3 hours ago) so this must be a little letter.

Darling, I believe, sincerely and <u>most</u> seriously, that I shall not Cluck much any more. Thank you for waiting until you were <u>sure</u> you loved me before asking me to marry you, my love. Because, I need have no fear that your decision was too rash, too unadvised, too sudden – and that, like the Lightning, it will cease to be ere one can say 'It Lightens'.

I am rested, darling, and infinitely happy. I feel as though, if it were suddenly to turn into an icy March day, I should not notice the change in temperature – (though I expect my teeth would chatter just as loudly as though you'd never asked me to marry you at all! Darling, isn't it odd how one can exist on a dozen planes at once?).

TUESDAY 9 SEPTEMBER Joan had a letter from Sheila yesterday evening with bad news of Hamish, darling. His squadron was shot to pieces over France and he was the only pilot to return. Rather than land in France and be taken prisoner he flew across the Channel, desperately wounded, with his wireless and controls shot to pieces, and crashed about 200 yards from the coast. He was too weak from loss of blood to open his rubber dinghy (his Mae West he calls it, darling) and he struggled and shouted in the water for nearly an

hour until a soldier swam out to rescue him. He has been in hospital for some weeks but he's home now, still limping badly and, Sheila says, in very great pain. Darling, Joan and I <u>knew</u> something was going to happen to Hamish that night we dined with him at the Café Royal. His insouciance and aliveness had something rather terrifying about it. I think, if you'd been there, you would have noticed it too.

I had lunch with Joan & Joyce yesterday and we drank your health in a pale and insipid concoction which Joyce said was a Bronx Cocktail. Horrible – but we couldn't get any sherry. (That Gives one to Think, doesn't it, darling?) Joyce said that she Felt Responsible for it All, darling (meaning Us) but she was really pleased, I think, and she was warmer and more unaffected than she has been for a long time.

I wrote to Aubrey last night. My letter wasn't quite such a Good Story as I'd hoped. You see, darling, I find it rather hard to be flippant about being your Intended. As a matter of fact, I can feel myself coming over all Earnest – but, I mustn't lose my sense of humour, darling, that would be a major disaster – Hold on to a sense of humour.

I told Lionel and Dicky All yesterday evening. Lionel shook hands with me solemnly but with rather touching sincerity and said he was very happy. Dicky dimpled and a wicked gleam came into his eye: 'I shall put a Slow-Worm in your bed,' he said – and added, 'Did you say Gershon or Aubrey?' When he heard that it was really you, darling, he Capitulated with quite good grace.

On Friday evening, Joan & I are going to the Pictures with Joyce and then to supper at the Baronial Hall. This will be Joan's first encounter with the Nathans en masse. I hope they don't flatten her out completely. I shall have to talk to her like a mother about Flagged squares of butter, and <u>not</u> looking as though she'd like a second helping. (The riot caused by Oliver Twist, darling, is <u>nothing</u> compared with that which would Flare Forth if anyone asked for More in the Nathan ménage.)

Mrs Wright Fell Ill last night – so Joan & I had to get our own breakfast this morning. Darling, I have a Lot to Learn – the act of getting an egg out of the frying pan without making it look like a dirty dishrag not being the least thing. (Talking of dishrags

– Dicky spilt the water last night, and after he'd wiped it up with a <u>filthy</u> cloth, threw it (the cloth, I mean) on to Lionel's dinner plate, whereat Lionel picked it up in silence and with great dignity and threw it full into Dicky's face! It sobered him up more than somewhat – That's the only language Dicky understands. His behaviour thereafter was <u>almost</u> unimpeachable.) We were all Falling Over one another trying to be Helpful – Joan broke the lid of the soup-tureen – and Lionel smashed the Cona – so I thought I'd better retire upstairs and write to Aubrey! Joan and I have decided that Arm-Chair Domesticity is All Very Well in theory, but that actually it's easier to be a Civil Servant than a good house-wife. But we shall learn, my love. In time you and Ian will be able to say 'Look What I've Got' and you won't be referring to our Academic Achievements either.

<u>THURSDAY 11 SEPTEMBER</u> Joan & I are lunching with Celia today, darling. Great Solace. She told Joan, dryly and without a trace of emotion that she was sex-starved & that she intended to give up teaching and go into the Forces as an Antidote. She added that this would also solve the stocking-problem. It was All Very Well, she said for people with Smooth legs to go about stockingless, but what if, like her, you happened to have Stubble Trouble? A friend of hers who had Stubble Trouble shaved her legs – but the next time she put on a pair of stockings – she laddered them with the bristles! <u>Dear</u> Celia.

Dicky undoubtedly has a Perverted Sense of Humour. The other day my mother & Lionel & he spent the day with Peggy Davies, and Lionel went up into the loft. While he was there, Dicky took the step-ladder away, and Lionel, stepping blindly out of the dark, crashed to the floor. He has a scar nearly three inches long on his face. Pa was so angry with Dicky (so he said) that he refused to speak to him – and took it out of poor Lionel instead! You know the line – How <u>could</u> he be so careless? Why didn't he <u>look</u> where he was going? As the ladder is fixed perpendicularly to the flap of the trap-door, and as you step down it backwards – Lionel <u>couldn't</u> have seen it, darling – but nevertheless Lionel got a violent tongue-lashing and Dicky, basking happily in his Disgrace got nothing at all. Fantastic!

Darling, we had a wonderful lunch with Celia. Her reaction to the news about us was 'Excellent. Most Gratifying – Of course we've all been waiting for this for years.' She asked me to give you her regards. 'But I don't suppose he'll remember me – I'm Big but they never do.' How gratifying it is, darling, to find that one's friends don't change at all, even after one hasn't seen them for years.

Tomorrow night Joan & I are dining with the Nathans, darling. Oh! woe is us or are we, whichever you happen to prefer.

Oh! darling, I'm glad you're pleased that I'm your Intended – and thank you for telling your parents that I'm a warm-blooded intellectual – very neat, darling – but I'm rather frightened at having to live up to what you've told your family about me, my dear love. What will they say when they find out that I'm only a rather negligible little cluck after all? (Don't tell me.)

FRIDAY 12 SEPTEMBER Dicky is a little beast, my love. He was having Scenes with my parents all day and in a fit of spitefulness he threw Lionel's gun out of the window and smashed it. Then he took Lionel's bicycle and vanished. In the evening he locked my parents in their bedroom and pushed a note under the door saying: 'Don't expect me back tonight – your accursed son, Dicky.' They were terribly distraught and went all over the district looking for him. After about two hours he appeared, intensely amused, the little wretch – he'd been hiding behind the dining-room curtains all the time. He demanded Apologies all round with unparalleled insolence – I felt quite sick – My mother was exhausted with anxiety and he strutted about like a bloated cockerel and said he'd meant to teach her a lesson. He wanted her to realize with whom she was dealing and he hoped she'd be more circumspect in future. My God!!! In order to meet your wishes and not get embroiled, my love, I went upstairs and seethed in my bedroom. I detest him so much, darling, the sadistic little brute, that it makes me feel quite exhausted to think of him.

SATURDAY 13 SEPTEMBER Darling, I've been remembering all sorts of odd things about the time when I first knew you. I remember struggling painfully with your frayed dressing-gown cord and then buying you a new one. I remember saying in my note to you –

'Wear this – for me' and being very frightened that I'd been too Forward. I remember crying all night later, because you'd said that I'd bled all over another girl's hair which was in your coat-pocket at the time of the accident. Was that true, my love? I shan't mind now – After all, you only have one Intended, my darling, & incredibly and miraculously, it's I. You can hang all the other girls' hair over your desk in our house, darling, as Trophies.

TUESDAY 16 SEPTEMBER Yesterday, I had lunch alone with Joyce and she told me her All. She's been Having Trouble with her Family. Just after she Came Down, darling, her mother went to her desk to get some visiting cards and found two letters from Gordon – which she read and Bore Off to his Lordship – who thereupon Forbade him the House and ordered Joyce to Cast him Out of her Life forthwith. How horrible for her, darling. But I can't help feeling that she doesn't mind very profoundly – She & Gordon now meet outside the Baronial Hall. I have a feeling that the Whole Thing was designed purely to Save Rations.

Darling, Nelly Ionides told my mother that she'd be very happy if you and I would spend a Sunday with her and Basil at Buxted. Oh! my dear love. Let's go on the very first whole weekend you're in London, shall we?

Darling, Mr Crotch has just been in to consult me about a lad who has been 'Exposing Himself Indecently'. There is, says Mr Crotch, no Precedent for Indecent Exposure in an office – only in a park – and that Lad got let off on grounds of Ill Health. 'Do you think this boy is suffering ill-health?' I said. 'Not on your life,' said Mr Crotch and added coarsely, 'He's probably suffering from Rude Health.' At this point Mr Proper came in, which rather dried up Mr Crotch's flow of rhetoric – I can't say I was sorry, darling. I am not fond of Mr Crotch in his cruder moments though I always smile politely, if a trifle frostily.

WEDNESDAY 17 SEPTEMBER I spent yesterday evening trying to persuade Joan not to Cast Ian Out of her Life – with rather embarrassed support from David.

I feel sad because of Joan's troubles – I wish you were here to make me happy again, my dear love. I am so helpless over Joan.

I often think that seeing one's friends unhappy is almost worse than being unhappy oneself because one feels so arid and stultified. The worst time I can ever remember in my life was that weekend when you were so unhappy over me. The time we went to *Dear Brutus* and Queen's Hall and your eyes looked so terribly tired and frustrated, my dear love. It was your sorrow that I couldn't bear then, darling, not mine. Do you remember that café in Soho with the photographs of blowsy music-hall stars and the slatternly waitress – and the bottle of Chianti? It was there that you said, for the first time, that you loved me, darling – and you said it so sorrowfully. That weekend turned out All Right because we were suddenly able to laugh at your regrets over the Wild Oats you had not Sown. Oh! darling, I believe we shall always be able to laugh our sorrows away in the end, as long as we're together. That will be our salvation. If one could never laugh, one would either become bored – or frenzied. Darling, I love you because I can laugh with you and cry with you and be silent with you.

FRIDAY 30 SEPTEMBER Terrific Scenes with Dicky last night – I was Laying the Table for supper when he came in – rent the Blackout curtains asunder – and opened the French windows to go into the garden. 'I shouldn't do that,' I said mildly. 'We'll have the Police on our track.' 'Oh! Go to Hell,' he said in a hatefully insolent tone! 'Very well,' I said. 'If you go out that way I'll lock you out and you'll have to come in through the kitchen.' He went out and I locked the door. This was at 7.30. At 9 my parents were still Imploring him to come indoors – and he was swearing violently and saying he'd come in through the dining-room or not at all. I dissociated myself from the whole thing – ate my supper with Joan & Jean and later went to bed. But I understand that the Cataclysm erupted far into the night – and this morning Pa was Not Speaking to Me although Dicky is in High Favour. Darling, the injustice of my parents' attitude over Dicky makes me unjust to him.

THURSDAY 2 OCTOBER Darling, I am sad today – I think it's largely on account of Joan, who looks dreadfully ill. My parents are rather unsympathetic in their attitude. They take the view that she has

Mishandled her Affairs – that she's been very unwise over Mr Sims – that she ought to come home in the evenings and rest instead of going out and indulging in light diversion. Their view is that Ian's attitude springs from the tone of her letters and her accounts of Frivolities with others. As usual, this is the conventional & short-sighted view, darling – and it causes me a good deal of personal anxiety and sorrow. If you were away, my love, I should not act as Joan has done – but I don't condemn her on that account. She's temperamentally very different from me, and I feel sure that she's acted in the best way for her own peace of mind. Because she's very sensitive, she's conscious of my parents' attitude (though I always deny it, darling, whenever she refers to it) and it's an added anxiety for her. She is in a mood to take offence at everything – and it's really very painful to watch her.

TUESDAY 7 OCTOBER According to your mother, my love, you are a One – So you are, according to me. Darling, she says you are: 'The dearest fellow one could possibly wish for' – I say 'He is a man, take him for all in all. I shall not look upon his like again.' She says: 'We have always placed a high regard for his intelligence and reliability.' I say: 'For his bounty, there is no winter in't – an autumn 'tis that grows the more by reaping ...' and 'He is likely when he is Put On, to prove most Royally ...' and to your mother 'Oh! wondrous tree that can put forth such fruit.' It's only a matter of idiom, darling – We both mean the same thing. You needn't worry, my love, I shan't write to her in these terms. I don't want your parents to start getting Suspicious about my Frontal lobe – as well as Basil! You shall see her letter, darling, when I've read it to my parents. Incidentally, darling, I think it's Significant, not to say Symbolic, that her name is Gertrude, though it's a Great Sorrow to me that she signs herself Gertie – I'm sure Hamlet's mother never did.

Darling, am I right in thinking that Sunday, 19th is the day on which we hope to go to Buxted?

I'm writing provisionally to Nellie on that assumption – Oh! before I forget, you must on no account Betray your Feelings about Dogs to Nellie and Basil – or neither of us will ever be asked again – At any rate, I don't believe even you will be able to resist the Stately Grandeur of Cliquot, and the enchanting willy-nilly of

Silvo. Darling, please may we keep a miniature poodle as well as a cat when we're married?

Pa has had a message from Lord Bearstead about a job – but I think it will take him back to Egypt. My poor mother is in a heartly cluck.

<u>WEDNESDAY 8 OCTOBER</u> Darling, Joyce's party was an unqualified success. There were no men – only two Assistant Principals from Joyce's Ministry and Joan & me – and one other girl whom I've met several times before. We talked of the Didactic Purpose of the Comic Strip – and Boys' and Girls' School Stories – one of them had a theory that the change in emphasis from the group or team of boys and girls who had adventures in the school stories of our youth to the single hero or heroine today showed a definite fascist trend (I couldn't say, darling, never having read any). Then, one of the others said she'd come upon a most <u>appalling</u> book the other day which she'd read out of sheer curiosity – she'd never <u>seen</u> anything so crude and disgusting – Title: *No Orchids for Miss Blandish*. Then Joan & I said what we thought of it – and I put forward the view that *Lady Chatterley's Lover* was a much more <u>deliberately</u> pornographic book – though I did say that I found it difficult to suspect Lawrence, whose artistic integrity seemed to me to be above reproach, of writing simply to pander to a dirty-minded public – Then Joan said something very illuminating and very clever, darling. She said she knew why I resented *Lady Chatterley* so much – She said I was completely detached from the animalism of the Gangsters & their women in *Miss Blandish* because I felt I had no connection with them – They were creatures of no education and no intellectual stature and I <u>expected</u> their attitude to sex to be different from mine on that account. But Lady Chatterley – ah! different – <u>She</u> was a cultured, sensitive and intelligent woman – and yet she found complete rest and fulfilment in a relationship with an inarticulate and untutored handy man – and I resented it, just as I resented <u>all</u> the relationships of <u>all</u> my intelligent women friends with men who were less intellectual than themselves.

As for Pa's return to Egypt, he has to decide today. If he goes back, darling, it will be ostensibly to look after his practice –

even he will not know the real purpose of his journey until he gets there – but it is an important one. But this is <u>absolutely secret</u>, darling. <u>Please</u> don't breathe a word of it to my parents or anyone else. You know, if he goes, I shall be quite sad. I have grown rather fond of him in the last few months – now that he's brushed away years of accumulated resentment by the only possible means – a generous-minded attitude towards you.

<u>THURSDAY 9 OCTOBER</u> Darling, I inadvertently had tea with four Titans of the Treasury yesterday – and this is how it happened. We had a very small point to raise with Mr Gomme about some locally entered staff in West Africa – It could have been cleared up in a moment on the telephone – but owing to the Sinister Frill on all Government Telephones which say in Tall Red Letters 'SPEECH ON THE TELEPHONE IS <u>NOT</u> SECRET' I had to go and see him about it. When I arrived Mr Gomme was leaning back in his armchair with his legs crossed and a cup of tea balanced on his upper knee – and lying at full length on the Conference Table was a Lank Swarthy man of Immense Height. He had a tea cup beside him and he was absent-mindedly blowing a succession of round, fat little smoke rings. He sat up slowly when I came in and was introduced to me as Mr Munro, whom I knew by name as the arch-snooper-in-chief of the Treasury. Then, darling, a red-haired youth effervesced into the room as though he had just frothed out of a ginger-pop bottle – He was Mr Shilleto – a principal with whom we sometimes correspond. Mr Gomme, a tired-looking, grey man with disintegrating spectacles, gave us each a cup of tea – and then a smallish dapper man came in – the Great Crombie – The Assistant Secretary before whom we all tremble – a lot of Boyish, Undergraduate Chatter followed his entry – He sat happily on the floor and Mr Shilleto leaned negligently against a suitcase, and inveighed against the habits of inveterate First-Class travellers. Mr Gomme was reminded of Baedeker's comment on the Beirut-Damascus railway which was 'Ladies, accompanied or unaccompanied, must always travel First – Gentlemen, unaccompanied, may travel Second as there is a Third Class'. Nice, don't you think, darling?

Joan & I were woken suddenly at about six this morning by a thunderous Banging at the Back Door. Joan came into my room

& said tentatively 'Do you hear that?' I said Dramatically 'I Hear a Knocking at the South Entry.' (We thought it was the Dead Vast and Middle of the Night you see, my love) So we woke Pa & all three of us crept Cautiously down the stairs – We thought the Nazis had come – that they had Murdered Mr & Mrs Wright in their Shelter Bunks and were now Launching an Attack on Us. 'Who's there?' I said timidly. 'Oo the 'ell do you think is there?' said Mr Wright's querulous voice – we looked at our watches and found that it was 6 a.m. Mr & Mrs Wright had been Inadvertently locked out by Aunt Teddy – What an anti-climax, darling.

Darling, Nurse's baby wails incessantly and all the women cluck round him – but last night I went in to him and yelled back. He was Stunned & stopped at once. Moral: treat 'em Rough.

TUESDAY 14 OCTOBER Darling, the little 'indecent exposure' boy has been allowed to resign & he has written in thanking Mr Crotch and promising to 'turn over a new leaf'. 'I only hope it isn't a fig-leaf!' was Mr Crotch's comment when I took the letter into him.

FRIDAY 24 OCTOBER Leslie didn't come to dinner after all – He was suddenly Summoned to Conclave by Marghesson* (can't spell him) but he arrived at 11.30 (after we'd all gone to bed) and getting no Change out of the door-knocker he went to a nearby telephone box and woke my parents up. He was talking to Pa until 12.30 – but I slept through it all and knew nothing of it until the morning. Sigmund was very amusing about the Beaverbrook–Stalin meeting.† He says Beaverbrook ordered everyone to Memorize their documents & leave them on board ship for fear of spies – but everybody cheated and made notes in their diaries. Then he was convinced that all the rooms would be full of microphones – so he ordered a huge Radiogram, and whenever he Called a Conference he turned it on full blast and all the delegates handed round notes! A sort of 'igh-class game of Up-Jenkins, darling.

* Viscount Margesson (1890–1965) was a British Conservative politician.

† In September, Lord Beaverbrook had attended with the USA representative the First Moscow Conference, pledging British aid to her new ally.

Darling, do you know much about Mental Ages? We were discussing them at the meeting yesterday in connection with reassessment of salaries. Mr Crotch wanted to apply a 'rule of thumb' – DMO* said he thought people ought to be assessed on their Mental Ages. Mr Crotch says, in the last war, they tested the American Army and found that their average mental age was 8 something. A great Blow to everybody.

How do you determine a person's mental age, darling? Surely by their power of understanding increasingly complex intellectual problems. When I first went up to Cambridge at 19, I wasn't able to understand Eliot – but in my third year, I could understand Eliot and Joyce. Surely this means that I was older mentally at 21 than I was at 19? Mr Crotch says no, that I had simply acquired more background. Where do you draw the line between increased background and increased intellectual understanding, dear? A person can surely read 100 books relevant to the understanding of Eliot and still not understand him, whereas another can read 50, and see him All as a Pattern. I agree that I am not mentally older than I was at 15 just because then I tried to argue with my parents on matters where we have no point of contact, whereas now I say nothing because I have learnt by experience that it will do no good – but I think I am mentally older than I was at 15 because then I only understood a very limited number of books, and now I understand a much less limited number. Oh! darling, what a clumsy exposé. My mental age doesn't seem to be showing up too well at the moment!

SUNDAY 26 OCTOBER Joan had arranged to go to Limpsfield for the weekend, darling, and she went to bed early on Friday evening. Pa trapped me in the dining-room and gave me a Histrionic Harangue – which was a fantastic mixture of maudlin sentimentality and brutal indictment on Joan's relationship with Don Sims. He Declared his Intention of Saving Her from Herself – he said naively that he'd noticed that she was Losing Interest in Him (Pa) lately, which was a Bad Sign and showed a marked lack of Balance – and added that he was horrified at these 'weekend rendezvous'. He

* Director of Military Operations.

held me with his glittering eye, darling, and I wriggled like a beetle on the end of a pin.

In the morning, after I'd gone to work, Joan was given an expanded version of the tale I'd heard – and now she's quite haggard with anxiety and distress. Pa expressed Disappointment at Joan's arrangements for the weekend when it was probably his last in London. So Joan didn't go to Limpsfield – and my parents went to the Davies' after lunch yesterday and got home at 11.30 at night – and today they've gone to Oxford & they'll be back in time for dinner.

Darling, I'm sizzling with anger. Why the hell can't Pa keep his tentacles off Joan? She's unhappy enough as it is. I am anxious about Joan's relationship with Mr Sims, only because I think he's going to complicate things with Ian when he comes back, and because I don't understand it – but Pa takes much the same view of it as he did of Uncle Emile's songster. Darling, he doesn't know about people being happier if they're allowed to make their own mistakes. Uncle Emile, for instance, was the kind of man who wanted an experienced woman for his bed. He also wanted to keep his illusions about her. Pa destroyed his illusions about the Singer from Rome – so he married another experienced woman – and a much more dangerous kind of bitch she was too. Darling, I'm so unhappy about Joan, I'm quite incoherent. She's being subjected to the same kind of Hell as I was when I wanted to go to Blackpool, except that the stakes are not nearly as high – but the indignity and the distortion are there in equal measure. N'en parlons plus.

Victor and I talked of love in the evening. He said that the trouble with most men between 20 and 25 was that they were sexually restless and looked about for a satisfying bedfellow. When they found her, they became disappointed and disillusioned because only one-tenth of their personality was engaged in the relationship and satisfied by it. The right approach, he thought, would be to look for a companion, in the wider sense, and to fall in love with her naturally and gradually. He said he had always become violently excited over an attractive woman – and expected a great deal – and had found – nothing. He wants the same things from love as I do, darling – Emotional Comfort and rest – and the

delight of sharing friends and pleasures. He said he'd never known me so much at peace. Oh! my darling, I have everything I want from love. Are you satisfied too? He told me about the girl at Oxford and the divorced woman in S. Africa – and he said that as soon as he became a normal human being again with a future and an anchorage, he was going to look for the things I had found.

Darling, I wish I could make Joan happy. Yesterday afternoon the Nautical Surveyor who had showed her over the ships on Tuesday, cornered her in the Ministry of War Transport and asked her to Live in Sin with him. Life is full of complications – but the trouble with Joan is that she can't be sexually neutral with men, as I am with all men but you.

I'm going to tea with Lord Inverforth this afternoon. I hope I shall be able to talk of you and arrange for us to go to the Hill together one afternoon.

MONDAY 27 OCTOBER I had a quiet afternoon at the Hill – Lord Inverforth was very Dour about us. You see, darling, he has spent his life successfully preventing Nita from getting married because he couldn't bear to part with her – and, although she's 50 now, when I told him that I was going to be engaged, he gave her a Repressive, Cautionary look and said: 'A Woman's troubles Begin with Marriage.' It was really very funny, my love.

TUESDAY 28 OCTOBER Oh! woe. The Powers can't manage a 'plane for Pa – so he'll have to go in a convoy to Takoradi* and fly from there. He's in an appalling state of nervous excitement – and my mother is in a perpetual state of suppressed cluck – so the atmosphere at home is not exactly restful – particularly as Nurse, for some unknown reason, is in a foul temper and does nothing but snap at Joan & me from evening till night – of course, Joan's mood of Stygian Gloom doesn't help much, darling.

I had a letter from Sheila yesterday. I told you, didn't I, dear, that the CR don't think her 'suitable' for an Assistant

* A port on the coast of what was the Gold Coast, and is now Ghana. During the war Alec Alexander carried out various government jobs, including lecturing for the Ministry of Information, Enemy Aliens tribunal work on the Isle of Man, and unspecified business in Egypt.

Principal's job? Well, it's their loss. She's going in to the WAAF on Friday morning at 7 a.m. She's going to telephone Joan & me on Thursday evening – which will be her last Gesture as a free woman, she says. Hamish was in Edinburgh on leave last week. Sheila says the atmosphere of strain and tragedy surrounding him and Charlotte is oppressive – Poor Charlotte, darling. Thank God for your eyes.

You know, my love, my father is growing really fond of you. He said, with Genuine feeling, yesterday that it would make him very proud and happy if you were to get your Commission before he left England. I wish he weren't so erratic emotionally. There are times when I hate him and times when I'm quite honestly fond of him. But he has an extraordinary power of making other people unhappy from the best motives in the world.

<u>WEDNESDAY 29 OCTOBER</u> Darling, today is Joan's birthday and she's having a lunch party at 'À la Brache' for my parents and me. Last night she had a letter from Ian in reply to her telegram. He said that he wasn't prepared to commit himself in any way – that he didn't want to be tied until his future was assured, and that he wasn't sure that she was the best person to help him in his career. He would, however, always be her friend etc. Darling, why do men always imagine that it will be a comfort to a woman to know that the man she loves will 'always be her friend?' It's a Glaring Error, my love. Poor Joan, she looks so pale and ill – I feel so hopelessly inadequate – I can only sit and make small sorrow noises. Pa's reaction was typical. After Joan had told me what was in her letter, I went downstairs and warned my parents not to ask her what Ian had said. Pa looked very concerned, and his eye roved about the room seeking a solution. Then he clutched his brow and said: 'Danby!* She must meet Danby.' It was wonderful – in the midst of all my distress I went away and laughed & laughed and laughed.

<u>SUNDAY 2 NOVEMBER</u> Pa is leaving London on Wednesday. We know his sailing date, but it mustn't go down on paper, darling. He's going by sea to Takoradi and thence by air to Khartoum and Cairo.

* Dudley Danby, private secretary to Lord Lloyd.

Darling, Nurse is very tiresome. She keeps making two-edged remarks about Joan and my looks. Mr Sims and Mr Blair gave Joan a white Fox fur from Spitzbergen – and Nurse said: 'But you can't wear a fox fur. You're not the type.' (Preening herself Kittenishly – She obviously thinks she is the type.) 'You never go anywhere where it would be suitable to wear foxes.' (A palpable lie, darling.) And she keeps thrusting her wretched child under my nose. 'You haven't been in to see my baby for days,' she says, which makes me Truculently determined never to go and see it. After all, darling, I think you are the First Wonder of the Western World – but I don't tickle you under the chin in front of callers and say 'Isn't he sweet?' and 'Don't you love the way he enjoys his food?' Last night, when Joan and I came up to bed, the baby was yelling lustily – Nurse followed us up and said querulously, 'You've woken my baby.' – which irritated me more than somewhat – first, because we hadn't and secondly because she was going to wake it herself to give it its evening meal. 'I'm going to debunk that baby if it's the last thing I do,' I said to Joan with suppressed fury, and Nurse heard Joan laughing, and came out of her room & attacked Joan virulently for laughing at her baby! Poor Joan. Darling, I'm sorry, but I'm irritated beyond endurance by people who go all starry-eyed over babies, just because they are babies. It's much the same sort of attitude as Nellie has towards her dogs – Fantastic – It's not that I don't like some babies, darling. I thought David Turner was a most entertaining child – (and he was only a year old when I first met him) but I don't like all of them, any more than I like all dogs or all adults or all dresses or even all vinaigrettes. D'ye get the point, my love? Nurse's baby may turn out all Right, but at the moment he is just an ecstatic bottle-sucker with a face as round and bloated as the moon.

Darling, I must leave you to finish 'The Psychology of the Interview', 'Getting Things Done in Business', 'How to File and Index', and 'The Psychology of Selecting Employees'. My God! Who'd be a Civil Servant.

THURSDAY 4 NOVEMBER Mr Danby is a nice little man, darling – A little mimsy, but definitely intelligent in an unobtrusive way. He came to supper on his bicycle! At 10.45 he got up timidly, fluttered a

vague hand and said: 'Well I must be pedalling away.' Darling, it's odd how many different ways different people have of doing the same thing. There's the Mistress of Girton and her Black Charger approach to the bicycle – Bernard Waley-Cohen, and his self-conscious, Hearty attitude – and Mr Danby, who treats his bicycle as though it were meditation or the wings of thought or of poesy – Definitely a whimsy, thistledown approach. I must write a book about it.

MONDAY 10 NOVEMBER My mother brought Nurse's baby in before lunch and put it on my bed. It wriggled and gurgled and clawed at my hair, and smiled quite winningly at me. Mrs Greenberg came in, having been bidden to lunch – She was no end took aback – to find me in bed – with a baby beside me! Darling, I have a feeling I'd be quite pleased to have a nice baby – provided it was a very clever baby – and how could it help it, my dear love, if it belonged to us?

Darling, I did have a happy weekend. Each time we're together I feel more and more safe and comforted. I never believed it was possible to be so rested and so happy. Thank you, my very dear love.

TUESDAY 11 NOVEMBER We had a bit of an Alarum yesterday. Jean was operated on suddenly for Appendicitis and my mother and Aunt Teddy Shot Off to St Mary's Hospital in Haste and Confusion. She's doing nicely. I'm all in favour of appendicitis, darling – Lots of Flowers and Attention and Cosseting and very little pain. The most comfortable illness I ever had.

Darling, there's no doubt about it that Nurse carries Mother Love a bit too far. Yesterday evening she left her baby, naked from the waist down in my arm chair. 'Don't worry if he suddenly Spurts a Fountain on to the chair,' she said. 'Don't worry?' I said indignantly. 'All over my only arm chair?' 'Oh! well,' she answered. 'Why should you worry? It will be beautifully fresh and clean.' Well, darling, there was I, Speechless. However, nothing happened so I didn't labour the point when she came back into the room.

But, emphatically, there should be limits to Maternal Devotion. There's one thing about Ismay's baby, my love. With its

heredity, it will <u>never</u> perpetrate an anti-social act of <u>that</u> kind. Such a thing couldn't be <u>contemplated</u>.

FRIDAY 14 NOVEMBER Aubrey rang up last night, darling – he's in London for a week on Dark Affairs and he's bidden me to lunch with him today at Simpson's. Isn't it odd, darling, how one doesn't go to a place for years, and then, quite accidentally, one keeps going back to it?

Darling, the Government says Pulp your Love-Letters for Shell-caps. I sometimes think that wars have a <u>shattering</u> effect on people's sense of proportion. Please don't have mine pulped, darling. I hate to think of my verbal mollocks hitting a German a-midriff – It would be like kissing a Strange Man. Have you read the Whimsy *Times* leader on the pulping of letters? It is silly sooth – Take no account on't.

You know, darling, I think, if it can be managed before Aubrey goes abroad, you and he and Joyce and I ought to have an evening's outing together.

Darling, Aubrey was in Civilian Clothes and thrice his Old Self, if not more so. He's writing a history of Syria in his spare time which is 24 hours a day. He finds Oxford Dreamy & Commercial – and he finds the Nathans terrifying in their Hearty Brutality. 'Lord Nathan gives me whisky without water & then stands and watches me squirm.' He's all in favour of an outing à quatre before he leaves – I didn't suggest any Destination as I wanted to hear your views first, my love. He says Bernard Lewis is at Station X. How inevitable, darling – Everybody ends up there. I rather wish I'd taken the job that was offered to me there – then you could have Moved to Y Sigs. Oh! My dear love, what a Solace <u>that</u> would have been.

SUNDAY 16 NOVEMBER I'm going to be a Sister of Mercy, not to say a Little Ray of Sunshine today, my dear love. As soon as I can Bring Myself to get up, I shall wait upon Jean at St Mary's Hospital – (appendicitis). Thereafter I shall call on Ellis at St James's Court (Septicaemia, poor soul, but he's out of danger now). Then I shall have tea (without bread & butter) with Joyce at Wilton Crescent (broken foot).

Did I tell you that Aubrey's sister was reading English at Oxford? It came Over her in a Wave one night – She's an Impulsive Girl is Carmel Eban. Aubrey does all her Latin – but she has to wrestle with Anglo-Saxon alone. Aubrey is living in a Whirl of Zero-Hours. He's had three already. His next is Thursday. He's coming to dinner tomorrow evening and I'm hoping he'll tell me that it has been postponed again.

By the way, Nurse's baby and I are getting terrifically matey. He loves my red Siren-Suit – and stares at it ecstatically. He's growing rounder & rounder and he now has at least three expressions (ecstasy, for food and colour – vacuity, and purple rage) and when he's asleep he snores lustily and looks exactly like a bishop. I'm rather attached to him.

TUESDAY 18 NOVEMBER I got this term's Girton review yesterday my love, and it tells me that Miss Bradbrook is now a Temporary Administrative Officer at the Board of Trade. What a beautiful thought, darling. I can imagine her sitting on her bureaucratic desk with her knees humped up, showing six inches of primrose knicker and saying, in her Thin, ethereal voice: Oh! dear, what a lot of files ... There doesn't seem to be any muscle somehow in the imagery of this minute – and the Symbolism is all confused ... it's all so esoteric and technical ... they don't seem interested in the texture or depths of the sea – it's all flat and concrete – a sort of arterial road – the ships are just large lorries – how sadly unlike Conrad.'* (I've just tried to ring her up at the Board of Trade, but she's in Bournemouth – I forgot they had a Branch there. Oh! woe. Joan & I had hoped to take her out to lunch.)

FRIDAY 12 DECEMBER Darling, I came home to find a message from Sheila that Hamish has been missing since Monday – with 9 other fighter pilots. Oh! darling I'm stunned and bewildered with a stifled drowsy unimpassioned grief – I have a dull headache and a to-hell-with-everything feeling – and I'm haunted by a picture of Charlotte sitting in their flat waiting for him to come home. Oh! God. I don't suppose we shall hear for months whether he's been taken prisoner

* The Polish-British author Joseph Conrad (1857–1924).

182

or killed. I think he's dead. He had an aura of death about him when we last met. Oh! my dear love, I hope I'm wrong. Hamish was one of the gayest, happiest, whimsiest friends I ever had.

Oh! Darling, I can't believe it – I can't. It's queer, my love, but it all feels very remote – because you're so close to me that I can see everything else through the wrong end of a telescope. Nothing can hurt me very much now – but the outlines are sharply and cruelly defined at the end of the telescope.

SUNDAY 14 DECEMBER Joan and I met Sheila in Surbiton yesterday evening, darling. We all went to Kingston and ate baked beans on toast in the Regal Cinema to the strains of dreary incidental music off accompanying the film *They Dare Not Love*, or something equally impassioned. We all talked rather brightly and nervously and we all felt like Hell. They can't find out anything about Hamish because the whole of his Squadron was lost, and so there was no one to make a report. On the whole, though, Joan and I were a little happier after we'd seen Sheila because she has such an enormous fund of good sense and resilience.

Darling, my mother has just telephoned to say she's had a cable from Pa in Cairo. She was sobbing with relief – The best she'd hoped for was a telegram from some dreary outpost. I'm so glad, darling.

MONDAY 15 DECEMBER Darling, the maddening unhurriedness of AI is wearing me to a shadow. S7 have promised to ring Mr Parsons as soon as your papers come through. If he bothers them any more they'll begin to get Suspicious. When I do hear, darling, I shall probably know where you're going for your training and where they intend to post you after that. I gather that eight people were selected for Commissions (Intelligence) A & SD on Wednesday and there are a lot of formalities to be gone through before their papers reach S7 for final action.

SECRET. Darling, I couldn't bear to wait any longer so I asked Mr Crotch to investigate for me. He went and saw someone very exalted in S7 who put through an urgent enquiry. You have been passed by your Board – but before any action is taken you have to be cleared from the Security angle – (You haven't any

subversive activities that I Wot Not Of, have you, my love? No, I thought not) and they haven't even made the usual enquiries yet. The High Personage told Mr Crotch that some people were selected in August and haven't been Commissioned yet – but he thought that as you were selected for a semi-technical job they might speed things up in your case. Darling, if this letter were to Fall into the Wrong Hands, I should be Severely Shaken up for a gross breach of Professional Confidence – so Guard it well – and don't be surprised if there's a long time-lag before you hear anything.

My mother has just telephoned to say that Victor is in London for a fortnight, and that he's having an exam at the Admiralty in a few days time. He's having dinner with us tonight – He isn't staying with us because he wants to learn more about Life in a Seaman's Hostel, and he probably has an eye on the odd Wild Oat – (My mother is a hospitable woman, darling, but Wild Oats are in Short Supply in our house). But, on second thoughts, I'm probably wrong. Last time Victor and I exchanged Girlish Confidences, he never wanted to see (or sow) a Wild Oat again.

WEDNESDAY 17 DECEMBER Darling, I'm going to be a Godmother – Ismay has asked me to become the Spiritual and Intellectual Patronne of her Child – because 'Charles & I both feel that we would like our child to have a godmother of whom we are both so fond' which I think was an Uncommonly Civil thing to say, don't you, darling? And how I shall de-prim that child, darling. I'll get rid of all its Social Inhibitions by putting it onto the Bawdier bits of Chaucer in the teething stage. Darling, it shall be to me what the mouse was to Lavoisier or the Guinea-pig to many another scientist. I shall Experiment on it – and if it's a success, I shall bring up our children on the same lines – What a unique opportunity my love. Of course, if it turns out to be exactly like its parents I'll know I've been Pursuing the Wrong Line and start all over again. Poor Ismay, she little knows what a Cuckoo she's invited into the Nest.

But, jesting apart, darling, I'm really rather touched at having been asked.

Darling, have you heard that they're not going to make gold wedding-rings any more? I am Torn between Fear of Hubris and the urge to suggest that you should buy a gold wedding ring

for me while you can and keep it in safe storage for Future use. I loathe platinum and jewelled eternity wedding rings, darling.

THURSDAY 18 DECEMBER Aunt Teddy has gone to a Nursing Home with a Boil in some remote and unmentionable zone. (I can't find out its exact location. She is not averse from showing it to her intimates with a sort of gloomy pride – but she won't talk about it.) I always said Aunt Teddy would only leave us when she was carried away in a hearse, darling – If, for hearse, you read ambulance, I was right again, my dear love.

Jean is back from Torquay, and she has promised to try and find out about the Future that is being planned for you by the Mighty – in greater detail – but she's in a mood of Great lassitude and may do nothing about it for days.

MONDAY 22 DECEMBER Victor's interview at the Admiralty yesterday was successful and he is going to an Officer's Course at Greenwich shortly.

Darling, it was a nice lunch – Sheila told us of her Lurid Experiences in Air Raids. We sat Enthralled. She made her voice all tense and breathless and we couldn't stop listening – She ought to write it all up. She really has a marvellous gift for narrative. 'Everybody, including Allan, lay flat in the road, but I couldn't bring myself to it – I couldn't ...' breathless pause ... 'I'd just had my grey suit cleaned ...' 'And when we came out of the shelter at dawn there were rows and rows of pure white cart-horses tethered to the railings in the grey light ...' She has heard, through Allan's bank, that he is in Ismailia – so I expect Pa will hear from him soon.

Darling, Elizabeth expects to be Thrown into prison as a Conscientious Objector. We asked her where she lived today – as we can never get in touch with her – She fumbled vaguely in her bag and then said: 'Oh! dear I've left it at home.' (Meaning her address.) She's getting more like Miss Bradbrook every day. It's truly wonderful.

TUESDAY 30 DECEMBER Darling, I'm in bed with a week's sick leave. (Influenza.) Oh! my love, what a terrific Solace that would have been if you could have been here on leave at the same time.

Pan* was more pan-like than ever yesterday. (I've thought of yet a third reason for his name. When he moves it is as though all the cooking pans had fallen from their appointed places, with a sudden and terrifying crash.)

WEDNESDAY 31 DECEMBER Darling, a very happy New Year to you. Perhaps in the New Year of 1943 & 44 I shall lean across our bed and rest my hand on your hair and kiss you on New Year's Day. I feel so close to you now, darling, that it's almost as though you were here.

Did you hear Churchill last night, darling? Oh! darling, the gramophone is a wonderful invention, because it can record for posterity the rich Overtones of Implication and Significance in the PM's voice when he said: 'The French General's told the Cabinet that Britain's neck would be wrung like chicken's within 3 weeks.' (Rich pause.) 'Some chicken' ... (Further Pregnant pause) 'Some neck ...'

David rang up last night to tell me that Sylvia had started work at the Treasury on Monday and that they were going to be married – in Edinburgh – on February 9th or 10th. As you know, they wanted it to be in Oxford – but I gather that there were Parental Fireworks because of What the Congregation Would Say and David & Sylvia decided that Dr Daiches† might have the satisfaction of seeing one of his children married after his fashion. Poor David, he's going to have to submit even to having his name in the *Jewish Chronicle* – I could feel the Vibrations of his Squirms even in the bakelite of the telephone receiver! (Thank God, darling, that Pa, far from objecting to our being married in Cambridge, will probably go all maudlin on us with Fruity Satisfaction.)

I expect to be allowed up today, darling, but the doctor says I must stay in the house until my chest clears – at the moment it's tightly and wheezily obstructed.

* Pan was a new pet name for her brother Lionel.

† Dr Salis Daiches was the de facto Chief Rabbi of Scotland.

January–May 1942

If the old year had ended in a glow of happiness for Eileen, it was a bleaker picture abroad. The Japanese attack on Pearl Harbor had been followed within days by the loss of HMS Repulse *and HMS* Prince of Wales, *and the new year only brought with it fresh failures, with reverses in the North African desert, Malaya and, on 15 February, the worst disaster in Britain's military history – the surrender of Singapore and 80,000 British and Empire troops.*

It was not just in the Far East that British power had proved illusory – before May was out Japanese forces would also take Burma and stand poised on the border of British India – because the news was no better from the other major theatre of war. The heady days of victory over the Italians now seemed a distant memory, and as Tobruk and its garrison of 33,000 fell into enemy hands and Axis forces advanced on Egypt, Alexandria's cannier shopkeepers began to build up their covert stocks of Rommel and Hitler photos.

For Hitler, though, the desert campaign had never been more than a sideshow, and it was events on Germany's Eastern Front that were shaping the future course of the war. In the early weeks of the summer Operation Barbarossa had achieved spectacular success, but by the beginning of 1942 – to the jubilation of Eileen's plutocratic fellow-travelling friends – the German advance had been driven back from Moscow and Hitler denied the quick victory that everyone had feared.

It was not only that arch-enemy of real and imagined fascist fifth columnists, Horace Samuel, who was aglow at Russian heroics, because 'Everything', *as Eileen told Gershon, was* 'Russian now'. *At Cambridge,*

Eileen had steered a wide berth of anything that smacked of political earnestness; but as she took her bath to the sound of 'My lovely Russian Rose' on the wireless, ate 'Charlotte Russe' at the Lyons Corner House or had her lunch with Joan in a Russian sandwich bar in Oxford Street, she found herself part of an improbable national consensus that stretched from Churchill and the Daily Express at one end of the Russophile spectrum, to trade unionist leaders, munition workers and the Communist Party at the other.

There were also other new allies visible in London now – Canadians like Joan's new man, Captain Sims, and 'nice Americans in chocolate brown tunics' – but the only tunic Eileen was interested in was Gershon's new officer's uniform. She had spent a large chunk of Air Ministry time in December desperately pulling strings on his behalf, and on 1 January her cousin Jean phoned from Bletchley with the news that after a successful board, and subject to his MI5 vetting, Sergeant Ellenbogen of Y Sigs was now Pilot Officer Ellenbogen, attached to the Intelligence Directorate.

For Eileen, too, a transfer within the Air Ministry was imminent – from S2 to S9, the Secretariat Division for the Air Member, Supply and Organisation Department Bush House, Aldwych – and with it would come one of the richest friendships of her war. Gnawing away, though, at her new-found happiness and confidence was the knowledge that Gershon would soon be going overseas. She had always known at some level that he would be posted, but knowing it intellectually and emotionally were different things. As the date for Gershon's embarkation approached, the bleak prospect of a long separation lay ahead.

Separation

THURSDAY 1 JANUARY 1942 A happy new year to you, my darling. I'm sorry to part with 1941, though – it was a Vintage Year in happiness for me – particularly the last half of it, my dear love.

Darling, Miss Bradbrook is coming to London tomorrow and Joan and I are taking her out to lunch (Whoops of Solace).

Oh! my very dear love, Jean has just telephoned and I have the best possible New Year present for you. Your Commission is Through – Darling, I'm crying with happiness.

You mustn't breathe a word to a soul – I am not even telling Joan – It will probably be several weeks before you hear anything – but now it is only a matter of weeks and not of months as we feared.

SATURDAY 10 JANUARY We've just seen an announcement in *The Times* about Marcus Rueff's death. (He has been missing for months.) It is now known that he died of wounds in Libya. I was very fond of Marcus – I knew him best during the gloomiest days of my adolescence (between the ages of 16–19) and he always listened kindly and sanely and humorously to my morbid introspections and told me that I'd be alright once I got away from home. (In which, it turned out, he was perfectly right, darling.) He was a cultured and unpedantic humanist – with a passionate interest in printing and binding. I used to think he might grow up into a second William Morris.

I'm reading Defoe's *Moll Flanders*. It is very funny – because Defoe was a dirty old man who pretended to be a moralist. *Moll Flanders* is a zestful and roistering account of the life of a 17th century whore – <u>but</u> in his preface, Defoe is at pains to point out that although her amorous adventures are the <u>liveliest</u> and most entertaining parts of the book – nevertheless it is the <u>end</u> which treats of her Deportation and Conversion which the reader should mark and digest most carefully! The old hypocrite.

MONDAY 12 JANUARY You know, darling, the intellectual development of Pan & his generation is much more seriously affected by the war than ours. That generation is genuinely war-minded – <u>actively</u> war-minded – not, like ours, resigned to war because it is inevitable. Sigmund & I were talking, the other day, of the Significance of these new youth training movements. We agreed that the regimentation of adolescents in their leisure hours was a sinister development of Government Policy & was far too like total-fanaticism to be healthy. Oh! darling, if the war goes on much longer we're going to lose sight completely of the ideal of the free development of the individual during its intellectually formative years. What an awful tragedy.

WEDNESDAY 4 FEBRUARY Darling, I'm having a day's sick-leave and I've remembered what it was I had to tell you yesterday – one or two odd anecdotes for your concert.

You know, Churchill, even in his interlude of back-benching, was renowned for his verbosity – but his rich flow of oratory was not always looked upon with the same adulation as is accorded to it now. It is said that one day he met a tubby and ungainly political opponent in the lobby of the House. They disliked one another cordially, and Churchill dug him playfully in the flabbiest part of his Massif Central and said: 'Well, well, when can we expect the Happy Event – and what are you going to call it?' The other man looked at him Balefully, and then said coldly, 'Well, if it's a boy, I shall call it John and if it's a girl, I shall call it Mary, but if, on the other hand it is, as I strongly suspect, only wind – Then I shall call it Winston.'

THURSDAY 5 FEBRUARY Darling, Joan and I talked exhaustively and comprehensively of Joan yesterday. I told her what I thought – quite dispassionately and uncensoriously – and she put forward her defence – which she obviously believes very sincerely – as long as she was sure of Ian's love she wanted nothing else – but the shock of finding that his attitude had changed was such that she had to hold on to something, and Mr Sims was at hand and he was reassuring and comforting. She makes no demands on him nor he on her. I can't accept their relationship with any degree of assurance, darling, and I told her so – but on the other hand, I'm not prepared to sit in judgement on either of them – and so, having once said what I think, I shan't discuss the subject again.

Darling, I rang up Mrs Eban last night and she's looking forward to seeing us all in the early afternoon on Sunday. She says she's very much looking forward to meeting me – which is very Civil of her. She was so Voluble on the telephone that I wasn't able to ask her if she'd heard from Aubrey. Her voice reminds me a little of my handwriting, if you see what I mean. Darling, the *Daily Mirror* Psychologist says that people with Small Cramped Handwriting are always very economical if not mean! Am I economical, if not mean, darling? No, I was afraid you wouldn't think so.

THURSDAY 12 FEBRUARY The Egyptian Embassy reception was terribly dreary. The foot of the great marble staircase was banked with fresh daffodils and paper peonies – and the reception rooms crowded with meaningless women in mink and ermine and great nobbly jewels. The only enlivening encounters I had were with Pilot-Officer Norman Bentwich, very self-conscious in his uniform and twittering to be sent to the Middle East. He's at Horseferry Road at the moment and most of his work is done in the still watches of the night. The other encounter was with Colonel the Lord Nathan of Churt who Bore Down Upon me, accompanied by his Consort Billowing above her furs – and said: 'Miss Alexander, I believe? Are you a Principal at the Air Ministry?' When I told him I was not, he said with enormous relief: 'I thought not – Sigmund Gestetner said you were and when I contradicted him, he assured me that you had an arm-chair and a room to yourself.'

I said that this was perfectly true but that it was just accident and that Furniture did not always Proclaim the Post.

FRIDAY 13 FEBRUARY Darling, Joan rang me up yesterday evening, while I was in Mr Crotch's room. 'What did Lear say about Cordelia's voice?' she said, without preamble. I answered with Admirable Promptitude, though I sez it as shouldn't: 'Her voice was ever soft, gentle and low, an excellent thing in woman ...' to which Joan replied 'Damn, I've lost a glass of beer ...' and rang off.

SUNDAY 15 FEBRUARY Darling, everywhere I go, people congratulate me on having Attained you – and I swell to bursting-point with Pride in you – and Come Over All Look-What-I've-Got. I'm referring to Mrs Todd, Sigmund's two sisters & his niece and Miss Kay & Sister at the Dragon School.

Pause, in which Churchill announced, after a lot of devil-ish fine oratory which convinced no-one, the fall of Singapore. Oh! God.

Darling, I love you so much, I'm breathless and pale when I think of it (so I'm nearly always breathless and pale, my dear love). When will you knock on my door at the Air Ministry and say, 'Hello' very quietly and matily – and then kiss me with your mouth still cold from the wind, and make me feel, even in such times as these that to be young is Very Heaven? (Fancy Old Wordsworth saying that! It's the only thing in all his Outpourings that explains Annette.)

WEDNESDAY 18 FEBRUARY Dudley Danby is expected to pedal along for dinner tomorrow evening. I think my mother feels that she ought to make some effort for Joan. When she told us that he was coming to dinner – she and Joan both giggled weakly and Joan thanked her Elaborately and Solemnly for all she was doing to Further her Interests.

Darling, it is both true and untrue that no man is an island entire of itself ... I feel that very strongly when I think about Joan, who has resolutely cut herself off from the mainland. She thinks she is self-sufficient and self-governing – but actually I think she's going to find it more and more difficult to carry on anything more

than a tourist trade with the rest of the world. Autonomy is all very well for a hermit – but Joan is not prepared to be a hermit, and in her diplomatic relations with people on the mainland she is sweeping and ruthless – Oh! darling, I'm very unhappy about her – and when I say any of this to her she gets so angry that there's nothing left for me to do but be silent.

MONDAY 2 MARCH Darling, I hope you didn't have too hellish a journey. I felt ashamed as I lay in bed rubbing my cheek against a cool pink linen pillow slip, and curling my toes into the little warm, smooth hollow made by my hot-water bottle – and thought of you, cramped and jolting in a cold train, with nothing to comfort you but your book on codes and your German Grammar.

Mr Crotch has come back from Harrogate, smarting with indignation because all he's had from his wife since Tuesday is a post-card giving him her address. You'll never have cause for complaint in that respect, will you, my dear love?

Thank you for a week of your love and generosity and infinite gentleness and kindliness, my very dear love.

TUESDAY 3 MARCH Darling, I had an enchantingly meaty airgraph from Aubrey yesterday. He says he is universally cherished by my rela-tives as 'the man who knows Eileen's fiancé', and that Pa is a 'shameless enthusiast of Gershon's qualities in governmental and legal circles'. He adds that he's met dozens of my 'somewhat galli-cised' school friends who all remember me in terms of my 'distaste for physical exercise'. He demands to be Told All. Moreover, darling, he seems to have Fallen a Victim to Hollow Promises and is still a Lieutenant.

This evening, darling, Clad in my Best Attire, I shall make my way to the Deserted House of a Bachelor of Uncertain Reputation and Hold Converse with him on Matters of State. Reputation, they say, is a Bubble – but I feel sure that mine is safe with Leslie (– but not so sure whether this fact is a compliment or an Indictment, darling!).

<u>WEDNESDAY 4 MARCH</u> I was with Leslie for an hour and a half yesterday evening, darling. He remembered you very well – 'A double first in Classics and Psychology'. He asked me when we were going to get married – When I said I didn't know he gave me a penetrating look and said: 'Why?' I told him you were going abroad and he shook his head sadly.

Then we talked of the war. He said he believed we were losing it – The nation was apathetic and the Government short-sighted and still nursing the dead concept of the White Man's Burden. 'You know, Eileen,' he said rather diffidently, 'I believe in ideals – is that naive of me? I begin to think that it is. If the British Empire is a free association of free peoples then it is a magnificent organization. If it is conceived as a conglomeration of Dagos ground beneath the heel of a Superior White Race – then it's evil.' We talked of India and the Far East and shuddered at the way in which realms and islands seemed to be as plates (a small Spanish coin) dropped from a hole in our pocket. (I didn't think of the quotation – or rather misquotation at the time, darling – I wish I had!) We talked of the Jews – Good Jews and Bad, Flashy, Black-market Jews – We agreed that part-assimilation was the only solution to our problem. We discussed the place of the Jews in English cultural, social & economic life. We were interrupted by the arrival of a bobbing, heel-clicking refugee professor who had come to read German to Leslie for an hour – (Leslie loves being read to). He (Leslie) looked tired and ill – His hair is very grey and he had two buttons of his waistcoat undone. He was wearing soft knitted house-slippers and he sat listlessly in his chair – but his mind was as keen and sharp as a razor. It's a tragedy, darling, that such a man should be shouldered out of Office and disregarded. He liked talking to me, darling, and asked me to go and see him again. He promised to dine with us as soon as we could guarantee a moon and a taxi! I hope we shall be able to provide both before you leave. I do so much want you to meet him again.

<u>FRIDAY 6 MARCH</u> Mr Crotch is in a very matey mood today – He keeps coming in and interrupting me with idle chatter. Yesterday he said pathetically: 'My wife's idea of marriage is to curl up against me in bed like an affectionate kitten – and go to sleep – and I used to be

such a good seducer too.' I've come to the conclusion, darling, that men are all children.

SUNDAY 8 MARCH Ismay entertained me with an account of all the more social aspects of her confinement. I looked at Isobel who has a thick crop of reddish hair and looks, poor child, exactly like Ismay's mother. Heredity is a fearsome thing, darling. The birth of her child was nearly 3 weeks overdue. If you ask me, darling, it's a clear case of Inhibition – she just couldn't bring herself to do anything as Basic as Giving Birth – It was only Force Majeur and the threat of a Caesarian operation which forced her to it in the end – combined, of course, with a strong sense of Social Duty.

Darling, Mr Crotch informed me yesterday that he intended to Teach his Wife a Lesson by committing Adultery. As a matter of fact I think he's begun already – He's going about looking very cock-a-hoop – And he's reading *Jurgen* again. Jurgen is very adulterously minded & Mr Crotch is always saying that he's his counterpart in literature. That's what comes of turning over and going to sleep when you're in bed with your husband, darling – but I don't think I shall need the Moral Lesson implied in Mr Crotch's Confidences, do you, darling?

FRIDAY 13 MARCH Darling, my ring gives me infinite and increasing pleasure. Everybody thinks it is beautiful, even my mother, who finds it hard to forgive it for not being an emerald. When I arrived home with it last night she shook her head sadly and said: 'Not even a drop of champagne – I hadn't any in the house.' I assured her, darling, that she could open a frothing magnum for us, if she liked, just before you left. This comforted her. Darling, for our private use, let us fix the date of our engagement at September 5th, 1941 – The rest are but the trappings and the suits of betrothal. Do you agree?

Joan was telling Sheila in the hearing of Mrs Turnell yesterday that I had been quite hysterical the night before at the thought of my new work – and Mrs Turnell said: 'Hysterical? She's probably oversexed.' Joan solemnly assured me, in her bath, that she thought Mrs T Had Something There. Her thesis was that anyone who attached such importance to physical love must be oversexed!!!

Morbid Monogamy was just as much a form of being oversexed as Morbid Promiscuity. If you were normally sexed and were not detained by religious or moral scruples then, although you might be fastidious, it didn't much matter to you whether you were a virgin or not. As I knew, darling, that Joan was partly paying me out for the things I said to her on that Sunday morning when she was so aggrieved, and partly feeling resentful because my unrestrained absorption in you was very much like her disastrous relationship with Ian, I took it very coolly and matily – and my good nature was rewarded, darling, because, this morning, she withdrew it all. Poor Joan – Ian's defection has simply destroyed her balance – I've never known anything so awful.

THURSDAY 17 MARCH Darling, I had a very interesting lunch with Sylvia. We discussed *The World Jewish Review* and travelled thence to your qualms and uncertainty about Jewish Orthodoxy. She said that she understood your attitude very well, and that she had been through a similar stage herself. She believes that every critically minded person is bound to question the validity of Jewish Ritual but that the shedding of old habits of mind is bound to be rather a painful process. She agrees with me, darling, that Jewishness, in its best sense, is a State of Mind – indefinable but unmistakable – and that it has nothing to do with religion or race. We decided that the only way to develop our peculiar intellectual potentialities was to become <u>socially</u> assimilated – to be strictly selective and highly critical in our religious practices and, above all, not to segregate ourselves arrogantly from the non-Jewish world.

WEDNESDAY 18 MARCH Darling, I was almost roused to irritation by a remark of Mr Crotch's yesterday. He is fond of referring scathingly to my lack of sexual charm – Normally I'm quite pleased by it because, darling, it would make me feel ill to be attractive to him – I don't want to be attractive to anyone but you <u>actively</u> although I should like our <u>friends</u> to think that I was a nice sort of solace for you to have – but I should be physically sick if Mr Crotch found me attractive because he's the kind of man who takes an Inventory of a woman's body and then tots up the totals. However, yesterday I <u>was</u> almost angry – I said: 'I don't expect Mr Shearing will want to

196

have me,' and he said, 'Well, what man would? A full-blooded man anyway.' I just raised my eyebrows & walked out of his room. I like Mr Crotch in his official capacity, darling, and I respect him for his undoubted ability and drive – and his confidences quite entertain me – but I loathe his attitude to women, although I know it's the result of a painful psychological tangle arising out of his relations with his wife. I have been able to laugh at his remarks up till now – but, oh! darling, after you've gone, I know I shall take everything he says as a personal affront – I do hope I'm transferred before then.

Joan & I are going this evening to see *Wuthering Heights*. I don't expect we'll like it – but I want to see what Merle Oberon & Laurence Olivier make of it. At least they have beautiful voices.

THURSDAY 19 MARCH *Wuthering Heights* was bad – because the relationship between Catherine and Edgar Linton was sentimentalized – and the long break in the relationship between Catherine & Heathcliff (while he was in America and she was rejoicing in her new life – forsooth!) invalidated its power. Joan said: 'It would have been alright if the producer had read the book ...' and there's no doubt, darling, that she spoke the Last Word on the film.

TUESDAY 24 MARCH Darling, I'm wore aht. I'd forgotten what it was like to do an uninterrupted day's work. I spent the day drawing up an agenda for a meeting on voluntary canteens on RAF stations.

Group Captains, Wing Commanders & Squadron Leaders flicker across the screen of my consciousness incessantly, darling. I sit at a very small table opposite Mr Murray and when people come in with queries I Watch and Listen. Mr Murray signals messages across to me with his eyes during the conversation. He has very expressive sherry-coloured eyes, and sometimes they say: 'This man is a fool – pay no attention to him' – at other times: 'I should listen to this, you'll get a lot of fun out of this Bird,' or: 'This man knows his subject – It might almost be worth while taking notes.' After a few of these ocular messages, darling, I asked him if he'd said what I thought he had. He was very much amused & said that was exactly what he had thought of our last 3 callers.

THURSDAY 9 APRIL You know, I've been saying, ever since Pan got his airgun, darling, that it was illegal to use it in London? Well, there's a Police officer in the sitting room this very instant – all Solemn, telling them that he isn't going to Summon them this time, not wishing to Spoil their Careers. When Dicky first heard about him, darling, he went very red and said: 'I'd prefer to take legal advice before I speak to him.' The Plain-Clothes man, who is Very Large, was not, however, prepared to wait for Dicky to get in touch with his Attorney – so they're both in with him now, darling.

FRIDAY 10 APRIL Darling, I read a heart-rending document today – It was a dossier put out by AI1(z) about conditions in West Africa & it consisted mainly of extracts from Airmen's and Officer's letters to their wives, Solaces, families & friends at home. What a horrible catalogue of drink and women & homosexuality & venereal disease, darling – all couched in the baldest and most explicit language – because, after all, the extracts were from private letters and were never meant for publication. And always the bitter cry of boredom – boredom – and no letters from home. (It is from the postal angle that we're dealing with the problem, darling.)

May–December 1942

Gershon would arrive in Egypt at a fraught moment in Britain's desert fortunes. On 21 June Tobruk and its garrison had surrendered, and by July Rommel's men were just sixty-odd miles west of Alexandria with Egypt, it seemed, theirs for the taking.

In Cairo, where on 1 July – 'Ash Wednesday' – the air was grey with the smoke of burning documents, the 'Flap', as it was euphemistically known, was 'on'. At the British embassy a German speaker was designated to stay on to liaise with the enemy, and amidst rumours of a Cretan-style airborne assault and plans to whisk the ambassador and his family to safety, Cairo and Alexandria's British communities prepared to abandon Egypt.

While the panic proved premature – by the end of July the German advance had been fought to a standstill at a small coastal railway station called El Alamein – for the newly arrived Gershon, the real work was only beginning. In the earlier campaigns against the Italians the Cairo intelligence operation had achieved some startling successes, and with Rommel's forces still only sixty miles away, the work of the 'Y Service', feeding Bletchley with encrypted enemy information from its headquarters in the old Flora and Fauna Museum at Heliopolis, would again play a crucial role in the coming battles.

Back in England, it would be a month before Eileen had a letter from Gershon – posted from the Cape, with the date cut out by the censor – the first of over two hundred that he would write to her from Egypt. One of the first things she had done after he had left was to buy herself a binder for his carefully numbered letters, and in the same civil service spirit she now took advantage of the new 'airgraph' – an ingenious solution to the

problem of flying tons of mail out to the forces – to supplement her regular letters with a weekly 'digest' of events at home.

For anyone with Eileen's handwriting, too, the size of the airgraph form, 11 x 8¼ inches, was a positive challenge – she could get in 350 words to Gershon's 200 – and for the duration of his stay in Egypt it became a regular part of her literary armoury. She would send off her letters – maximum weight half an ounce – as normal, and then once a week give an abridged version on an airgraph, take it, with a 3d stamp affixed, to the post office near St Paul's, where it would be checked by the censor, microfilmed onto a roll of film, and flown out to Cairo to be processed and delivered in an envelope as a photographic print just over 5 inches by 4 in size.

It was not just conversations with Mr Murray on the 4th Dimension, or Joan's flirtations and Dicky's outrages that filled her letters, either, because with Gershon now in Egypt, there was nothing in the progress of the desert war that did not concern her. And the war, at last, was beginning to turn the Allies' way. In August, Lieutenant General Montgomery, one of the rare successes from the Battle of France, had taken command of the Eighth Army and, on 23 October, after a prolonged build-up, launched a massive British offensive against the Axis forces at El Alamein. Twelve days later the battle was won, with Rommel's beaten army in retreat. In terms of scale, Alamein might have been nothing compared with Stalingrad, but its psychological impact was enormous. Egypt was safe and in Britain the church bells were rung for the first time in two and a half years. At the same time, too, American and British forces successfully landed in Vichy north-west Africa and Eileen could at last dream of an end to the war in Africa. There would be no Second Front in Europe in 1942, as Stalin and the British public had wanted, but a year that had begun with a whimper was ending with a bang. 'Now this is not the end,' Churchill told the Lord Mayor's Banquet audience on 10 November. 'It is not even the beginning of the end. But it is, perhaps, the end of the beginning.'

9
Limbo

<u>FRIDAY 1 MAY 1942</u> Darling, you sounded never so weary, never so in woe. What you need is a course of Solace. Come to London, my love. That will cure your malaise. I agree with you, darling, that the work of a computer is not up your strasse. It demands a singularly restricted type of mind which you have not – besides, darling, all computers end up by being a little mad. There is a Wildness in their eye, an electric unruliness in their hair, an unkemptness in their person which marks the Fanatic. I would not want you to give yourself up Body and Soul to Computing – It would be reflected in your mollocking, my love. You would see it all as a Pattern of Interesting Combinations – Horrible – I shudder to think on't. No wonder F. L. Lucas has had such a rapid succession of wives, darling. He was always a computer at heart.

<u>MONDAY 4 MAY</u> I read a nice phrase in a document today, darling. It referred to Fitters at a particular Unit. It read: 'They were not imbued with the fighting spirit. The spanners had entered their souls.' It was a very High-Level Document too, darling. It's nice to know that the Great Ones have a touch of poesy in their make-up.

<u>THURSDAY 7 MAY</u> Darling, my mother had 4 letters from Pa yesterday, and in the last one he told her that Gino Grassi, the son of out neighbour Mr Carlo Grassi, had been killed fighting for Italy in Libya. At first, darling, I felt nothing but irritation with Mr Grassi for being such a <u>bloody</u> fool. Serves you right, I thought, for

strutting about like a peacock with your Fascist button-hole and your Commandatores. And then I thought, no – bigger men than you have been attracted by the glamour of power and titles – and I was just terribly sorry. Gino was a spoilt, raucous lad, he can't have been more than 18 when he died, darling. He was their only child and had always been very delicate – and they adored him. Mme Grassi is a very beautiful Jewess, a tall, gracious figure with glossy black hair and lovely bones. Mr Grassi is like a little black bantam – rather a pathetic figure for all his Big Booming Voice and his posturing. He used to say that Mussolini wanted to make a bigger and better Italy – a splendid aim, he thought, and what did his Politics matter (!!!) provided he enriched his people and aggrandized his country? His friendship with Hitler was natural – Hitler treated him like a Gentleman, the representatives of the other powers treated him like a Dago. Poor little man. What price Fascism now?

TUESDAY 12 MAY Mr Murray's typist, Miss Anderton, kept me at the AM very late this evening telling me <u>her</u> All. She is a very intelligent woman – a cripple – rather fat and ungainly. She told me that she'd been engaged to a man in the RAF who had wanted nothing but the little money she'd been able to save, and who had lied to her consistently. She said she was an only child of very puritanical and domineering parents who had never allowed her to meet any men – and that she didn't suppose she'd ever get married now as all the men of her age who were worth while were married already – and if they weren't there was something wrong with them. She said she very much wanted to get married and have children, darling. Poor soul – I like her so much. She has character and brains & deserves to have what she wants.

SUNDAY 17 MAY Darling, you have worked a miracle – You have created a core of warm serenity in my spirit, so that however far away you go and however long you stay away, I shan't be afraid. I have been through all the preliminary & painful stages, darling; I have been strung up to a terrifying pitch of nervous excitement in the early stages of my love; I have been swamped by blind, uncontrollable fear – but now I feel comforted and rested and trusting and

wonderfully secure. God bless you for it, my darling. It's no good trying to tell you how humbly grateful I am, I can only hope that my kisses and the touch of my hands have told you what, for once, I lack the glibness to say. I feel that there's something of the restful clarity and maturity of Shakespeare's last plays in our love now, darling. I feel that I can say the words of Donne's 'Valediction' with something more than a wish that I could rise above material circumstances as he does. I have been very near this state of mind ever since I became really certain of your love and last night I knew I had reached it – it is very like the wonderful restfulness that follows a terrifically excited mollock. I expect I shall have minor relapses after you've gone, darling, but the core of serenity will stay with me, my love.

MONDAY 18 MAY I'm having lunch with my mother & Mrs Fanshawe at the Berkeley which I shall enjoy. Mrs Fanshawe is Sir Victor Harari's daughter – and one of the most entertaining and brilliant women I've ever met. Mrs Fanshawe's husband has just been made a Major-General. He's a grandson of Sir Evelyn Wood – and is nothing but a Besotted Bland Clod. He is consistently unfaithful to his wife but he has no compunction in living in luxury on her father's money. He can't divorce her because he's a Catholic & anyway it would ruin his career which neither of them want. Besides which, with the Inconsistency and Illogicality of Women, she loves him and would rather have a piece of him than nothing. She also has a mad French Cook called Mrs Shelley whom she keeps on only (I suspect) because she's such a fruitful source of fantastic anecdote.

Darling, I was playing rummy with my mother, Aunt Teddy, Joan & Jean when you rang up. (Anything for distraction, I thought, anything, anything.) When you said Mercredi I thought you meant Wednesday week – and then I realized – Oh! darling, I put up a very good show – I could hear my voice saying quite coolly 'Really?' as though it were someone else's voice talking of something quite casual. I hope to God I shall talk to you alone tomorrow night, my darling.

Write to me always, darling, and remember, nothing which concerns you is too trivial to interest me. Remember too that

women love to be told they are loved – even though they know it already – and be damned to the censor.

God be with you, darling. You know, I believe there must be a God, to have conceived anything so clear and serene as the happiness you have given me – if there is, my darling, I thank him for your love.

WEDNESDAY 20 MAY Darling, there are times when Providence is not unkind to me. I was walking towards the 'bus at Chalk Farm this morning (and if I say I was feeling Bloody, I shall be guilty of a gross and fantastic understatement) when Miss Carlyon tapped me on the shoulder. I went with her by tube to Leicester Square, darling. She's working for a theatrical casting agent and, as usual she has stepped into an atmosphere of sheer fantasy – I'm never sure whether she creates her own atmosphere, darling, or whether she Divines it by means of some sort of occult instrument. Anyway, she's working for a bawdy old Manager whose Private Secretary is a Low Church Gentlewoman, Upright and Viceless. He calls her Chubby, presumably on account of her mature contours (she is 58) although Miss Carlyon didn't say she was plump – and he says things like: 'Chubby, you old trollop, hurry up with that letter ...' As Chubby is rather slow-moving on account of her age, she is often rather slow in replying to a Summoning Bellow from the Inner Office – and an Apoplectic Call is often followed by a heart-rending fit of coughing and: 'Come on Chubby, darling, if you don't hurry I shall be dead and you won't need to bother,' whereat Chubby rises stiff – pointedly and unsmilingly, note-book in hand and stalks with dignity towards the voice.

Darling, please don't grow a moustache – even in a Spirit of Jest or Whimsy – It will probably Come over you in a Wave but, if it does, say 'Avaunt' and 'Hence' as repressively as possible and Forget About It. I don't know why men in Tropical Climes always seem to Hanker after Moustaches, darling – I think it's all due to a sense of being insufficiently Clad – bare knees are compensated by Wooliness on the upper lip – Nevertheless, my love, I implore you to Eschew all thoughts of it.

FRIDAY 22 MAY Darling, the realization that you've gone is growing on me gradually. If anything happens to you darling it will kill me, so help me God. Without you I'm like a puppet whose strings have been cut off. For God's sake be careful not to eat raw vegetables which haven't been properly washed in permanganate of Potash – and raw fruit.

SUNDAY 24 MAY I forgot to tell you about Mrs Fanshawe's hens, darling. 'My dear,' she said, 'They're cannibals. They eat all their eggs – They love them. It's disgusting to watch them savouring them. When Evelyn (her husband) is at home, I make him sit in the hen-house, my dear, and seize the eggs as they emerge. I'm sorry, my dear, but there's a war on and I just can't afford to be Delicate and Look the other way – One can only hope that the hens understand ...' at the other end of the scale is Mrs Aubertin who keeps her chicks in Joan's bedroom because she thinks that surroundings are so important during the Impressionable period of one's life.

Oh! Darling, I wonder when I shall get a letter from you. I'm being a good little girl and carrying my gas-mask everywhere – with the result that I am the Scourge of the Waitresses in restaurants (because they all trip over it) & the bane of 'bus passengers' existence (because they invariably Graze their Rear Elevations on the corner of the case). Never mind, darling, it's All for Love and I Take no Account of the Discomfort of others.

THURSDAY 28 MAY I enjoyed my dinner with Jean & Bernard Lewis, darling. You should have heard him on the subject of the Jewish Rabbinical School at Bletchley, darling! He said the new candidates turned up as nice pink-faced little boys in school caps – in their 10th week they were Pale and Gaunt with corkscrew curls and threadbare black coats – in their second year they had bent backs and sparse hairs on their chins – in their third year they had goodly and verminous spade beards – and some of them even survived to pursue a post-graduate course. The local inhabitants were no end puzzled, darling. They thought they were colleagues of Bernard's!

Darling, Joan's Mr le M is going to America. As a Parting Shot, he rang her up last night to say that on his way home at

midnight of the previous day (can you have midnight of a day, darling? I suppose so, there are, after all, 24 hours in every day in the broadest sense of the word. Anyway, I can't keep repeating 'night') he walked through Hyde Park and was surprised to observe a man & a girl being Wanton on a Park Bench. Fascinated by the sheer Athletic Ingenuity of the feat, darling, he paused and stared at them in a spirit of disinterested scientific curiosity. The man looked at him coldly: 'Have you no sense of decency, sir?' he said. 'I perceived,' said Mr le M 'that I had made a Social Error and so I Passed on into the Night.'

SUNDAY 31 MAY Joan & I went to Abbey Road to try and find someone to Do the Garden for us on his free day, (Our Gardener having left, darling, because he said that we never got any vegetables because we were all too bloody lazy to pick them – which was pretty Harsh considering that my mother spends most of her time almost blowing on the shoots to make them grow) but we saw nothing but Leering Faces all the way down the road – so we Beat a Maidenly Retreat and arrived home – without a gardener. Darling, when I think of the Soldierly & Dignified Bearing of those very same men when you and I were wont to walk down Abbey Road together!

SUNDAY 7 JUNE Darling, I'm desperately tired – It's a terrific emotional strain to make myself talk of you with some measure of detachment. I had a long talk to Joan today about her and Ian and suddenly all the pieces fell into place & I could see exactly how her relationship with Mr Sims arose, darling. It was because she had nothing to hold on to – no core of hope and certainty of happiness as I have. If you had gone away while our relationship was at that stage, my very dear love, it would have killed me. Joan being Joan, it drove her into the arms of another man. Oh! darling, I can't write any more – I'm so tired ... so tired. Goodnight, my love.

FRIDAY 12 JUNE Darling, Horace & I sipped exiguous White Ladies (really all water with a sniff of gin and a drop of lemon) in the Savoy. It always amuses me to see Red Horace accommodating himself luxuriously in the Strongholds of Capital as to the Manner

Born (as indeed he is, darling.) and, on this occasion, he had to fork out the disproportionate sum of 10/- for the privilege of sipping the Thimbleful which cheers but certainly does not inebriate among spat-and-polished guardsmen and flat-chested ladies of leisure & unimpeachable virtue.

SUNDAY 14 JUNE Darling, I got home to find Joan Glowing. She says she has Laid the Ghost of Ian at last and has Fallen in Love with a Civil Servant (Temp) at the Ministry of Supply. He's divorced, darling. His wife ran away with a Producer and he's Partially Bald – (Joan's Young Man, I mean, darling, not the Producer – at least he may be for all I know but it's of No Consequence) but otherwise he sounds alright. Oh! darling, I hope this isn't going to make her unhappy. She's had far too much frustration and strain for her years already. For Future Reference, my love, his name is Robert Walker and I am to meet him soon. Of course you shall Know All, my darling.

TUESDAY 16 JUNE About Robert Walker's father, darling. He's a nudist, not from conviction but because he likes wandering about in the sunlight with nothing on. He met his 'Mel' at a Nudist Camp and immediately installed her in a London flat. This enraged his wife who had been indifferent to all his other Infidelities but refused to be Done Down by a Cross-eyed Nudist. (Mel is extremely cross-eyed, darling.) So she left him. Mr Walker also met a rather timid little girl at a camp. Because it was obvious that she'd have been much more comfortable with her clothes on, he wrote her down as a fool, and when one of his sons subsequently brought her to his house (fully clothed) and introduced her as his fiancée, he Went Up in Smoke and shipped him off to America without compunction, delay or enough money to pay his passage home. However, he returned in due course, darling, and married the girl (still wearing all her clothes – and she's never undressed since).

Darling, Joan's Robert Walker is the Richest piece of copy she's ever unearthed. No doubt a lot of his fantastic environment is enriched by Joan's Fancy but I suspend willingly my disbelief & give myself over happily to Poetic Faith. His brothers (including Gilbert, who is a friend & Colleague of your cousin Asher) went to Oxford because at that time Mr Walker believed that Oxford was

the only place which Produced Gentlemen. Later, however (no doubt owing to some chance encounter in a Nudist Camp or to Mellow Cogitation in the Sunlight) he decided that the only <u>real</u> Gentlemen were engineers, so he bundled the rest off to London University to read Engineering, willy nilly. (And I gather it was considerably more nilly than willy, my love.) As a matter of fact, darling, there's an *embarrass de richesse* about that family's Doings to say nothing of the vagaries of their friends – some of whom are friend's of Victor's too.

<u>WEDNESDAY 17 JUNE</u> I've just overheard a Beautiful snatch of conversation over the telephone, darling:– Mr Murray: 'No, I don't <u>think</u> they'll eat the aircraft. – Yes, I admit that cows will eat almost anything.'

<u>FRIDAY 19 JUNE</u> I am going to meet Joan's Robert Walker tonight, darling, they are taking me to the Odeon as Horace & Estelle are coming to play Bridge and Joan and I will be *de trop*.

Robert Walker turned out to be rather smooth-faced and dimpled with gingery hair and a Little Tonsure – like Uncle Sam's and yet not like Uncle Sam's, if you see what I mean, my love. Joan said quite casually on the way home that she hoped I liked Robert as she was going to marry him. This may just be a momentary whim, of course, but I don't think so. Oh! darling, if she <u>does</u> marry him I do hope she'll be happy.

<u>SATURDAY 20 JUNE</u> Oh! my darling, I wonder when I shall have news of you. I don't like the turn the Libyan Campaign has taken, my love. I hope the fighting won't come too close to you, wherever you are. I'm frightened, darling. It's not that I'm afraid of death but that I feel you and I have so much to live for.

Darling, I have spent the evening staring out of Joan's window at rather a puffy Mae Westish Barrage Balloon that reminded me rather of one of those lecherous fish in Walt Disney. Joan was assailed with a violent attack of Decadence this afternoon and she retired to bed immediately after supper. I watched my balloon and half-listened to the cluckings of a rather Fussy bird at the end of the garden while she told me all about her and Robert.

They intend to get married at the end of the summer. Darling, I think she'll be as happy as she could be with anyone but Ian. She doesn't love him as she loved Ian but it's not possible to love two people in that way in a life-time but I think she is in love with him, which is another thing altogether. She finds him stimulating and attractive and amusing and she's able to make a terrifically Good Story of him. I wish she had married Ian though darling I shall miss her dreadfully when she goes, darling, although she won't be far away. (Mr Walker's flat is near John Barnes's.) She hasn't told my mother about it yet because she's afraid she may think she's being rather Precipitate (so do I, my love, but I'm making the best of it – It is, after all, not my affair).

SUNDAY 21 JUNE Joan has told my mother about Robert, She Took it Well, but rather Anxiously – even when Joan, anxious to say the Right Thing, assured her that he was a Good Cook!

Darling, mum has just been in, Billowing above her Nightie, to give me a little Homily on Smoking. 'That you should smoke like that with your Fiancé risking his life is not only unpatriotic, it's Disappointing.' Talk about non-sequitur, darling! And she meant it – because whenever she comes over All Solemn she always talks about Pa as 'Your Father' and she's never referred to you as 'Your Fiancé' before, my Solace. Oh! darling, I am smoking too much. I even smoke on Saturdays – but I really need it now. I hereby register a Solemn Oath that I shall try and give up or at least seriously cut down my smoking when we're married. I mean it, darling, because I know how you hate having to kiss what you call 'My Lady Nicotine'.

The news of the fall of Tobruk is startling and terrifying, my love. The only comfort is that we and the Americans have a great host of fresh, untried men and that our production is on the upgrade while the Germans must be worn out by now and their production is on the decline. This isn't wishful thinking, darling. According to my interpretation of the news it can't be otherwise. If you were here, darling, I should be much more optimistic about the situation than I was when Tobruk fell to the Italians – but now the menace is a personal one and I can't assess the situation as a clear-headed observer but only as a frightened little girl who loves you.

Joan's Robert came to dinner tonight, darling. He is really a most interesting man. He says I'm a Purist, my love. What do you think he means? – and, if you know what he means, do you agree with him?

I was lying in my arm chair this evening before supper – three parts asleep, and I had an overwhelming impression that you were with me and I got into an extremely excitable state of mind. I had the sort of upward gasp inside that I get when you bend forward to kiss me, darling, or put out your hand to touch my body when I'm in an excitable mood – but you weren't here to make me excited and then wonderfully rested, darling, with your hands still and gentle. Oh! My darling, you weren't here.

MONDAY 22 JUNE Darling, I'm reading C. S. Lewis's *Screwtape Letters*. It is a very brilliant, subtle and witty treatise on Temptation, in the form of letters from a practiced advocate of the Devil to his nephew, a pupil-tempter. I'm fascinated by it.

I had a letter from Margaret this morning, darling, asking me to stay with her next weekend. I shall go, darling, although it will be queer and empty to take a train from the same platform as you did when you went away from me for the last time before you left England.

Darling, I've offered to write and tell Ian about Joan – because she can't bear to write herself. It will hurt me to do it, darling, because their love was something very real and valuable – something I could understand. I'm not sure that I can altogether understand this new business – though I'm probably just rather bewildered by its suddenness – but the fault, dear Brutus, lies not in themselves but in my obtuseness. Darling, I never feel so strong a sense of inadequacy and so bitter a sense of failure as when my friends are in trouble and I can't help them. Do you remember when you and I had lunch in that Sinister Italian cafe in Soho after 'Dear Brutus' and you were so unhappy, my darling, and I could do nothing but cry and say that I couldn't bear to see you unhappy? Oh! My darling, I love you and I believe that our love keeps us near to one another. Darling, there must be a God to whom I can give thanks for this great gift.

TUESDAY 23 JUNE Darling, Robert Walker paid me a compliment – via Joan. He told her that he thought I was a very gifted conversationalist – quite an artist in fact and that the only time he felt it might not come off was if I was nervous and overdid it. I preened myself no end, my love. You know, darling, I seldom <u>believe</u> the nice things people say about me but I'm always enchanted to hear them and I roll them happily on my tongue and feel as though I've had a tonic and as though perhaps I was wrong about myself after all! When anyone is <u>displeased</u> with me, darling, it has exactly the opposite effect. I feel that I've been going about with my nose skyward thinking myself No End of a One when really all the time I was a rather ludicrous, inept creature. Darling, you've got a very suggestible little cluck – do you mind?

Jean came upstairs with me, darling, and talked to me very sincerely and seriously about herself – without a trace of affectation. For the first time for longer than I can remember she shed the service manner. Darling, I'm <u>very</u>, very sorry for her. She's had an extraordinarily tough time being buffeted between the Lechery of her Chiefs and the Old-World Courtliness of Square (whom she would like to marry). I'll tell you the whole story when we meet.

WEDNESDAY 24 JUNE Oh! my dear love, we've just had a telegram from Pa to say that you're with him. My hand is shaking so much, my darling, that I can hardly write. I am sending a wire to your parents at once, darling. Now I shall be able to go to Rugby really happily, my love. Providence is infinitely kind, my darling. I'm going to celebrate by sending you & Pa a telegram in the lunch-hour and by taking Joan Fisher (to whom I owe a meal) out to lunch.

Darling, Mr Crotch has just rung up to say that A/SO Crotch has been posted to St John's Wood & that the Marital Breach is healed and also that Mr Corless's daughter who was reading Classics at Girton has got a First! Isn't that nice, my love? This is a good day for nice things to happen.

THURSDAY 25 JUNE Darling, I got your letter 2, posted on 29. 5. 42, at Sigmund's this evening. I read it before dinner, during dinner and after dinner. Fortunately, you had recovered from your pictur-

esque and plural attacks of seasickness before we started our cauliflower au gratin!

Darling, I wonder if the Free French Medical Officer is the one Mrs Crews (you remember – the Don with the prettiest legs in Cambridge – according to Sidney Birkowitz) was going to marry. I don't suppose we shall Ever Know now – but it's a Beautiful Thought. She's in Ankara, you know, Waiting for Him. (<u>Her</u> French Medical Officer, I mean, darling, not necessarily your friend.)

Joan's Robert says that, now that he has met me he's going to give up the Cinema. He far prefers my version to the film, he says. It's Uncommon Civil of him, darling, and Clever too, in a crude way. He and Joan naturally want our Goodwill and Blessing and how better can it be won than by a little of the Balm of Flattery?

Darling, if you should see Aubrey in the near future would you please ask him if he has Cast me Out of his Life for ever? I haven't had a letter from him for <u>centuries</u> – only tantalizing snippets of information from Pa and Mrs Eban. Tell him it's a Great Sorrow to me. I'm sending your remarks about the Free French officer, who spoke so glowingly of the pro-British feeling in France before he escaped, to the Intelligence people, darling. This is the sort of information they want. I mentioned it to Mr Murray and he advised me to do this.

<u>FRIDAY 26 JUNE</u> Darling, Joan is going to Dorset with her mother tomorrow for a week's leave. Mrs Aubertin is spending the night with us. Mrs Aubertin is a little stunned over Joan, darling, but She's Taking it Very Well, All considered. Darling, I was so ashamed of myself this evening. My mother said that it was about time I gave up 2 baths a day and I said I was <u>dirty</u> twice a day and we wrangled a bit and I asked Mrs Aubertin what <u>she</u> thought – and she said: 'Well, Eileen, I <u>never</u> have a proper bath except when I go away from home because we only have a tin bath.' Oh! Darling, I'm going to give up my morning bath from Monday. Slap me for a pampered little wretch, my love. Mrs Aubertin is a Delight. She's just as Willy Nilly as Joan if not more so & she sees Joan without a Single Scale before her Eyes, without a bit of Rosiness about her

spectacles, but she's none the less fond of her for that. That's how we'll be with our daughters, darling, shan't we?

MONDAY 29 JUNE Darling, I saw in this morning's *Times* that Eddie Ades had been killed in action. I never knew him, except by sight, but I know that you and Aubrey liked him enormously & that you must be sorry. I'm sorry too, my darling. We shall be a depleted generation – those of us who survive this war.

Darling, I met Joyce for lunch. She has Taken to Riding Everywhere on her Bicycle. This is a Sinister Sign I think and Bespeaks the Influence of Bernard, which appears to be reasserting itself – and with Gordon thousands of miles away – well! well!

THURSDAY 2 JULY Darling, when you say in your telegram: 'All Well and Happy' do you refer to your little Band of Brothers-in-Arms or to Uncle Tom Cobley and all, by which disrespectful designation I refer to the Mosseris and their many Lateral Shoots? By the way, darling, if you mean my relatives I think 'happy' is a peculiarly unhappy choice of words, because anything less communally Joyous than the Mosseris there never was, don't you think? In fact, darling, Pa and I have often described them to one another as a Covey of Black Crows, always at their best in the neighbourhood of a Corpse – but perhaps we were being unkind – anyway there were so many more of them in those days, my love.

SATURDAY 4 JULY Darling, such goings-on! I was walking peaceably down Wardour St after an excellent lunch with Aunt Teddy and Jean at an uncharted Kosher Restaurant – not I regret to say, sanctified by the Spit of the Illustrious Beth Din – when I suddenly got mixed up in a Brawl. Outside Chez Victor there was a waiter – and a woman. The waiter was small, black, Italian, wiry-haired and wiry limbed and the woman was Desiccated and Drab and in the Government office-cleaner tradition. She had an enormous pot of beer in her hand. It was obvious that the Woman did not love the Waiter nor the Waiter the Woman: 'Treat me like a Prostitute,' she said heatedly, 'Me with 7 generations of respectable working people be'ind me.' She then went on, with fascinating fluency of speech on the circumstances of his birth, his sexual oddities and

other intimate details of his life. He gave as good as he got if not better, darling. I don't know which epithet it was which finally Shattered her Self-Control – I only know that, when it left his lips, he she and I were in a straight line. She Swung her Pot of Beer – he Ducked and lo! I was shaking myself like a damp puppy with my hair beer-dewed, my jacket and dress froth-and-brown speckled, and my poise seriously shaken. I drew myself up to my Full Height, wiped a trickle from my cheek which felt like a Beery tear, begged the pardon of the assembled crowd (I don't know what for, darling, force of habit, I suppose) and Passed on with Dignity. Now that it has dried off me leaving a faint aroma but no stains to speak of, I am able to look back upon it as an interesting experience, my love. Never say again that I Don't See Life, darling. It would no longer be true or just. Anyway, now I know what Socrates felt like when Xanthippe emptied a Malcolm all over him which is surely Something. I forgot to say, darling, that at one point in the altercation, she said, <u>spitting</u> with Rage: 'Chez <u>Victor</u>! Same name as that swine over there ...' pointing to Vic Oliver's* portrait over the Hippodrome Opposite – '<u>and</u>' she added as an afterthought, 'his Fat Father-in-Law', by which I take it that she meant our Revered Prime Minister!

Joan Pearce came to dinner this evening, darling. Her conversation was Liberally Peppered with 'Dam' fine's' and 'Old Bitch's' and she kept slapping her not inconsiderable thigh with Gusto and saying: 'Army Life Suits Me', but she's a good soul really, darling, beneath all those Layers of Khaki.

MONDAY 6 JULY Darling, I've had rather a shock. I had lunch with Susan Wyatt today and about half way through the second course she said that she & Woodrow were separated & that she was living with someone else. I said I was sorry, darling, but it sounded fantastically flat and inept and then she told me that it was the complete absence of <u>rest</u> in their relationship that had worn them both down. I can't understand how anyone can marry a person with whom they are not at rest, can you, darling? Darling, I <u>hate</u> sepa-

* Vic Oliver, Austrian-born British actor and comedian (1898–1964), was married to Sarah Churchill; they divorced in 1945.

rations & Divorces – I wish they never happened. Let's not have any in our family, my very dear love. I feel shaken and unhappy – as I felt about Joan at the time of the Ian debacle. I wish so many of my friends weren't so unstable emotionally. Susan looked so pale and thin and unhappy.

TUESDAY 7 JULY Darling, the Uneven tenor of Joan's Emotional Way is more uneven than ever. M. le M has come back from America with a first-class duration-of-the-war job in his pocket for her. Now she's torn between the prospect of staying in England and marrying Robert and of going to the States and Carving Out a Career. I'm sorry for her, darling, except if it were my case there would be no dilemma. I wouldn't for instance take the English Chair at Jerusalem University if it were offered to me on a gold, emerald-studded salver unless you were coming with me. I would not accept a Government portfolio if it meant that I shouldn't have enough time to write you a long letter every day, my dear love. It may sound easy to give away the moon when you haven't got it, darling, but in my case it happens to be true. With Joan it is not now 'when I marry Robert ...' but 'If I marry Robert ...'

WEDNESDAY 8 JULY Darling, I had a letter this morning from Basil. He has had his Army calling-up papers. He's going to make one more plea for the RAF and if that fails, he's not going to do anything more about it. I've made exhaustive enquiries here and I've satisfied myself that the vacancy position in the RAF Medical Branch is such that there's a chance in a million that his application will meet with any success. There's a staggering waiting list, darling. Basil is coming to stay with us on the 19th so, if Mrs Turner can have me I shall go to Cambridge this Saturday afternoon and take Monday and Tuesday as annual leave so that I shall have 3 full days at Girton Corner.

Darling, I think I've managed to persuade Joan that she'll be running away from a real chance of happiness by going to Washington. The root of the whole trouble, my dear love, is that she's so terrified of becoming really involved again in an emotional relationship and thus laying herself open once more to the possibility of getting hurt, that she has an instinct to slide out while

there's still time. Poor Joan – Ian has more to answer for than he will ever realize.

FRIDAY 10 JULY Darling, Jean brought her friend 'Square' to dinner tonight and I showed him my vinaigrettes. He's really a most entertaining man – and he talks about food as others talk about Great Music or Great Poetry – and because I have a touch of the gastromanic in myself, my darling, I was rather pleased with him – at least I should have been on any other evening but tonight I have such an appalling sense of fear and loss that nothing really pleases me. I am Sick and Sullen, my darling. I have felt today for the first time since you left that I simply <u>can't</u> go on without you. Of course, I shall go on, darling. I <u>can</u> go on because I know that this is only a mood which will pass – leaving me once more with a sense of your unalterable nearness, because you see, my very dear love, you're always near me – At the back of the 68 'bus – in the narrow, tortuous streets of Soho, in the Entrance hall of Bush House, in my room, even in my bed, my darling – and tomorrow I'm going to be very near to you indeed – at Girton Corner where you were so infinitely kind, patient and gentle with me. Darling, I'm crying – I haven't cried very much since you left because I've never really <u>apprehended</u> before that you'd gone for a terrifyingly indefinite time. Darling, when you come back I shall be so greedy for your smile and your comfort and your companionship and humour and your kisses and the touch of your hands that I'll never be able to let you out of my sight.

SATURDAY 18 JULY I really wanted to sleep when I got in this afternoon, but Joan wanted to talk. She's decided to live with Mrs Mair for the month of August because she finds it hard to think of coming up against Pa until she has sorted out her ideas about Robert. Pa is going to say some very bitter things about Joan, darling, and it's going to hurt me a lot. I'm frightened and I wish you were here. Joan is frightened of Pa as I am, my dear love, because he can be so very cruel from the highest possible motives. His rigid, unreasoning, unbending Puritanism is terrifying – no less terrifying than the intellectual demands he makes, which used to make me ill with anxiety at Cambridge. He's a very strange mixture, my darling, of

real kindliness & incredible hardness. Oh! Darling I do so wish you were here and that we were married and had our own home. I wish it so much that it's a real ache. You see, darling, Joan's standards are not my standards – but I'm not prepared to say that mine are right & hers wrong. I am only prepared to say that mine are right for me. As a matter of fact, darling, the only girl of our generation whose standards are almost exactly the same as mine is Sylvia.

SUNDAY 19 JULY Darling, only one Profound Thought was born of a night of sleeplessness, snuffling and brooding, & that was that Pa was a cross between Mephistopheles and Father Christmas – a disconcerting combination, my dear love.

Darling, I've decided that I'm a Girl of Simple Needs. The only things I <u>must</u> have are you – and friends to whom I can write and talk at length about my other friends – and access to books – and constant Hot Water and Paper Handkerchiefs or High Grade Cotton Wool for Duncan. The rest are luxuries which I can dispense with if I must.

I had a long discussion with Joan about her Future. Her latest plan is to stay with us and try and persuade Pa that Robert is a Good Thing. I've no doubt however that she will change her mind a dozen times before Pa arrives in England. Robert came to tea this afternoon. I'm rather frightened of his attitude to Joan, darling. I don't think he understands her at all – which, of course, isn't surprising considering he's only known her for 6 weeks. Think how little you and I knew of one another after six weeks of fairly continuous meeting – and, moreover, <u>we</u> were not blinded by any violent physical attraction.

MONDAY 20 JULY Darling, Joan is thinking of getting married on September 5th which is the anniversary of the day on which you asked me to marry you. I hope they decide finally on that date, my dear love – I'd like something specially nice to happen then. (What I should like best would be for you to come home on that day, my darling. Lay it to thy heart ...)

WEDNESDAY 22 JULY Darling, I'm in some sorrow because under the accommodation reshuffle in Bush House, I shall no longer be with Mr Murray, but in with the two TAOs and the other TAAs. Oh! woe is me – though actually I've been extraordinarily lucky to have been with him for so long.

THURSDAY 23 JULY Darling, I was talking to Basil until very late last night. He came up to see the snap I took of you punting on the river in which you're laughing very characteristically with your mouth wide open. Do you remember, darling? He has a sort of naif curiosity about love in general and our love in particular – and because he's so sincerely fond of you, darling, I told him a very great deal about my love for you since its inception – more than I really wanted to – certainly more than I ever told anyone else – except you, of course, my darling. You see it's quite clear that he has been brought up in the Tradition which believes, like Shaw that 'Most young men greatly exaggerate the difference between one young woman and another'. The whole discussion arose out of my mother telling him laughingly that I had always said I would never love or marry anyone. He thought this was a Very Queer attitude and I tried to explain to him something of the terrible emotional risks involved in love. I said that I realized now that the risks were worth taking – that it was worth staking everything on a gamble – even if it ended in disaster as it did for Joan – but that, before I realized the superabundant richness of the harvest that could be reaped from love, I could only see and fear its dangers. He said that when I talked about love he supposed I must mean something quite different from the affection which grew out of sharing a home and children – like the love of your parents for instance – I assured him that I did – I said that I was as completely bound to you now as though we were married and that if you had wished it before you went away, I would have lived with you as your wife – although, I added, I was in one way (and only in one way, darling (though I didn't go into this with Basil) and you could have overcome that completely if you'd wanted to – and still can at any time if circumstances should make you think it advisable for our well-being or happiness) & perhaps a rather selfish way, glad that you had not, because of my parents, who felt

very strongly about these things. He nodded, darling, and I think he began to see what I meant by love – and then he went up to bed. I hope you don't mind my having talked to him like this, darling, but I wanted him to know how completely and unreservedly I love you, how you are my life and my spirit and the stimulus of my intellect.

SATURDAY 25 JULY Darling, working for Mr Murray has done me all the good in the world. He is a man who, when he sees something wrong, doesn't Shake his Head in Sorrow – and leave it at that – He goes to see somebody about it – or writes to them about it – and he doesn't let it rest until he sees some sort of result.

Basil asked me the same question about inter-marriage as your father had asked, and I said that I valued love more highly than any religious creed – at which he said: 'Ah! then you do set a high value on some worldly things.' I couldn't explain to him, darling, that to be at rest in your arms takes me nearer to timelessness, to eternity and to the harmony of the spheres, if you will, than anything else in the world – nearer to God, in fact, or first causes or what you will. It is because your kisses can take me beyond time, my darling, that I am so repelled by promiscuous mollocking which means – nothing. It is because I was instinctively conscious of what love could mean that I was so censorious of promiscuity in the past – before I knew you.

WEDNESDAY 29 JULY Oh! My dear love, damn Malaria. I want you so much to be well so that you can fill your life with new activities and experiences – so that you are always alert and laughing. (I'd give a King's Ransom to hear your laugh now, my darling, and to see your smile.)

Darling, d'you remember the time (on the top of a Girton Corner 'Bus) when you were so shocked because I said three-quarters seriously, that I wished you had some sort of illness which would keep you with me always? Well, today I almost wished that you could have malaria 3 times so that they'd send you home. Almost – but not quite, darling, because malaria is a beastly clinging disease if you get it more than once.

THURSDAY 30 JULY I forgot to tell you last night of a Fantastic conversation between Sheila and her C/O. It went as follows:

> Sheila (very Well-Bred) 'May I speak to Section Officer Ffinch-Close?' (That really is her name, darling, believe-it-or-not.) 'Hullo? This is Kilpatrick, Ma'am. I've had my interview, Ma'am. Quite satisfactory, Ma'am – but I have to report to Air Ministry again at 0900 hours in the morning, ma'am – my pass expires at 11.59 hours, ma'am – Kilpatrick, ma'am, – yes, ma'am, thank you ma'am.' Then she put the receiver down & said: 'What a fat little fool that woman is!!!!' Oh! the Duplicity of woman, my dear love.

Darling, Sheila says that one of the most Frustrating things about being separated from Allan is that he never <u>answers</u> her letters sentence by sentence. You will answer mine when they arrive, won't you, darling?

SATURDAY 1 AUGUST I had a long & rather emotional letter from Basil, this morning, darling. He says that his stay with us and his talks with Joan & me have made him feel very strongly the lack of all the advantages of having been at one of the 'parent universities'. (Talking about parent universities, darling, my MA arrived this morning. Much Handsomer than yours!! Very large and be-waxed and be-ribboned. But I'm still glad you got yours first. I wonder why. Queer, isn't it?) Basil says he has written you a long and 'very intimate' air mail letter. Oh! dear, I feel rather embarrassed by proxy, darling.

TUESDAY 4 AUGUST Darling, I have at last Impressed Pan. (You have no idea, my love, how difficult it is in some families to impress younger brothers!) He was talking about types of aircraft and I tossed off a few half-remembered facts that I'd seen in documents which were Secret then but are Secret no longer and he thought I was No End of a One. The fact that I wrote Shakespeare, darling, carries no weight with him at all, but when I give him 2 years-out-of-date information about the Climbing Power of Hurricanes or the speed of Spitfires he is Speechless with Admiration.

Darling, I've just decided that Resilience in food when Carried to Excess, has its Disadvantages. I'm writing in Fuller's and I've just finished eating a lamb cutlet and when I applied the edge of my knife to its back it Bounded Away from it as though it thought it was still in the meadows where it had lately Gambolled – and it scattered peas all over the table as it ricocheted coyly off the plate. I went in Hot Pursuit and when I finally captured it, crammed the whole of it in my mouth (which wasn't difficult, darling – it was a pathetically exiguous cutlet) and swallowed it whole. It was rather like swallowing a squash ball but, Comforting Myself with the thought of its protein content, I Took Heart.

WEDNESDAY 5 AUGUST Darling, Dr Minton has just been to see me, He says I shall have to stay in bed for a week on a milk diet. It's nothing to worry about, my dear love. It's just the shock of your going away & anxiety about Joan & Pa's return & one thing and another that's roused my damned ulcer a bit – and I'll have to look after it as a preventative measure – so please don't be concerned about me, my darling, by the time you get this I shall have forgotten I was ever ill.

THURSDAY 6 AUGUST I got very cross with Joan last night. She hasn't been feeling at all well lately so while Dr Minton was here he examined her and said that her trouble was anemia due to excessive loss of blood as a result of the remains of a cyst on her ovary. In telling me about it she said: 'He hurt me terribly when he touched my ovary.' 'Oh!' I said innocently. 'Did he prod it with a pencil – That's what he did to my ulcer place & I yelped like anything.' She looked at me queerly & said: 'You can hardly conduct an internal examination with a pencil.' So, darling, as a matter of Academic interest I asked if it were possible to examine a virgin internally and she said of course it was and asked me what I understood by a virgin. I said vaguely that I supposed a virgin had some sort of skin inside with a hole in the middle – and she said, Good God, she was sorry for you, having to cope with anyone who knew so little about herself – to which I replied Indignantly that I knew quite a lot really but that all the books I'd read took it for granted that the reader knew exactly what the term 'Virgin' meant.

Then she went on to say that, for a successful physical relationship a woman must know something about her anatomical make-up. I said nonsense – that my physical relationship with you was completely successful – and she said, I couldn't have had any real physical relationship or I couldn't be so ignorant. I said that I thought it was possible even to be wanton without registering any anatomical details – because when one is in a state of erotic excitement with the person one loves the emotional & the physical are so closely bound up that at the same moment as one is, in one way, more conscious of one's body one is in another least conscious of it. She just looked Superior & said that if I chose to regard sitting on your knee as a physical relationship, I was welcome to it – and, as I was not willing to discuss the matter with her in any detail, I dropped it – but, dammit, darling, I'm not going to allow myself to be given an Inferiority Complex about my Capabilities in Physical Love. You're satisfied with me, aren't you, my darling, and as our relationship develops you will teach me all that it's necessary for me to know? You'll be satisfied with that arrangement, won't you, my very dear love?

SATURDAY 8 AUGUST Darling, I was looking idly through the *Jewish Chronicle* this morning when I suddenly saw an obituary notice on Ram Nahum.* He was killed in the raid which smashed up the Union, darling. It will be a great sorrow to Victor, darling. They were at school together, you know, and were very great friends. It seems only the other day that we met him in Bridge St with Sheila Matthews, both of them looking incredibly scruffy. Oh! My love, I'm sorry. (Not that I ever really knew him, but he was one of the most familiar figures in Cambridge – one of the landmarks.)

Captain Sims came and sat with me for half-an-hour this afternoon. He's looking very lost and *desorienté* since Joan 'took up with' Robert. I do think Joan has become utterly unscrupulous with men – quite regardless of their feelings, darling. It's as though she were paying them back for Ian's treatment of her. Poor Joan.

* Ram Nahum, a Jewish communist and brilliant young physicist, was killed in Cambridge by a stray bomb in July 1942.

SUNDAY 9 AUGUST Aunt Teddy has an enormous pimple on her nose, darling, and it has done nothing to Sweeten her Character – but she has, nevertheless, gone out to dine with Jean (She's taken to eating potatoes in Large Lumps. Lord Woolton said they weren't fattening – at least not as fattening as some things. Joan & I think she's the vainest woman we know.)

MONDAY 10 AUGUST By God! darling, I wish I could rid myself of this turbulent mail-consciousness. It's absolute Hell. I say to myself, don't worry little girl, you'll get letters, telegrams & airgraphs all in good time – but it doesn't help, darling. The truth is that I've been spoilt, my love, because the mails were quite inexplicably regular for the first month after you'd reached your destination. Oh! darling. I'm glad you can't see me now. Wisps of hair have broken loose from my plaits and are straggling all round my face – I've got on an ancient pair of pyjamas with an enormous hole in the seat and a button missing half way down the front. (What's the good of having a button missing with you thousands of miles away from me, my darling?) I am Distraught.

TUESDAY 11 AUGUST Darling, you should see Aunt Teddy's nose. It has swelled to a Great Fiery Bulb – a veritable Belisha Beacon. When I look at it I am reminded of Falstaff's observation about Bardolf's nose, which was that had a flea walked across it, it would have seemed a Damned Soul burning in Hell Fire. Last night Aunt Teddy was clucking because we had no buckets of water about the house. I suppose she feels that if her nose suddenly catches fire (and it looks, darling, as though it were about to Burst into Flames at any Moment) there will be nothing with which to extinguish it before she is Consumed Utterly.

Victor & I were talking about really great women last night, darling, and Victor observed that most of them had been childless. He cited Queen Elizabeth, Emily Brontë, Jane Austen, George Eliot, Virginia Woolf. He thinks that if a woman has a high creative output, darling, then she can't bear children – because the bearing of children is such a tremendous emotional & physical upheaval that it's bound to detract from their power to create in

other directions. Perhaps there's something in what he says, my dear love. What do you think?

Dr Minton is very pleased with me. He says I may get up & go out today. I'm to be X-rayed tomorrow & on Thursday I'm going back to work. And, darling, alas! I've got to eat more so as to keep my gastric juices busy – Oh! I hope I don't get any fatter. (Actually, darling, I've lost rather a lot of weight.) Joan is having injections, darling, to stimulate her Ovaries. She has a theory that Dr Minton has given her these injections because he thinks she's Undersexed! Well, I suppose everything is <u>possible</u>.

Joan thanks you for your kind messages – but she says it's no good asking her not to be rash – Caution is not in her Nature.

By the way, darling, you <u>must</u> get hold of and read C. S. Lewis's *Screwtape Letters*. They are absolutely magnificent. He is undoubtedly one of the very great men of our time.

<u>WEDNESDAY 12 AUGUST</u> Darling, I want every detail, however trivial. I want to know why you smiled when you were crossing the road to my father's office – what you thought about when you were lying in bed with malaria – what everyone you see says to you and what you say to them – what sort of a room you have in your new quarters – everything, darling, I'm insatiable. Darling, thinking aloud on paper must become second nature to you – it must, my dear love – otherwise you will seem infinitely far away and it will break my heart. I was devising Tortuous Schemes for being with you again in my bath (don't misunderstand me, dear, I mean that I was Devising Schemes in my bath) today. I thought that perhaps I could persuade my parents to go back to Egypt to pack up our things – and then I could get transferred to the AM in Cairo and you could get some leave & we could be married. Oh! Darling, I wish something could be done. Please don't be angry with me for saying this, my darling. I know you have work to do – I don't expect you to post long letters as often as I do – but I know you will understand – you always understand. That's one of the reasons why I love you so much.

Darling, Anthony Eden has an Aunt and his Aunt has a home. It sounds innocuous enough, doesn't it? But don't be deceived, my love. Anthony Eden's Aunt is a Woman of Character. She wants us to have her House & she spends her entire time Hawking it Round government Departments. Today, (Mr Murray being in Hospital about to be Bereaved of a Wisdom Tooth) I interviewed her – and, darling, she said: 'Have you any papers about this?' I said yes & outlined the position. 'I want to see them,' she said. My God, it was a Bad Moment, darling, but your Alarmed Little Cluck Wriggled out of it rather well, I thought. I looked Very Reserved & Dignified and said: 'Miss Talbot, there is nothing in those papers which you could not see – but may I put it like this, watertight privacy of papers in government departments is essential in order that every case, however open and above-board, may be discussed with the utmost frankness & freedom between Heads of Divisions. This freedom is an essential part of our Democratic Administration – and if Private Persons have access to papers concerning themselves or their property, this freedom is destroyed. I am sure you would not like that to happen.' She lapped it up, darling, and went away like a lamb.

Joan is in the Throes of more emotional Complications – she's had two long letters from Ian from Sierra Leone which makes it quite clear that his attitude was entirely due to the fact that he didn't want to rope Joan into a life which he looks upon as something very like Hell. Darling, Joan's life is like one of those electric toasters that keep shooting out pieces of toast which Hit you in the Eye. I wish I could help, darling, it's awful to stand by and see her like a ship in a black storm driven I know not whither.

You know you were saying the other day in one of your letters that one seldom saw the Gorgeous East as one imagined it, my love? Well I saw it like that – once – it was when Ismay was staying with us in Cairo – but that's an Irrelevant – not to say Incongruous detail. The King wanted to raise some money for some charity (I forget what) and so he persuaded one of his Aunts to lend her palace for an evening party. It was a wonderful palace, darling, built in the form of four corridors at right-angles to one another enclosing a courtyard with a lake in the centre. The courtyard was hung with the most wonderful opalescent brocades

and there were small tables everywhere covered with scarlet velvet gold-embroidered cloths like the one I had at Cambridge. Do you remember, darling? There were no electric lights, (It was a very bright moonlight night, darling) only huge candles – heavy Turkish silver candlesticks – Tall, many-branched monsters towering above my head. All the Palace entourage, darling (and they seemed to run into thousands!) were dressed in Turkish costumes, heavily embroidered and jewel-studded and the Princesses, who had a sort of open box to themselves, all wore white chiffon draperies with great emerald, ruby and sapphire embossed brooches in their turbans and cascades of diamonds on their fingers, wrists and (oh! Woe to have to bring in a Homely Note, darling) their Uniformly Substantial Bosoms. A wide parquet bridge had been built across the lake for the cabaret and dancing – and the buffet, darling, piled high with bowls of iced caviar and mountains of iced stuffed vine-leaves, aubergines, courgettes, and artichoke hearts – and wondrous silver dishes of water-melons, mangoes, peaches, apricots and Alexandria Grapes.

Mr Murray & I were talking about Gandhi today and saying what a damned scandal it was that the popular press was tonguing him as a traitor and a coward. Oh! darling, why doesn't someone say: 'This man is a Saint, but history has taught us that Saints are born far ahead of their time and therefore the world is not yet ripe to follow his teaching. We cannot accept his doctrine because he is speaking for generations far more civilized – far more highly developed than our own. He is a visionary who can only see far into the future and who knows nothing of the present. Let him go his way in peace ...' It is the visionaries, darling, who lead the way forward, but it is the practical men who prevent it from falling into chaos. There is a place for both.

SUNDAY 16 AUGUST Joan has just been in to report on a long conversation she's just had with Pan on the subject of Aunt Teddy. It started by his Sighing Heavily and saying: 'You know, Aunt Teddy has a Beautiful life – She needn't even listen to Family Rows unless she wants to.' (There was a full-dress Drama over Dicky last night, darling, but I won't bore you with the details. It was just rather sordid and very noisy.) Joan then told me in Parenthesis that a few

weeks ago, when David & I were discussing Philosophy after dinner, she noticed that Aunt Teddy Switched Off her instrument in the middle. Oh! darling, how Humiliating!

Darling, Joan may be getting married in two or three weeks' time. I can't say very much because she's asked me not to – but I wish you were here, my darling, so that I could talk to you about the whole thing & clear away some of the clouds of confusion and bewilderment in my mind. I hope it will not result in unhappiness for her – posting with such dexterity to once-used sheets.

MONDAY 17 AUGUST Darling, Joan told me this morning that she had reconsidered her request that I shouldn't say much to you about her marriage – because she felt that, knowing that I always discussed everything with you which touched me at all nearly, she couldn't ask me to keep silent about this. She is almost certain, my darling, that she's going to have a baby. (And I don't think she's wrong this time, my dear love.) She is very happy about it. She says that she's quite certain that she loves Robert, but she has been so much hurt once that she would never have been able to bring herself to the point of getting married only circumstances had forced it on her. She feels, too, that to have a child very soon will be the best way to start off married life with Robert, whose self-confidence has been badly shaken by the failure of his first marriage. As Joan can't have been going to have a baby for longer than 3 weeks, if she is married immediately the dates can be fairly safely camouflaged. Those are the facts from Joan's angle, darling. For my part, I would have wished her to marry in different circumstances. Her whole emotional outlook since her break with Ian has bewildered me, my dear love. Clearly I am in no position to judge – but I wish I could understand. My main concern now is to back her up with my parents. We've decided to say that Robert can only get leave in 2 or 3 weeks' time – and that if they're not married then, they'll have to wait a year or else be married on one day and go to work the next. Of course, they're going to be terribly hurt if she can't wait until Pa gets back. I only hope he will be back by then to find everything settled. I want, above all things, to spare Joan any unhappiness or bitterness on account of hostility at home. All this

227

needs <u>very</u> careful handling, tact and a good deal of play-acting. I tried the play-acting out on Joan Pearce at lunch today. I could see that it carried complete conviction with <u>her</u>, but oh! Darling, Pa is another matter. He is *l'homme du monde par excellence* – and he is not easily deceived – and if he's <u>not</u> deceived his criticism will be ruthless and very painful. At the same time as all this is spinning round inside my head, I have to present an unruffled front to Joan, who must clearly not be allowed to get into a panic. Oh! God I wish you were here, my darling. It's like moments like this that I realize how <u>tremendously</u> I rely upon your wisdom and sanity. By the time this reaches you Joan will probably be married and the Crisis will be Over, so please don't disturb yourself on my account, my darling. *Il n'y a pas de quoi.*

<u>TUESDAY 18 AUGUST</u> Darling, Joan's problem is getting more & more complicated. Robert doesn't want a baby at this stage, & Joan says that if he won't have it she'll never feel the same about him. She's seeing a doctor this morning, my love. They both change their minds every 5 minutes & I don't know where I am. It was incredibly painful to see Joan last night in an absolute frenzy. I'm so desperately sorry for her, my darling – and I feel so helpless.

Darling, Joan has seen the doctor & he says that in view of the state of her ovarian cyst the baby can't possibly develop beyond two – or at most – three months – so the problem settles itself you see, but in rather a horrible way.

Darling, I'm telling you all this because I always have & always shall discuss things with you as though you were my husband and because I know that you'll never speak of it to Joan or anyone else. (Though she knows that I've told you the outline of the situation.) It's an incalculable comfort to be able to talk to you, my darling, otherwise I should go nearly mad with anxiety for Joan who is very near collapse.

<u>WEDNESDAY 19 AUGUST</u> Darling, the copy that I'd been pining for walked into Fuller's and dropped into the seat beside me – like Manna. It was Edith Carlyon. I asked her if she was still enjoying her work with the Theatrical agents & she said, 'Adoring it, my dear. The Manager now calls me a Dreary old whore when I make a typing

error so I feel that he has really come to accept me as one of the family.' Then she told me about a fan-letter which Robert Helpman had had from an old lady about his ballet of *Hamlet*. She said that she'd always known there was something wrong with *Hamlet* and now she realized what it was – it was the words. Seeing my face when she told me this Edith roared with laughter & said she had known I would look just like that and had been longing for an opportunity of causing that very expression to flicker across my face.

THURSDAY 20 AUGUST Darling, Pa arrived back at Break of Dawn this morning, much Larger than Life Size and as Expansive as a Walt Disney Cockerel. His first remark was that you and I must spend our honeymoon in the Game Reserve in S. Africa! Ye Gods! Can't you see us Mollocking among a Pride of Lions, my love?

SATURDAY 22 AUGUST Darling. I'm having a sort of nightmare – like all that Hecate nonsense in *Macbeth* – and the people in my nightmare are floating upward in a sort of sickle movement like the skeletons in 'Night on the Bare Mountain' – you remember? There's Joan, darling – She has lost her way – she looks frightened – she's floated outside my line of vision. There's one of our clerk's – her fiancé died in an aeroplane crash in W. Africa. She has an empty look – She has lost her way too – We have all lost our way. My way is towards you – but there's a wall – and a locked door that way. I am lost on the other side of the wall. There's Pan, who wants to fling away his future at the controls of an aeroplane. Oh! he's badly lost, my darling. Only David & Sylvia are not lost, my dear love, because they are together. My parents are not lost – but they've completely lost sight of Pan and me whom they do not in the least understand – not when it comes to fundamentals anyway. I am but mad nor' nor' west, darling, but the wind shows no sign of blowing in a southerly direction at the moment. I wonder if you know how I love you? I don't think you can – I don't think anyone can except me to whom it is a miraculous & blinding light – and we have to be separated when we're so young and have been and could be so happy. Oh! The pity of it, my darling, the pity of it.

SUNDAY 23 AUGUST I forgot to tell you, my dear love, that Joan's Robert was Looked Over by Pa on Friday evening and that he Found Favour. Thank God, darling, that's one fence o'er leapt. This morning Joan & I are going to walk along Finchley Road to Robert's flat to meet a musician friend of him – an impecunious young man who has been, in his time, a Harmonium Player on street corners. He rejoices in the Picturesque name of Jerry Bird.

Darling, when Pa got to the railway station on his way to London, he saw a diminutive boy of about 10 or 11 leaning on a wagon & he said: 'Would you like to earn some money?' 'Yes, sir,' said the lad with commendable promptitude. 'Well, then,' said Pa, 'Find me a Porter.' 'I am the Porter, Sir,' he said – so Pa loaded on the luggage & the lad wheeled the wagon. Pa says he never worked harder in his life to earn someone else a shilling.

Robert's friend, Jerry Bird, is extremely long and lank and dirty. He wears check shirts (very loud check) & he sees himself as a Mute Inglorious D. H. Lawrence. We walked back from Robert's flat, darling, and Robert was talking to me about the attitude to sex of Joan & Sheila & me. He said that all the women at London University (including his first wife) had an abounding sexual curiosity. They sought sexual experience, darling, for its own sake. He said that until he met Joan & Sheila & me he had always thought that women who were only interested in love – as distinct from sex for its own sake, were either undersexed or, to a greater or lesser extent, inhibited. Isn't that odd, my darling? The only girl I knew at Cambridge who had that kind of interest in sex was Joan Wilson – and we all thought of her as an Oddity. Robert says that, on the whole, the women at London University looked upon their work as a matter of very minor importance. Their main purpose in going to the University was to find out more about men. I wonder how true that is of the Provincial Universities, my love.

THURSDAY 27 AUGUST I can understand why people go mad, my darling. They do it to escape from emotional responsibility. I don't think the business of living can ever be a clear-cut issue. I don't suppose my case is more complex than anyone else's but look at the burden of emotional responsibility that's crushing all the vitality out of me, my dear love. Let me take Pan as a starting point. He's 17,

darling, and he wants a little time to himself to sort out his ideas & to work out some kind of personal philosophy – but if he goes into another room to be by himself – if he goes out alone, my parents think he's selfish – that he's neglecting them – and Dicky. If I ask him out to lunch so that we can talk – my parents say: 'Dicky must go too.' So Pan is an emotional responsibility, darling. The fashionable philosophy of the schoolboy is Crucify the Hun. The Humanities – the value of knowledge – all these things are, by comparison, academic trivialities. So Lionel doesn't read any more, darling, he works endlessly at navigation & mathematics and aircraft recognition – and when someone says: 'The Russians must have accounted for two million Germans,' he says, 'Good,' and he says it with relish. I'm no Pacifist, my darling. I believe that this war is necessary, but it's heart-breaking to see anyone as potentially good as Pan talking about the killing of men as though it were the same thing as bringing down a bursting bag of grouse. (I dislike blood sports, darling, because potentially they foster that spirit.) If Pan could have some time in which to develop independently – either at school or at home, darling, he would very quickly become a different person, I think – but even when he comes into my room at night to talk – my mother says: 'It's time you were in bed, Lionel.'

Then there's Joan, darling. I have, on the one hand, to try and help her to straighten out her emotional tangles and on the other to sweat blood to keep the real facts from my parents – and there's the added complication in that I feel that she's mishandling her life most crazily and I can do nothing – because that is no-one's business but her own. The only clear-cut issue, my darling, is my love for you – and even that is complicated by our parents' attitude. If you're able to come back before the end of the war, my darling, we're going to have to face grave complications vis-a-vis our parents when we say that we want to be married. (In this case, darling, I think my parents will be more amenable than yours.) Oh! darling, I'm in such a tangle that I simply don't know what to do or say or think.

Darling, Pa had lunch with Leslie yesterday. He (Leslie) is in such confusion of spirit that he's going to stay in a monastery in the north of Scotland for a week to try and sort out his ideas. Poor

Leslie. I would not need to go to a convent to sort out my ideas, my darling, if I could be back in your arms for an hour with the warmth of your hands on my hair and body – with your head on my breast and your wonderful smile very close to me, darling. Oh! My dear love, I'm so sorry for the people for whom kisses are nothing more than sensation, who don't know what it means to be lifted above time and space by love – for whom the love which is God is not compressed into and symbolized by one man. Those people, my darling, don't know the meaning of being alive.

FRIDAY 28 AUGUST Darling, Joan talks of going to live with Peggy Mitchell. (She's going on leave today.) She wants me to Boost the Idea with my parents. But I can't, darling – I just can't bear at the moment to put forward a suggestion of any kind which is likely to meet with antagonism and criticism of Joan and the Younger Generation and this, that and the other. You see, darling, as I may have said before, my parents are not such fools but that they'll realize that any suggestion of leaving us will be an admission that Joan isn't really happy with us – and, darling, it's no good sheltering one's eyes to it, it is impossible for anyone to be really happy in our home for long – anyone young, I mean. If we are tired at the end of a day's work, we are Effete and Decadent – if we go out we are indulging in Frivolous Activities which are Out of Place in War Time – If we go to our rooms to write letters or to get away from Dicky's noisy insolence or slobberings, we are selfish and inconsiderate and we treat the house as a hotel or a boarding-house – If we are uneasy because there aren't any letters, we are unbalanced & hysterical – If we discuss ethics, our attitude is symptomatic of the Degeneracy of our Generation. Of course, I'm over-stating the case, my dear love, but I'm not misrepresenting it as grossly as you might think.

SATURDAY 29 AUGUST Darling, have you ever read *The Brothers Karamazov*? I was thinking about it the other night – thinking that it was the greatest novel ever written. It is as vast in its scope as the *Divina Comedia*. It is the journey of a man through Hell & Purgatory to Spiritual rest. I've only read it once, darling, but it's so powerful and tremendous that I should need to read it six times before I

could absorb a tenth of its significance. Please read it, my darling, if you haven't read it already – and tell me what you think about it. In the meantime, if I can find the leisure, I shall read it again (It's 3 years since I last read it) because the details are very hazy in my mind – only the impression of spiritual power remains.

<u>MONDAY 31 AUGUST</u> Darling Prince Habib Lotfallah* was here this evening when I got home. He's a client of Pa's. His brother was the favourite candidate for the throne of Syria after the last war. We used to know them all in Cairo & we looked upon them as a Huge Joke – but all the Great Ones here seem to look upon old Habib as quite a Personage & he's persona grata with the lot of them. He said to me: 'Your fiancé is *seulement Pilot Officer, hein? Reserve volontaire?* A pity – I could not make him more than an Air Commodore.' It was obviously a genuine sorrow to him, my love! He was talking about his brother's marriage (which has dissolved in a nice *je m'en fichiste* oriental kind of way) & he said, in French: 'You understand my brother has given too much freedom to his wife. Pardon me miss, but women must be held fast, otherwise they fly like my sister-in-law.' (He speaks execrable French, darling.) He's a comic old bird, my love.

Darling, I want to talk to you about Joan again – but I want you to make a mental vow before going any further that you won't be angry with her for causing me anxiety – that you'll never speak to her of this (because I've no right to speak of it even to you, my darling, only I shall really <u>collapse</u> if I <u>don't</u> talk to you, my dear love) and that you'll remember that Ian's attitude was such a tremendous shock that she has never recovered from it & that therefore, her actions can't be judged by any <u>normal</u> standards.

For the last week she's been away. My parents think she was in Cheltenham with Robert's people but actually she's been staying with Robert a few hundred yards from here. She's been having the business that I told you about put right artificially – that's why I was almost crazy with anxiety last week, my darling. I couldn't get any news of her because she hadn't told Robert I knew

* A Cairo-born Ottoman diplomat, the prince was involved after the First World War and the fall of the Ottoman Empire in Middle Eastern Arab politics.

about it & I had to put up a terrific show at home – as far as my parents were concerned, darling, everything was normal – everything was grand. Today she told Robert that I knew & I went to see her after work. Darling, she looks appallingly ill but she says she's very well & very happy & that everything went off splendidly. (My God!) Then she walked a little way along the road with me & said suddenly that she was going to live with Robert very soon. I felt very faint, darling & said: 'You mean you're going to marry him?' She said, no, that he was not prepared to be married yet – his last marriage had been a failure because he'd entered into it too suddenly – but that she couldn't live away from him so she was going to move into his flat. Darling, it was as though I'd been hit over the head. I said: 'Joan, I've never been so distressed about anything that was happening to someone other than myself in all my life. You have said a hundred times that you couldn't bear the lying & the sordidness of a situation of that kind – And it would be one lie on top of another. Could you go to your family & say to them: "I'm going to live with Robert as his wife, because he doesn't want to marry me yet?"' She said she would, darling, but I simply don't believe her. I said: 'Well, when you come and tell me that you've said that to them, I shall reconsider the whole situation.'

Darling, I've watched this relationship from the beginning and although Robert is a man of immense charm and intellect I think he is more selfish than anyone I've ever known. He mixes in a set of people who have no standards & above all, no sense of emotional responsibility. The Great Thing is to Express Oneself, and everything & everybody else can go hang. Up till now he's only met people like himself – people who tossed aside their families, their friends, everything for the sake of their own personal whims. (His remarks about the women he'd known at London University were very illuminating in this connection, darling.) But Joan is not like that – she needs her friends and her family & he wants to uproot her – to wipe out her entire background & all her interests at one blow – for his pleasure – and because she's infatuated & has just emerged from a gruelling emotional & physical experience, she'll agree to anything. I said: 'If there were any obstacle to your marriage, Joan, I would gladly say, "If you love him it's right that you should live with him as his wife," but there's nothing in the

way of your marriage except Robert's personal notions – It's childish and utterly fantastic & I can't pretend that I can condone it in any way,' and I left her, darling. I was trembling violently & I felt really ill, particularly as she looked so terribly pale and thin – but I couldn't let it pass without making a stand. It's only for her sake, darling, only for her own sake. I can't bear to think of her living as Robert's mistress until he gets tired of her & blandly & with the utmost charm, turns to some new form of amusement.

I liked him so much, darling, that I believed (in spite of his short-lived first marriage, in spite of the fact that Victor, who knows him slightly & who has psychological acumen far beyond his years said: 'Oh yes, grand company but thoroughly unreliable with women') that he would make Joan happy. Now, I don't know what to believe, darling. Joan may love him in her own way, darling, but it's not love as I understand it. If I felt sure, even of her love for him, I would say perhaps she'll be happy in spite of everything – but I'm not sure even of that. Oh! thank God, my darling, that I'm going to marry a man whom I trust in my soul – a man who has proved his unselfishness & miraculous gentleness and consideration over a period of years. Darling, I didn't know how wonderfully & miraculously lucky I was until I saw Joan's dark startled eyes tonight against a painfully white, drawn face. It's the most terrible experience I've known – since the Blackpool business. In a way it's worse than that because, in that instance, I had my knowledge of the essential goodness and rightness of my love for you to hold on to and the unshakeable certainty that of all the men I'd ever known you were the most honourable and the kindest. I must put out my light now, darling, I hope to God I shall be able to sleep.

TUESDAY 1 SEPTEMBER Darling, I was feeling so ill when I got home tonight that I went straight to bed. Then Joan came home & we talked for a very long time & I implored her not to be wanton any more with Robert until they were married – because, darling, I just can't bear to think of what might happen to her mental & physical health if she had to go through all this again. I got quite hysterical, darling, & I couldn't stop crying & the perspiration was soaking through my pyjamas – But I think it's going to be alright now, my dear love, and I feel happier about her than I have for weeks. She

was even able to laugh and tell me that Mr Morris (her Principal & the husband of the Female Weeder, Grade III, you remember, my love?) had Found a Candidate for her Hand – a Farmer who was Contemplating Taking a Wife come Dung-Slinging time. I'm going to talk to Robert, darling, & try & make him see my point of view. It's worth it, my dear love, for Joan's sake. Please tell me that I've acted rightly & fairly for Joan's interests in all this. It matters to me so much that you should not think that I've been stupid or unkind or muddle-headed. It's one of the hardest things in the world to know how to act when one's friends are in trouble, darling.

Poor Sheila, she wrote me such a sad letter yesterday saying that it would be the second anniversary of her wedding in a few days' time and that she felt like Hell though she was trying to keep her sense of proportion & to remember how much more trying conditions were for Allan.

Darling, I'm as limp as a dishcloth after my terrific emotional catharsis but, in a way, I'm tremendously relieved because there's a hope that Joan's tangles may, after all, straighten themselves out easily & naturally. Oh! my darling, I'd gladly give 20 years of my life to have you here <u>now</u> – for an hour.

THURSDAY 3 SEPTEMBER I've had another letter-card from Aubrey, darling. He says the Smouthas have Migrated to Palestine. This is how he describes them: '... a family of indecent opulence, even for Egyptian Israelites, but full of resigned benevolence towards the Universe as long as it was prepared to conduct itself on sound business lines at a round six per cent.' A description of almost terrifying clairvoyance, darling. He also says, darling, that on seeing his portrait in Oils you remarked, in the presence of the Artist, that it was a good likeness in itself, but that it wore an Unwonted Air of Indigestion.

MONDAY 7 SEPTEMBER Darling, Helen Huxley told me a very sad story about Ram Nahum. Did you know Winifred Lambert? I only knew her by name. She married Mouse Vickers during one of his leaves. They only had a week together when he was whisked off to Greece where he was taken prisoner. She was living with Nahum when they were bombed, and, as I think I've already told you, she wasn't

killed, but had to have both legs amputated – and now, darling, her husband is bound to find out that she was sleeping with Nahum on the night that he was killed. This sort of thing makes me furiously angry, my darling. I can bring my relativist judgement to bear on cases of infidelity where the husband is overseas and is indulging in the same sort of thing himself – but I can't swallow this, darling. I think nine out of ten women of our generation are lacking in guts. Because their husbands or their lovers are away and because they're lonely & unhappy, they drift into casual liaisons without any thought of what repercussions it may have on the men who have been uprooted, whose professional training has been suspended & whose whole lives have been unsettled & disorganized. Damn them, lewd minxes. It was a real comfort to hear Helen talking of her fiancé with serenity and unshakable loyalty after he'd been in India for two years. It almost looks, my dear love, as though loyalty were a dying virtue – It's all part of the Dead Hand of Cynicism which is so dangerously fashionable. The Theory is: nothing matters anyway so what the Hell? Oh! darling, it makes me so unhappy. What signs are there in all this that there is any hope of a brave new post-war world?

TUESDAY 8 SEPTEMBER Darling, Jean is contemplating marrying Square when he gets back from Canada. (He flew over with the first Lancaster – which is no secret, my dear love, as his photograph was in all the papers – at least there was a photograph of the Lancaster in all the papers and an indeterminate blur beside it, part of which (Jean says) was Square – but they do say Love Distorts the Vision, my darling, though, in my own case, I've discovered that the assertion is pure nonsense.) Square would be rather entertaining as a cousin-in-law, darling. He is a man of exceedingly good taste – in furniture, pictures & food & at the same time, he's a simple soul. When anybody else thinks of getting married, darling, I always prop the Candidate Up against a Wall next to my Solace, and he (the Candidate) always topples down in an inconspicuous & uninspiring heap – and I give an ineffably smug and happy little private smile – but don't tell my friends, darling, they mightn't like it. (Joan Suspects, darling, and has occasional Bursts of Fury but No one else Knows – except you.)

Darling, two Beautiful things happened while I was at the War Office. A Peppery Colonel at another desk answered the telephone and said: 'Hot Baths? Hot Baths? What on earth are you talking about? Oh! <u>Horse</u> Guards.' And then a very High Horse Guards Official was put onto my major who said: 'I don't know <u>why</u> you aren't getting boiled sweets from your NAAFI sir ... no, sir ... of course, sir ... Will Barley Sugar do, sir? ... Certainly, sir.' That Lifted the Pall of Gloom a bit, my dear love.

I am reading *Crime and Punishment*, darling. What a Titanic figure Dostoyevsky is, darling. What a master of Symbolism at its highest. With what infinite subtlety and sensitivity he explores every cranny of delicately balanced minds. Oh! darling, there's no doubt that he's the greatest novelist of all time.

Darling, a telegram has just arrived for Joan from Ian. My mother opened it by mistake. It just says: 'Count me out. All the very best.' Oh! darling, I don't know why this makes me feel so unhappy – but it does. I think that, if Joan had waited steadily and unwaveringly for Ian, everything would have been alright when he got back. But it's not in her nature, darling, to cut the erotic element out of her life altogether for years at a stretch. She simply can't do without it (though she'd never admit that, my love) but I'm so sorry – so sorry.

Darling, I had a very happy afternoon with Edith Carlyon. She was rather tired & depressed I think & she wasn't bubbling over with anecdotes but she told me that one night when Ninette de Valois was making a <u>fantastically</u> silly speech at Sadler's Wells – introducing a new choreographer & saying 'you see how it is – I mean, one doesn't run a theatre for one man's plays' and Dauntless old Lilian Baylis – who had been sitting in the front row of the stalls bellowed across the footlights: 'I think you're forgetting Mr Shakespeare, dear,' which rather appealed to me.

Darling, Joan came to dinner tonight. She's spending a fortnight with Doris Spicer, a family friend. I've told you in my letters, darling, though they may not have reached you yet, that Robert wants her to leave here and live on her own. Last time we talked about this she was determined not to do it because

she knew how much it would hurt my parents – but now it's quite obvious that Robert has talked her round & she's determined to go, whatever the cost. I feel very resentful about the whole thing, darling, because though I can see her point of view very well, I think Robert makes very exacting demands on her all along the line – and she capitulates every time. It seems to me that he takes everything he can get & is prepared to concede nothing in return – not a very happy foundation for marriage. He is determined to get married in his own time – not in Joan's – and oh! darling, there's a lot more in it than that, but I've told you all about it in my letters. I wish I could persuade myself that Joan was old enough and wise enough to look after herself – but she's not, my darling, and Robert's attitude to women is extraordinarily callous and hard-boiled. He may be a Man of the World and very experienced and all that – but there's none of the gentleness and tolerance and wisdom of my dear love about him – none at all. Oh! I'm worried for Joan, darling – so worried.

THURSDAY 17 SEPTEMBER Darling, I had a very interesting lunch at the Egyptian Embassy. It started badly because the taxi driver took me to the wrong door and a startled Irish Maid in Curling Pins opened it a crack. I looked a little surprised and said I was expected to lunch. 'Oh! No, indeed you're not,' she said. 'Lady Jessel is expecting nobody.' I apologized, darling, and Fled Precipitately. Amr Bey, the world squash champion was at lunch. I didn't speak to him much. He is a dapper little man & his English is better than the Ambassador's, which is saying something. Nashat Pasha was in Berlin for 10 years, darling. I asked him what he thought of the German Leaders. Of Goebbels he said: 'He's a brilliant man – a mind as sharp as a razor. One of the most fascinating conversationalists I have ever met – but no morals unfortunately.' He said that Hitler only had two ideas – one was that he was a Great Man – The other was that the Jews were the Curse of the Earth – any other idea he might have only entered his head on a short lease or could be blown in and out by the lightest breeze. 'He never tells a lie or intends to break his word,' he said. 'It's simply that he becomes a whole-hearted supporter of any scheme that's put to him (except if it affects the Jews or himself) until someone comes along with a

new one which drives the first one out of his head.' He added: 'He's house-painter.' I forebore to remind him, darling, that Christ was a carpenter, but I did say: 'Oh! but surely that needn't necessarily have anything to do with it' – and he said: 'Oh! but I mean he's a house-painter in character – though he is no longer a house-painter by profession.' Of Goering, he just said, 'Pouff' and I felt that there really wasn't much more he could say. I was rather amused by all this, darling, it's rather heartening too because unless he was absolutely certain in his own mind that if ever he were sent back to Berlin, there would be new political leaders, I doubt if he'd have thought it advisable to give us the Low Down on the Unheavenly Triplets!

SUNDAY 20 SEPTEMBER Darling, Pa was very funny at lunch today about the Finns and the war. He said that the Finnish Ambassador had pointed out in Washington that the Finns had never accepted the German attitude to the Jews. The Jewish population of Helsinki, he said, is carrying on normally – his shop will shut on Yom Kippur as usual!

I'm so terrified for Joan, my darling. I was talking to Mr Murray the other day & he said that he thought that the only thing to do in a case like hers was to try and shock her out of it – which is what I did, darling, but it was no use. The history of her relationship with Robert, my love, has been a shattering blow, not to her but to me – So much so that I simply find myself unable to talk to her now. I expect I'll get over it, darling, but for the moment I find the whole situation unendurable. She has thrust aside every consideration which seems to me to be important – loyalty to her family & friends, personal fastidiousness and honesty, her sense of proportion and values – everything. Do you know, darling, that when she read Ian's telegram, which distressed me so much when it arrived, she just laughed and said: 'How like him to make a Lavish Gesture at this stage of the proceedings.'

Darling, my sense of loyalty to Joan is undergoing a severe strain. I think she is a lesser person than she was and that she's let herself down almost irrevocably. If she leaves us just so as to be able to sleep with Robert with less subterfuge and inconvenience, I know I shan't be able to swallow it. Life is so

damned complicated. Oh! My very dear love, I want to be married to you and to live and work beside you and to sleep in your arms. I want to hear you say to your friends, 'This is my wife.' I want to learn to be a clever wife and a clever lover from you, my darling. I want to be alive again.

<u>TUESDAY 22 SEPTEMBER</u> Darling, I've had a terribly distressing evening. Joan, who intends never to come back to us, has been trying to enlist the co-operation of David & Sylvia & Jean in making things easier for her with my parents & me. She has told them half-truths & has made it appear that I'm taking up a wholly unreasonable attitude. David came to do a couple of hours' Greek with Pan this evening & we discussed it at great length – and I could see more & more clearly, my darling, that Joan had simply ceased to give a damn for any of the things I care about & there isn't any longer any common ground on which we can meet. I believe that her relationship with Robert will lead to nothing but another debacle. (Oh! my dear love, how glad I should be to be proved wrong.) I should have liked to have saved her from that but as it doesn't seem as though I can – she must go her own way. There is no point in our meeting and recriminating over and over again. She said to Jean that it was all very well for me to condemn her for adopting a line that would hurt my parents – but that if <u>I</u> wanted something & I could only get it by hurting them, I'd jolly well hurt them and be damned. Is that true, my dear love? I don't believe it is, but I suppose I'm as much given to self-deception as the next person & I think in some ways you know me better than I know myself & are therefore more competent to answer my question. David says it's no good my distressing myself – that Joan is old enough to lead her own life & that she's the sort of person who, if the Robert affair <u>does</u> end in disaster, will recover from it quite quickly & be quite happy with someone else. That may be true, darling, but in the meantime she has jettisoned every standard that she's ever professed. I don't <u>ask</u> that she should have <u>my</u> standards, my darling, I only ask that <u>she</u> should stick to her own – and that is exactly what she isn't doing. Oh! God. I am unhappy, darling – at the moment I feel very bitterly resentful – but in time I shall get over that & perhaps I shall be able to meet her on casually friendly terms.

You know, darling, I have an idea that Dicky will finish up as am Ambassador! His Diplomatic Machinations are so expert – even at the age of 14. On Sunday night he Took One Look at the Overcrowded & Stifling Overflow of the Synagogue & decided to go home, but he knew there'd be an uproar afterwards if he just walked out – like that – so he Pondered, darling, and a Great Thought Came to Him. He Came Over Faint, Rushed into the Street, Seized the First Passer-By and said dramatically: 'Take me back to 9 Harley road, I'm ill.' The Passer-By, presumably Stunned by the Suddenness & Unexpectedness of the Onslaught, complied meekly. When he got him inside the house, Dicky instructed him to ring up Dr Sillcock & tell him to Attend upon him Immediately. Dr Sillcock came, Diagnosed Nerves, took his temperature (which was 99 and no wonder considering the Dimensions of his Dinner!) and left – and Dicky Retired to Bed Triumphant – getting from my parents a due measure of hush-voiced sympathy instead of the Spanking he so Richly Deserved. I hope they make use of his Special Qualities at the Peace Conference! There's no doubt about it, my dear love, Poor Academic, Brilliant Pan will be left standing by Dicky, who has as much <u>real</u> intellectual capacity as could comfortably be fitted into a pea-nut shell. How like Life, Life is, darling, as Miss Carlyon was wont to say with such Profundity.

FRIDAY 25 SEPTEMBER Joan came to dinner this evening, darling, & Robert fetched her soon afterwards. I could find nothing to say to her, my love. I just felt desperately uncomfortable and inarticulate the whole time she was here. Oh! God, I hope I get over this soon, darling. Joan is too old a friend to break away from because of one mistake – one act of thoughtlessness.

Oh! Darling, Jean has just told me that she may be able to hold out prospects for me in your part of the world. To present Pa with the offer of really important & responsible work for me, my dear love, would be the best way of persuading him & my mother to take me to you or even to let me go to you alone. We could live together in the Bungalow, my darling, and we could be so incredibly happy. Oh! God be good to me and take me to my very dear love, to live with him and sleep in his arms as his wife.

<u>SUNDAY 27 SEPTEMBER</u> My mother is too far-seeing by half, darling. She came in just now to ask me if I'd quarrelled with Joan. She said she'd felt there was something queer in the atmosphere when Joan was here the other night. I said I hadn't, darling & it's true. Oh! darling, I'm going to make a real effort to smother my prejudice & resentment. The other night, when she was here, my mother asked her if she was thinking of getting married. She said: 'Oh! no, Robert may be going to America soon – I wouldn't go with him just as a wife – and I haven't a job to go to.' Now, darling, she's always said that she wanted to give up working when she & Robert were married & have a child. It looks frighteningly as though Robert doesn't <u>want</u> to marry her. That wouldn't matter, darling, if it weren't for the fact that he asked her to marry him before he slept with her and that <u>she</u> undoubtedly wants to marry him. If she'd gone into her relationship with her eyes open it would have been a different matter – but she <u>didn't</u> – and because Robert is completely insensitive to the emotional implications of a woman's love (you've forgotten more about that, my darling, than he ever knew) his actions are likely to be terrifyingly unaccountable. Oh! darling, I can't be angry with Joan. I have no right to pronounce judgement on the validity of her love. Whatever else it may be it is a predominately <u>generous</u> kind of love and if you're bent of giving everything he wants to a particularly selfish and grasping kind of person you can't help hurting other people in the process – but oh! I do wish. Darling, that she'd loved someone gentle and kind and protective – Someone a little like you, my dear love.

<u>MONDAY 28 SEPTEMBER</u> I had a very unsatisfactory day yesterday, darling. I got up so late that Aunt Teddy & I had to take a taxi to meet Jean at the Waldorf for lunch. Aunt Teddy said she couldn't afford a Taxi so I said I'd pay for it – and, not content with that, darling, and just to make the position Quite Clear she said just before we got to our destination: 'I haven't any change, dear,' to which I replied rather sharply I'm afraid, that I'd <u>said</u> I was going to pay for it. Is *Schnorrer** the kosher word I want, darling? I believe it is.

* *Schnorrer* is a Yiddish word meaning beggar or sponger.

Darling, Jean's friend Square has just come back from America and he brought her – a lemon! She's promised to show it to me next week if it's still there.

<u>SUNDAY 18 OCTOBER</u> Dr Minton came to see me yesterday, darling. He poked me in the stomach & was vastly gratified to find that I didn't flinch. Then he looked at my throat & said that though it was inflamed there was no infection, which was very satisfactory considering the state of my tonsils. Then he said suddenly: 'You're not happy, are you?' I smiled sadly & said I could hardly be expected to be happy when I was separated from you for an indefinite time, darling. He said: 'You live in the past, don't you? You must look forward to the future, you know' & then he asked me, darling, if we'd ever been Wanton. (At least he used a more Technical Term than that, my love, but you don't mind if I translate what he said into our idiom, do you?) I said that neither you nor I had ever been wanton with one another or with anyone else. He asked how old you were, darling & then he said: 'It's a very rare and fine thing for a man of 25 to have conquered his impulses for so long – it will make your marriage very much richer.' I asked him, darling, if this lean & sallow abstinence was dangerous to your health. & he said: 'No, Sexual Continence is never harmful in a young man. It becomes harmful between 35 and 40 but before then it strengthens the character. I have a very wide experience of sexual cases and I've always found that the most loyal & passionate husbands are those who have controlled their impulses before marriage.' He added, darling: 'You know, of course, that these impulses do exist in every normal young man?' I said I did, darling & I asked him if he thought it would have been better for you if we'd been lovers before you left. 'Oh! no,' he said. 'I'm very glad you were not though most people would have been in the same circumstances. Your separation would have been much more painful physically for both of you if you had been.' Then he looked at me very shrewdly, darling, & said: 'You're craving for it now, you know, though you may not be aware of it – You've certainly no need to be ashamed of it.' (I said hastily that I wasn't ashamed of anything about my love for you.) 'It's very natural. As a doctor, I should be much more worried about you if you were not.' He went on: 'You're highly

emotional & highly sexed – but you're rather a Curious Case because you're completely Monogamous and that makes everything much harder for you.' He looked at me again for a moment, darling, & said: 'You never desired any other man, however handsome or attractive & you never do now, do you?' When I said I didn't he nodded wisely & said: 'I know.' Then he smiled & said: 'You're lucky, you know, because when you & Gershon are together again you'll get far more from your love than most people ever dream of.' He went away leaving me much comforted, my darling.

Last night while I was seeing Duncan I heard this conversation between Pa & my mother:-

> Pa: 'It's immoral to blame me.'
> Mum: 'It's no good – we can't get on together any more.'
> Pa: 'But I was only advising you.'
> Mum: 'I have a Mind of my Own & a Will of my Own and I must Go my Own Way.'

Good Lord, I thought, is our house Disintegrating? And then Pa said: 'After all, darling, you must remember that it was my Call – I said 2 hearts if you remember.' They were talking about bridge, darling. I laughed so much that I set myself a-coughing.

Darling, on Thursday I'm moving out of Mr Murray's room so as to be with the two Principals & the other assistant Principals in the Division. Oh! Woe. I shall miss our Philosophical Discussions. Never mind I shall go on Bobbing in and out of his room and talking of This & That whenever I find him disengaged.

<u>WEDNESDAY 21 OCTOBER</u> Darling, Mr Murray has just Decreed that I am to drink coffee with him every morning after I have moved my quarters and that if I have any ideas, Philosophical, Sociological or Literary, I am to lay down my pen & books & come straight into him and talk. 'Otherwise,' he said, 'I shall be denied the spiritual food which I have grown to expect since you came into my office.' It was providential, my dear love, that I should have been taken away from the distressing influence of Mr Crotch's easy & almost

adolescent cynicism and put into the care of Mr Murray, with his great wealth of culture & serenity & faith – so that it was possible always to look into the future (our future, my darling, yours and mine) instead of at the muddle & frustration of the present.

MONDAY 26 OCTOBER Darling, your letters 34, 37 & 39 were waiting for me when I got home this evening. So you're learning to ride, darling? Good – I like riding – we must ride together in the desert as soon as it's cleared of Nazis.

Oh! darling, I can't explain Joan's attitude to wantonness – I don't understand it at all. You can suspect you're going to have a baby, darling, a week after it's started, by Not Being Decadent at the right time. After 3 weeks, when you're sick in the mornings & always fainting about the place as well, you can be pretty sure, although a doctor can't confirm it until it's been developing for about 6 weeks. Please, darling, don't have 'occasional lapses or (if you can bear to wait for your little Solace) pre-marital experiences'. I'm a selfish little cluck, my dear love, but I love you so much that it would make me tremendously happy if you could wait to be wanton for the first time with me – but if you can't wait, my darling, you know I shan't love you less – provided you give me your word that it's necessary to your well-being and happiness.

WEDNESDAY 28 OCTOBER I had a long letter from Sheila this morning, my dear love, all about Joan. She says: 'Judge not lest ye be judged' and suggests that the teaching of Christ on the subject of forgiveness is worth considering. In reply, my love, I pointed out that Christ's forgiveness extended only to those who were repentant or who had sinned through ignorance. Moreover, it's only people of very high spiritual development who can accept a standard lower than their own & yet keep their integrity. I am not so highly developed.

SATURDAY 31 OCTOBER Darling, I was just paying for a very Dreary lunch in Fullers (everything was 'Off') when the girl at the Cash-Desk Hissed in my Ear Conspiratorially: 'Would you like a cake?' and Before I Knew Where I Was I was walking down the Strand balanc-

ing an <u>enormous</u> lemon layer cake in the palm of my hand. I've never been the subject of so much Attention in my life, darling, as I was during my journey across the 100 yards or so which separated Fuller's from Bush House. If those Glances of Eye-Popping Desire had been directed towards me instead of towards the cake, darling, I'd have felt constrained to Call a Policeman! I shall take it to David & Sylvia this evening, my dear love. No doubt they'll be able to Demolish it at Sunday tea.

Darling, I overheard a Wonderful Conversation between our cleaners in the cloakroom this morning. It ran thus:

> 1st Cleaner: 'I bought an underset the other day, dear, and the man said: "That will be seven Coupons." I said, "You'll excuse my mentioning it but my daughter bought an underset the other day and she only gave six Coupons." So 'e said: "Ah! Yes, but your daughter 'ad open French knickers and you've got closed ones."'
> 2nd Cleaner: 'An Extra Coupon for a piece of elastic? Fancy now!'
> 1st Cleaner: 'Yes, dear, and when I told me mother – eighty-one she is, she said: "So now they charge you an extra coupon for being Respectable? No wonder things is all upsy down."'

And, darling, there's no doubt that there's Something in what the Old Girl Says.

<u>WEDNESDAY 4 NOVEMBER</u> Pa was in the Antique Art Galleries today, darling, and he saw a man whose face was very familiar buying Battersea Enamel Decanter Labels. After he'd gone Pa said to the woman in the shop: 'I'm sure I know that man. What is his name?' She told him, darling, that it was Laurence Olivier and that he was buying the decanter labels for his wife. (Vivien Leigh, darling, though Pa wasn't aware of this.) He had told the woman that Vivien Leigh had only had one hat since the war started & that all her friends had implored her to get a new one or to buy some sort of decoration for her old one to make it look a bit different, so he was giving her the decanter labels mounted on hat pins, darling,

so that she could have a brandy label in her hat one day and a claret one the next and so on!

FRIDAY 6 NOVEMBER Darling, I'm dining with the Nathans tonight. I never felt less like a Social Outing in all my life. It's almost past the time when my mother might ring up to say that there was a letter for me, & the telephone is as Silent as the Grave. Oh! my dear love, I really am on the edge of hysteria. Oh! Hell, darling, if my mother doesn't ring me up soon – I shall scream. I've just been discussing with Mr Needham, the Gloomy fact that everything Lethal these days is either Rationed (like Gas and water) or unobtainable (like almost any of the poisons you could name). Of course there's always hanging but I expect all the Aluminium Hooks were swallowed up in Beaverbrook's Spitfire Drive & the iron ones went with the Duke of Bedford's railings. A girl can't even Snuff Herself Out in Comfort in these Hard Times. No, darling, I think we'll stick to our original agreement. I shall live until you grow tired of me & then you'll smother me from humanitarian motives. Oh! My dear love, I'm so desperately unhappy. I can't be flippant any more – I can't.

SATURDAY 7 NOVEMBER Dinner with the Nathans last night was rather entertaining, darling. His Lordship was away so Lady Nathan, Joyce, Bernard Waley Cohen (who still Hovers Hopefully) and I dined à quatre. The piece de resistance of the meal, darling, was a Duck which Lady N carved with noticeable clumsiness. Then after we'd demolished all the politer portions of its anatomy, my love, Bernard & I simultaneously asked for the carcass. I chopped it in half, darling, & Bernard had the Fore and I had the Aft and you should have seen her Ladyship's face as we wrestled with the Bones. If ever the comment 'She'll never be the same again' was justified it was then! After dinner, darling, I initiated Joyce into the Art of Tapestry (which was why I'd been asked) and then Bernard offered me a lift home on the back of his bicycle – a proposition which seemed to me to be neither Seemly nor Safe, so I Declined with thanks & Took a Taxi.

SUNDAY 8 NOVEMBER Darling, this morning's papers are full of the American landing in North Africa. If this comes off as a coup – as it seems it must – it looks as though the Middle East will be free of Germans in quite a short time, my darling. What then? Will you be sent home or shall I take further steps to try and get to you, my dear love?

WEDNESDAY 18 NOVEMBER Joan came to see us yesterday evening. She had had dinner with Robert & his Ex-Wife* the night before. I'm glad you haven't got an Ex-Wife, darling, at least not a real one. I couldn't make a Thing of Her like Joan seems able to do. I should just sit and Glower at her with Deadly and Unabated Loathing. If I'd been Joan, my love, the dinner party would probably have finished up by my dropping an arsenic tablet into her coffee. Oh! well, I suppose it Takes All Sorts to make a World, darling.

FRIDAY 20 NOVEMBER We had a dinner party last night, my love, & Dr Minton was one of the people there. He told my mother in no Uncertain Terms what I've often said less brutally, & that is that Dicky has a mild form of Oedipus Complex & that she encourages him up to the hilt – and so she does, darling. She has him in bed in the mornings & both She & Pa love him to slobber over them. Pan & I look upon Dicky as the Goneril & Regan of our family, darling, to our joint Cordelia. Pa at least really believes, darling, that because Dicky is always hanging round his neck that he is fonder of him & my mother than we are whereas actually while Pan will go to tremendous lengths & personal inconvenience to spare my parents pain & I will too, to a much lesser extent, Dicky won't put himself out a millimetre for them. Oh! darling, I wish my parents would realize that they're not doing him a kindness by their attitude.

TUESDAY 1 DECEMBER Darling, December has started well. Mum has just telephoned to say that there are two letters waiting for me at home. If I had a bonnet, I'd toss it over a windmill, always assuming, darling, that I could find a windmill. (I do love windmills, darling, don't you?)

* The actress Jenny Laird, real name Phyllis Edith Mary Blythe (1912–2001).

Aren't you being a little Disingenuous, my darling, to suggest that I might not like wanton letters? Do my letters sound as though I wouldn't like them? Have I ever behaved as though I mightn't like them? My Silly Darling Solace, I love them. Let's have lots more – and Pooh to the Censor.

MONDAY 7 DECEMBER Darling, I met the postwoman on the way to the 'bus this morning and, with Magnificent Nonchalance, she Handed me Letters 47, 48 and 49 (Parts 1 and 2), with the result, my love, that I'm quite sick with nervous excitement & happiness.

Now about Bosoms, darling. I have seen <u>dozens</u> of my contemporaries in their baths, and none of them have firm or resilient bosoms. (Even Sheila, who has a really beautiful body, my darling, hasn't the sort of bosom that you see in *Lilliput*.) I've discussed this subject impersonally with doctors & some of my friends, darling, and it's generally agreed that except in the case of ballet dancers and professional athletes, the muscles of a woman's breasts begin to slacken between the ages of 18 & 21. You'll notice, darling, that in most magazine photographs the women are either lying flat on the ground or have their arms above their heads but because I love you so much and because I would do <u>anything in the world</u> to give you pleasure, I'll do deep-breathing & arm stretching exercises every morning & evening in the hope that it may have some effect.

How typical of Said to try & polish your carpet slippers with Cherry Blossom, my darling. He hasn't changed at all since I saw him last.

With the 9 letters I had from you today, darling, I got one from Aubrey. It's a masterpiece of Spacing, darling, Never was so little said in so many square inches of paper – but it was as beautifully phrased as it was beautifully spaced – so I didn't mind. He tells me of his third pip and says: 'I believe that it was done in deference to my conveyance which always carried me with an aggrieved air, as though I was Beneath Its Station. Now the proprieties are appeased.'

Darling, I've been leaving your thoughts about what Dr Minton said to me till the last because I wanted to answer them very fully. (Mum has just been getting Agitated because she says I

ought to be resting instead of writing, but I know it's best for me to be talking to my dear love.) Oh! my darling, how could you believe that I could possibly laugh at you? I do understand your feeling of frustration with all my heart, my darling. I understand that you can't help feeling at times that you've been cheated of something that other men have known, but is it wishful thinking on my part, darling, that you're going to have something that those other men have not known – something perhaps less usual & commonplace & that is your first complete sexual experience with a woman who loves you with all her heart & with all her soul & body and who lives only for your pleasure & your happiness, my darling. Your guarantee of fidelity is the best that I could possibly want, my very dear love, for it grows out of the great unselfishness & tenderness for which I love you more every hour, every minute. I'm glad, my love, that 'there is a substitute for sexual intercourse', which can give you some measure of relief. You see, darling, I have grown to understand, through my great love for you, that you have physical needs which must be satisfied but I can't think of any relationship with another living person as being simply a satisfaction of a physical desire. Darling, it would be impossible for you to 'be with' another woman without comparing the experience in some way with our experience together & that is what I couldn't bear. Do you understand, my darling? It's not so much a moral question as an intensely personal emotional one. Darling, you are keeping to your chosen path finely – all the more finely because you are so splendidly honest morally with yourself & with me.

TUESDAY 8 DECEMBER The Shadow of Impending Aunthood was across Aubrey's brow, darling as he wrote the letter-card which reached me yesterday. Why, he asks, does his sister Do These Things, without consulting him first? – and he asks with more than a faint note of plaintiveness in his voice.

It may comfort you to know, my darling, that Miss Bradbrook & your Rival (?!!) C. S. Lewis are at Daggers Drawn. He told an unkind little story about her (not by name, of course) and Peter Rabbit in one of his books & she's never forgiven him. (He was her Tutor, darling when she was Researching at Oxford. When I saw him for the first time I said to Miss Bradbrook: 'I never

expected him to be like that. He looks like a Prosperous Publican.'
'He is like a Publican,' she said unkindly. 'Exactly like a Publican.'
But it's no good, my darling, she respects his intellect as much as I
do & as any medieval scholar couldn't fail to do since he has writ-
ten the finest piece of Medieval literary criticism of our time &
perhaps of all time.

FRIDAY 11 DECEMBER Darling, Miss Malyon is a fool! I noticed when I
took Mr Murray his coffee that she was reading Turgenev & I asked
her if she was interested in the Russians. She said she didn't know
much about them but Tchekov puzzled her because all the people
always behaved in exactly the opposite kind of way from herself. I
suggested, darling, that she should read *The Brothers Karamazov* &
she said that she'd read *Crime & Punishment* but had found it
Depressing. I said that I didn't see how a book could be depressing
when it was a study of complete regeneration through suffering
(which is the essence of great Tragedy, darling, & tragedy is never
depressing. It is only when nothing is resolved, when the windows
aren't opened & the atmosphere of suffering is still stifling at the
end, as in *Measure for Measure* & *Troilus & Cressida* that depression
comes in at all). This seems to me so elementary, darling, that I
can't understand how anyone who read English for 3 years can be
so obtuse. However, there it is. Mr Murray listened to our conver-
sation (which I'm afraid, darling, tended to be rather Unilateral)
with obvious amusement. I could see him thinking: 'There's Eileen
Alexander up against something she can't cope with at all &
doesn't it make her irritable.'

Joan & Robert hadn't very much to say tonight, darling.
Joan has got fatter & Robert looks very tired & almost middle-
aged. Robert's ex-wife is living in London & is going to broadcast
with Vivien Leigh in *The School for Scandal* on the first Sunday after
Christmas. Joan & Robert spend a lot of time with her, darling, &
it struck Joan as irresistibly comic that the other night at a rather
Drunken & Riotous Theatrical party, their host kept introducing
Robert and Mrs Ex-Robert to everyone as husband & wife & Joan
as the wife of someone she'd never met in her life before. I don't
know if something has gone wrong with my sense of humour at all,
darling, but it didn't strike me as even mildly comic.

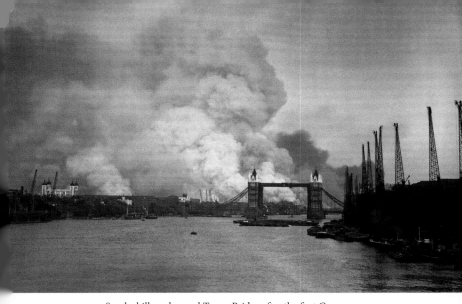

Smoke billows beyond Tower Bridge after the first German
air raid of the Blitz, 7th September 1940.

St Paul's Cathedral narrowly dodges destruction, 1941.

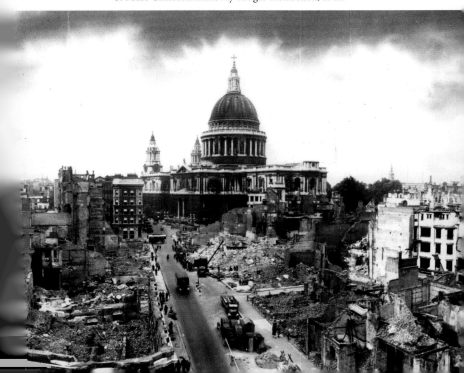

Eileen Alexander.

Gershon Ellenbogen, *c.*1947.

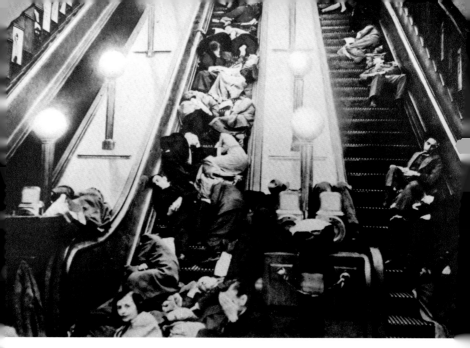

London Underground
escalators packed with
people sheltering from
an air raid, 1941.

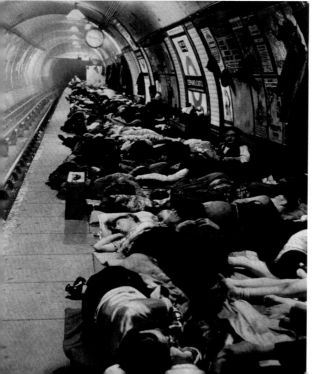

Crowds of people sleep
on the platform of
Elephant and Castle
London Underground
Station, 1940.

The twin guns of the anti-aircraft battery at Primrose Hill that Eileen so often
heard answering the German bombing 'in no uncertain terms'.

Eileen and her father.

Eileen.

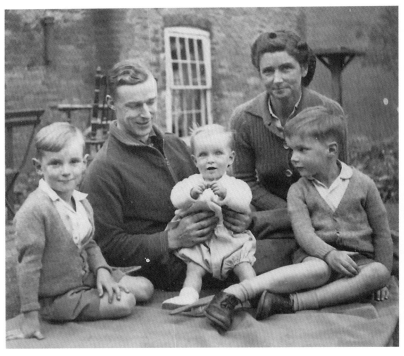

Oswyn Murray's family (Oswyn left) around the time Eileen visited in summer 1943.

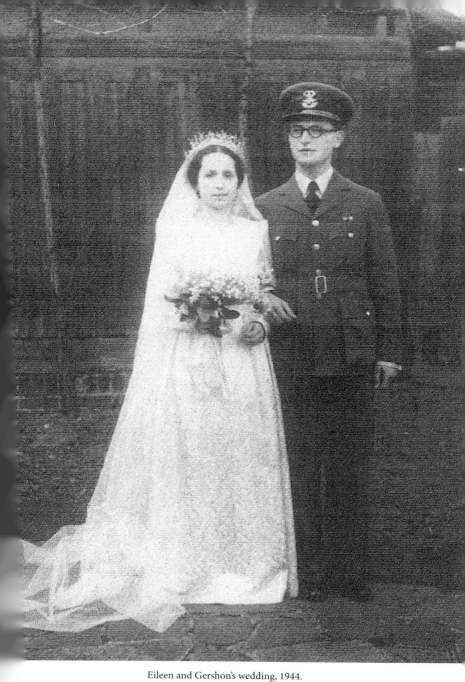

Eileen and Gershon's wedding, 1944.

Katherine 'Kate' Ellenbogen, Gershon and Eileen's daughter, was born in January 1945. Pictured in 1951.

Kate's wedding to Peter Whiteman, 1971 (Gershon right, Eileen third from right).

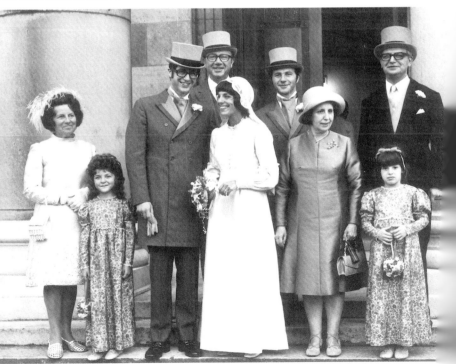

I'm not looking forward to Joyce's party tomorrow, my love. Joan & Robert are going too & we're wondering whether we're going to get a Real Meal or just a Well Bred Snack.

SATURDAY 12 DECEMBER Darling; First Impressions of the Party before I've had time to Embroider it in my sleep. A Captain Norman Hoptoph, who said he had known & liked you (I should hope so, my love!) at Cambridge & who was now doing Psychological Tests in the Army said he wished you hadn't had such an Inferiority Complex about yourself as a psychologist, darling, because you had struck him & everybody else as an 'extraordinarily brilliant chap who just wouldn't listen to anyone when they told you so'. (A nice man, darling. I Warmed to Him at once.) We had a terrific argument about Philosophy & Sociology & he said that in trying to Reform the World you had to take into account the fact that the average level of intelligence was very low. I said I wasn't prepared to believe that & he said he knew it was. Then the Devil got into me, darling, & I said: 'Your Intelligence Tests told you, I suppose?' He said he had got that impression from them so I said: 'Do you consider that there are any other Criteria of Intelligence besides Tests? Would you say that it was not possible to get a First at Cambridge for instance without being Intelligent?' He said he would certainly say that – so I said: 'Well, suppose I told you that I'd had a first at Cambridge but that I'd been doing intelligence tests regularly every 3 months since the age of 5 and had never got more than 5%.' He looked stunned, darling & said that they must have been Wrongly Administered or Something. I said Not at All – the Most Eminent Psychologists in the World had agreed that my intelligence was that of a youngish age & had found me Very Interesting. At that point, my love, Bernard announced that the Taxi was ticking away & I left Joan (who hadn't been in on it before) to carry on the argument. (I hope she didn't give me away!) Actually, darling, I only did one Intelligence Test in all my life. I don't remember whether I distinguished myself but I don't believe I did. I was Harassed by the Time Limit I remembered & very Bored by the questions which seemed to me to be leading Nowhere. And now I've gone and given Captain Hoptoph the impression that you're going to marry a girl of sub-apiary intelligence. I wish

I didn't Warm Up to a Good Story quite so enthusiastically, darling.

Darling, I'm not very happy because I was going to go to the pictures – & then Mum pointed out that it was the day of National Mourning for the Jews – but she pointed it out so Censoriously that I said Defensively that I was going anyway. Oh! darling, I hope it's not callous of me. I don't feel callous about the sufferings of the Jews or any of the other suffering peoples of Europe – but I don't see that much could be gained by sitting at home & brooding on it – but now I think I oughtn't to go & yet I don't see what good it could possibly do not to go. I'm in a dreary enough frame of mind as it is. And my parents have just had a terrific scene over Bridge & after considerable Storm Effects, Mum has Stumped Upstairs to bed – I hate my parents to quarrel, darling, & Bridge seems such a bloody silly thing to quarrel about. So there's thunder in the Family Air & I made an Ass of myself at Joyce's party.

SUNDAY 13 DECEMBER I feel dizzy & exhausted & enraged with Pa who stayed in the morning room till 3.30 this morning in a Pet with Mum over Bridge – so, of course, she didn't get any sleep. He's like a child, darling – like Dicky in fact. Mum has been mildly annoyed with him about something for a week or two (I believe it's over smoking! He's always Vowing to cut his smoking down to 10 a day & then he Consumes his 10 before dinner & if someone deals him a good hand at Bridge or the 8th Army advance 100 yards in the 7 o'clock news or someone in Parliament says something Complimentary about the Beveridge Report, my love, he says: 'Vic, darling, you'll let me have an extra cigarette to celebrate that won't you?') so she's been rather Distant with him – you know, the Do-What-You-Please-I-Have-Ceased-To-Care Line, darling. He hasn't said much about it, but I could see that he was very hurt & the whole thing Flared up into a First Class Row at the Bridge table. It may be a good thing, darling, because it should clear the Air & make them both feel better.

You know, darling, I've never approved of Mum's view of a woman's function in a love-relationship. She's very proud of having kept Pa dangling for years. She says that that is what made

him 'respect' her – and occasionally she reverts to the coquettish Genre even now combined with more than a touch of masochistic martyrdom & it makes me very angry – but Pa is much worse. (Oh! my God, he's just gone into the bathroom, darling, saying: 'I'm not saying a word.' That is always a prelude to a perfect flood of Ciceronian invective!) He behaves exactly like Dicky on these occasions. He's not happy until he has everybody crying & wishing they were dead – & after hours of Hell, he & Mum have a Terrific Reconciliation & he says: 'Have you got a nice chocolate, darling,' & they're both delighted with themselves – and only I am left with an after-taste of nightmare for weeks afterwards. It used to make me ill when I was a child, darling, but in the last few years I've forced myself into some measure of detachment & I've been helped by the realization (though it's rather a bewildered realization) that, in a queer way, they almost enjoy these scenes which, incidentally, have been much rarer in the last year or two – so much rarer that I was beginning to believe that my parents were growing up at last.

Five minutes later. Darling, it happened exactly as I said – Tears all round – Ciceronian invective – Beautiful Reconciliation – Reminiscences about their Happy Times together – with one slight variation – Pa wound up with: 'Let's hurry up & get dressed so that we can have a nice cupper coffee.' Darling, if I weren't so shaken I'd laugh.

You know, darling, Joan is trying very hard to show Robert to me in a very flattering light. Last night, every time he made some trivial remark in a flippant vein she laughed exaggeratedly & said over & over again: 'You know Robert never fails to amuse me – even after I've known him all this time & should be Indifferent by now.' (What I'd like to know is why on earth she should be Indifferent after she's known him 6 months? I've known you 4½ years, my darling, & I get less Indifferent every day.) And when he got up to get a cigarette she said: 'I don't know what I'd do without Robert to fetch cigarettes for me.' It gave me quite a pang, darling. There was a time when Joan didn't give a tuppenny damn what anyone thought of her friends & now she's striving almost hysterically to Put Him Across. I hardly know her, my dear love.

<u>THURSDAY 17 DECEMBER</u> Oh! My love, I've just had a most <u>fantastical</u> interruption in the form of a telephone call from someone in Public Relations to say that as a result of an article in the *Daily Star* about a dog who had been on operational flights over Berlin & Northern France & Belgium & who was now 'grounded' – & very Narked about it, they'd had a letter from the RSPCA asking for details of the instructions governing the carrying of dogs in operational aircraft! (I wonder, darling, whether they're annoyed because the dog in question is being Thwarted or whether they think he ought never to have been allowed up at all.) I referred them to KR's,* darling which says that dogs & cats & 'other canine or feline animals' mustn't be carried in Service aircraft. Mr Murray & I were much amused, on coming across the passage quite accidentally one day when we were looking for something quite different, to note that snakes, crocodiles, boars, bulls and rabbits could apparently be taken on operational flights with Impunity!

There are Plans Afoot to dislodge Aunt Teddy but I don't suppose they'll have the slightest effect – but, I shall, of course, keep you Informed of Progress.

<u>SATURDAY 19 DECEMBER</u> Darling, yesterday was a very distressing evening. I got home to find Pa Muttering Gloomily to Himself: 'I'm feeling very ill,' Mum very tearful, Aunt Teddy trembling violently & the colour of a bowl of porridge. Then Jean came & mingled her tears with the rest – and I was achingly sorry for everyone – for my parents because they <u>hate</u> being unkind & yet felt that unless they made some sort of stand they'd be saddled with Aunt Teddy till Doomsday – for Jean because if she <u>did</u> have her mother to live with her she'd have not a chink of privacy – not a moment of peace. Aunt Teddy is incapable of letting anyone else live their own lives, darling – but sorriest of all for Aunt Teddy because she hasn't a single interest in life & she's acutely conscious of the fact that she isn't wanted anywhere. When she came in to me crying piteously & gave me the vinaigrette she'd bought me for Christmas I felt quite ill with pity, darling, & I cried too. Oh! dear. Poor Soul, darling, for all her faults she's a pathetic, lonely creature

* King's Regulations.

&, in her queer way, I think she's really fond of us. She's going to Gerta's today, my darling, knowing she isn't wanted there either. Oh! darling, I'm so unhappy about all this. God, how I wish all human issues weren't so hellishly complicated.

Darling, I was thinking the other day, in connection with the loss of idealism which arises out of wantonness without love, of Mr Crotch. I remembered his having said to me one day: 'My wife had so little interest in physical love, so little emotion about it that although she's incredibly prim & conventional she allowed herself to be seduced by me before we were married – she looked upon the whole business as totally insignificant. The girl I lived with before I met my wife was a naturally wanton little animal & the contrast was a great shock to me – but, of course, all women are either wholly animal or totally insensitive, like my wife.' I suggested that I wasn't, darling, & he said: 'Oh, well, after you're married, Gershon will find out that you're either one or the other – I wish him joy of it.'

SUNDAY 20 DECEMBER Oh! darling, as I was listening to the broadcast report of German brutality to the Jews in occupied Europe, I remembered that forgotten man who shot himself in the League of Nations to call the attention of the world to the Nazi persecution of the Jews. No one heard the shot then, darling. It was only when the rest of Europe had a taste of the Nazi whip that Europe began to think – long after the harm was done. I hope you & I will be able to play a part in the building up of a better world.

Darling, Pan has just come in and he Wants to Talk. I'm terribly tired. I must Shuffle him off Tactfully. He's getting too old for me to say: 'Bed – Pan' or preferably: 'Pan – Bed.'

SUNDAY 27 DECEMBER When I spoke to Mrs Eban on the phone, my love, she said, in rather a luke-warm kind of voice, that Joyce was rather pretty wasn't she? I said that I thought she was very good-looking & distinguished – pretty was hardly the word – slight pause, then Mrs Eban said: 'If you don't mind my saying so, my dear, I think you're much more intelligent than she is ...' I said I didn't mind at all, darling, but it never fails to surprise me that people who know

us both superficially & have only her poise & charm & assurance and my nervous chatter to go on should think that. Basil surprised me too once, darling, by saying that after our evening walk to Granchester, when you raised all those Blisters on my feet, you told him that I had far greater depth of character & intellect than Joyce. You see, my darling, I shouldn't have said that I was more intelligent than Joyce – just intelligent in a different kind of way. She's more intelligent socially & in her work as a Civil Servant (She's making a great success of it, my love, & I am not) I am more intelligent academically and about people (I think Joyce's judgement of people is superficial & obtuse, darling.) but the fact remains, my dear love, that I never got to know you and Aubrey really well until I met you <u>with Joyce</u>, I would have been too frightened alone, too certain that neither of you could possibly want to be with me – but with Joyce I was a convenient fourth. I've never <u>wholly</u> recovered from my astonishment, my darling, in discovering that I could be interesting to both of you in my own right – but – shall I tell you a secret, my darling? Joyce's obvious amazement, though I could so well see what she meant, cut me to the quick! <u>Are</u> women really as queer as you're thinking they are at the moment, my dear love?

Thank God for your letter, my darling. If I hadn't had it, I'd have gone to work tomorrow half crazy with sorrow. I'm going to listen to the *School for Scandal* on the wireless tonight, my love. Vivien Leigh is in it <u>and</u> Robert Walker's ex-wife whose stage name is Jenny Laird. Have you ever heard of her, darling? No, neither have I. More tomorrow, my dear love.

<u>MONDAY 28 DECEMBER</u> Darling, listen to this for a bit of Higher Truth! My parents asked me yesterday evening what you'd said in your letter & I was Surprised but Interested to hear myself telling them that you'd been to a birthday party given by my step-cousin Rosette & had remarked that her dress was cut so low that you felt irresistibly impelled to offer her a safety pin.

Darling, I was amused at your remarking that you were rather disgusted to see Jews wrapping themselves round large quantities of Ham but could apparently take them behaving like the creatures of the Demi-Monde to which they belong with such

sang-froid. I could forgive them the Ham, darling, if their emotional standards were a little higher.

The School for Scandal was enchanting, my love. Vivien Leigh as Lady Teazle was exactly like a Dresden figure of an Arcadian lady. Robert Walker's ex-wife was alright but she was the milk-and-water Maria who is anyway Neither Here Nor There. Joan, for some obscure reason known only to herself, is terribly anxious that Robert's ex-wife should make a Good Impression on me – perhaps to establish the fact that Robert has good taste – though I should have thought the material point would have been to establish his wife's good taste in having married him. As for that, darling, if she thought she had good taste when she married him, she obviously thought better of it when she ran away from him, but I'm not going to let it worry me, darling. Joan's Life is Her Own from now on – and although, every time I see her, she tries to provoke me into some sort of comment on the situation, I am callously refusing to get involved again. I just can't <u>bear</u> any more of it, my dear love.

January 1943–March 1944

One of the less predictable consequences of the terror of the Blitz was that the sharp divide between the civilian population and the fighting man that had bedevilled the First World War was no longer there. It would be deep into the war before service casualties exceeded civilian, and if there was nothing particularly heroic about Eileen's war – nor Gershon's for that matter – few wartime letters so brilliantly capture the huge attritional strain – the social dislocation and corrosive loneliness, the nervous breakdowns and failed relationships – which was the reality of life in many areas of wartime Britain.

This is especially true of the letters of 1943, when the wearing effects of thirty-nine months of war are there in every line Eileen writes. By the end of the summer the Axis armies would be driven out of Africa and Italy out of the war, but with D-Day and a Second Front still eighteen months away and no sign of Gershon's return, the vast majority of letters from this period are those of a desperately unhappy woman at the end of her tether in a world of disintegrating emotional and ethical values.

The quality of Eileen's misery is so intensely personal that it is easy to forget that the malaise that infects these later letters mirrors the country's mood during these middle years of the war. There were certainly victories – Stalingrad, North Africa, Sicily, the U-boat war – to lighten national spirits, but as the Allied leadership passed from a weary Britain to the USA and the Soviet Union and minds turned towards the reconstruction of the post-war world, the brief but genuine sense of national purpose and political unity that had marked the early years of the war began to fray.

Not even the military successes could be unequivocally enjoyed. Victory in North Africa and the fall of Mussolini had been countered by the Nazi advance into unoccupied France and Italy, while the slow progress of the Allied advance up the boot of Italy only added to the growing frustration that the real fighting was being done by Russia. In the Far East, too, where India was in turmoil and only the Chindits, led by Eileen's controversial friend Orde Wingate, offered some solitary propaganda comfort, there was still less to celebrate and it was little better on the home front. A growing number of illegal strikes (all strikes during the war were illegal) was just one symptom of this, and the government's decision at the beginning of 1943 to postpone the implementation of the Beveridge Report – that symbolic document in the evolution of the welfare state – raised the spectre that all the hopes for a different and better post-war world, all the determination that the sacrifices of the people would be rewarded in a more just and equitable state, that the shameful class inequalities revealed by the evacuation of the cities were a thing of the past, would go the way of the promises made during the First World War. For the country, as for Eileen, it would be a long year.

The Long Wait

FRIDAY 1 JANUARY 1943 Darling, your letter 58 was waiting for me when I got home this evening. Oh! what a Solace, my love, to start the New Year with a letter.

Darling, apropos of French Knickers & Respectability, you've no idea what a lot of difference a bit of elastic can make. When Jean came to stay with us in Cairo, my love, she met a Man on the Boat & he Arranged to Seduce Her (with her full Knowledge & Approval) in the Eastern Exchange in Port Said. However, when the Hour Came she couldn't pull her dress off because she had very tight sleeves and one of them got caught on her elbow – and this gave her time to Think Better of it and so she decided not to be seduced after all (Not on that occasion anyway). The end of the story, my love (in case you're interested) is that she pulled on her dress again and walked out of the Hotel with Dignity.

SATURDAY 2 JANUARY Darling, your letter 59 arrived before I left the house this morning. Darling, your saying: 'I can't offer you any prospect of my moving from here I'm afraid,' made me feel as though I'd been shot. I am lapt in Darkness Visible.* My staying power is being gradually stripped away & each fresh piece of evidence of the impasse that we have reached over this bloody & apparently interminable separation is more appalling & more terrifying.

* From *Paradise Lost* (1667) by John Milton.

I'm having lunch with Miss Malyon because I hadn't the courage to say no – but she's the sort of girl who believe that to have Europe over-run by the Reds (sic) would be just as bad as to have it under the Nazi yoke – so I don't expect very much comfort from her, my dear love. Oh God! How I hate everyone & everything, my darling, except you, whom I love with dangerous fanaticism.

SUNDAY 3 JANUARY Darling, when I first loved you I thought I could not have loved you if you had been the kind of man who had believed that Woman's Place Was in the Home & that Intellect was out of place in the Female of the Species – but I was wrong – I could love you if you shut me up in a dark room & never let me see a book or a picture or another living soul – because in you there is enough to fill my mind & my spirit for ever and ever and ever, my dear love.

MONDAY 4 JANUARY Darling, Mr Murray has just been in to ask me to have lunch with him & his wife.

Darling, Mrs Murray is rather like the mother deer in *Bambi*. She has the same kind of large, gentle brown eyes & velvety muzzle. She's extremely charming & carries herself beautifully. I enjoyed my lunch. We talked of Mr Murray's cousin, The Tutor of Girton & they seemed much amused, my love, when I said that the trouble with her was that she was born with a hockey stick in her mouth. I am always a little taken aback, darling, when people seem really delighted with something I say off-hand.

Oh! darling, I've got a Confession too – only it's one that I'm afraid is going to make you really angry. I'm smoking like a chimney – I daren't tell you how many a day – but I can't help it, my darling, if I didn't drug myself with cigarettes I couldn't get through the days at all. I promise you most solemnly, my dear love, that the moment I hear you're on your way home, I shall give it up altogether.

Miss Anderton, poor soul, is crippled with rheumatism, darling. Her fingers look like ping-pong balls but she can't take any sick leave because she just can't afford to live on her salary without overtime. Isn't it monstrous, darling? It makes me Fume & Fret but my Fuming & Fretting is hopelessly ineffectual because I can't do anything. And to add to the general fracas she's just lost a stone

out of her engagement ring & when she goes to get it replaced they'll tell her that the stones aren't diamonds, which in itself doesn't matter, of course, but I know it will disturb her because she thinks they are.

SATURDAY 9 JANUARY Darling, quite unexpectedly I enjoyed yesterday evening. I find Square an entertaining Period Piece – The Bon Viveur of the 18th century par excellence. Quite unreal, full of fantastic affectations – he would not have been out of place, darling, between the pages of *The Rape of the Lock*. He is, if anything, even more Restoration than 18th Century, so I knew him at once. He's a Excellent Creature in expensive & synthetic surroundings, my dear love, but I can't imagine how anyone could possibly think of marrying him. I'd as soon marry a Sèvres dinner-service! However, each to his own, I suppose – but Jean is in for a Tough Time.

SUNDAY 10 JANUARY I forgot to tell you, darling, that I had a discussion on the 'bus with Mr Goodman about the Art of letter-writing. He said that the test of a good letter was that it should be interesting to a reader who knew neither the writer nor the recipient. I don't think that's altogether true, do you, my love? A letter (I exclude love-letters, darling, which are in quite a separate category) is essentially a personal thing. I should say a test of good letter is that you should be able to hear the writer speaking as you read – you should be able to relate the words on the page to the individual stresses and mannerisms which are part of the writer's personality. Then, ipso facto, the letter will be interesting even to someone who doesn't know the writer, provided that the personality of the writer is in itself interesting. Ismay's letters, for instance, darling, are characteristic enough. She speaks in clichés – she thinks in clichés and therefore she writes in clichés – but they're dull letters because she's a dull person.

THURSDAY 14 JANUARY I was talking to Kitty Thorpe about my Morbid Childhood yesterday, darling, and telling her about the time when I thought my mother was trying to poison me. The Moral I was attempting to Extract from the story, darling, was that my

Cloistered and Isolated up-bringing was All Wrong not to say dangerous. I said that as soon as I went to school I became quite normal, except perhaps a little more hard-working & solemn than other children – but she said she didn't agree – that even now I wasn't the typical, normal girl of 25. She said that there was nothing abnormal about me in the sense of my not being sane, of course, but that I was definitely a little different from the normal or average and that therefore I couldn't generalize about the effects of a particular kind of up-bringing from my own experience. Do you see what she means, darling? I was surprised but perhaps that's because I have rather a tendency to believe that everyone is out of step except me.

Incidentally, darling, I met Pierrette Wack (Girton – Modern Languages – Joyce's year) at Joyce's party. She is at the Board of Trade & I asked her if she knew Susan Wyatt. She said oh! yes, she did – that was the girl who was Living in Sin with her Principal – who asked to be transferred to another Branch because she thought it Unwise to work all day with the man you slept with at night? I said regretfully that it was. Oh! my dear love, I do wish my friends wouldn't Live in Sin except with their husbands or the men whom they love and are going to marry. I know it's none of my business but it's a most terrific sorrow to me all the same.

FRIDAY 15 JANUARY Darling, Gerta didn't put up with Aunt Teddy for long. She told her in no uncertain terms that she must go, after she'd been there a week, & now Auntie has moved in to Mrs Seidler's. I don't know how Gerta could do it, darling. Of course, Aunt Teddy is a parasite – it's true that she has no interests (except Bridge & Rummy) and no Guts that you'd notice – but she is deaf & lonely & if anyone is to be responsible for her I think it should be Gerta. Mum is so upset about it, darling, that she's beginning to regret that she ever asked her to go – she only did it, my love, because she & Pa had no privacy at all while Aunt Teddy was with us. Aunt Teddy is not what you'd describe as a Little Ray of Sunshine about the House, darling.

SUNDAY 17 JANUARY Darling, your little Solace has been on Manoeuvres. Clad in a mud-dappled Boiler Suit with a fine array of last war ribbons adorning my Bosom and tripping over the trousers which were designed, at a modest estimate, for a 6 foot Tough, I did Stirrup Pump and Bucket Exercises on the foundations of a Bombed House. But the climax of it all, darling, was the Fire. It was a huge fire of damp logs in a Zinc Hut and I had to Crawl Through Six Inches of Mud to get to it and even then I had to be very careful not to Let It Know It Was Being Followed. You should have seen me, darling, with grime in every crease of my palms & smudges on my face & neck and my ring caked with mud (but I soaked it all off in Ammonia) & tears streaming down my face from the smoke. I'm sorry to have to tell you, my love, that my parents seem to have some sort of Hold Over the Postwarden because they didn't have to wriggle on their Bellies through Fire & Brimstone but were told that their mock fire practice was good enough. (They did this some weeks ago & left the Post without a Stain on their Garments.)

WEDNESDAY 20 JANUARY Darling, I had a letter from Miss Bradbrook this morning asking me to meet her for lunch on Thursday. What a Solace, my love. She says her brother Leslie (the Don Juan one, darling) is in Nineveh and that his views seemed to coincide with the prophet Jonah's. What were his views, darling?

Who do you think has just telephoned? Joan Friedman – she's in London for two days from ... Shhh! I asked her to dinner – That ought to provide a bit of Copy, my dear love! She said coyly: 'Is that Eileen? Can you guess who this is?' Well, darling, what a question. Could there be two Voices like that in the world? I sincerely hope not.

FRIDAY 22 JANUARY Darling, I'm Exhausted. Joan Friedman is even Mucher than she was at Cambridge. Two years of Teaching have Consolidated or Emphasized the Didactic Streak that was always strong in her ('What I feel is that in This War it's our Dewty to be Uncomfortable') and three months of Hush-Hushing at You-Know-Where has added a sort of Subterranean Rumble to her general manner, which is quite intolerable. ('There are Secrets Locked

Within Me which I Shall Carry to the Grave!') I told her Bluntly, darling, that at the AM their stuff wasn't even labelled 'Most Secret'. (It was a Lie, my love, but I <u>had</u> to do it in self-defence – but she was No End Deflated to discover that I Knew All.) She's almost bald! She's got a few Sparse Straggles on Top and that's all – and she's gone the most <u>peculiar</u> shape – just as though she had been Stuffed.

Darling, the more I think about Joan Friedman, the more irritable I get. She was saying how wise I had been not to have gone into her Racket – and I said: 'Well! I don't know, I might have been in Cairo by now.' To which she replied Sententiously: 'You Don't Know How Lucky You Are to be Living at Home & Having your Parents to Look after you.' I nearly snapped: 'Well, I'd have been a good deal luckier if I'd had Gershon to look after me', but I didn't. I was particularly angry at her having said that in front of my parents, darling – because Mum's favourite Argumentative Gambit is that I Couldn't Get On Without her – as a matter of fact, darling, it would do me a lot of good not to have her to do everything for me. Then Joan Kept having Digs at my Lack of Domesticity & my parents took the Look-even-your-Cambridge-friends-have-noticed-it line. Peggy Ungar always used to be irritated by Joan's Smug Feminine-Artsism, my dear love, particularly as she (Joan) is such an incredible Muddler & even <u>knits</u> sloppily.

Darling, I've just skimmed through what I've written and I'm rather shocked at my childish Querulousness. I've even forgotten to give you Joan's Regards which she Entrusted to me for you with what I thought was Unduly Exaggerated Solicitude.

<u>TUESDAY 26 JANUARY</u> Darling, Comb the Sphinx round about the 11th February – you may see my name among the List of Guests at the Egyptian Embassy for King Farouk's birthday Do. It will be Ineffably Dreary, my darling, but it will give me an opportunity of wearing my new black dress & my beautiful stockings.

Darling, Mum & I are just Back from Manoeuvres. We became the Late Lamented Early on in the evening but as nobody bothered to mention this to us until much later, when volunteers were called to fight a fire in St John's Church, we Dashed Off there, nothing daunted & I will say, my love, that we did very creditably for a Couple of Corpses – except that for the first quarter of an

hour I was pumping away feverishly & Mum kept shouting: 'There isn't any water coming out of the nozzle, No. 2.' (That's me, darling.) We Cast About for a Warden to examine our hose when I suddenly noticed the entire coil of hose neatly done up at my feet – Mum had been training the disconnected extension on the fire for 15 minutes! I can't help Seeing What the Borough Warden meant, darling, when he said that the Harley Road fire parties were Enthusiastic but Inexperienced. Nevertheless, we came home flushed with triumph – soaked to the skin and covered from head to foot with Honourable Mud. I've never participated in anything so Exquisitely Absurd, my darling, in all my not uneventful life.

WEDNESDAY 27 JANUARY Darling, I've always been fascinated by complete stillness. As a child I used to go away by myself on to the moors at the back of our house in Drumnadrochit & sit uncomfortably on a nobbly grey stone – staring at the scrub and heather and the chequered patterns of the farm-land on the hillside opposite. The only sound there ever was was the sound of the burn trickling over the pebbles and that is a sound which is almost more hushed than silence – and I used to be so terribly detached from the stillness of the hills & the moors, darling, so terribly untouched by their still-ness. I was so restless that it was almost physically painful. The first time I can ever remember being completely at rest, my darling, was that last evening when you came to see me in Maidenhead hospital & you sat beside my bed & held my hand against your face. That, I think, was the moment when it became impossible for me not to love you – because all my life I had been terribly & nerv-ously craving for something – and then I knew what it was, darling. It was complete rest of mind & body & spirit – and I suddenly realized that you were the only person in the world who could give it to me. (I did love you before that, darling, but not quite irrevo-cably, I think.)

THURSDAY 28 JANUARY Darling, I'm bubbling over with All. Miss Bradbrook typed a minute for Coupon Control to the Chief Accountant of the Board of Trade & an article on 'Little Gidding'*

* 'Little Gidding' is the fourth poem of T. S. Eliot's *Four Quartets*.

for 'Theology' on the same afternoon – and, as they were both about the same size & shape, sent the minute to the editor of 'Theology' and the article to the Chief Accountant. (It was a Very Cross minute, Miss Bradbrook said, darling.) The Chief Accountant returned the article with a chit saying 'What is All This?' but the Editor of 'Theology' said that he would publish the article with pleasure but couldn't do anything about the minute as he didn't understand one word of it & he really didn't think his readers would either.

Then, my dear, there is the perfectly <u>Beautiful</u> story of Mrs Crews (You remember her, of course, my love. Mr Birkowitz thought she had the Best Legs in Girton & she went to Ankara so as to be able to Keep in Touch with her Young Man who is a French Army Doctor.) Recently, darling, she decided that Ankara wasn't Much of a Place so she came home but was torpedoed on the way. When the torpedo struck the Ship she couldn't decide whether to Take her Divorce papers with her & Jettison her hand-bag or vice versa but she soon discovered that she needn't hurry unduly, collected all her valuables, Organized Herself Generally & came up on Deck in a Leisurely way & got into the nearest life-boat. Later on the U-boat came to the surface, drew up alongside her boat & the commander said: 'Vot is the name of this ship or boat?' Mrs Crews wasn't going to Have That so she said briskly: 'Don't be silly, my man, ship & boat are the same thing,' whereupon he Trained a Gun on her & repeated his question rather more fiercely than before. She was not one whit put out by this, darling, & said crossly: 'We're not going to tell you. If you want to know you'd better ask the Captain, he's over there somewhere ...' Pointing vaguely at a clump of boats in the distance. She says with Pride, darling, that after that the U-boat Slunk Off with its tail between its legs and the last she saw of the Truculent Commander was a Beautiful Picture of him Solemnly Turning over the pages of Lloyd's Register to make sure that the Captain hadn't given him a Dud name! After 36 hours, darling, they were picked up by a destroyer who hailed them through a Microphone with the words: 'Come along aboard & have a cup of tea, dearies.' As far as I can see, darling, her adventures more than compensate for the fact that communication with her Frenchman is considerably more diffi-

cult than it was in Ankara, but I gather that even in Ankara she was so irritated by the Barrage of Censorship between her & her Solace that she almost Created a Diplomatic Incident. What a wonderful woman she is, darling! – and she gets more & more like herself every day.

Darling, Miss Bradbrook is as sick of the Civil Service as I am &, 'Fore God, she's thinking of joining the WRNS. Can't you see her, my love, with a fringe of primrose knicker showing coyly below her skirt and her Wisps clinging like vine-tendrils to the band of her little sailor-hat? It's a thought so beautiful, darling, that I was hardly able to withhold a Fat Chuckle when she told me.

Miss Bradbrook thought that I was looking rather wan – but what can you expect with my Iron Lung in the Middle East. Oh! I do love you, darling.

SUNDAY 31 JANUARY Did I tell you, my dear love, that Mrs Crews was now working in the BBC Turkish News Service? Oh! God, I wish you could come home & do that.

Darling, I've had a very quiet day. Joan came to lunch &, as my parents were out for the afternoon, she stayed with me until nearly 6. As long as we were talking impersonally, darling, & chuckling over the fantastically Enthusiastic Platitudes of Commander Campbell in Brains Trust it was as though we were back at Cambridge but then she started talking about Sheila, my love, & saying that she doesn't think she & Allan would ever be happy together again & that she hoped they'd have the sense to realize it & get a divorce. Oh! my darling, Joan & I have travelled a long way along very different paths. I never thought I should hear her talking about Writing Off a marriage as though it were a Bad Debt. I remember Sheila's wedding, my dear love. I remember being immensely touched by the dignity & solemnity of the Marriage Service – Allan was so terribly pale, darling, & so obviously happy. Why should Joan think that they won't be happy when he comes back? (Rhetorical question, my darling, you can't possibly know the answer.)

<u>MONDAY 1 FEBRUARY</u> Darling, it doesn't seem right to Look a Gift Horse in the Mouth, but when Mr Morrison of Drumnadrochit sends us a Hamper full of 4 cockerels and a drake – all alive, scrabbling & hungry, how should we Take It? The idea, my love, was that they should in due course be killed under the Auspices of the Beth Din so that Mum could eat 'em too – but what are we to do with them meanwhile? If we're not Very Careful, my love, we'll find ourselves Getting Fond of them & wanting to keep them as Pets. No, my love, I feel that this Gesture of Mr Morrison's was Well-Intentioned but Unfortunate. A little Civil Service caution in this case would not, I feel, have been Misplaced, darling, because the Repercussions are going to be Somethink Orful.

<u>THURSDAY 4 FEBRUARY</u> Miss Bradbrook is coming to dinner and I'm having lunch with Joyce, darling. Joyce phoned me in one of her Well-Bred Moods when she rang up and told me she wasn't going to renew her subscription to the London Library because she was only interested in the very <u>latest</u> books and you couldn't get them there until they were too old to be of interest. I'm very fond of Joyce when she's being natural, my love, but not when she's being the Hon. Joyce and Liking it.

Joyce was very Trying, my love. Terribly Bored & Drawly so that everything I said clanked on to the floor like a dropped penny. Darling, I do most terribly need a letter, or better still a bundle of letters. I feel like a butterfly pinned to a board today.

You're probably right about Women being more Personal in their Discussions with their friends than men (in fact, darling, I know you are) although Miss Bradbrook says that the <u>essential</u> psychological difference between a man & a woman is that a Man has an Infinite Capacity for Absorbing News.

I don't think I need tell you how superabundantly, breathtakingly happy your New Year message made me – the message that said: 'I have never, never, never felt less inclined to be unfaithful to my better half, my beloved solace.' Darling, that is worth more than all the Emeralds in the East. It's as though you had poured a shower of stars into my lap. Darling, Miss Bradbrook said tonight: 'So few of us are wholly integrated now. This is a disintegrating period, and it is only through personal relationships that

we can wholly fulfil ourselves.' She's a very profound little person, my darling.

<u>SUNDAY 7 FEBRUARY</u> This evening, my dear love, Mrs Fanshawe was Musing on Men & said that it was quite astonishing how much they would Swallow in the way of Flattery. I drew myself up to my FH and said you weren't in the <u>least</u> vain & she said: 'You tell him he's the Sun & the Moon & the Stars & see if he doesn't Lap it up like Cream.' I said, nothing, my dear love, for the very good reason that you <u>are</u> the sun & the moon & the stars but she misunderstood my silence & said: 'It's no good being embarrassed about it – just try it & see.' I still said nothing, my darling. What <u>could</u> I say?

<u>MONDAY 15 FEBRUARY</u> Darling, I had a most terrific argument with Mum this morning while I was in my bath. She came into the bathroom & waved the newspaper account of the appalling Jewish butcheries on the Continent in my face. 'You see,' she said Dramatically, 'These People are not human at all.' I tried to explain to her, my darling, that as long as the vast body of the people of any nation were barely literate it would always be possible to lead them into excesses of vicious cruelty. I said that the French as a Nation were perhaps the most independently minded in all the world and yet they swallowed the camel of Nazi Domination. I reminded her of the hysterical adulation that was given to Chamberlain when he came back from Munich – of the Cult of the Umbrella. I said that it was possible to feel, not only of the tortured Jews but of the Germans that there but for the Grace of God go I and that therefore it was immeasurably important, for the purpose of post-war regeneration to remember that the German people, as human material, were exactly like our people – fickle, gullible and intellectually lazy. The Germans, like ourselves, <u>must be trained to think</u>. They must learn to accept nothing prima facie. They must learn to ask themselves, What is Good? Mum completely misunderstood the whole drift of what I was saying, my darling, because she said: 'You must be completely inhuman not to be revolted by what's happening.' After that, my dear love, it was no good going on. Mum has a lot of blind spots, darling, and because

she's such an extraordinarily sensitive & understanding person in so many ways, it's always a shock when I stand on one of them.

About writing you a letter-card every day, my dear love. You see, darling, each day I seem to have so much to say to you that willy-nilly it fills a whole letter-card. My only fear is that it might become burdensome to you to have to read so much. As far as I'm concerned all my creative energies, all my critical & social faculties, all my moods and thoughts and, above all, the boundless sea of my love for you go into my letters to you. Because I am all yours I must give you the whole of myself as far as possible, but, my darling, if you just haven't time to read so much, tell me – I shall understand & I shan't be the tiniest bit offended. I know you love me, darling, & you needn't be afraid that I shall think you love me less because your work makes it impossible or irksome for you to read such long letters.

FRIDAY 19 FEBRUARY My darling. When I got home there was Victor waiting for me like Manna from Heaven. He's sleeping in your room & it was with almost a physical pain in my heart that I went up the stairs to see him when I came in. He was folding up his underclothes with intense deliberation when I got in & I could hardly speak to him because I was thinking if it had been you, my darling, we should have been lying side by side on your little bed. This was in my mind, my darling, while I said hesitantly & abstractedly to Victor: 'What cheer? I expect you've travelled a long way since I saw you last,' and I added, darling, because my mind was so full of you that I couldn't bear not to say your name: 'I wish you had called on Gershon in your travels.'

SUNDAY 21 FEBRUARY Darling, I haven't had a very good day. Mrs Eban was Bent on finding out All (if there was any All – a matter which she had to admit was Open to Doubt) about Aubrey & Joyce. I Eluded her Grasp like a sliver of wet soap, darling, but in the end I thought it wise to say that (i) Aubrey had never said anything to me about what he felt or did not feel for Joyce (ii) that Joyce was Walking Out reg'lar with Another. She went on to talk about Us, darling, & said she'd never seen anyone So Much In Love as I Am outside a novel. (Non-committal & Embarrassed noises from your

little Solace, my darling. I hadn't even the self-possession to explain that it was all because there wasn't anyone else like you in all the world, my dear love.) I'd have far preferred to stay at home & talk to Victor. I've seen far too little of him this weekend & he's rejoining his ship tomorrow. He told me a Beautiful remark that the Petty Officer made the other day: 'Marriage, my boy,' he said (He's been married about 40 years) 'is a crazy business. You give away one half of your food so as to get the other half cooked.'

MONDAY 22 FEBRUARY Oh! my darling. It's a Bleak Horizon at the moment. Gandhi, the only Saint that this century has produced, is dying – Jews are dying in hundreds of thousands – the Beveridge Plan has been castrated – we are suffering reverses in Tunisia – something is rotten in the state of civilization, my dear love. I'm afraid, darling. In the past year so many little green shoots of hope have been springing up everywhere and I've been saying to myself: 'Woho! Here's a Brave New World for my dear love & me and our children – a world of light, clean garden cities and social justice and books for everybody.' Everyone has been talking, my darling – but what is happening, my dear love? Darling, I was right to turn away from the news – because what can I do about it?

TFRIDAY 26 FEBRUARY My darling, I've had a terrifically busy day. In the train a Colonel's Wife in Sables and a smoked Zaikon asked me the Way to God. I almost said Absent-mindedly in the words of Tinker Bell, darling (or perhaps it was not Tinker Bell – anyway it was someone in *Peter Pan*) 'second on the left & straight on till morning'. I wish I had, my love, but instead I just Gaped & when I'd recovered myself Sat Up & Waited for more. It came, darling. She'd noticed that I was reading Ouspensky.* She was much Exercised in her mind about Religion. Her British Israelite friends thought her Roman Catholic friends were Heading Straight for Hell (she begged my pardon, my love, for not Mincing Her Words). Her Roman Catholic friends thought her Spiritualist friends were Charlatans. Where, therefore, was God? And they were all so sincere, bless them. I suggested, darling, that if she wanted to find the highest common

* P. D. Ouspensky (1878–1947) was a Russian esotericist.

factor of all religions she'd better read some philosophy – starting with William James's 'Varieties of Religious Experience' (Pause while she wrote Feverishly in a notebook what time the Colonel, who was sitting opposite, read *Esquire* with Terrific Abstraction.) It was all Very Beautiful, darling. She almost Wept when we parted at Cambridge Station. I trust she Finds God in due course!

When I got to Girton, darling, I called on Portress who received me exactly as though I'd just come out of my old room & said that she thought Miss LT was out. Darling, Portress hasn't changed a tittle. Nothing has changed – outwardly – but oh! my darling, it's not really the same.

SATURDAY 27 FEBRUARY I spent most of the afternoon with Miss Lloyd Thomas, my dear love. I told her that there was, of course, a condition attached to the College Prize and that was that we insisted that it should be awarded to our daughter. She agreed that that was Very Proper, darling, & when a rather shy student called to see her she said: 'This is Miss Alexander – she has just Presented a Prize to the College. You will probably win it. Her daughter is going to win it too.' The student, darling, made noises of Polite Interest & then said diffidently, 'How old is your daughter?' I said: 'Well. As a matter of fact she isn't Here at All yet,' & Miss Lloyd Thomas added hastily – making matters considerably worse: 'There's a little matter of a marriage ceremony to be arranged yet.' The poor student, darling, not being able to Make Anything of my Innocent Contours was, I could see, left with a Hazy Impression that she'd wandered into a perfect Morass of Loose Living.

SUNDAY 28 FEBRUARY Darling, Miss Lloyd Thomas has given me a pot of Honey & Mrs Turner is giving me eggs Ooh!

Aubrey's letter-card, my dear love, was a Gem. His best touches were 'Latest Tel Aviv shop signs': 'Dressmaker. All patterns for Home Wear & Street Walking' and Shop owned by Mr Adam moved across the road; here is the notice: 'Adam has Transgressed Here'. (First Archaeological Evidence of Original Sin.)

Darling, evidently Norman Bentwich has been Less Discreet in his letters than I have – about himself I mean! Ask Aubrey to tell you the story. It is, in its way, Very Beautiful.

Oh! my darling, I'm rich indeed. Letters 72, 73 and 74 arrived this morning. Of course, darling, I shan't mention his Social Unreliability to Aubrey. You know, my love, I've never found Aubrey unreliable about appointments but I've often heard from other people that he was.

Darling, I do see what you mean about Zionism as an expedient & to that extent I accept it but of course that is not Zionism. Zionism is the movement which strives to restore the Kingdom of Zion as a National Home for 'God's Chosen People', not as a refuge for the persecuted – otherwise Uganda would have done just as well.

I am prepared to agree with you about the general level of intelligence today but that is because they just haven't been given a chance. Elementary school education just isn't education at all because it doesn't teach you to think, it only teaches you what to think which is a very bad thing. Darling, I shall regard it as an excellent sign if our children spend most of their early youth saying Why? Why? Why? Why? We shall do our best, shan't we, to answer them truthfully and to give them plenty of loopholes for contradiction?

Darling, I should have said that Jewish Theology was concerned not so much with preaching morality as behaviour. You said yourself that your father was more concerned with observing the letter of the law than with ethical conduct – & I've noticed it in a number of other Orthodox Jews. That's why I don't feel in the least as though I'm Letting the Side Down, my dear love, when I acknowledge & even preach my unorthodoxy in Orthodox circles – because I regard Orthodoxy as completely worthless except if it's practiced as a piece of Historical Symbolism – in the same spirit as the Medieval Mysteries.

Miss Malyon told me at lunch today that her Intended expected to be back from Washington in the middle of this month – and she expects to be married a few weeks after that. I tried so hard to sound as though I didn't mind, my darling, but I did – terribly.

Darling, Kitty quoted an extract from a diary of the period concerning the Duke of Marlborough which read: 'This day my lord came home from the wars & pleasured his lady three times ere

he took off his boots.' I like that so much, my darling, that I suggest that sometimes, just for a change, when you want to be wanton you should say: 'Shall I pleasure my little lady?' because that, my darling, is what it will be and my answer will always, <u>always</u> be: 'Yes, darling, please.'

Oh! darling, everything round me feels quite vague & unreal because I'm so wonderfully happy. This succession of letters makes me feel that the lean weeks have been worth while.

<u>WEDNESDAY 3 MARCH</u> Darling, Joan & Mhairi left hurriedly because the sirens went. (Reprisals for the Berlin raid, I suppose.) The anti-aircraft fire is so terrific now that it's really terribly dangerous to be out in it, so they dashed away in the hope of getting home before it started. Darling, I was really horror-struck by Joan's appearance tonight. She was terribly haggard & drawn & looked really <u>old</u>. I wonder what's the matter. I keep saying to myself, my love, that it's no use worrying but I can't help it. She's taken such crazy risks with her health & I'm afraid she's beginning to pay for it.

<u>SATURDAY 6 MARCH</u> Darling, I'm In Disgrace with Pa. And this is why. At a quarter to eleven last night when I was almost asleep he Burst into my room, jammed on the light and waved an American newspaper in front of my face. There was a sort of Proclamation, my love by a lot of Distinguished Americans about the necessity for having a Jewish Army. I dragged my eyes open, darling, with an immense effort of will because I was still very much under the influence of Gas & said, 'Splendid', because that seemed to be the Right Answer as Pa obviously thought he was On to a Good Thing – but then, to my Absolute Horror, darling he started reading the Proclamation (which ran into 9 columns – and the paper was bigger than the *Times*!!) I said: 'Look here, it's nearly eleven & I want to get to sleep,' at which he Looked Like a Thundercloud & said: 'How Dare you Speak to me Like That. I don't feel I ever want to Talk to you Again' – and Swept Out. This morning he wouldn't speak to me when I went in to say 'hello' before going to work.

What I hate most, my darling, about living at home is that I have no privacy <u>as of right</u>. My parents very bitterly resent the

fact that I like being alone. Pan feels exactly the same. My father is <u>stupid</u> about people and he is kind only when he happens to be in the mood for it – in short, my love, a charming man to meet socially but an <u>impossible</u> person to live with – not impossible for Mum, darling, because she loves him – but impossible for anyone else.

TUESDAY 9 MARCH Darling, <u>letter 88</u> arrived this morning. Oh! my dear love, I wish you could dream about being Wanton with me instead of all those other Wild Oats. I can only hope that they're people you don't know, but don't tell me – I'd rather not know. Darling, I hope you don't mind marrying a girl with no Sub-Conscious because I <u>definitely</u> haven't got one. I <u>never</u> mollock with anyone but you in my dreams. Once Aubrey put his arm round me in a dream as a sympathetic gesture & I was simply Horror-struck.

SUNDAY 14 MARCH Darling, it did surprise me to hear that the mail of most of your colleagues is 'meagre'. How do they keep in touch emotionally & intellectually with their wives over a long period of separation? Every day brings with it new impressions, new ideas, new sounds & colours & patterns. The tissues of the mind renew themselves every hour. How is it possible to come together again without fear if you only keep in touch sporadically – if there is no continuity in the patterns of your shared thoughts?

Behind every single one of your letters I can hear your voice & see your smile – sometimes I can feel your arms tightening round my body and your hands awakening the whole range of love from tenderness to passion in my breasts. It's a miracle, my darling, and I'm grateful to you for it with true and profound humility. You see, my dear love, it's natural for <u>me</u> to express myself in letters. Almost, it's my métier – but I know that it isn't the same for you – and yet you have succeeded in doing it as you have always succeeded in doing everything that could give me pleasure & joy.

Oh! My darling, you give me so much, so much – it's <u>not</u> that I'm easily pleased, my dear love – I'm exigent & capricious & until I loved you I was discontented & dissatisfied with everything except my work. I ask so much of love, my darling, & I find it all in

you. Is it a wonder that I'm jealous & possessive when I have so much to lose?

For the last ten minutes I've been looking out of the window unseeingly & letting the remembrance of our time together soak into my body & my spirit. So many images have flickered across my line of vision darling. Sitting under a tree with you on Hampstead Heath, laughing & eating Lyons' Charlotte Russe with the cream squelching out of the corners of our mouths – crying and shivering in your arms outside Norman Bentwich's house – lying back on my bed at Girton Corner with your face smiling above me while I told you that Aubrey's whole personality was the result of Extensive Living-in-Sin – reading in your arms for hours together in the chaise-longue – skipping along by your side in the sunset at Southport with the sea a-glitter with metallic lights – sitting on your knee at Victoria Road while you read your law-book and ran your fingers idly across my breast so that suddenly & startlingly I was excited for the first time in all my life – standing beside you with your arm supporting me in a crowded, jolting train bringing us back from Richmond on August Bank Holiday – lying beside you in the scorching sun by the river at West Drayton. Oh! darling, all that & so much more.

MONDAY 15 MARCH While I was having morning coffee this morning with Mr Murray, darling, The Director of Movements telephoned him & he said to Miss Malyon afterwards: 'Wednesday night or Thursday morning at Euston,' so I suppose that means that her Solace will be back on Wednesday or Thursday, my dear love. Oh! God, darling, I wonder what I should do if I got a message like that. I expect I just shouldn't be able to take it in. I should be completely numbed.

Miss Malyon came in just now, my darling, <u>radiating</u> delight. Oh! my God.

TUESDAY 16 MARCH Darling, I'm sorry I shall have to Disobey you & deny that you are spiritually of coarser texture than I am – you are, as you say, not naturally monogamous & no doubt in another age, my love, you'd have collected a Fine Set of Concubines about you – but, as you so perspicaciously surmised, darling, the first batch

would soon have been Lying about the Floor in Dead Heaps & you'd have some difficulty in replacing them because others would be Shy of Taking the Risk. (You should see the Ineffable Smugness of my expression as I write, darling. I think you'd find it necessary to Spank me for being so Blandly Homicidal in intent if you were here.) But some of the finest spirits in the world, my darling, have been promiscuously minded. The man who is spiritually coarse is the one who can't see the distinction between casual wantonness & love – who can't see that the difference is greater than the difference between the sun and a 5 watt lamp. You can see and understand & appreciate the distinction, my darling, just as Shakespeare could or Donne. Oh! God, my darling, how can you use the word coarseness in relation to yourself? I have seen an undue amount of sexual coarseness for my years, darling, and I know that yours is one of the most delicate minds & spirits that I know – & of that, my love, I really am a judge.

Darling, in calling me unreasonable & stupid in my attitude to Pa you are only telling me what I've admitted already with shame in a recent letter. It may be illogical of me, my dear love, but it made me tremendously happy to be called unreasonable & stupid by you on that account. You see, darling, in a rather queer way I think I'm fond of Pa, (I <u>know</u> I'm fond of Mum) & <u>I</u> may attack him but I'm delighted when you reprove me for it. Do you understand, darling?

I didn't know about the effect on Wantonness of Hashish, darling, nor can I, as you rightly suspected, contribute to the discussion on Wantonness among the Fellahin – but I won't have you taking Hashish – not even on the Try-Everything-Once principle – besides, my darling, you're much too clever a lover to need any artificial assistance!

I can't write my book on vinaigrettes now, my love, because I'm too busy writing to you, and when I'm not writing I'm reading, and when I'm not reading, I'm working.

MONDAY 22 MARCH Darling, Joan has just telephoned to tell me that she was married on Saturday morning. No one was there except Sheila who came from Oxford for the occasion. She didn't even mention it to her parents until afterwards. Oh! my dear love, it's the most

enormous relief. I could have wished it to have happened other-
wise. A hole-in-corner Registry Office wedding isn't really Joan's
idiom, I hate to think what Mr & Mrs Aubertin must have felt
about it, my love. And Joan is the person who is always accusing
me of selfishness vis-a-vis my parents! I didn't believe Robert would
ever marry Joan, darling, but it's typical of him to do it in this way
once having made up his mind to marry her at all. Oh! Well, I'm
not going to worry any more about it, darling. The really impor-
tant thing is that Joan should be happy. Maybe Robert will improve
with time.

Darling, Pa has a new word. It supercedes 'a Fine Bit of
Oratory' in his vocabulary – it is 'Symphony'. His lectures, darling,
are now Symphonies. One of the really Beautiful things about Pa is
the enormous enjoyment he derives from himself – and all without
a trace of self-consciousness – it's Wonderful. Darling, I wish you &
I were more like him. Life would be a lot easier for us if we were.

Darling, in spite of my relief at Joan's marriage & knowing
that at least there won't be a recurrence of the hell she went
through a few months ago, I hate the atmosphere of the whole
business. I've tried to pretend to myself that I don't but it's no
good. Oh! my darling, if you were here you'd talk to me sanely &
wisely & make me see that there's nothing to Cluck about now &
anyway, even if there were, nothing could be gained by it. I was so
overwhelmingly grateful for your wisdom & understanding when
there was all that trouble about Captain Sims, darling. Oh! God.
Come home to me soon, my dear love. I can't do without you.

My darling, I came home to find Mum & Pa in a state of
great anxiety because they were afraid I'd be hurt & unhappy on
account of the fact that Joan had got married without telling me!
Of course, darling, it's true that they don't know that I have no
right any longer to Joan's confidence but even if I had I shouldn't
have been hurt because, in the first place, I don't see why she
should tell me what she didn't even tell her parents &, in the
second place, if I hadn't been so bewildered & distressed by the
circumstances & manner of her marriage (which I know to be
contrary to everything she had hoped & wished for) I'd have been
so happy on her account that there wouldn't have been time to be
hurt. You know, darling, I believe I have failed Joan as a friend. At

a time when she was unhappy & uncertain all I could find to do was to attack her chosen course of action & to keep away from her when I found I couldn't shake her resolution – the tragedy is, my darling, that when I tried to make amends I found that there was such a gap between us that I could no longer understand what she was saying – & now I've lost my chance & instead of being pleased because she has what she wants or says she wants I can only feel that if she has changed as much as that, I have nothing more to say to her. I tried to remember what she used to be like – while I was buying her wedding present, my dear love, but I could only remember her as she used to be with Ian – absolutely honest, sincere, devoted, highly intelligent & alive with whimsey humour & it makes me want to cry instead of to rejoice. Oh! darling. Life is so hellishly complicated, my love.

 Boysie Sassoon was married yesterday – it was in the *Times* this morning. As for the thought of Boysie being Wanton, my love. Well! I'd as soon have expected it of Adele. Let us Draw a Veil over that part of the Proceedings.

TUESDAY 23 MARCH I was a bit Alarmed last night, my love, when Pa said with a sudden Penetrating look that he couldn't see what Joan's hurry to get married was. You see, my love, she told me on the telephone that she & Robert had intended to get married in June but they'd suddenly decided last weekend that there was no point in waiting. If it's the same trouble as last time, darling, it will be the most shattering blow to her parents & anyway I've no doubt that Mrs Aubertin is wringing her hands over the Gossip that has certainly spread over Conington like a Plague with a lot of Impetus from the Village Cats who have anyway always been jealous of Joan's outstanding success, both socially & intellectually.

WEDNESDAY 24 MARCH I had lunch with Sylvia today. She was saying that she thought that Joan's marriage was, on the whole, a Good Thing, even if it finished up with a Divorce because she felt that she couldn't have stood the strain of another debacle & that the fact of being married will do a great deal to restore the self-confidence that she lost over the Ian business. I think that's true, darling, & I think, as Sylvia does, that Ian is at the bottom of

everything that has happened to Joan since he left. I believe that Joan's love for Ian was of the same stuff as my love for you, my darling. If you had left before we were engaged & if your letters had been colourless, impersonal & sporadic I should gradually have withered up, my dear love. I shouldn't have 'Taken a Lover' as Joan did but I should have become ill & fretful & selfish & bitter which is just as bad in its way.

Oh! my darling, I do respect Sylvia's tolerance & wisdom. She's so much more like you than like me in her judgements of other people.

Joan came to dinner tonight, my darling. Robert had gone out to a party & she was to have been alone for the evening so she asked if she could come here instead. The more I see of Robert's Methods, darling, the more I love you. I know that I don't need to ask you if you would leave me to go to a party four days after our wedding. She didn't even have a new dress to be married in, my darling – Joan who so loves new clothes – because Robert said it was unnecessary & extravagant.

SUNDAY 28 MARCH My darling, *Heartbreak House* wasn't over until nearly 10 & I wasn't home until nearly 11.30.

Estelle & I met, darling, in Leicester Square Tube Station &, with characteristic Dynamic Vigour, she swept me before I knew what was happening, into a Slum Public House of such Cob-webbed & Evil Aspect that I felt that this was indeed my first Venture into the Celebrated London Underworld. There were a few sailors about the place & one or two Threadbare Professional Bruisers but Estelle, nothing daunted, ordered a Port & a Sherry. 'Sorry,' said the bar-tender firmly, 'We Don't Serve Ladies – It's against the Law.' 'What?' exclaimed Estelle, in ringing tones. 'In this Day & Age? – & they try & inveigle us poor women into the Services. Poo!' 'Sorry,' said the bar-tender Uncomfortably. 'I didn't make the Law ...' whereupon we Swept Out. Estelle Raged all the way to the Theatre & tried to persuade me to Write to the Papers about it. I shrugged, darling. I said: 'Oh! well, it doesn't really worry me. I'm sure they can't have mistaken us for Ladies of the Town.' 'What?' she said. 'You think they didn't? Well! That is adding Insult to Injury.'

Darling, it looks as though Mr Murray's departure from S9 is <u>much</u> more Imminent than I expected. What a Heartly Sorrow. He is the only one of his kind – the others are all – Civil Servants, so no replacement will do. You know, my dear love, if you <u>do</u> come home soon, I shall try and get out of the Air Ministry into something more closely bound up with the Humanities. I don't know what, but we shall have all the time in the world to consider it.

<u>MONDAY 5 APRIL</u> I had a letter card from Aubrey, darling. I do enjoy Aubrey's letters, my dear love, but I don't see them in their Best Light on the days when I'm expecting letters from you. I gather that he is or soon will be with you, my darling, looking for Fresh Fields to Conquer. He seems to be a-weary of the East, my love, & vows that all Sinister Rumours that he intends to Desert the Flowing Gown for Nationalist Politics are nothing more than the Baseless Fancies of Wishful Thinking on the part of Mr Shertok. (He doesn't use quite those words, darling, but they are none the less his idiom.) He says, darling, that if he is to play any part in the Political Future of Palestine in the post-war world it will have to be by Remote Control.

<u>WEDNESDAY 7 APRIL</u> Darling, it's silly of you to say that you get a reputation for Cleverness by quoting my quotations & ideas. It isn't the <u>matter</u> that counts, it's the manner. Genius, my darling, consists very largely in Putting Across what oft was thought but ne'er so well expressed. Remember, my love, that Shakespeare never <u>invented</u> a plot in his life except *The Merry Wives of Windsor* & that is no Great Shakes <u>as</u> a plot. No, my darling, intelligent plagiarism is of the essence of good conversation & good writing. Please stop underestimating yourself. I take it as a Personal Affront. Darling, I can't help admitting that I'm Hoping that, if I talk long enough and loud enough & persuasively enough, you will one day wake up to the fact that you are a Superlatively Good Thing & that I'm <u>not</u> the only person who thinks so.

THURSDAY 8 APRIL Darling, your little Solace is Rill Ill, so much so that writing is a very painful and laborious process. By the time Dr Minton got here yesterday evening, my dear love, every gland in my head & neck had swollen to the size of a plover's egg & was hurting horribly. Dr Minton says it's one of two things – German Measles or Rundownness. Unless I break out into a cluster of spots today, darling, it isn't German Measles. There is also a slight chance of it being Mumps. I hope by this afternoon Dr Minton will be able to say more definitely what's the matter with me.

Pan & Dicky's reports arrived this morning, my dear love. Dicky's is Awful but Pan's just couldn't be better. He got a First in every subject.

Darling, Dr Minton says I have German Measles. It's the most painful illness I've ever had – except Jaundice. (Dr Minton says I shall get better very quickly once the rash is past, my love.)

Oh! darling. Mrs Eban has just telephoned Mum to say that Aubrey has become an Uncle and that he is staying in Cairo with you. I'm so tremendously glad. I'm sure your Morale will go up by Leaps & Bounds while he's with you.

Darling, Dr Minton says he's never seen a more ferocious attack but that I've got a Resilient Constitution & no one has ever had the slightest ill effects after German Measles.

SUNDAY 11 APRIL Darling, I had an undisturbed night & I have no temperature this morning. I'm getting better.

When I think of Miss Anderton, darling, I realize that however intelligent people may be they simply can't educate themselves without some guidance. Her idea of improving her English is to study some bloody silly Pitman's Publication called *How to Express Yourself in English* in fifteen lessons. Instead of poring over this Turgid Nonsense, my love, she ought to be reading Dr Johnson & Jane Austen. She'll learn more from them in an hour than she could ever hope to learn from Pitman's fifteen volumes. But she's too old to start now, darling & I can't advise her because she's badly bitten with the Practical Bug. She thinks I am Impractical – that I have my Head in the Clouds & that therefore my advice is useless to her. I dare not say too much, my darling, because having left school at 15 & having fought bitterly for her very life against bullies

of all sorts ever since, she is constantly & painfully on the defensive & might think that in criticizing her method of self-education, I was despising her.

Darling, there's one thing I must tell you because I can't keep anything from you – though I didn't really want to talk about it. For several weeks I have been negotiating for Miss Anderton to see Sir Ernest Graham Little about her boils because she's had them for 3 years & has been treated by Panel Doctors & Hospitals without the slightest effect. They haven't even bothered to take a blood test, darling. All they've done is to Poultice her & send her away. I wrote a long letter to Sir Ernest about her several weeks ago & yesterday Lady Little rang up to say he would see her & would take charge of the whole treatment if need be. I've led Miss Anderton to believe that the AM are going to meet any expenses, darling, because she'd never accept the money from me, but actually I shall pay for the treatment. You see, my darling, I can't bear to think that because she's poor & a cripple this infection should be allowed to drag on & sap her strength as it has done for years. I want her to have the best care in the land as I should have myself, my darling – & now she's going to have it. I know it is the right thing to do, my dear love, & I hope that if you knew her & the history of her medical treatment & her courage & strength of character, you would want me to do this. Darling, I know I can't help the whole world – perhaps one day the Beveridge Plan will do that for me. But where I can help, I feel I must. You do understand, don't you, my dear love?

WEDNESDAY 14 APRIL Tell Aubrey, my love, that I shall write to him as soon as I've got rid of my bread-and-butter birthday correspondence and (in reply to a Query) that, as far as I know, Bernard Waley Cohen is not having another Innings &, as far as I know again, never has had another since Joyce suddenly Saw Him All As a Pattern while she was in her bath one day. Needless to say, darling, She's Never Been the Same Since. Aubrey does not know of the Revelation in the Bath, my love (Though I'm sure I told you at the time) because he's never before mentioned Bernard. What he said in his last letter was: 'What cheer of Joyce? I suspect some new period of Waley-Cohen intimidation. I used to recognize the

symptoms in temporary apathy.' I quote this, darling, so that you may know what Tone to adopt in handing on my message. Peggy Ungar tells me, darling, that Mrs Eban spent 3 solid years trying to persuade Aubrey's cousin Charles to let her have a Glimpse of Joyce. Well! Well! Well!

Miss Anderton telephoned, my love, just before I went for my walk, to say that she'd seen Sir Ernest & that he had discovered that she's had chronic appendicitis for years & that that is probably the cause of the boils. I shall have a full report from her tomorrow or the next day, darling. God! Darling, but it makes me furiously angry to think that she has been treated by <u>three</u> panel doctors & a hospital for her boils & none of them ever examined her carefully enough to find out that she had an inflamed appendix. Equality? It's just as well that I've had a sedative – otherwise I'd be prancing about with Rage & Frustration.

Dr Minton came to see me very late last night & said I could go back to work on Monday. He told my parents that if there was the remotest chance of bringing us together they should seize upon it.

Twenty-six seems a great age today, my darling. I feel too old for the weather, my love, too old & too tired.

FRIDAY 16 APRIL My darling, I'm feeling so much better today that I hardly recognize myself. I'm going to meet Miss Bradbrook for lunch. Afterwards I shall go and have myself photographed for you in my new black dress with the tartan collar.

You know, my darling, it's a queer thing but when I heard yesterday of Brigadier Kisch's* death I could, although I knew him very well, remember only one thing about him really vividly & that one thing coloured my whole impression of him as a rather prim & mimsy little man. When I was about 12 and a terrific Virtuoso with a Yo-Yo he asked me to stop playing with it 'because the up-and-down, up-and-down is Very Agitating'. What a thing to remember a man by, my love, especially a man who lived to become a great expert on mechanized warfare! It's a good thing I wasn't Called Upon to write his Obituary notice, isn't it, darling?

* Brigadier Kisch died on 7 April 1943, after stepping on a landmine in Tunisia.

SATURDAY 17 APRIL Darling, if any more people look like getting married before us I shall Lay Aside my Dignity and Scream. There's yesterday's *Times* Blazoning Forth the Betrothal of Matthew Waley-Cohen (men must be Scarce in the West Country, my love) to a Junior Subaltern in the ATS. I forget her name but it begins with 'W' and it might be Jewish & it might not – though I expect it is – The Waley-Cohen Character – a Marked Inclination to Toe the Line.

TUESDAY 20 APRIL Jean has Come Over All Back-to-the-Land, darling. She's buying some land in the Home Counties and she intends to grow Recherché Vegetables on it. Well, well, well! I'm lunching with her today at a Kosher Restaurant, my love. I don't feel like lunching with anybody. I should have preferred to read *The Idiot* all by myself in a Dark Corner.

WEDNESDAY 21 APRIL Darling, Joan Pearce's Young Man, who has been in W. Africa for 2½ years is expected home any day now. She is Glowing with Satisfaction, darling.

 I never liked him. He once attempted to drop a miniature sausage down my neck in a fit of Tipsy Bonhomie at Joan's 21st birthday party. (I'm glad alcohol never has any effect on you, my dear love.)

THURSDAY 22 APRIL You know, my dear love, there isn't the slightest doubt that Dostoyevsky is the greatest novelist that ever lived. Coming to work this morning I was reading *The Idiot* and the effect was so tremendous that I felt quite stupefied and bewildered when I looked out of the window to find that the bus had drawn into the kerb at my stop.

 Darling, if there were any sun I should like to be lying in it – but not alone. I want to lie in the sun with you, my darling, & I want you to undo the buttons of my dress & slip your hand inside my brassiere as you did on that first day when you touched my naked breast, my darling, & excited me so much that I could only gasp & beg you not to make me get up & go to the pictures. Do you remember, my dear love? You didn't excite me completely then – that came afterwards but you made me realize for the second time

in my life (the first, as I've told you, darling, was in your room at Victoria Road) the overpowering joy that you could call up from my body & my spirit. These are but fancies of an idle brain, my dear love, because there is no sun & you are still many thousands of miles away.

FRIDAY 23 APRIL There's a tremendous commotion going on in the house because Aunt Teddy has just come back to Take Shelter from the Guns for the Night. Whether this will Prolong itself into a 6 months' visit is impossible to foretell, darling, but I shouldn't wonder. Last time she came to stay it was for a weekend but it was 18 months before she left.

WEDNESDAY 28 APRIL You know, darling, just as an experiment I've tried a New Line with Dicky. I've tried to make him see the Error of his Ways by explaining in great detail the Ethical & Social Enormity of his Conduct – and it's really painful to see, darling, that what I say doesn't strike a spark. He simply doesn't understand about Right & Wrong. He watches me with his hard, black eyes and then when I've said all I can closes the subject with some cheap, cynical sneer. Oh! Darling, he's one of the most convincing pieces of evidence that Ouspensky Has Something when he says that there are some people who can't progress spiritually – because they have no real desire for spiritual progress – however favourable their opportunities. Dicky has had every possible opportunity – and yet he is so sodden in self-conceit & materialism that there's an impenetrable barrier round him. Perhaps it amuses you, darling, to hear me discuss a child's character so solemnly – but (and this is what everyone tends to forget because he has a deceptively childish appearance) he is nearly 15 & in some ways he's an old 15 too. Oh! darling, it causes me an immense amount of distress & anxiety because I can foresee that one day Dicky is going to give my parents a shock from which they'll never recover. &, though it will be largely their fault for not whipping it out of him in time, I don't want it to happen.

SATURDAY 1 MAY Darling, Nurse is going to have another baby. I'm sorry for Nurse, darling. Allan is a fanatical Roman Catholic & Contraception, in his eyes, is the Instrument of the Devil – so Nurse will have a baby every 10 months until she grows too old. Oh! well, if Mrs Gaster survived 16 I suppose Nurse will too – and anyway, Who Am I to Talk?

I had lunch with Miss Malyon today & I said wearily with my mouth full of smoked salmon that I felt as though I were getting to the end of my rope. She said it astonished her that I could be so 'entertaining & bursting with mental vitality' if I felt like that. I looked at her in amazement, darling, because it seems to me that since you left I have been duller than a clod & older than a boat. She told me that the other day after one of our coffee sessions Mr Murray had remarked that you were lucky because I was such good company & that she'd replied that our coffee sessions brighten up the whole day & he agreed. All I can say, darling, is that some people are easily pleased – and I am <u>not</u> referring to myself.

MONDAY 3 MAY Yesterday was a good day, darling. I was wrong when I said Mrs Eban & Mrs Halper were indistinguishable from one another, my love. They are only superficially alike. Both are voluble – but if you scratch below the surface, darling, you find in Mrs Eban a high degree of intelligence & humour – a sincere desire to understand her fellow creatures & her children (though it must be admitted, my love, that her desire doth outrun her performance) and a fundamental honesty & forthrightness. Mrs Halper is quite another matter, darling. She's bigoted & stupid & fanatical. She is also a Social Climber of no mean effort & achievement & she has no sense of humour whatsoever. Her philosophy of life is that all Jews are Gods & all Others Devils at worst and Riff-Raff at Best. Bearing all this in mind, darling, it will not surprise you to hear that she & I differed violently on the Jewish Question.

TUESDAY 4 MAY Dr Minton has just been to see me. He says I am suffering slightly from a 'hyper-thyroid' due to my 'psychological condition' & that I must stay in bed for a week & sleep as much as

possible. He was so kind, my darling. He says, my dearest love, that constitutionally I'm perfectly normal & healthy & that once we are married and the fear of separation has been taken away from me I shall enjoy a physical robustness & vitality such as I have never enjoyed. He says that his only <u>effective</u> prescription would be a telegram to you Ordering You Home. If <u>that</u> could be arranged, he says, he guarantees that in a week my thyroid glands would be behaving with perfect decorum. Oh! God. I know he's right, my darling.

Jean dined here last night, my love. You know, darling, I like her so much better now that she has abandoned casual wantonness for Square. Darling, it is an appalling limitation in me that I <u>can't</u> accept a promiscuous outlook in my friends. I've tried to be <u>Enlightened</u> & Broadminded & Tolerant but it's No Good. I hate it, darling, & I can't even pretend that I don't.

FRIDAY 7 MAY Darling, my nerves are screaming like scorched brakes this morning. I hadn't really conceived that anything so damnable could happen as not getting any letters this morning, but I was quite wrong, my dear love. That is precisely what <u>has</u> happened.

Mum & Pa are in a Resentful mood this morning, my dear love, because I'm feeling less well than I did yesterday. Mum talks of taking me to a nerve specialist, but what the Hell is the good of that? Dr Minton knows & I know & Mum knows what's the matter with me – one letter from you, my darling, will do more good than all the Neurologists in the world.

They had an interesting evening with Mrs Churchill, darling. Pa's Appeal was, as he is the First to Admit, Squinting Modestly Down his Nose, Eloquent. Mrs C was Tremendously Moved (This is Mum's version) and when she heard that Pan & Dicky were at Harrow, her Cup was Full. Mum & Pa found her very charming, darling. She is very soignée and attractive looking &, it seems, has a very warm manner & a keen interest in everything that goes on around her. Pa Dreams that she may say to her husband at the Conjugal Board or even in the Conjugal Bed, darling, that she heard a man the other day who didn't make speeches – he Conducted Symphonies in prose of his own composition.

Darling, Dr Minton has just been to see me & he says I must go away for a week or ten days & that right rapidly. The only place where I can go at such short notice & where I know I shall feel as much at home as though it were my own house, darling, is Girton Corner, so, watched over by Mum, Pa & Dr Minton I telephoned Mrs Turner who says she'll be glad to have me at once and for as long as I like. I'm waiting until tomorrow afternoon, darling, in the hope that I shall get some letters before I go.

You see, my darling, I am yours for better, for worse, and I can't live without you. I can only drag my slow length along like a wounded snake and wait for you to come home to me carrying the gifts of love and life in your hands.

TUESDAY 11 MAY　Darling, I had lunch with Nancy Bailey & mercifully she is unchanged & wholly delightful. She told me, in the Deepest Confidence, darling, that she was beginning to get quite Alarmed about meeting old friends because of the Change that seemed to Come Over Them in Practically no Time. She said that she had recently met an old school friend whom she hadn't seen for years. She had been looking forward enormously to the meeting, had Parked her Daughter on a Neighbouring Great-Aunt & Pranced Off to the Appointed Place in High Jubilation. She had expected the friend to be in WRNS uniform, darling, but she wasn't. Nancy remarked on it casually & the girl confessed that she had been Cast Out for sleeping with 12 different men in a fortnight!

WEDNESDAY 12 MAY　Oh! darling, I can't wait for your Stinging Rebuke (I hope it lashes me to the marrow) for trying to lead you astray in the matter of wild oats. Every now & then, my darling, my Conscience compels me to give you an Opening, lest you should need it at any time but oh! God, do you know what it costs me to do it, darling? I expect you do. After that I Wait in an Agony of Apprehension & Emotional Turmoil. Not only do I not want you, with all my heart, to Sow Wild Oats – the very thought of it makes me Feel Ill. Ergo, my Gesture has no value.

THURSDAY 13 MAY My darling, today has been an eventful day. First there was the news about the end of the fighting in Africa. May I dare to hope, my dear love, that that may mean that you will come home soon? Oh! please dear God that it may.

I forgot to tell you, darling, that when I went into Girton yesterday evening, I met Matron (the old Battleaxe) in the corridor & she said: 'Ah! Alexander – the girl who used to telephone to Cairo once a week. You'd better come to tea tomorrow.' So I did, my love. She gave me 3-decker sandwiches with one hand and waved the Union Jack with the other. 'She said: 'You never liked Egypt, did you? I expect it was the Egyptians – A poor lot – but show me a nation that isn't a poor lot – except us, of course.' There isn't a fraction of tongue in Matron's cheek, darling. She's an Outpost of Empire. I can't think of a more incongruous place to plant it. She made Short Shrift of my Thyroid: 'Nerves,' she said succinctly. 'Always were a bundle of nerves. Thank God the First Year are a Healthy Lot.'

Portress, darling, is unchanged in spite of having lost 19 teeth and being Resplendent in a brand new set of Dentures – which she showed me with Immense Pride.

I almost forgot to tell you, darling, about Matron's fantastic remark about Jewish Atrocities on the Continent. She asked me if I thought the stories that were being put about were true & I said gravely & sadly that I was afraid there was no doubt that they were – the evidence was so overwhelming. She said: 'How dreadful. I wish you hadn't told me. I felt better as long as I could believe that they were exaggerated.' Darling, that is so much the attitude of the Government & of all but a very few enlightened humanists (& they are to be found mainly in the House of Lords & the Universities) that it made me feel rather as I feel when I hear my contemporaries discussing their Sex-Lives, that I am battering my head against a brick wall.

FRIDAY 14 MAY Darling, I'm cross with Adele for her attitude to Aubrey but I too can understand how it came about. Nevertheless, Adele has all the Temperamental Attributes of a King's Mistress without the necessary Compensating Charms. (Not that I'm complaining of that, my love, considering the Intimacy in which

you Twain are Placed.) As for Aubrey, darling, his Manner (which I <u>richly</u> enjoy) is his Misfortune and I know very well that that is why his young woman left him & why Joyce never took him seriously. He is too much the Grand Seigneur: He has never learnt how to Come Off It – & one thing a girl needs more than another (& Adele is no exception) is a man who can be boyish from time to time. (It's one of the things, my darling, that Mum loves so supremely in Pa.) Aubrey Gambols at times but he Gambols like a Loveable Elephant & <u>not</u> like a very merry, giddy, frisky, jolly little lamb – until he learns to do that, darling, mark my words no woman (& again Adele is no exception) will ever love him.

<u>SUNDAY 16 MAY</u> I'm sorry to Contradict you, my love, but Bernard Lewis is right about your potentialities as a scholar – you have much greater depth than Aubrey. Memory & concentration, my darling, can be acquired. Receptivity & understanding cannot. Aubrey is a Doctor Johnson but you are a Plato. Don't contradict me, darling. It is my business as a humanist to distinguish between the Johnsons & the Platos of this world. At the risk of sounding complacent, my love, I must ask you to Apply to My Tutors who will tell you that I am Good at It.

My darling, I had hoped that we should not discuss the unbearable possibility of your capture & death but since you <u>have</u> referred to it I can't leave it at that, my dearest love. If you were missing, my darling, of <u>course</u> I should not give up hope of your being a prisoner of war. Just as I couldn't endure to live without you so I couldn't bear to die while there was a possibility of your being alive. In the event of your death, my darling, you <u>must</u> please understand that there would simply be no shadow of a possibility of my being a happy wife & mother or even a useful member of society. I'm deadly serious, my dear love, when I say that without you I am <u>nothing</u> – unless you understand this you will never understand my love. I don't believe in an afterlife (though I am very much inclined to believe in eternal recurrence) & therefore I don't believe that in such circumstances, my death could cause you any pain. As for my parents, my dear love, their grief at my death would be painful – but it would pass. Their grief at my desic-

cation & shrivelling up if you were dead would last as long as They or I lived. If we had children, my darling, that would be different. I would not desert the responsibilities that you had left me but we have none, my dearest love, & I can't live without you. I can live away from you, but not without you altogether. As for marrying someone else. Oh! God! My darling, you must see how wildly fantastic that suggestion is – but, don't worry, my dear love, I am Confident that we shall be together in time & have such joy of one another that all the world will wonder at it.

Yes, please, darling, I want to lose my virginity on our wedding night. There will only be two people in the world on that night, my darling. The rest can clamour to their hearts' content. They are shadows – nothing more.

I was simply Horror-struck by your account of the airman who wrote two letters in exactly the same terms to two different women. I can't remember ever having been so Shocked in my life before. I wish you had followed your Inclination in that instance.

I had tea with Miss Lloyd Thomas yesterday & read the draft regulations for the Eileen Alexander Prize. They start, my darling, by saying that The Prize was presented by Mr & Mrs Alexander to commemorate the betrothal of their daughter Eileen (English Tripos, 1939) to Gershon Ellenbogen. Oh! my darling, is that Good? I think it's terrifically good.

FRIDAY 21 MAY There were terrific Purple Passages in the *Times* & the *News Chronicle*, darling, about Brigadier Wingate who is described as a relative of and successor to Lawrence of Arabia. Apparently, darling, he conducted a brilliant three-months raid on Burma, 'one of the most daring operations of the war'. He is described, with Characteristic Fulsomeness, as 'A dreamer & a soldier'. Of course, my love, there is no doubt that he is one of the most remarkable men I've ever met. He has Genius, I think, & he is that rarest of all combinations – a humanist of the first rank and a Man of Action – so that all his Action is directed by quite extraordinary imagination.

It's no good thinking that for me you are a man like other men – you are nothing like other men. You appear as far above

them as the sun appears above the earth and for the earth, my darling, there is only one sun though I know there are other suns for other earths. You are asking me, at the setting of the sun, to accept a 100 watt bulb in its place.

Darling, when I got back from lunch Kitty & I Got Talking about Bosoms. I said Impersonally that it was a queer thing that so many men had the impression that there really were more than a tiny proportion of women who had Bosoms like the Girls in the picture-papers. Kitty (who has a very good figure, darling) Laughed Heartily at this & said surely the kind of man who read the Picture Papers Faithfully couldn't fail to read all the articles on how film stars spent hundreds of pounds on having paddings & mouldings fitted into their brassieres in accordance with Current Fashions in Bosoms. As for photographs of naked girls, darling, she said, as C. S. Lewis has said before her that it was mainly a matter of lighting and posing. I said that I understood that there were women who did Bosom Exercises & did she think they Did Any Good? She said that it was queer that I should ask that because it reminded her of something her family doctor had said to her when she went to see him about some Tummy Trouble shortly after she was married. He remarked that she had grown very thin – particularly in the Bosom (you would have no quarrel with her Bosom now, darling) & he said that it was a curious thing that there was only one thing which invariably filled out and strengthened a woman's breasts & that was regular and complete erotic satisfaction. Darling, I almost Wept with Joy to hear this because it's Obvious that my Bosom has a Chance after all – no, far more than a chance – a certainty. Kitty asked him if that was the reason why Wild Oats so often had firmer bosoms than other women & he said he believed it was because there certainly wasn't any other way of maintaining the Right Kind of Bosom after the age of 18. (Kitty later asked her sister & brother-in-law who are doctors what they thought of this theory & they said it was a Medical Commonplace. Nobody could explain it but everybody knew it.)

SATURDAY 22 MAY My darling, Brigadier Wingate is still Front-page News. In fact, my love, more than that, he's the subject of the *Times*'s second leader this morning. The *Evening Standard* devoted

two full pages to him and gave Mrs Wingate's address. I shall write to her, my darling. I have an idea that her husband's absence leaves as terrible a gap for her as yours does for me, my dearest love, except that in her case there is the added burden of his constant physical danger.

My darling, Victor is here. He's joining a Destroyer flotilla for Coastal Convoy work tomorrow. I'm so tense with excitement, my darling, that I have hardly been able to listen to a word he's been saying. My mind did grasp one anecdote though, my dear love, that deserves to be put on record. He was recently offered the Favours of a hideous & pathetically haggard middle-aged Prostitute. These he declined, but when she told him she was Destitute – all her Old Gentlemen having been Evacuated & the young men wanting something better, he asked her to dine with him & then gave her a present of some money. He tells me, darling, that they had a long talk about Prostitution & she very fervently & cogently put forward the view which, as I remarked to Victor is held by Kenneth Walker, that prostitutes are an essential factor in the protection of the Sacred Institution of Marriage. She bitterly deplored the growing tendency towards promiscuity in middle-class girls & Victor swears that her attitude was obviously very genuine & born not of self-protective Trade Unionism, as I half-seriously suggested, but of sincere Compassion.

Apropos of Victor's encounter with the prostitute, darling, he left behind his *Encyclopaedia of Sexual Knowledge* in order that I might read all about the result of a recent Gallup Poll on 'Do Prostitutes enter the Profession for Pleasure?' I haven't read the chapter yet, darling, but I was glancing through the book last night trying to find out the location of the sensitive spot at the seat of Wantonness. It appears, darling, that it is not covered over by the maidenhead but that it is, in fact, one of its boundary points. On the other hand, my love, the book says that the reason this place is often so sensitive in virgins is that they spend a lot of time in their youth exciting themselves by touching it (how horrible, darling) which makes it more & more sensitive. From the Geographical Description of the Seat of Wantonness in the Book, which is more explicit and lucid than any I've ever met before, it seems, my love, that you hadn't actually discovered the spot. The

Book also says, darling, that Men have Erotogenic Places all over them just like women. Have they, darling? The Book says it is the Duty of a Good Wife to ask her Husband where they are. How I loathe reading books on Wantonness, darling. It's all so unreal and mechanical. However, my darling, reading them does show me what I knew already – that all other men are fools and that my Solace is the cleverest lover in the world.

WEDNESDAY 26 MAY My darling, yesterday evening at 7 o'clock, I gave up smoking – You remember, I said I would, my dear love? I feel intensely nervy and irritable and dizzy at the moment but that will wear off and by the time we're together again, my darling, I shan't even want a cigarette if you offer it to me – and you will not have to kiss My Lady Nicotine ever again.

I'm finding it the most terrible effort to write, my darling. The craving for tobacco is one of the most beastliest of all physical sensations. It makes you sigh and feel absurdly short-tempered and intolerant and it makes intellectual concentration almost impossible. I can't believe, my darling, that I shall feel like this for very long. Of course this time of intense excitement is not really the best moment to try and do without cigarettes.

I had a long & charming letter from Mrs Wingate this evening thanking me for mine. She asks kindly after you & says she'll get in touch with me next time she's in London.

THURSDAY 27 MAY My darling, Sylvia was quiet & serene and restful and I feel a great deal better. She brought with her, my dear love, the books (discreetly wrapped in brown paper) on marriage which she read before her marriage. Last time we met, darling, I was telling her how much I hated most of the books on marriage that I'd read & she said that she had read two very slender books by women doctors which were impersonal, intelligible and helpful. As Sylvia has very much the same kind of mind as I have, darling, they will probably make the same impression on me. I don't want to read Technical Tomes, my dearest love. All the technical knowledge that I need, my darling, I know I shall get from you and, arrogantly perhaps, I believe I know a good deal more about emotional love than most of the doctors who write about it – but I feel I must read

one Good Book on Wantonness and one on Contraception before we're married, my dear love, as a basis for your instruction.

FRIDAY 28 MAY Darling, I didn't tell you how Joyce stood in relation to Aubrey and or vice versa for a number of reasons, – (i) because I thought you knew already (ii) because I thought, in spite of what you've told me of your relations with him on Personal Topics (iii) because I thought that it was more than likely that he'd show you the letter in which I Told Him All. But it seems that I was wrong, my love, so I'll give you a brief résumé of the situation. Joyce isn't seriously interested in Aubrey at all – any more than she is in Us. She has travelled along a different road but she has a kind of ashamed loyalty to us all because we were once her friends. That is really all, my darling.

I suppose Aubrey's 'lengthening list of sundered threads' simply means Joyce & Joyce's Predecessor in his affections, but since everything is relative, two names at the age of 28 is quite a considerable list & I think his remark was not unjustified. Poor Aubrey. I wish he weren't so hopelessly incapable of handling his own emotional affairs.

SATURDAY 29 MAY Basil arrived unexpectedly for dinner, my darling. He's restless & depressed and terribly lonely emotionally. He finds suddenly that he is bored when he goes home. He is losing his old bearings and hasn't yet found new ones. He is, in fact, in very much the same state as you were in when I first knew you, my dear love. He left at 10 to go to Edinburgh for a course in Tropical Diseases and thence to Liverpool on Embarkation Leave. He is Seething with Speculation about his ultimate destination but knows nothing definite.

He says too, darling, that ever since he was posted to the Field Ambulance Unit with which he is now he has had a foreboding that he had not long to live. I explained to him that that was nothing more than a fear of the unknown which came to every man I had ever known – every sensitive man at least – who was faced with the prospect of going into battle for the first time. Basil is self-observant, my darling, without being self-understanding, in which he differs very strikingly from you, my dearest love.

Darling, you know it's odd how even when parents & children have a strong similarity of intellectual outlook, as my parents & I have, the most extraordinary barriers are always cropping up.

Last night at dinner Peggy Davies was talking about Twins and I told her what Mr Long had said about the Growing Up of twins being especially interesting to watch. She asked me what sex they were and I said boys. 'Oh!' said Peggy, 'I shouldn't like twin boys – I should like one of each.' I explained to her, darling, that those weren't real twins because real twins developed from a single split cell and <u>had</u> to be the same sex whereas twins of different sexes were two separate cells developing at the same time. This morning, darling, Mum expressed Shocked Amazement that I should have discussed 'Such Things' in mixed company!!! In all her years of married life, she said she had never referred to matters of that kind to anyone but Pa. Pa intervened here to say hastily that while he realized that Times had Changed and People Thought Differently now about what was or was not Suitable Drawing Room Conversation, I ought to Respect the Older Generation whose views were different from mine. <u>Well</u>! darling. I just <u>gasped</u>. It was obviously no good <u>arguing</u> with Mum – anyway I was struck so Dumb that I couldn't think of anything to say but I find it dreadfully stultifying to discover suddenly in that way that Mum or Pa are speaking to me in a Foreign language. Do you see what I mean, my love?

You know, darling, the more I see and read the more <u>certain</u> I am that the Jewish Racial-Persecution bug is one which extends far beyond the Jews and should be treated as part of the whole heart breaking & morally revolting tendency to persecute racial minorities. I was reading an article the other day in Kitty's *New Statesman* on the American Negro question, my dear love. The persecution there, darling, is only less horrible in <u>degree</u> than the persecution of the Jews and the reason why, in spite of occasional lynching there is, on the whole, not much actual thuggery in America towards the negroes, is I am sure, because they have not the same dangerous habit as the Jews of rising to the top in the Callings that Matter. (That may very well be because they've never had a chance, darling.)

I remember feeling physically sick, my love, when Mum told me, a year or two ago, after having met and talked to him at a Party, that Paul Robeson had remarked that he'd tried to get his son into every university of repute in America, and, having found all the doors closed against him, had finally sent him to Moscow University. Besides all this, darling, I have a vast body of terribly distressing stories about the treatment of the Negro troops in this country both by the Americans & by ourselves – & I'm haunted by a report I saw some months ago on Teaching the RAF a 'Right Attitude' (God!) to the colour-bar question in S. Africa.

You see, darling, all this leads me back to the conviction that the only way to cure the Racial Minority Disease is to teach people about right and wrong – not to segregate them into separate states. Oh! no, no – and if I didn't believe in the ultimate perfectibility of human nature I should have in the end to believe that racial prejudice was incurable and I can't believe that, my darling.

Jean gave me Bone Soup (and let me chew the Bone, my love) and stuffed veal & salad & tinned peaches and then, being very late we Cast About for a taxi to take us to the Cinema. We found one, darling, just at the moment when it was being hailed by a Man in a Monocle & German Spats (believe it or not) and a chocolate brown suit. As we were going his way he offered us a lift which we gratefully accepted, darling. He turned to the driver & instructed him to drop us at our cinema & then to take him to Portman Square and then to Claridge's: 'I'm dining at Claridge's,' he explained quite redundantly and added, taking out an Opulent Cigarette Case: 'Do have one of my hand-rolled Turkish Cigarettes – I am at the Bank of England.' This seemed to me something of a Non-Sequitur, my love, and anyway I prefer my cigarettes rolled by machine – it's more hygienic, so I declined politely & Took Out a Craven A. Beau Brummel, darling, is a Beautiful Thought but when you meet him in the flesh he's an Awful Ass.

Jean is feeling rather Woebegone at the moment because Square is in America. She really loves Square, you know, my darling. I was rather surprised. Shall I tell you how I know? She said suddenly, apropos of nothing: 'You know I should never have believed that any man could be as kind and gentle as Square.'

That's the surest sign of love in a woman, darling, a sort of wonder-ing gratitude for her lover's understanding. A man expresses another aspect of the same thing, rather differently. If he loves a woman he says: 'I never believed a woman could love me so much' or 'There isn't another woman in the world who could love me so much.' Do you see what I mean, my darling?

FRIDAY 4 JUNE My Bosom isn't getting any Bigger or Better. Darling, I wonder if you know how much sorrow the inadequacy of my Bosom causes me. You see, my dear love, the greatest joy that I know in the world is to lie in your arms with your hands on my breasts – it's perfect, dazzling, bewildering joy, my darling – when I remember it, I catch my breath with happiness and then I remem-ber that my breasts are soft and small and disappointing and that's all I can give you in return for all the unspeakable delight that I have from you. Darling, you have often said you can love me, Bosom and all. Please say it again.

I had a solitary lunch with Plato. One of the queer things about the illness of loneliness, my dear love, (and it is an illness like any other) is that most of the time you feel not as though you were actively ill, but as though you were recovering from a painful disease which had drained all the strength out of you.

MONDAY 7 JUNE Darling, I don't know how I could have forgotten to tell you, but the most fantastic thing happened the other evening. Ismay rang me up & in reply to the usual polite enquiry about Malcolm & Charles she said with absolutely unmistakeable 'Naturally-my-brother-in-law-and-husband-always-do-the-Right-Thing' Overtones: 'They've both been slightly wounded. Malcolm was in Hospital for seven weeks – Charles for nine.' Isn't it typical, my dear love? Darling, Ismay has Missed her Vocation. She ought to have been an Undertaker. Only in dealing with Dead Bodies can one go through life being as True to Form as that without even getting a Jolt – although I don't suppose she ever will get a Jolt, darling – that's the Pity of it. Darling, I must Get to Work on Isobel, although I'm bound to confess that she's not very Promising material at the moment though I might be able to Lure Her Away from the Straight & Narrow with Raisins for which she appears to

have a positively Freudian passion. I expect Ismay was frightened by a Christmas Pudding or something before she was born.

TUESDAY 8 JUNE As a matter of psychological interest, my love, does Aubrey show you my letters? Talking of Aubrey, darling, Mrs Turner has once or twice said something about him which I've never mentioned to you because it was so fantastic that it hardly merited repetition. Aubrey's reaction to this situation however, darling, has suddenly made me see why Mrs Turner had the impression she did. What she said, my love, was that, given half a chance, Aubrey would have loved me – and now I see how she came to be misled in that way. I know, darling, that Aubrey has not and never has had and never could have the slightest trace of emotional or erotic feeling towards me but I have just realized that he most sincerely and profoundly wants to be loved in the way that I love you – and so there is a tinge of wistfulness in his attitude to me, darling (It's very marked indeed in his latest letter) which has nothing whatever to do with me as a person, my love, but only with what I represent, which is unswerving and exclusive love. Do you see what I mean, darling?

SUNDAY 13 JUNE Pa tells me, my dear love, that there's a Leader in the *Observer* attacking de Gaulle up hill & down dale. That makes me tremble with rage, darling. After all, it was de Gaulle and de Gaulle only who came over to us when our fortunes were at their lowest ebb – it was he who organized the Free French Forces – it was he who was the first to be condemned to death in France for his pains. Giraud & the rest jumped our way only when the tide was turning in our favour. Oh! how sharper than a serpent's tooth it is to have a thankless ally. It is because I prize the absolute values so highly – human justice, human kindliness, human gratitude – that this kind of thing makes me so furiously angry.

MONDAY 14 JUNE Darling, Pa was telling me yesterday that my Egyptian shares which he & mum made up to £2,000 on my 21st birthday have doubled in value since the war. You once said, my dearest love, that you thought £5,000 was enough money on which to start married life and now I have more than £5,000 in my own

right. Darling, I know this is illogical of me but I so much hope that we'll be able to manage our lives without any form of regular financial assistance from my parents. I think we should, don't you, my dear love, with my capital reserves and our joint potential earning capacities? I want most profoundly & sincerely to help you in your career, my darling, but I want to help you by my own efforts. I think I could help substantially towards covering our expenses by writing book reviews & theatrical & film reviews. I can easily meet the people who count in that particular milieu. Sir Alfred Davies knows Charles Morgan well & has often offered to arrange a meeting between us. John Morrison, an old family friend, is a partner in Collins & knows all the critics. All I need, my dear love, is your Moral Support & the rest won't be difficult.

Some weeks ago, my love, Peggy Davies gave me a pair of black artificial satin Briefs which she had Spread Out of. They're French Pattern with brief open legs – quite Obscene. I loathe them. I think black underwear is pretty Nasty anyway but I've seldom seen anything as Nasty, darling, as these Breeks. When you see them you will laugh till the tears roll down your cheeks. However, the Coupon Situation being what it is and my black suit being opaque enough to warrant the shedding of a petticoat I wore them – and every time anybody so much as <u>looked</u> at me, darling, I wanted to Burst with Tears and explain that I was <u>Not</u> that Kind of Girl.

TUESDAY 15 JUNE My darling, I had a letter from your father this morning saying that 12 days ago your mother had an operation and that although she's had a bad time she is progressing favourably now. He adds, my love, that she should have had the operation after you were born but has been putting it off for the past 26 years! Your mother, darling, is unpardonably irresponsible about her health.

WEDNESDAY 16 JUNE Darling, I don't know whether either Kitty or I or both of us had a particularly Wanton Air about us this lunch-hour but, be that as it may, we seem to have been the Focus of the Attentions of practically the entire Middle-Aged Male Population of London! The Culminating Incidents were when a Moth-Eaten Newsvendor with an Obscene Leer and No Teeth shouted:

'Wotcher, darling?' and later a Bus Conductor Blipped me all over the head with *The Star* & then put his arm round me (and I ducked more rapidly than I've ever ducked in all my life, my love) & said: 'I didn't meanter frighten ya, little gel.' Really, darling, I think I shall have to Hire Me a Bodyguard.

My darling, letters 133 & 135 were waiting for me when I got home. At first I cried a very great deal, my dear love, but the sort of horrible cowed stillness that has followed up my tears is something much more terrifying and something which I've never experienced before.

It's no good, my darling, no good at all, I am just about to embark on the most painful & difficult phase of our separation – a phase without hope. I can't believe the war will be over in a year and anyway to think of a year – another year without you is the most unspeakable torment. My darling, it's true that Mrs Wingate was without news of her husband for months when he was in danger but Mrs Wingate has one great, I might almost say unparalleled, advantage over me. She had eight years of emotional rest with her husband before he ever went away from her. She has never had the years of hell & fear that I had because you were always on the point of leaving me. She never had to cling to him in breathless terror because he was going away from her for the night. That has always been a horrible shadow over my happiness with you, my darling, and until we're married I shall never, never be free from it. I can see the enormous difference that two years of marriage have made for Margaret & Sheila, my dear love. They have known complete emotional security and I have not & you'd be amazed at the strength it gives them, my darling.

Darling, I've been staring blankly at this page for some considerable time. It's the most tremendous muscular effort to keep my fingers curled round my pen. Not for the first time since you left, my dear love, I feel as though I'd been ill for a very long time. Oh! what a poor thing my love is, my darling, when it can cause you nothing but anxiety and disquietude – and yet it's such a great love – such an overwhelming tide of love – I'm drowning in it, my love.

THURSDAY 17 JUNE My darling, just to show you that I can still smile (albeit a little wanly) even after a night of wakefulness and terror like last night, I'll start with the story of what happened to Kitty on the 'bus yesterday evening.

Two women in front of her were discussing Savings, my love, & one said to the other: 'I 'ad a sister-in-lor oo 'ad a sort of saving disease. Wouldn't ler 'er 'usband go out evenings for fear 'e might spend a bit of money. Well – after all, we're all 'uman – and now she's expecting 'er seventh.'

I don't believe for a moment that the war – even the war in Europe, will be over in a year's time. As you know, my darling, I always believed if we were going to win, it would be a long & slow & painful war. Now that it's obvious that we are going to win I still think it will be a slow process. In the last war, my darling, when the Germans started to collapse they collapsed quickly and on a grand scale – but then the Kaiser was nothing more than a political enemy & he knew that after the peace he would be treated as a political exile. Hitler and his crew are the moral enemies of Europe, my darling – even if we are disposed to allow them a Gentlemanly Eclipse after the war, Russia will have no quarter, and the German leaders know it. They will flog the dead horse of resistance to the last drop of German blood. Ultimately, of course, darling, the German army will give in through sheer exhaustion but not soon – not soon. Remember, my love, that with 4 German Divisions in the field it took us a year to drive the enemy out of Africa when the whole weight of our armour was thrown in against them. It is said that, at a conservative estimate, there are 40 German Divisions in France alone. I believe that Italy will snap like a dry twig in a high wind – but not Germany.

MONDAY 21 JUNE My darling, letter 132 arrived this morning – a lovely letter, my dear love. Thank you for saying that I needn't do Bosom Exercises any more. It's true that I would have been Glad to do them for your sake if there had been the slightest hope of their achieving any results but you see, my love, I knew that they wouldn't help & that's why, as you say, they served only to make me painfully conscious of my shortcomings. There is nothing to forgive, my darling – you didn't know that exercises couldn't possibly help – I did.

It's no good trying to explain to other people why it is that every moment away from you is a lifetime of hell. I was reading the first Canto of the 'inferno' again the other night, my dear love, and I noticed, not for the first time, that Hell, for Virgil, consisted in knowing Heaven & not being able to get there. A very profound conception, my darling, and one which Milton was aware of as well.

WEDNESDAY 23 JUNE Darling, why is it Typical of me in particular to have got the Topography of the Seat of Wantonness the wrong way round? After all, my love, I've never seen a Seat of Wantonness & I don't suppose I ever shall – least of all my own which I could only see by doing the splits upside down in front of a Cheval Glass. I'm not likely to perform an acrobatic feat of that Magnitude, darling, even in the Pursuit of Knowledge. However, my love, the important thing is that I Got it the Right Way Round in the End, isn't it?

SATURDAY 26 JUNE Darling, I don't know enough about Brigadier Wingate to be sure that he is a wholly admirable person but of this I am sure – He has genius & one of the penalties of genius is that people who have it antagonize a great many people who haven't. It may be that the Hon. Edwin is not fair to Brigadier Wingate simply because he doesn't understand him – but I couldn't say for certain until I knew much more about both of them.

'Corners', Bramley, Surrey 11.55 p.m. My darling, my new era of self-discipline has begun today & these lovely surroundings are helping me enormously. The Murrays have such an enchanting old house, my dear love – all the rooms are on different levels with funny little worn wooden steps leading up and down and low ceilings everywhere with knobbly oak rafters – and they have mellow & gracious furniture – and their garden is a mass of cottage flowers, my darling. Oswyn was being an Arab when we got here, darling. He was wearing a brilliant green turban and was quite naked except for a brightly coloured bath towel which was draped round him rather precariously. He had a Camel which he rode with Fearsome energy. It was two cushions set rather wide apart,

my love, but Rudolph Valentino never Streaked Across the Desert more Wildly & Gloriously.

Oh! I love you, my darling – and I mean to be good & cheerful for your sake.

SUNDAY 27 JUNE My darling, I'm sitting in the Murray's library and I'm covered in ink because my pen has sprung a very spectacular Leak.

I'm not feeling very well this morning, my love, because I slept badly – I always do in a strange bed.

We had breakfast in the garden, darling. Home-grown honey and crusty home-made bread & eggs laid in the back garden. There was Ham too for the others, my love. I think hams are lovely things to have on a breakfast table. They're such a lovely rich seasoned colour. I have no urge to eat ham ever but I just enjoy seeing it there – in the same way as I enjoy seeing hams hanging from ceiling hooks in a cottage kitchen.

After breakfast, darling, I gave Ruth her sky-blue teddy bear & she loved it. She sucked it ecstatically and tried to Tear it Limb from Limb – no doubt Freud would have a lot to say about the Dark Symptoms of all this but, as usual, he'd be Right Off the Point, my love. Then I taught James to use his drawing slate & read Oswyn's book to both of them. I thought I'd made a Terrific Hit with Ruth, darling, because she Waggled her Toes at me and Gurgled and Beamed – but then I discovered that I owed my popularity entirely to my Trinket Bracelet at which she kept Clutching Fascinatedly – and that Deflated my Ego more than somewhat.

Oh! darling, this is a lovely room. There are books & books & more books & for a waste paper basket, there's an old leather fire-bucket ornamented with a Ducal Coronet and a Twirly initial. I have always intended, my love, that we should have fire buckets for waste paper baskets in our home

Mr Murray has gone all Rural this morning, darling, in a faded navy aertex shirt and grey shorts & sandals. He looks absurdly like Oswyn & not really very much older. Mrs Murray is busy in the kitchen & Mr Murray is Mending Things and the children are Rollocking in the garden. (Oswyn was a Puckish little English boy this morning in a sun-suit and a Bottle-Green jersey but now he's an Arab again – but it looks a pretty Tough Bath-

Towel, darling, & seems to be able to Take almost as much Punishment as our Prospective Bed.)

MONDAY 28 JUNE My darling, I'm back at work & feeling a little Weary. I spent the whole of yesterday in the open air except for the half-hour in which I wrote to you, my love, and Fresh Air is No End of a Soporific. I didn't do very much, darling. Everybody else was Intensely Active. Oswyn and James turned themselves into Red Indians in the middle of the morning and Kept Charging Into me with Murderous Intent. The rest of the time they were Immersed in a Red Indian Tent Bloodthirstily Decorated with Red and Black Skulls – which was just as well, my love, because Oswyn's Red Indian Trousers have split all down the front seam and the Murray's had some rather Seemly Visitors to tea!

Mr Murray, looking about sixteen in his absurd little shorts, was busily engaged in hauling a fruit-laden plum tree branch which had been half torn off of the tree in a gale back into place and in Lashing it to the trunk with the aid of Pulleys, ladders and miscellaneous ropes. The Village doctor's prospective son-in-law was sitting high among the branches shouting instructions.

Mrs Murray was cooking & cleaning & feeding Ruth and watering tomato-plants & picking peas with unflagging energy and Mrs Hatch (the friend who lives with them, darling) and her little boy, Jeremy, were reading a book in a corner.

In the evening, my darling, Mr & Mrs Murray & I went for a long walk through sunken lanes shaded with overhanging trees & paved with moss & wild strawberries and looked across the Surrey Downs from a great open field planted with corn and oats & vivid purple and pink peas.

I'm very sleepy, my dear love, because I was talking to Mr & Mrs Murray about the Post-War World until after midnight last night and I got up at crack of Dawn. Darling, I takes orf me 'at to those Stalwarts who, like Mr Murray, live in the depths of the country and Rise with the Lark to get to their desks in time – but if I were to do it reg'lar I should very soon be Dead, wouldn't you?

<u>FRIDAY 2 JULY</u> Darling, I rang up Mr Crotch to ask him what chances there were in Met. for a cousin of Jean Lewis's who has a Chicago degree in Science & who wants to come back to this country. As usual I enquired after his wife & he told me that she would be Divorcing him at the next session. He says, my love, that she has Found an Amenable Youth of about her own age & that she wants to marry him. He, Mr, Crotch, is providing the evidence. Darling, he's been away from the Ministry for quite a considerable time with a nervous breakdown & even apart from that I know that it must have hit him very hard because much of his cynicism & bitterness & crudity had its roots in frustrated love. I have always known that, my darling, but I believed that his own surface callousness could only antagonize his wife still further & that he ought to make an effort. Perhaps he will be less bitter & restless once the whole thing is over. I hope so – at any rate, darling, I shall ask him to dinner one night because he's already very restless & unhappy at the moment.

<u>SATURDAY 3 JULY</u> I had a letter from Basil today, darling, telling me that Raphael Loewe has got a Military Cross. Good for Raphael. I'm not a bit surprised of course, because anything more Bloody, Bold & Resolute than he had become in recent years, I've never encountered.

<u>SUNDAY 4 JULY</u> While I was waiting for Margaret at the theatre yesterday evening, darling, I had a long conversation with the Woman Who Tears the Tickets. I feel that she must have started life as a Barmaid because she had all the Outward Signs – Black Satin Sheath – Synthetic Ginger Lambswool fluffed out on the top of her head – a large Chunk of Ersatz Jewellery on her plump bosom. She told me, darling, that her husband had recently been killed in an air raid: 'It's a funny thing,' she said. "E said to me two days before 'e was killed "Molly," 'e said: "I've been in the Boer War and I've been in the Great War and I've served my time in India – and now I'm going to die in London with no weapon in my 'and to defend myself." – and two days later 'e was dead.' I gathered, darling, that she found *The Moon is Down** a bit tame after the Non-Stop Nudities

* American wartime propaganda film concerning the German occupation of Norway (1943).

which had preceded it. It always amuses me, darling, to see Posters of Naked Wild Oats next door to the Horseguards and within walking distance of every Government Department in the country. I suppose, my love, they're intended to Solace the Legions of Tired Civil Servants and Whitehall Warriors.

TUESDAY 6 JULY My darling, talking about our problem with Joan hasn't helped. Her line is: To Hell with the old people. Do what you want to do – They'll Come Round – my parents did. She talks of minor inconveniences to me if I go against their wishes. She doesn't seem to realize at all that they have a point of view. Oh! I am bound upon a wheel of fire, my darling. I don't want to hurt my parents, my dear love, and above all, I don't want them to hurt you – even indirectly but I'm getting to the stage where I feel that to save my sanity I may have to take a step which will antagonize them permanently. I shall not act precipitately, my darling. I shall try over & over again to make them see my point although I know it's hopeless. They are no more actuated by Reason than I am. It's my peace of mind against theirs. The only difference is, my darling, that as long as I'm separated from you I have nothing – but if I go to you they will have one another and the boys & their friends. I have so much more to lose by staying, my darling, than they have by letting me go to you. If only I could make them see that. Oh! God, if only I could.

Darling, today is the worst day I've had since you left. You see, my love, each Black day is Blacker than the last because there's a greater weight of cumulative unhappiness behind it. Darling, I hate writing you sad letters because then I feel that I'm being more of a Burden than a Solace. It's a cruel paradox, my dear love, that if I loved you less it would be easier to take ruthless steps to go to you – but the thing which haunts me most is that if I flout my parents I may reawaken the old implacable, unreasoning resentment of the accident days against you. You may say, my darling, that such resentment would be unreasonable & God knows you'd be right – but this is not a matter of reason at all. The stand my parents are making is an emotional stand – so is mine. It is emotion pitted against emotion. Mum & Pa may build up specious reasons for their attitude but in fact the point is that they are afraid for me

to undertake the journey – they are <u>jealous</u> of the fact that being with them is no consolation for not being with you – they are <u>outraged</u> at the idea of our being married without them – they are <u>angry</u> at my refusal to accept their wishes unquestioningly. Fear, jealousy, outrage, anger, darling. They are all emotions & they're far more difficult to cope with than a thousand reasons – however cogent, however clearly defined, however sturdily backed. Against that, my darling, I am putting love & more love and yet more love. Reason is no good to me & it's no good to them. Each of us knows what we want & we are fighting to get it.

Oh! my love, my love, whatever else I may have been doing in the last few weeks I have certainly <u>not</u> been earning my salary. If only I were less tired.

Tomorrow perhaps I shall be able to write you a saner, calmer letter but now I am powerless to do anything but cry & wring my hands. How weary, stale, flat & unprofitable seem to me all the uses of this world when we are not together.

<u>WEDNESDAY 7 JULY</u> I almost forgot to tell you, my darling, that I had an Air Letter from Aubrey yesterday evening. He presses me <u>very</u> strongly, darling, to urge you to steer clear of Jean's racket. He says that he has 'endured a wretched few months for no other reason' than that he happens to have got himself mixed up in it. This so exactly corroborates the many heart-breaking instances of injustice & Sharp Practice that I wot of, darling, that I now wish with all my heart that I had never asked Jean to give your name to the Great White Chief. However, darling, it is not irrevocable because even if you are Seen you can always retreat Gracefully by saying that you're too busy to consider any change for the present. It was on the strict understanding that you wouldn't be in any way committed, darling, that I agreed that Jean should Go Ahead. Aubrey is still depressed & unsettled, darling, but it's clear that he takes comfort in his Literary & Cultural Pursuits. He says: 'I find the better minds turning away from politics towards education & literature' and that, he Obviously Feels is a <u>Good</u> Thing.

My darling, letters 142 & 143 arrived this morning. I respect your views about the congenital badness of many Germans. It is a view, darling, which is held by other men whom I sincerely respect – most particularly Colonel Samuel who is by nature one of the kindest & gentlest people in all the world. There is no doubt whatever, my dear love, that you have a case, but I can't believe that the pressing of a button – even if it meant exterminating only the evil people in the world – is the right solution to the problem. Darling, it is true that there are some Conservatives who are not unkind but that is either because they are muddled thinkers or because they are not really Conservatives, in exactly the same way as Aubrey is not a Zionist. (I still adhere firmly to that, my darling.) You see, darling, real Conservatism is an unkind creed. Last night at dinner I nearly smashed the heavy oak dining-table in my fury when Peggy Davies, in reply to my remark that the main fault of the public schools was that there were not enough to go round, said that it was Very Wrong to Educate People Above their Station. That is Conservatism, darling & it is a brutal philosophy. The Nazis wanted to keep the Jews 'in their place' – if they could have done it by pure economic Crowding Out I believe that there would have been no massacres – but they couldn't. The Conservatives want to keep the Insolvent Classes 'in their place' which is a state of insolvency. It is true that the best Conservatives don't want to oppress the poor, darling, but they want to Patronize them. They want their medical services to depend on charity, their livelihood to depend on the goodwill of their employers. I don't think that it's an exaggeration to say, darling, that what the Conservatives are fighting is the abolition of slavery. After all, my love, a lot of the American negroes were happier & economically & spiritually better off under slavery than they are now & yet I'm sure that not one of them can possibly regret the nominal abolition of slavery – because the idea of slavery is degrading & humiliating. Conservatism degrades & humiliates a vast body of the population – it differs from Nazism in that it does not torture any section of the population. A man who is kind and also honest, my darling, can't be a Conservative because humiliation & degradation are repellent to any kind man who sees them as such. No kind man,

however dishonest intellectually, can be a Nazi of his own free will, darling, because although it is possible to call humiliation & degradation by nicer names, it is not possible to call torture anything but torture. You can say, darling, that in certain circumstances torture is justifiable – that is what the Nazis say & that is what the Inquisition said – but you cannot pretend that it is not torture – and a kind man cannot accept the idea of torture in any circumstances – that, darling, is why you could only press the button if it meant a quick & painless death. I agree with you, of course, darling, that there are some people who are potentially more kind than cruel and others who are potentially more cruel than kind but I do suggest that history has shown that education does on the whole make most people rather more kind than they were before. What I mean, darling, is that there is, on the whole, less brutality in the world now than there was in the middle ages and I believe that the cause is that more people have been taught to think for themselves, although obviously not nearly enough people have been taught to think nearly enough. I am not sure, darling, that education will eliminate cruelty, (except as a mental disease) but I think it may – and I am sure we ought not to decide whether it will or not until every living person has had exactly the same education as you and I have had.

As for Aubrey & Zionism, darling, this is what I mean. Real Zionism means the Cult of Zion. It involves the concept of the Spiritual Destiny of God's Chosen People, and obviously every true Zionist must feel it his spiritual duty to return to Zion & prepare it to receive his people. How does that tie up, my darling, with Aubrey's almost violent repudiation of Mr Shertok's suggestion (which I had mentioned to him) that he intended to settle in Palestine? No, my dear love, I am sure that Aubrey's Zionism is a matter of political expediency. Like Pa, he sees no other possible solution to the Jewish problem (Pa calls himself a Zionist too, darling).

I get a lot of fun, my dear love, out of the conflict of our views about Me – I expect you do too. You see, darling, I'm No End of a One where judging people is concerned but I certainly can't swallow the notion that I have a Towering Intellect. You, on the other hand, have great faith in my Intellect but you don't

think much of my judgements of people. I don't mind a bit, darling, on the contrary I rather enjoy it – but I wonder which of us is right?

Before I forget, my love, Pa met a man yesterday who sat two seats away from Churchill at the Guildhall luncheon the other day & he heard him say <u>very</u> sadly to his neighbour: 'You know, in this war I have had a great many crosses to bear but none so heavy as the Cross of Lorraine.'*

SATURDAY 10 JULY Estelle rang me up this morning, my love to ask me to go with her to see a play about Dr Johnson at the Arts Theatre Club this evening. I shall enjoy that, darling. I am always as much entertained by Estelle's Dynamic Response as by the play itself. There she sits, darling, with her Auburn Tresses piled high & her wiry body encased in Emerald Green Corduroy or Rainbow-coloured worsted Crackling like a Firework. What a woman, my love, but how much poorer the world would be without her.

I am determined, my love, to start collecting material for my little book on vinaigrettes. This will involve buying a strong magnifying glass & examining the marks very carefully. I shall begin by preparing a catalogue, my dear love & once having all the material together I can always expand it into a book – when we're married, darling, & the war has dwindled to an ugly memory. I shall go to the Victoria & Albert & study their collection which I've never seen but which I'm told is very fine.

SUNDAY 11 JULY Darling, *The Judgement of Dr Johnson* (I hadn't realized that it was by Chesterton, my love) wasn't bad entertainment. It presented a shamelessly sentimental picture of the Great Cham, darling. The chief character – a little American woman, was played by Robert Walker's first wife, darling. Joan has often talked about her, my love, & has always given me the impression that she was extremely attractive & soignée but I thought she looked a hard, flat little piece, myself, & she certainly can't act. I think, my love, that Chesterton's ideas in the play are pretty Phoney, darling,

* The Cross of Lorraine was the symbol of Free France and the Free French forces during the German occupation.

but Jenny Laird's mimsing and frimping didn't make them any better.

My darling, we've had a Free French Staff Captain here all day – an amazing man. He arrived in England 3 weeks ago after months in German & Spanish prison camps. Every time he got into a Tight Spot, my love, he said to himself 'Woho! I'm a Jew – I'm not going to be Done in by No one' – & he wasn't. Judging from his experiences, darling, he has collected enough material to write an exhaustive treatise on the Black Markets of Europe. His progress across Germany, France, Spain & Portugal, my darling, is the story of one Dam' Black Market after another. I used to think, my love, that Lloyds were pretty Progressive in their Policy of covering anything but Lloyds have nothing on the Black Markets of Europe. There, darling, you can buy or sell anything from human life to pre-1914 Camembert (if you can catch up with it). His name is Meyer & Pa knew him when he was the Egyptian correspondent for *Le Temps*. I don't really like him, darling, because he's been separated (not by Law but by circumstances) from his wife (who is in Cairo) for four years & he doesn't seem to give a damn whether he ever sees her again or not. I never like men who are indifferent to their wives, my darling, but he's entertaining to listen to, none the less.

THURSDAY 15 JULY I travelled to work with Mr Cherrick, my darling. He was talking of Mrs Wingate, who is in London for a few days & he was saying that she has just recovered from a nervous breakdown – so you see, my darling, she too must find prolonged separation from the man she loves an unendurable strain.

Oh! my love, I'm sick with nervousness about today's lunch. I am so afraid that the hour may slip by in social tittle-tattle and the opportunity of getting Mr Bennett to persuade Pa that it would be a Good Thing for me to go to you, may be lost.

My darling, I don't know what I expected Mr Bennett to look like – I suppose I identified him in my mind's eye with Sir Edward's gracious and courtly dignity – but I certainly didn't expect anything quite so black-and-white and Booming drinking large quantities of Undiluted Gin. Every word he said to me, my darling, Rapped me on the Back so that my teeth rattled. 'Trouble

317

with you,' he said, 'is that you're too clever to get any <u>normal</u> job, what?' I explained to him patiently, my dear love, that I'd gladly take a job as a <u>Stoker</u> if it would get me to you any sooner but that the Ministry of Labour didn't feel the same way about it. 'Eh! What?' he said. 'Wouldn't mind coming down a peg or two to be with the young man?' I assured him that for my own part I wouldn't mind at all but that you and Pa & the Government had views on the subject. Then, darling, he told me in all seriousness & with real kindness that I should be wary of writing sadly & anxiously to you because you were a 'fine, sensible young man' & would be perfectly happy in Egypt except for the anxiety I was causing you. Oh! my darling, I'm so terribly sorry but I <u>can't</u> write to you as though I were happy when I'm not. Mrs Bennett is a rather mousey woman. I imagine that she must find the bristling efficiency of her husband a little wearing. <u>I</u> certainly did. It's not fair of me, darling, to speak so of a man who has been genuinely kind to me & whose only purpose in Rating me so Soundly was to infuse into me a little of what he would no doubt describe as 'Pep', but by God, darling, if he sells Wireless Services as Energetically as he sells his Notions about Life I wonder that there are any rival Cable organizations left if the field at all. Oh! my love, I <u>do</u> see what you mean when you say that you wouldn't like to be an Employee of his who had happened to Get on the Wrong Side of him. I was right to be Fearful of this meeting, my darling, because, far from trying to persuade Pa that it would be a Good Thing for me to go to you, he was much more bent on persuading <u>me</u> that I was Fussing needlessly. There is nothing for it, my darling, but to write off this meeting & start again with Pa. Oh! God.

Mr Bennett is going from here to Algeria, my darling, & thence to Cairo. He will bid you to share his 'Tiffin' (Ye Gods!) when he returns to your part of the world. Darling, I have a Very Personal Question to ask you – Are you Tiffin Conscious? If so please Grow Out of it and that Right Rapidly. I would still love you, my darling, if you were to say to me: 'What about a little Mollock after the Next Tiffin but two?' but I can't in honesty deny that I should be Badly Shaken – <u>very</u> Badly Shaken.

FRIDAY 16 JULY This evening, my dear love, Mr Crotch is coming to dinner – & Jean & Square.

Mr Crotch spoke very little, my darling. He has lost much of his breezy cynicism, my dear love, & he's rather bewildered & lost. I'm very sorry for him, darling. It was Square who Held the Floor both at dinner & afterwards. He really is a good Raconteur, darling. He told us of his experiences as a Meteorological Observer in France during the last war. One of his jobs, darling, was to Crawl up a Steep Hill at 1 o'clock in the morning & Take Observations. This he found rather Wearisome, my dear love, & so he soon discovered that there was a weather-cock on a neighbouring Church from which he could Observe the Wind Direction! It struck him as a little odd, darling, that during the 6 months he was there the wind was blowing steadily in the same direction at 1 o'clock in the morning. It was only when he left, (having Let his Successor in on the Weather Cock) that he had a Stiff Letter from the Corporal who took his place pointing out that the weather-cock was stuck & had been for years.

Square was saying that he had recently been to a Jewish Wedding in the St John's Wood Reform Synagogue and that it had saddened him to see a Jewish Ceremony stripped of all its traditional character. He said, darling, that he believed the great strength of the Jews lay in their traditional and historic bonds & that it would be weakened by breaking those bonds. Of course, I disagree with him, very strongly, my darling. I see no sense whatever in upholding a way of life or a religion simply because it is old. Religious conservatism is never as dangerous as political conservatism because every religion, even such a disconcertingly un-spiritual religion as Judaism has some ethical basis, whereas the political or social traditions which conservatives in all countries strive to preserve are based, not on ethics at all, but on the Greatest Good of the people who had the power when the tradition was started – but still it is not a Good thing.

MONDAY 19 JULY Mrs Heath, one of the Bush House Cleaners who Does for Pamela Malyon's Young Man in her spare time, came up to me this morning, Sighed Lusciously & said with the Gloomy Satisfaction of one who has had 20 years of it: 'Well, Miss, Miss

Malyon's Hour is Drawing Near, ain't it?' I admitted that it was whereat she Waggled a Roguish Finger at me and said: 'Don't you wish it was yours, Miss?' (She is the one who Nurses an Illicit Passion for your photograph, darling) As I didn't Mean What She Meant, my darling, I gave some non-committal reply & fled. She's a nice old soul, my love, but she isn't 'arf Licking her Chops over the Imminent Loss of Pamela's Maidenhead & I've no doubt that, in the Goodness of her Heart, she will do as much for me when the Occasion Arises.

TUESDAY 20 JULY You know, my darling, however rich we might be I should not want to put our children in the charge of governesses or even nurses after the age of four. The relationship between teachers & children in boarding-school is quite another matter because considerations of space & time & number make the intimacy which may arise between a child & its governess impossible. My childhood was made bitterly unhappy, darling, by my governesses. Either they slobbered all over me – which I hated – or they bullied me – which I hated almost as much – or they made me the recipient of their beastly confidences, which I hated worst of all. None of them ever stayed very long, my dear love, because I never wanted to learn the things they wanted to teach me (and I'm very glad I didn't, darling. None of it would ever have Got Me Anywhere) & also they thought I was 'Queer'. I spent most of my time before I went to school, my love, wondering whether I was mad because no-one, most particularly my governesses and my mother's family, ever seemed to understand what I was saying or thinking.

WEDNESDAY 21 JULY My darling, I have spoken to Mr Murray & he is writing to Lionel Thompson at the Treasury today. Oh! my love, if this bears fruit I shall be a step nearer to you. Mr Murray says, my darling, that he hasn't mentioned my lack of work to SI because he didn't want to Throw Me Upon their Mercy (bless him) but that he can't in all conscience keep me indefinitely with nothing at all to do.

Mum said she ought to start buying our sheets while there were still linen sheets on the market & while they were still Off the

Ration – and – er – would I prefer double or single sheets? 'Double', I said Firmly, my darling, and without a split-second's hesitation & the Look of Relief in her Eye was Unmistakable. So now the Die is Cast, my dearest love. You won't be able to Go Back on your preference for a double-bed.

THURSDAY 22 JULY My darling, one of the first things I loved about you was that you were the only person in the world with whom I could be silent without any sense of strain and one of the soul-destroying things about our separation is that I can only communicate with you with words. Oh! darling, it's driving me mad. There is a church bell tolling dismally outside my window, my dear love. It is saying 'Alone! Alone! Alone! Alone! Alone!' and it makes me want to put my head down on my desk and cry most piteously. You will have to teach me all over again, right from the very beginning, how to be happy, my darling. I have forgotten.

FRIDAY 23 JULY I am lunching with Ismay & my Godchild today. I do not enjoy being with Ismay, my darling, she has a mind like a plank & it bores me.

Darling, my Godchild has Changed. I won't say improved because I'm not sure that it is an improvement. What I mean, my love, is that, whereas before she was in the Caliban Class she is now rather like one of those smug creatures in the illustrations to that little book of Improving Verses that you gave me long ago. She ought to be wearing long Pantaloons & a Sun-bonnet, darling – they are Definitely Her Idiom. What is an improvement, my love, is that Ismay no longer produces a Diminutive Malcolm from a Shopping Bag at the end of lunch. Isobel now wobbles off to Duncan on piano-legs. She wears thick glasses, darling, & her Squint is considerably less horrifying than it was but her Stolidity appalls me. Nothing short of a shower of Sun Maid Raisins can bring so much as a Twinkle to her rather vacuous eye. I asked Ismay rather sadly whether she was always as Well-Bred as this. 'Certainly,' said Ismay with Hauteur, leaving no more to be said. Darling, we'll be able to Produce something a bit better than Isobel, shan't we? Our talk at lunch was Rigorously Domestic, darling. Is there anything in the world as unutterably dreary as

Household Chat? Never mind, my love, it's over now and it won't Happen Again until next Quarter.

I am not looking forward to Pamela's wedding, my dear love, with its reception at Claridge's. It will be all too, too correct. Pamela herself is not like Ismay, darling – she's too vague & willy-nilly for that & she has got a sense of humour – but her parents are and their lives are Organized up to the Hilt. Punctually three days before her wedding, darling, Papa presented Pamela with a will to sign leaving everything to her Issue via Mr Mackenzie and cutting him off without a shilling in the Event of his Remarriage! The idea was, darling, that Pamela would by that time be so Overcome with Wedding Preparations that she wouldn't have time to think about it – but she Fixed her father by ringing up her Solicitor & making him cut out the new marriage clause.

SUNDAY 25 JULY This hasn't been a Good day, my darling. I was with Mr & Mrs Lipschitz & their guests until nearly 6 & I consumed vast quantities of Energy on vague talk about Economic systems & kindred topics about which I know nothing. A man called Michael Foot* was there, my love – I gather he's Something Impressive on the *Evening Standard*, but I wasn't impressed. Among other things, darling, he said he didn't like Eliot because he Disapproved of poets who didn't rhyme & use recognized metres. It would be no less Senseless, darling, to dislike Voltaire because he didn't write in English! Is it surprising, my dear love, that I never read the papers when you consider the sort of people who make a living by writing for them?

MONDAY 26 JULY Darling, contrary to all Precedents, I have a lot of work to do – and that is a Good Thing – & even better is the news of Mussolini's resignation. Apart from the little personal comedy touch of hearing Mum say: 'We often used to play Bridge with Marshal Badoglia† during the Abyssinian Campaign & he always looked so

* The future Labour Party MP and leader; editor of the *Evening Standard* during the war.

† The brutal governor of Tripolitania and Cyrenaica and commander during Italy's annexation of Abyssinia. Badoglio became prime minister of Italy on the fall of Mussolini and died untried for his war crimes in 1956.

sad that I used to wonder whether he <u>really</u> approved of it!' My dear love, it <u>does</u> look as though Fascism is crumbling in Italy.

Joyce was looking very pale & weary at lunch today, darling. She hasn't heard from Gordon since the beginning of May (God! How awful that must be for her, my darling) & she has hardly any work to do. If she isn't given any more soon she's going to ask for a transfer. Darling, she says that Michael Foot is the <u>Editor</u> of the *Evening Standard*. Well, well, well.

<u>TUESDAY 27 JULY</u> Darling, I got out of bed in the night to see Duncan, having been awakened by a Siren and I stood by the window watching the searchlights threaded like ribbons through the clouds. At one point. Darling, they criss-crossed like the spokes of a wheel and caught a tiny silver plane – no bigger than a fly – in the hub of light at their intersection point. Searchlights are fascinating things, my darling. They are the only Instruments of War, except Barrage Balloons, which give me any pleasure at all.

<u>WEDNESDAY 28 JULY</u> I am going to one of Lord Nathan's Parties this evening, my dear love. Oh! Woe & alas – how I <u>hate</u> the atmosphere of the Baronial Hall. His Lordship Ballooning and Booming about the Place – and not <u>quite</u> enough to eat so that every time you have a sandwich you are Assailed with Pangs of Guilt.

Darling, there's the most Beautiful Intrigue going on on our Floor. There's a little Higher Clerical Officer, a married man of about 50 with married sons in the Forces and Kitty & I see him lunching about every day at Aldwych Corner with a Girl. As she can't be more than 21 and as she wears a wedding ring, darling, Kitty and I have always assumed that she's his Daughter-in-Law – but not at all! Recently he asked to be given a room to himself with an Assistant – (Mrs So-and-so would meet the Case Admirably, he added Casually). His Wish was Granted, my love, and Lo! His Assistant is the young woman with whom he so assiduously lunches on every day of the year – but this is Far From All, my darling. Yesterday, I had occasion to consult AMCO's and as our Branch copy was locked away in Mr Murray's cupboard I decided to borrow a set from this Little Man. It is not customary to knock on people's office doors, darling, so I just walked in – to interrupt

a Mollock which would have done Us credit, my dear love! When I got back to our room with the AMCO's, darling, I remarked casually to Kitty that I had interrupted a Tender Scene next door. I don't know quite what I expected her to say, darling, but I think I was rather waiting on a Testy 'Nonsense!' but not a bit of it. She just said: 'Yes, I know – that's always happening to me – I never go in there if I can help it.' I was Shaken to the Core, my dear love.

My darling, Lord Nathan's party Had Its Points. Joan rang me up at about 6 to say that Robert, at the last minute had offered so pathetically to go home & cook the supper instead of going to the party that she had Let Him Off – so we went together, my love. We went into the library, darling, & Lady N met us at the buffet with: 'Would you like some sherry? I think it's rather hot for Sherry myself. We also have fresh redcurrant juice. Perhaps you would like some of that.' I had the currant juice, darling, but Joan had the sherry – She won't be asked again. Then Joyce introduced me to Arthur Greenwood* who surprised me by being a very tall and stately man instead of the wizened little creature I had always, for some reason, imagined him to be. We talked about war pensions, darling, & he Encouraged me immensely by saying: 'What everybody must realize is that after this war money will no longer have any meaning. We will no longer need to scale down our plans to fit our resources, we shall have to create enough resources to fit our plans.' I nearly Broke into Loud Applause at that, my darling, but I confined myself mostly to a series of Vigorous Nods. This must have convinced him that I was No End of a One, darling (he hadn't anything else to go on, my love, because I was so impressed by his personality & his eloquence that I didn't say a word) because afterwards, when we were getting our things from the cloakroom he came up & said: 'Goodbye, Miss Alexander, I'm so glad to have met you.' I Glowed, darling, because I've been an admirer of his ever since his speech on the day before the outbreak of war. What's more, my love, he's the only distinguished Politician I have ever met who wasn't the most Awful disappointment.

* The prominent Labour Party politician, Arthur Greenwood, best remembered perhaps for the inspiring speech he made in the Commons which helped stiffen parliamentary resolve against Hitler in September 1939.

Last night, my dear love, I think I sank deeper into the quagmire of despair than ever before. My sense of loss at being away from you, my darling, was so terrible that I felt as though my body & my spirit were gradually being crushed to powder and my mind was being pulped to an amorphous mass.

I came home to find a pair of gleaming white linen sheets folded in a box on my bed – a present from Mum to Us & a horrible & morbid thought involuntarily crossed my mind though I drove it away as violently & as hard as I could. It was: 'Not for my marriage bed but for my shroud.' It's characteristic of this kind of mood, my darling, that I am obsessed with the idea that I shall die before I see you again.

Darling, I was thinking in the 'bus on my way to work of my intense antagonism to the feminine graces when I was a child and I suddenly realized that I most passionately did not want to be attractive to men and was fighting a fight for Women's Rights. You will have seen enough by now, my darling, of the women of Egypt to realize that they live according to a barbaric and crazy social system in which marriage & child-bearing are the only Respectable careers & in which Discreet Adultery is more readily tolerated than a profession for a woman. Of course, it was never like that in my own home, darling, but then, in that respect, Mum & Pa were regarded by their neighbours as Freaks. You see, darling, in spite of coming to England every year, Cairo society was the only society in which I had continuously lived until I grew old & wise enough to Know Better. I took it as the norm and fought against it with a vast & needless expenditure of energy & venom.

Joan came to lunch today, my dear love, & we had the most terrific argument with Pan about First Principles. I was shocked at finding Joan was 100% on my side, because I was expressing views which a year ago she would have attacked most rabidly & I know she was simply voicing Robert's views parrot-fashion. She has ceased to have any ideas of her own whatsoever, my darling, about anything at all from sex to housekeeping. I know I love you more single-mindedly and deeply than Joan loves Robert, my darling, but I wouldn't insult your intelligence by turning myself into a Porous Mat beneath your feet.

Oh! my love! Pan is in here reading Plato's *Republic* and smoking a pipe. I must turn him out or I shall be Asphyxiated – & my only excuse is – Sleep.

TUESDAY 3 AUGUST My darling, Mr Murray has had a reply from Lionel Thompson. He says: 'In the event of there being no opening in the M of I would Miss Alexander be willing to be considered for an ordinary straightforward Administrative post in Egypt, say in the Minister of States Office or the Middle East Supply Centre?' Oh! my darling, Miss Alexander would be not only willing but desperately eager to be so considered – what Miss Alexander's parents will say is quite another matter, my dear love. Lionel Thompson's suggestion is the least vague & academic that has been made so far. Lay it to thy heart, my darling, & I will Lay it to my Parents in the hope that they will not Fling it Back in my Teeth.

I want to tell you about a long discussion I had with Pa last night about the moral guilt of the Jews of the time for the crucifixion of Christ. My point was, darling, that although Pilate (with extreme reluctance be it pointed out) Signed the Death Warrant as it were, the moral guilt must be laid solely at the door of the people. It does no good to the Jewish case to deny this, my love, because in denying it one is, by implication acknowledging that it is a Valid Point – an utterly ludicrous notion, darling, because no one has ever held it against the people of Athens that their forebears were morally responsible for the death of Socrates nor against the English that they were morally responsible for the burning of Joan of Arc. What we should say is: 'Yes, undeniably the people of Judea were morally responsible for the Crucifixion – but what of it? Throughout history the masses of the people in all countries have been afraid of visionaries & have had them killed whenever possible. That is a human sin – not a Jewish sin.'

Darling, I won't argue any more about Aubrey's Zionism. I can see that there is some force in your argument – but Zionism is one of the things about which we shall always differ, my darling, but not I believe Acrimoniously. You see I am first a citizen of the world & secondly a Jewess. I think, my darling, though I may be wrong, that you have rather a special family feeling about the Jews which I have not. One day we shall talk about it, my dear love –

though I don't think we shall reach complete agreement, I believe that we shall concede one another a great many points because, in a matter of this kind, my love, it's possible for us to respect one another's point of view without sharing it.

Darling, Pa went over all the old stuff about you being moved and his Judgement Having Never Failed – but the upshot is, my dear love, that they have agreed, albeit reluctantly, that Mr Murray should write to Mr Thompson saying that although I should much prefer the M of I,* I would consider any Administrative job in the Minister of State's Office.

WEDNESDAY 4 AUGUST I'll tell you something that Aubrey (who is a Conventional Soul at Heart) said in a letter written when you were last in Palestine. He said, only one-third in jest, that your staying in Mrs Zaslane's house while her husband was away had Caused him to Raise an Eyebrow. If it caused Aubrey to Raise an Eyebrow, my love, it would have caused Aunt Regina, Aunt Jeanne, Uncle Maurice and Uncle Solly to have a collective Attack of Apoplexy (had they known about it.) My reaction (I had, of course, already heard about it from you & hadn't given it a single thought) on reading Aubrey's letter was to Raise an Eyebrow at him. I told him so too in my reply, my dear love.

MONDAY 9 AUGUST Oh! darling, Mr Murray has had another letter from Lionel Thompson. He writes: 'I have now heard from B. O'Donovan of the Ministry, that they would be glad to see Miss Alexander & suggesting that an appointment be made by telephone.' My darling, I'm trembling so much I can hardly hold my pen. I rang up Sylvia, darling, & told her & she says she knows Mr O'Donovan very well & will speak to him about me. We're going to lunch together tomorrow, my love, to talk over the situation.

Later: Mum has just come in & I've given her the gist of Lionel Thompson's letter & all she could say was: 'What? Are you still serious about that mad idea?' I told Pa when he came back from his lecture and he was not exactly co-operative but again there is no sign of insuperable opposition. He takes the line that it

* Ministry of Information.

'Will Break Your Mother's Heart that when the Moment came, you were incapable of making the Supreme Sacrifice.'

FRIDAY 13 AUGUST I read the Commons Debate on Women. All the women MPs spoke, of course, darling & I was driven to ask myself why it was that when a woman MP made a point it always grew into a very solid cube having far greater extension & volume than anything which could have been perpetrated by a man. Politically minded women are so <u>heavy</u>, darling. I wonder why, my love. It certainly isn't true, on the whole, of academic women. On the contrary, darling, the best type of academic woman, like Miss Bradbrook & Mrs Bennett, has a lighter & more delicate touch than a man – but not so with political women, my love. I <u>think</u> it may be because they have a sense of grievance, darling. I have noticed that in all branches of thought people with a grievance lose their sense of proportion & their sense of humour. That is one of the reasons why I was always irritated by Cambridge Socialists and by Zionists, my love. (It is also one of the reasons why I find it so difficult to take Aubrey seriously as a Zionist, my love. I have met thousands of 'em, from Dr Weitzman downwards but Aubrey is the only one I know who has both a sense of humour & a sense of proportion in relation to the Jewish problem. He simply doesn't fit into the pattern. As for Cambridge Socialists, darling, I never met <u>one</u> who had <u>any</u> sense of humour or proportion about Socialism except Eric Wilkes, perhaps, & he wasn't altogether serious about it.) But to return to Political Women, darling, although I deplored the Spirit of Lady Astor's remark I couldn't help seeing what she meant when she said: 'Other women Members have already dealt with nearly every aspect of women's work & I do not want to bore the House any further.' Of course, my love, Lady Astor herself is a <u>crushing</u> Bore but the point is that it is very saddening to see how yawningly Dreary women can make any discussion of their own problems seem.

I had lunch with Joyce. I'm really sorry for her. It's over 2 months since she heard from Gordon & she has no means of finding out whether he's alright or what <u>has</u> happened to him. She <u>could</u> write to his mother, darling, but I think she's putting off doing this, partly because she's afraid & partly because she doesn't

want to give the impression that she has any special interest in or claim on Gordon. She looks terribly ill and haggard, my darling, and I think this is affecting her more seriously than anything has ever affected her in all her life. The result is, my love, that she has dropped a good many of her affectations and is a very much more human person. I'm glad of that, of course, darling, but I think she's paying rather a high price for the improvement.

SATURDAY 14 AUGUST I had supper with Joan & Robert. I enjoyed my evening. They were at great pains to cook me a very recherché supper & they were so nice to me, my dear love, that when Robert remarked that his Finances were in a muddle owing to having had two wives in the same Income Tax year I was able to smile instead of being Horror-Stricken. Still, darling, on Mature Consideration my Prejudices have got the better of my Sense of Humour and I do, on Reflection, find it a pretty Horrifying Thought.

MONDAY 16 AUGUST Darling, Victor was saying yesterday how much the whole tone of the *Jewish Chronicle* irritated him & I agreed but said that once when I had condemned it to you on the grounds that it was Parochial you had pointed out, quite rightly, that it was after all nothing more than a rather larger-than-life Parish Magazine. Victor said, darling, that talking of being Parochial, the most Parochial thing he'd ever seen in his life was a headline in the *Isis* announcing the accession of Edward VIII which read: 'Magdalen boy makes good'!!! Rather Beautiful don't you think, my love?

MONDAY 23 AUGUST My darling, a Beautiful Moment awaits me. I had a note from Miss Bradbrook this morning saying that Mrs Crews was back in London & was hoping to be able to see me so I've asked them both to dinner on Wednesday or Friday. Miss Bradbrook tells me that Mrs C has Taken unto Herself a Turkish Housekeeper – because although she lives at Edgware she is Desirous of avoiding the atmosphere of Suburbia.

MONDAY 30 AUGUST I bought Dr Leavis's *Culture and Environment* in Bowes this morning and read the whole of it in the train coming back from Cambridge. It analyses the psychology of advertising &

the appeal of the press. It makes very clear, my darling, something which I powerfully & potently believe which is that to raise the standard of living materially all too often results in lowering it spiritually and suggests ways in which the vulgarization, sentimentalization, falsification & debasement of English in Advertisements, the press & cheap literature can be brought home to school children by judicious instruction & discussion. I must admit, my darling, that though Dr Leavis in the flesh drains his pupils dry as hay, Dr Leavis on paper is a Good Thing.

TUESDAY 31 AUGUST Darling, someone in S1 telephoned me to ask if I was still interested in the M of I project (!!!) because if so he intended to ring up today and make an appointment for me. Morale is soaring, my darling.

WEDNESDAY 1 SEPTEMBER Darling, the Establishment people phoned to instruct me to Attend for Interview at the M of I at 3 o'clock tomorrow. Oh! darling, it is fitting that the month of our engagement should begin thus.

Aunt Gladys was talking without knowledge or understanding when she said that I always got what I wanted as a child. It's true that, being a poor little rich girl with immensely generous parents, I always got what I wanted materially – but oh! God, that is not everything. The things I really wanted, I did not get, darling. I wanted desperately to be sent to boarding school in England. I wanted to be normal and I thought that I could only achieve normality by going to a boarding school. It was the most passionate wish of my childhood. When Dicky was born, my dear love, & my parents were in High Good Humour, I wrote them a letter pleading with them to let me go to school in England. I gave my reasons at immense length & I sent it to them through the post & waited breathlessly for results. What happened, darling, was that they laughed at me and told all their friends about my letter as though it were a Colossal Jest. I did not get sent to boarding school. My parents & Aunt Gladys get on only Very Sporadically, darling, & she is Out of Favour at the moment for calling Pa a 'Fat Old Fool' during a scene in S. Africa, a description which stung him more than somewhat – & I can't say I blame him.

THURSDAY 2 SEPTEMBER My darling, I hardly know how the interview went. I arrived a little early and was seen first by a very charming, plump woman called Mrs Burgess who put me through the Third Degree about whether or not I had any Ties in Egypt. I said rather evasively, my love, that I had relatives & friends & she looked in a rather Pointed Manner at your miniature which I had forgotten to take off – so I admitted that I had a Solace in the Middle East. We were then joined by Mr O'Donovan, who clearly knew very little about the Egyptian set-up – he is simply an establishment officer, though a very kind & friendly one, and he got the impression that it might be a little delicate to send a Jewish girl to Egypt. At any rate he told me that there was nothing doing at the moment but he'd let me know if anything should crop up later. Those words have an Ominous Ring, my darling. It may not be as bad as I think but I am in a palsy of terror lest it was simply a polite way of getting rid of an unsuitable applicant. So, my darling, all that is left for me is to wait feverishly and to hope & hope & hope. Oh! darling, darling, this morning I was standing tip-toe on the top of a mountain looking up at the sky and now I have fallen down a precipice & I feel as though every bone in my body had been smashed by my fall.

SATURDAY 4 SEPTEMBER My darling, the dinner party was rather a success. Jean & Bernard came early so I was able to tell them the sad story of my interview with the M of I & Bernard thought he could get a line on what had actually happened, my dear love, through his contacts in the London end of the Egyptian Section.

My darling, it seems that I was unduly pessimistic about the M of I. Mr Murray has just told me that he's had a message from Sı saying that Mr O'Donovan phoned to say that he couldn't make any definite pronouncement about whether or not he had a vacancy for me until he'd been to Cairo & looked about him.

THURSDAY 9 SEPTEMBER Joan is going to have a baby, my dear love, & she's bursting with delight & displaying the rather small Michelin tyre round her middle with tremendous pride. Even Robert pats it with grudging admiration from time to time, my darling, & murmurs affectionately: 'Gosh, you're going to be Enormous'.

You know, darling, Joan's Robert is the Quarest man I've ever known. Last night when we were talking about their Prospective Baby he said: 'Just about this time last year Joan was Fattening Up like this,' in a reminiscent tone of voice & Joan flinched visibly. How could he say a thing like that, my darling, how could he? And yet in his peculiar way I think he's fonder of Joan than he ever believed he could be of any woman other than his first wife and, fantastically enough, I believe his intention in making the remark was to reassure Joan because they're not certain yet that it is going to be a baby. What he meant was: 'You were right last time in thinking you were going to have a baby & you have practically the same symptoms this time so you're probably right again.'

While he was out of the room for a few moments, my love, Joan said fearfully: 'Oh! I do hope it is a baby, because it just happens that I've caught Rob in the right mood & he's pleased about it. If we had to start all over again he might decide that the moment was Inopportune.' Darling, it makes me tremendously proud to know that you understand your little Solace far, far better than Robert understands Joan although he has 10 years of marriage behind him.

SUNDAY 12 SEPTEMBER Darling, there is one comfort in peacetime – you don't have to wear your underclothes for five years. You see, my love, I haven't had a new brassiere or a new pair of breeks since before the war & the poor things are beginning to Feel Their Age. My darling, if I do get my job in Cairo I shall Fritter Away all my coupons on a frothy mass of impractical & beautiful underwear. I want you to undress me & carry me to my bath every night of my life and I know it will be much more fun for you to toss a lacy cascade of This & That on the bedroom chair than to send a solid bundle of Stockinette thudding against the upholstery.

Darling, Sigmund rang me up this morning to invite me to dinner & the pictures tomorrow evening. Then, my darling, he asked if I'd heard about Joyce's engagement. I said No & he told me that Lord Nathan had rung him up in Paternal Triumph to say that Joyce & Bernard were engaged. He said it so seriously, darling, that I don't think this can be just one of his Idle Jests – on a par

with Listening In on the Livings-In-Sin of his weekend guests –
but if it's true, darling, I'm shocked to the core (note the absence
of capitals, my dear love. I'm too shaken even for them.) Do you
remember: 'All for a handful of silver he left us ...', darling? I know
now exactly how Browning felt when he wrote that. The
cold-bloodedness of the thing is what shakes me so terribly, my
darling, because I know she doesn't love Bernard in the slightest &
this engagement can only mean that she is selling herself for the
things Bernard can offer. This is downright prostitution, my dear
love, and nothing has ever horrified me so much since Joan's oper-
ation. So Mum was right, my darling. Joyce has always been the
only one of my friends whom she has never liked (that's why I was
so furious with her for suggesting the introduction to Victor) and
she once said of her: 'In the end Joyce will marry Bernard Waley
Cohen because the only things that really matter to her in the long
run are money, influence and Position.'

I had lunch with Joan today, my darling. She is looking
very wan & tired and she spends almost the whole day being
violently sick.

MONDAY 13 SEPTEMBER My darling, it is true about Joyce. I had a very
brief note from her this evening saying simply: 'Bernard & I are
engaged! I'll tell you of our plans later.' Sigmund telephoned me
again this evening, my dear love. He says that if I believe that Joyce
is not happy about what she's doing I ought to try & stop it. I shall
ask her point blank when we meet, my love, whether this is what
she really wants. That is the most I can do. Don't you agree, darling?

Mrs Wingate is going to be at dinner at Sigmund's flat
tomorrow night, my dear love. I'm glad, because I very much
wanted to meet her again.

Darling, at times like tonight loneliness is something so
definite that it's almost like a corpse lying beside me, very white &
cold & still. I can feel its coldness & deadness against me, my
darling, and I want to run screaming away from it. The more I
know of other people, my dearest love, the greater the gulf between
me & them – of course it isn't so with rare people like Mr Murray
& David & Sylvia but it is with most people. That's why I can't do
without you, my very dear love. Oh! I can't, I can't.

<u>TUESDAY 14 SEPTEMBER</u> Darling, I've sent Joyce 3 white gardenias – very Chaste & Expensive – with an Austere little note. Expensive waxy flowers, darling, are going to be characteristic of Joyce's way of life henceforth. Chanel – the Ritz – Cartier. All the things which weighed so heavily on my Poor-Little-Rich Childhood. I feel, my dearest love, as though I were sending flowers to a funeral. Oh! darling, I was better able to endure Joan's emotional irresponsibility than this.

Darling, I want to have lots of fun with my will which I shall make on the day of our marriage. As far as material Bequests are concerned, you are, of course, to have everything I possess, except my vinaigrettes, which with your permission, I want to leave to the Fitzwilliam because I don't believe in the private ownership of National Treasures. At least, my darling, I shall want you to enjoy them during your lifetime but after that I should like the Fitzwilliam to have them, please. The fun will come in with comic little bequests. Darling, I'm going to introduce a wholly new Attitude to Will-making. I don't see why it should be a Gloomy, Dry-as-Dust, Legalistic Ceremonial. Death is not sad when you are happy – only when you are frustrated & unsatisfied. I should like to form a Society for the Propagation of Willy Nilly Wills, my dear love. Will you be my first member?

Darling, have you any knowledge of the connection between Venereal Disease & tea & buns in the middle of the morning? It puzzles me a lot because this is the sort of thing which is always Cropping Up in Sir Philip Joubert's Reports: 'There is a regular interval for tea & buns on this Station in the joint airmens & airwomens mess. There have been 5 cases of VD on the Station in the last 6 months.' It seems, darling, that the incidence of Venereal Disease is in direct proportion to the length of the tea-and-buns break, which are indissolubly wedded in the IG's mind. Can it be, my love, that the Heyday in the Blood is at its Height at eleven o'clock in the morning or have Tea & Buns some Aphrodisiac Properties that I Wot Not of?

<u>WEDNESDAY 15 SEPTEMBER</u> I came home in such an intense state of cerebral excitement last night, my dearest love, after an exhilarating discussion with Mrs Wingate (whom I am now to call Lorna,

darling) first on Zionism and then on the purpose & meaning of life, that I couldn't sleep because the threads we'd pulled out of the skein of philosophy went on unravelling by their sleeves right through the night. Her husband left again for furrin parts yesterday. They had a month together owing to the goodwill of the PM.

Joyce telephoned this morning, my dear love, to thank me for the flowers &, very nervously I Braced Myself & asked her if she was sure that this was what she really wanted. She said that it was, my darling – with apparent conviction. I'm lunching with her tomorrow, my love, & she has promised to Tell Me All.

I told Sigmund about my interview at the M of I, darling, & he said that he felt it his duty to warn me, to prepare me for, later disappointment, that it was most unlikely that, having once found out that I was Jewish, the M of I would offer me an appointment in Cairo. I can't bear to think of it, my darling. That way madness lies.

THURSDAY 16 SEPTEMBER Darling, I've been having lunch with Joyce. There really isn't much All to it, darling. It's just that in the course of one of Bernard's Quarterly proposals it Came Over her in a Wave (so she says) that she was going to accept. She is now flashing Lady Waley Cohen's Arf Oop on her finger and has become encased in a shell of enamel. I hope it isn't too brittle a shell, my dear love. They're going to be married in March and Papa has Stumped up for the Right Clothes for meeting Relatives and Bowing to the Tenants at Honeymede – so life for Joyce is a Welter of Dressmakers and Family Parties. She just doesn't speak my language at all anymore, my darling.

SATURDAY 18 SEPTEMBER Darling, I really enjoyed Joan's party immensely. First of all I am beginning to be rather fond of Bernard Waley Cohen – he has so obviously the Right Attitude to Being Engaged. He is bursting with Look-What-I've-Gottery, my dear love, and he Confided in me with pleasing naiveté that ever since last Friday evening he's been 'waking up with a jump' in the night and saying to himself; 'Good God – Joyce has accepted me at last.'

Joan is going to have a baby, darling, and Dr Minton anticipates no complications. Good! Good! Oh! Excellent Good i' faith.

My dear love, I've no doubt that the facts about Brigadier Wingate are true – it's only the interpretation which is wrong. If I were to say, my dear love, that the first time I met Brigadier Wingate he talked to me about his sexual organs it would be factually true but it would not be the truth – because he has a very profound, philosophical mind & uses personal metaphors to express general truths – and his use of this particular metaphor was neither strange nor shocking, darling, because it was so absolutely right for the particular generalizations about the Chivalric Code in which he was indulging.

MONDAY 20 SEPTEMBER My darling, Prince Lotfallah telephoned to Insist that we should lunch with him at the Ritz which we did after mild protests. We had a rotten lunch, darling, but it was amusing to hear old Lotfallah Hot on the Trail of a new throne. He was in an Expansive Mood, my love, & gave me a red enamel Utility lighter. Nellie & Basil and Nellie's daughter & son-in-law Vi & Robert Henriques* (Robert writes a lot of Bad Novels, darling, but he's a Good Man at Heart) were lunching at the Ritz too but we only had time to exchange a brief greeting.

Darling, one last crowning touch to a Good Day. Mrs Crews has just telephoned to ask herself to dinner on Thursday night.

Pan has been sick all evening, my dear love – mainly I think because Dicky smashed one of the best arm chairs into seven pieces (but Pan has put it together again with Durofix) by throwing it at him in a fit of crazed rage & Pan worried himself ill about what Mum would say about it & feared, not without justification, my love, because that's what happens nine times out of ten, that he might get blamed for the whole business.

FRIDAY 24 SEPTEMBER Pan has just come in to say: 'Really, the care you take over your letters to Gershon – one would think that you were writing for future publication.' I looked at him Sternly, my dear love, & said: 'Oh! no, I'm writing for a far more important reason than that.' But one day, he'll learn, my love. Pan is the sort of person who will love a woman as I love you.

* Robert David Quixano Henriques (1905–67), Jewish British writer, broadcaster and farmer.

<u>SUNDAY 26 SEPTEMBER</u> I had a salad at Quality Inn with Estelle, darling, & I had an old wound accidentally & very painfully re-opened. You see, darling, for some time now I have felt that Horace is less interested in me than he was. He seldom comes to see us & when he does he hardly does more than bid me good evening in between sips of beer. Estelle & I had been talking casually of Joan when I remarked lightly that Horace seemed to have Cast Me Off – was it perhaps because he found Joan more entertaining? To my astonishment, my love, Estelle took me up quite seriously on this & said that Horace <u>had</u> been extremely disappointed over my harsh & unreasonable attitude towards Joan's very natural & proper desire to lead her own life away from the irksome interference of my parents. I asked her very quietly what Joan had told her & it appears that she had made assignations with Horace & Estelle very shortly after she left us for the express purpose of 'justifying' her departure. The story she told, my dear love, was very much the same story as she told David & Sylvia & Sheila & Joyce. She couldn't call her soul her own in our house – she had expected sympathetic co-operation from me – one of her own generation & instead, when she left I had practically refused to speak to her & so on. Darling, it was a wicked thing to do &, as you know, an unconscionable distortion of the facts and it explains why almost everyone who knew us both was so Queer to me for a time after she left – the very time, darling, when I was quarrelling almost hourly with my parents for their criticism of her attitude & behaviour. Darling, in self-defence, I told Estelle the whole story but I made her promise to say nothing to Horace. I didn't want to tell her, my dear love, but I hadn't the character to remain silent under her rebuke. Of course, darling, it doesn't really matter because now Joan & I are on very Impersonal terms & we never talk of anything more fundamental than clothes or our respective Ministries but I can't help being strangely hurt all the same.

<u>MONDAY 27 SEPTEMBER</u> I'm in rather a wakeful mood, my dear love, so if you were here I'd like to lie awake with the light on kissing & clipping merrily with pauses for you to catch sight of the titles of some of my books and say, par example: 'The Booke of Margery Kempe. What's that about, darling?' And I would Shake my Head & say:

337

'*Pas pour Jeune Filles*. It's about a Dirty Old Woman in the Middle Ages who was in love with Christ & whatever she was after it wasn't an Immaculate Conception,' & you'd raise your eyebrow, my dear love & say: 'Dear Me, and what about *The Castle*? to which I would reply: 'Darling, I made a point of not reading *The Castle* – everyone at Cambridge who read Kafka omitted to shave or wear socks. They also walked in processions feeding Gruel to Distressed Miners.'

I was looking through my Poems this morning, my love. God, but they're Awful. I shall have to let you read them, darling, before we are married in case they make you change your mind. Patience Strong's Quiet Corner in the *Daily Mirror* seldom sinks lower. Whatever I may be now, my dear love, it's very certain that between the ages of thirteen and sixteen I was No Poet.

WEDNESDAY 29 SEPTEMBER Darling, Jean & Aunt Teddy, my cousin Robert & his wife & Bernard, our free French protégé, were here to dinner & at about 8.45 I brought Robert & Dorothy upstairs to see our furniture. They admired it & we talked of This & That in my room until about 9.20 when Mum called up to say that Mrs Seidler wanted to speak to me on the telephone. Oh! darling, what havoc was there in Mum's room. Her wardrobe had been wrenched open and your Damascus box, where she keeps most of her jewellery, was on the floor with trinkets littered all over the place – her handbag had been wrenched apart & there were sixpences & keys & handkerchiefs all over the floor. A very daring burglary, my darling. The thieves had climbed in through a bedroom window while we were at supper & had obviously been disturbed by the sound of our voices when we came upstairs & had fled leaving the whole place in confusion. They'd taken £50 in pound notes from Mum's drawer – £4.10/- and a gold fountain pen & gold cigarette lighter from Pa's pocket, Mum's diamond dips, worth £500, four or five of her brooches, worth about £100, 12 pairs of silk stockings & all the clothes ration books which were untouched because they have only just been issued.

Oh! darling, I would have been entertained by the Flatfoots blowing on the shiny surface of the furniture to see if their Steamy Breath showed up any finger prints and taking statements Right & Left if it had not been so distressing to see how Mum was affected.

She trembled & looked pale, my dearest love, & I know how she felt because all these things were presents from Pa. Everything, except the the money & the ration books &, of course, the stockings were fully insured, my darling, but money is no compensation for losing things you love & have worn on days when you were especially happy.

A CID man is coming tomorrow morning, my darling to Grovel on the Floor with a Magnifying Glass & I trust he turns out to be a bit more like Lord Peter Wimsey than his three uniformed subordinates. Darling, Pa & I had to do all the Detection for them! We thought of picking up Shiny Objects with a handkerchief to preserve finger prints. We suggested that there might be marks on the window sill. They just stood stolidly round & said that this was a CID Case – The Trade union attitude.

I'm afraid that I am writing wild & whirling words. I feel terribly ashamed, my darling, at my relief that they didn't step across the way & clean out my vinaigrette cabinet.

THURSDAY 30 SEPTEMBER Darling, this has been rather a Quare day Surveying the Wreckage & Making Statements to the Plain Clothes Man from the CID. (I am a Material Witness, you see, my love, because I Discovered the Remains. Joan is never going to hear the end of this. After all, my love, she witnessed what was only an Abortive Burglary. This was the Rill Thing.)

I was Impressed by the CID man, darling. He was Quiet & Competent & he Inspired Confidence and seemed to know his stuff. He dashed away to interview the local pawnbrokers.

Mr & Mrs Lipchitz came to dinner tonight, my love, & Mr Lipchitz told me that after my discussion with him and Michael Foot at their house one Sunday, Mr Foot had said, when I left, that I was too clever for a woman. In a queer way, darling, this stung me – perhaps because there was a Flavour of Patronage about it – perhaps because I have a tendency to Fight the Battle that was won decades ago – the Battle for the Rights of Women – anyway, my love, be the reason what it was in very Poor Taste, darling, since he's a great friend of Mr Mrs Lipchitz and I was terribly ashamed of myself afterwards but I couldn't do anything about it because the harm had been done. Darling, one of the things you'll

have to do for your little Solace when you've married her is to Curb her Tongue. A little Tactful Barracking, my love (an essentially unilateral Art) is what is required.

Another little bit of All, my darling, is that Estelle rang up this morning to ask me to tea on Sunday & mentioned casually that Horace would be there – so it rather looks as though she told him that I thought he'd Cast Me Off & he wants to prove that I still have a Little Niche in his Heart.

Apropos of our discussion about women & wantonness immediately after marriage, my darling, Victor told me something the other day which seemed to have some bearing on the matter. We were discussing Aunt Gladys & Uncle Solly & saying how strange it was that, in spite of community of interests & backgrounds and temperament, they were unhappily married – not Cataclysmically unhappy, my love, just Dissatisfied & Disgruntled – & Victor told me that when she was in S. Africa recently, & things were going Badly with her & Uncle Solly, Aunt Gladys told Doris that the trouble had started on their wedding night. Needless to say, darling, their marriage was not in any sense an Arranged marriage. Uncle Solly married Aunt Gladys because he loved her & she married him because he was Handsome & because she was Bored with Parental Restrictions & because she very much wanted children. She told Doris, darling, that, on her wedding night she neither knew nor ever guessed at any of the Facts of Life & that the discovery of what marriage meant was a shock from which she had never recovered & the thought of being wanton with Uncle Solly (or, for that matter, with any other man) filled her with Horror. This, my darling combined with Uncle Solly's misplaced Prudery, is, I am sure, the reason why, although they have consulted specialists all over the world & Aunt Gladys has had three operations, they have never had any children. Of course, darling, that really proves nothing because Mum, too, knew nothing about wantonness when she married but the fundamental difference was that she loved Pa very deeply & that he is very much more sensitive than Uncle Solly.

The fundamental factor in love is the desire to give your lover everything that it's possible to give him in passionate gratitude for the unspeakable joys which he has given you. (I speak as a

woman, my darling. I suppose it's a little different for a man.) To hold back or shrink away from anything your lover asks of you is impossible & unnatural. Do you remember, darling, that I told you once that I had a Genius for love? I know I have, my very dear love, but it has not yet reached full maturity – that will only happen when I am your wife. Oh! darling, darling, no genius can grow & prosper without inspiration & one day I shall tell you of the thousand ways in which you have inspired me so that, from an ordinary, restless spoilt little girl, I have become a visionary who knows the meaning of Eternity!

SUNDAY 3 OCTOBER This hasn't been much of a day, darling. Soon after lunch I set out for Horace's house. Joan was there, darling, & it was the first time I'd seen her since Estelle told me what she'd said about my attitude when she left us & that made me unhappy too. I hardly listened to the talk, darling, which was a pity because there was some Wholesale & Trenchant Debunking afoot. Horace said bluntly: 'My dear girl, you won't get a job in Cairo – not if they know you're a Jewess. They're going to Sell Palestine Down the River & they want as few Jews about as possible while it's happening.' 'They', of course, are Power Politicians Backed by Big Business. On the way home, my love, Joan told me that Joyce is getting married in December. Joan is feeling so ill that she thinks she'll have to give up her job immediately. She's sick all day & can't bear the sight of food. She looks very ill indeed, my love, and has lost about a stone in weight in the last fortnight. Having babies can be a Trial at Times, my darling. Never mind, my love, we shall have as many as you want. I Refuse to be Daunted.

MONDAY 4 OCTOBER I am back at my desk, my darling. Nothing has changed. My darling letters 175 and 178 were on the Hall table when I got home and they were the greatest comfort in the world.

I don't remember in the least what I said in my letter of congratulations to Lorna, my dear love, except that I remarked that the first time I met Brig. Wingate I got the impression that he would either be thrown out of the army on his Ear or become a Field Marshal & that I was glad to see that he was going to be a Field Marshal.

Darling, Parental Pressure is no excuse for Joyce. My parents combined Cubic Volume exceeds the Nathans' and if it had been exerted for 20 years to try & make me marry a man I didn't love or for that matter not marry the man I did love it would have got them precisely nowhere. I didn't say I liked Bernard, darling, I only said I almost liked him & the volte face was due to the fact that for the first time I saw him in the guise of real humility. One of the things I've disliked about him for years, darling, ever since he was a fourteen-year-old Dartmouth Cadet, was his overweening self importance but, vis-a-vis Joyce this simply doesn't exist. He's obviously humbly bewildered & quite pitifully grateful that such a creature as Joyce could deign to bestow her favours upon him – and there's no doubt, my love, that his new found humility becomes him.

WEDNESDAY 6 OCTOBER Joyce telephoned today, darling, to ask me to her engagement party on Friday week.

Darling, Mum found a Gloomy story in the *Daily Mirror* this morning about a woman who was Gagged & Bound by Thieves while they quietly removed her safe, leaving a jagged hole in the wall. As a result of this, my love, Mum is almost inclined to write a letter of thanks to our Burglars for being so Forbearing.

The size I have to write in order to get at least some of what I have to say onto an air letter form, my love, is getting me into Bad Habits. Yesterday poor Mr Murray had to Beg for Mercy because the drafts I had sent into him were writ so small and packed so tight with writing. I pointed out, my darling, that it would be in the National Interest to bring you home & spare his eyes & he agreed & said he wished he could do something about it. Oh! God. My dearest love, I wish he could. I wish I need never see an Official Paper in all my life again. I loathe the Civil Service.

After breakfast, darling, I found Mum in a State of terrific excitement because she'd just seen a Piece in the Paper about young Soldiers being sent home to marry their Solaces. I glanced laconically at the paragraph in question, my love, & found, as I'd expected, that it referred only to Prospective unmarried fathers. When I pointed this out to Mum, darling, she said Eagerly: 'Well, couldn't Gershon say he was about to become a Father?' Then she

added Anxiously: 'Your name wouldn't appear, would it?' I explained gently, my love, that it <u>would</u> & that anyway you'd be hard put to it to persuade the authorities that you were Responsible for the future birth of a baby in England when you've been away for 17 months! It's a pity, darling, that no one ever bothered to explain the Facts of Life to Mum. There are times when she must find it a handicap. Afterwards, darling, I Rebuked her for making a suggestion which would involve the Sullying of your Good Name while Protecting Mine but she said Airily that once you were home everyone would know it wasn't true. Darling, for an Intelligent Woman, there are times when the workings of my mother's mind are Distinctly Quare.

SUNDAY 10 OCTOBER Darling, Victor came to lunch, bringing with him Ram Nahum's younger brother, who's in the same Branch of the Navy as he is. Danny Nahum is a highly intelligent lad, darling & an amazing linguist. He asked me how well I knew his brother, my dear love, & went on to talk about him & Winifred Vickers quite uninhibitedly in spite of the fact that I had told him that I hardly knew Nahum the Elder at all. 'Winifred was in love with my brother,' he said bluntly, darling, & then he asked me about Mouse Vickers, whom I have never met. He seemed surprised, my love, to hear that he was still alive & he said: 'Winifred didn't like him at all. Can't think why she married him.' It seems, darling, that she has artificial legs and moves about with amazing agility, cheerfulness & undiminished vigour. That's an extraordinary story, my dear love, & I'm inclined to be very harsh in my judgement over the whole thing but I might see it differently, I suppose, if I knew all the facts.

MONDAY 11 OCTOBER I had an Air Letter from Aubrey this evening, my love, which was opened by the Censor. He (the Censor) must have enjoyed these extracts, my love: 'WSC* Resuscitated the "Spenser" in order to avoid the Duncanier association of his signature on Memoranda. When he signed plain WC zealous secretaries took it not as an intimation of assent but as a Suggestion for Disposal ...'

* Winston Spencer Churchill.

343

and 'Wingate once told me that he never did up certain vital buttons because of the time it wasted during a busy day ...' I note with relief and approval, darling, that he has put his Wistful hankering for Joyce behind him once & for all. He says magnanimously: 'I received an Advance Notice in a pleasant note from Joyce, which I liked & showed a nice feeling, for whatever that is worth – & on second thoughts it is worth a good deal.'

FRIDAY 15 OCTOBER My darling, Prince Lotfallah is after any throne that may be Going. He & his Brothers Sunk a lot of money in King Faisal's dynasty & were promised a throne which Never Came to Anything. This particular Scion of the family, darling, wants one of two things – either to get his money back from the British Government to whose advantage he says it is to have the Faisal lot on the throne of Iraq or to have the throne for which he has paid so liberally. (He feels particularly Bitter about King Zog of Albania, my love; he often spends the weekend with him but it's obvious that he hopes it Chokes Him.)

Darling, Joyce's party consisted in half a dozen dry rusks with a diaphanous layer of Potted Meat on top & some ersatz orange juice nominally enlivened with gin. I was talking to Pierette Wack who was a contemporary of Joyce's at Girton & who is at the Board of Trade & I asked her if she knew anything of Susan Wyatt. She told me, my love, that Susan had a baby recently but that she couldn't marry its father because neither Woodrow nor his wife would agree to a Divorce. It's at times like these, my darling, that I wish I didn't know about Life. It makes me terribly sad to see so many of my friends holding their marriage ties in such small esteem. I can't help regarding unfaithfulness as a terrible act of Sacrilege, my dearest love. I do try to be tolerant but I can't, I can't.

THURSDAY 21 OCTOBER This morning, darling, Mrs Wright stalked in with my coffee in a Fine Rage. 'Not a single enemy plane shot down last night,' she announced with Withering Scorn. 'A friend of mine,' she added, 'was watching the gun-fire the other night and it got nowhere near the planes which were very neatly caught in the searchlights. It's all because of this Nonsense of putting the Home Guard on to the Anti-Aircraft Guns. What, pray, should the

Home Guard know about Anti-aircraft guns?' I explained gently, darling, that neither I personally nor the Air Ministry as a Corporate Body was responsible for Anti-Aircraft and urged her to transfer her Displeasure from me to the War Office which she did in no Uncertain Terms.

I had a letter from Joan Pearce this morning, darling. It was a sad letter, coming from such a sunny & imperturbable person. I think I told you, my love, that last time I saw her she was a-glow at the prospective return from West Africa after 3 years of the rather dull young man to whom she was sincerely if unaccountably attached. She says in her letter, my dear love, that he got back at Easter & is still in this country but that she hasn't seen him since May. She doesn't offer any explanation or go into any detail but the tone of her letter is hurt & lonely. I'm so sorry, darling. I should not have said that Joan was a person of any great emotional depth & yet she has been, without being engaged or committed in any way, genuinely faithful to this young man during his three years of absence & this is the result.

Darling, shall I have to relinquish my faith in the perfecti-bility of human nature as a whole in the face of overwhelming evidence to the contrary or shall I be able to cling to it – as one ought to cling to a faith in spite of the pull of any reason? I don't know – please tell me, darling. There's Susan Wyatt tossing her marriage overboard without having given it a fair trial. (She & Woodrow have, after all, never been together for more than a week at a time.) There's Joan Walker, glibly preaching one set of stand-ards & practising another – there's Winifred Vickers, my darling, who lived with another man while her husband was a prisoner of war in Germany – there's Miss Anderton who (for all that in most things her standards are higher than those of many of my highly educated friends) would rather be married to a man she can't trust than not be married at all. These things make me terribly unhappy, my darling.

Darling, tonight Mum started on the old, old story of call-ing Pa 'Pa'. She made a Major Issue of it, my darling & said she'd Never Speak to me Again unless I stopped it. This struck me as so dam' silly, darling, that I just laughed derisively & that made her more Martyred than ever. Pa said he thought she objected to the

name because it was current in the Pubs to which I replied in my Grandest Mock Heroick Style that I was <u>proud</u> to hear that I was affecting the idiom of the Public House, the Club-Room of the Proletariat. Mum squeezed out a few tears & said that I always did what <u>you</u> asked me to which I replied that (i) You'd never ask me anything so idiotic & (ii) That the relationship between husband & wife was different from the relationship between mother & daughter. <u>That</u> Tore it, darling! My matey 'Goodnight' was greeted with Stony Silence, but I'm not letting it worry me, my very dear love. I think the whole thing is the veriest Balderdash. I shall go on calling Pa 'Pa', because it is *le mot juste* & I will not allow my sense of Artistic Fitness to be overridden.

FRIDAY 22 OCTOBER I must, for your entertainment, quote Quinton Hogg on Pa's College friend, Sir James Grigg. 'This man,' he says, 'was conceived & born in a pigeon hole, swaddled in red tape & educated in the Treasury. Finally he came to Manhood in the War Office and when he leaves us for Another Place there will be inscribed on his Tombstone not an epitaph but a Treasury minute which will read: Passed to you for consideration and Comment.'

I've just heard Mum in the bathroom Inciting Pa not to talk to me. Woho! Pa is trying to Reason with her, darling! He's not getting anywhere but it's nice of him to try.

SUNDAY 24 OCTOBER Darling, Carmel Eban, let out of the Wrennery for the afternoon, phoned. Floor scrubbing, she said, my love, was wearing her nerves very thin & she had telephoned, she went on, to be Steadied because I (yes, darling, she meant your little Solace) was the Calmest person she knew!!!!! (Darling, let's Get to the Bottom of this. <u>Why</u> do I always strike people who don't know me as being a marble effigy of Placidity?) Having implored Carmel to repeat that remark to my parents (who are there to tea, darling) I was transferred willy nilly to Mrs Eban who asked me Anxiously for an analysis of Aubrey's mood in his latest letter. I gather, darling, that he sounded very depressed & she wanted to know whether it was (i) War weariness (ii) Political Disillusionment or (iii) Something Personal. I assured her, my love, with as much conviction as I could Muster, that I was certain that it was a

combination of (i) & (ii) with no element of (iii) in it. She Clasped her hands to her bosom (Of course I couldn't actually see her, darling, but I know she did) & said: 'Darling, you're so necessary,' (I hate being called 'darling' by anyone but you) 'I don't know what I'd do without you.' At this point, my love, I Faked a very convincing Acking Coff and she said she mustn't keep me and rang off.

TUESDAY 26 OCTOBER Report has it, my love, that Mum (whom I have not set eyes on for two days) spends most of her time Wailing & Wringing her Hands – but that may be a Fabrication on the part of Pa – designed to Melt my heart. I'm very, very tired of all this Melodrama.

WEDNESDAY 27 OCTOBER Darling, I got sent home feeling rill ill at about half-past three so it was a relief to find Mum ready to Surrender Unconditionally. As she produced no ifs or buts my love, I was Magnanimous & agreed to try & remember not to call Pa 'Pa' in her hearing.

THURSDAY 28 OCTOBER STOP PRESS. My darling, Pan has Done It Again. He's got the Shakespeare Medal. He has now had the three most important English prizes that Harrow can offer. I'm so glad, my darling, and glad too that he has shown himself to be no Dusty Antiquarian but a Humanist of not inconsiderable Parts. And Pan deserves this, darling, if for no other reason than for having stood aside last year so as not to compete against Elliot Binns whose last chance it was.

FRIDAY 29 OCTOBER Darling, I'm back at work feeling rather shaky but otherwise much better.

My darling, I've just come back from a long coffee session with Mr Murray. He's leaving us on Monday week for – believe-it-or-not – none other than Jean's Organization. He will be the only Civil Servant in it, my darling, & I gather that his Mission is to bring forth Order out of Chaos. For his sake, darling, I'm glad because he has such uprightness & purpose that I believe he will succeed where others have failed & that will stand him in good

stead in the future – but it's the most terrific personal Sorrow, my dear love, because his friendship has helped me immeasurably in these dark months & I shall not meet with such another. His successor will probably be a man called Campbell from S5. A pleasant enough person, my darling, but of a mediocrity which is positively crushing. I hope Mr Murray is able to take Miss Anderton with him, darling, because if she suspects so much as the shadow of a slight she prickles up all over like a hedgehog. Mr Murray realizes as I do that she has such rare & admirable qualities that no amount of Watchfulness & Circumspection is too much trouble but most people don't & I doubt if Mr Campbell has enough perception to see what is wanted.

TUESDAY 2 NOVEMBER I had lunch with Jean today, my love, and I hated it because when I said that I hoped she'd look up Mr Murray & be friendly to him, she said: 'Remember – I'm in the enemy camp.' He's going to have a Rough Passage in that Racket, my darling, & if ever a man didn't deserve it, he doesn't.

WEDNESDAY 3 NOVEMBER I've just got back from the morning's coffee session with new hope. Mr Murray has been talking to a friend at the Egyptian Council who thinks that there may be a lecturing job for me at the Egyptian University. At any rate, my dear love, he's getting me a form to fill in. It's the brightest ray of hope so far. I should say, darling, looking back on the tapestry of my life that apart from my dear lord & my parents to whom I owe so much that it can't be reckoned, I am more deeply indebted to two men than anyone else in the world. One of them is Mr Grose who died before I could justify his confidence in me & the other is Mr Murray. Mr Grose Groomed me for Stardom in the intellectual sphere, darling, with immense patience & care & understanding and Mr Murray has given me wise & disinterested sympathy & help & good sound counsel in the saddest & darkest time of my life. I sometimes think it was a kind of miracle that I should have been taken away from the crude, negative cynicism of Mr Crotch and put under Mr Murray's care just before you went away. I am aglow with anticipation. Perhaps we shall soon have our honeymoon in Upper Egypt.

MONDAY 8 NOVEMBER Darling, I forgot to tell you a nice little snippet of All about Victor. Some time ago, my darling, with his flair for picking up Picturesque People he met an extraordinary Norwegian girl who is a medical student with several illegitimate children all with different fathers. Perhaps because Victor has a Nice Face, my love, she Bore him Off to a Corner House and sat there with him the whole night telling him the dazzling Colourful story of her life. Victor sat Lapping it Up, darling & was very surprised when she asked if it wasn't about time they had breakfast. He wrote to Doris, darling & told her about this – she mentioned it to Aunt Annie who Came Over in a Heartly Cluck & said she was going to write to Mum to ask her to Instruct Victor in The Facts of Life and Warn him against Predatory Women. The letter hasn't arrived yet, my love, but we're All Agog for it.

WEDNESDAY 10 NOVEMBER My darling, Joan spent most of the lunch hour saying how perfectly outrageous of Joyce it was to be planning a wedding on the 12 of everything, thousand guest reception scale. I defended her because I am far less shocked by it than by Joan's own wedding. I feel that the most that can be said of making a terrific splash at a moment like this, darling, is that it's in poor taste, whereas Joan's hole-in-a-corner marriage was a piece of unforgivable & selfish brutality towards her parents who were irreparably hurt by it.

Darling letters 188 & 189 arrived today. I read, 'I suggest, darling, that if our children called me Pa or Pop (or any other name which you did not like or vaguely suspected that I didn't like) you would soon enough make a Major Issue of it.' A hit, a palpable hit, my dear love, because now I see the whole thing so painfully clearly that I feel thoroughly ashamed of myself. If there was so much as a hint, a breath, a soupçon of disrespect or patronage in our children's attitude to you, I'd go nearly mad with distress.

FRIDAY 12 NOVEMBER Darling, Mum has just telephoned & she read me a letter that had come for me from Mr Murray's friend, Mr Blake of the British Consul. He says, darling, that he's sent my form to Cairo asking if there's a vacancy for me & that he'll let me know as soon as he gets an answer. He seemed to think he'd have definite

news in a week or two. Oh! my darling, I am dancing barefoot on hot coals & the agony will not abate until I have further and more definite news.

Mr Murray's successor will not be Mr Campbell after all but Mr Melville. Pamela's husband's report on him, my love, is that he is an educated and cultured man who made his mark in Classics at Cambridge. Felicity says he's an authority on Spanish Literature. Kitty tells me he's the father of twins. Mr Ormond says he's tall & Mr Needham says he's slightly bald – & that's All I Know, my darling.

SATURDAY 20 NOVEMBER My darling, I rang up Mr Crotch about my NFS* Call-up and he asked me to have a Chinese lunch with him & discuss the whole thing then. Divorce has mellowed Mr Crotch, darling. Instead of sneering at my love he now treats it with Respect and asked after you with solicitude & said he thought it would be very wise to go to you in Egypt.

My darling, your little Solace is happy. Deeply & content-edly happy – in spite of the fact that she's just got back from patrolling a fog blackened street & that her teeth are chattering with cold. The reasons, my dear love, are letters 191 and 193. Darling, do you know what it was that broke down the whole nightmare of the past few days? Two sentences, my very dear love. They were: 'I'm never angry with you for long, my darling, I love you too much for that. Remember that when you're down in the dumps.' Oh! darling, darling, I did remember & suddenly the sun broke through the fog and you were very, very close to me.

FRIDAY 21 NOVEMBER Miss Anderton & Joan are coming to lunch, my darling. I asked Miss Anderton because she has been terribly at sea & sorrowful since Mr Murray left us & I thought she'd probably sit at home Brooding over one thing and another. (Things aren't going too well with the Scoundrelly Young Man in Gibraltar either, my love.)

I'm still Glowing with Solace, my dear love, & today for the first time for months I felt no bitterness towards Joan & we talked

* National Fire Service.

pleasantly of pictures & the new house she & Robert were going to have when she has the baby &, with Miss Anderton of Assistant Secretaries in General & of Mr Melville & Mr Murray in particular. Joan had dinner with the Nathans the other night, my love, & Ursula was staying there. It seems she's going to Burst Upon a Gaping World in Cherry-red velvet and gold slippers at Joyce's wedding. Ye Gods! Mum thinks I might have been asked to be a bridesmaid, darling, & I suppose I might but I wouldn't care to share the Honour with Ursula. However, I wasn't asked & I can't say I feel very Pained on that account. Joyce & I have drifted very far apart since 1939. I don't think she's altogether unaware of the extremely Modified Rapture with which I received the news of her engagement, darling.

I am looking forward to Horace's views on Mosley's release,* my darling. My immediate response was profound disgust, my love, but Pa says he just can't believe that the Government would take such a momentous decision without very good reason. He believes that Mosley is dying, darling, & that the Govt. got into a panic lest he should die in Hollyway & so become a Martyr. On the other hand, darling, Gandhi was, as far as we know, a great deal more seriously ill than Mosley and he was not released. I should have thought that Mosley's following in this country was so small that if They made a saint & a martyr of him it wouldn't make much odds. If Gandhi died, my darling, he would be (and rightly) a Martyr and the repercussions would be terrific – but not Mosley.

MONDAY 22 NOVEMBER I enjoyed my lunch with Horace, my darling, because it always amuses me intensely to see the ease & sangfroid with which he slips into the role of Plutocrat. Whenever drinks are served, my dear love, whether in the Mile End Road Pub or Savoy Bar, Horace slips into his setting as naturally as a Dew-drop slips into the sea.

On the other hand, my darling, I was saddened to see how deeply Joan's anti-Alexander Propaganda had bitten into him. I

* Oswald Mosley and his wife Diana (née Mitford) were interned after the fall of France and the British Union of Fascists proscribed. After a debate in Parliament the Mosleys were released from Holloway prison in November 1943.

told him, quite lightly, though truly, my love, of the curious impulse I had to turn the notice saying 'Way Out' in the corridor in Bush House the other way round. I said, darling, that I supposed it was the result of long repression. (I was referring to the 18 months' repression which are behind me, my darling, the inevitable repression which comes from being separated from the only man in all the world whom I love or have ever loved or could possibly love.) Horace said: 'I suppose you mean having to be in every night by 9 o'clock and not having a latch key. Barbarous I call it at your age. Why don't you Stand Up for your Rights?' I assured him, my darling, that though Mum worried when I was out late in the blackout she wouldn't dream of attempting to stop me from staying out as long as I pleased – nor would Pa. I pointed out too, my darling, that I had no incentive to go out at night now & that when you were here, even when my parents were most violently opposed to my meeting you on Sundays & going to Cambridge with you for weekends I had done what I wanted. Horace said a Queer Thing, darling. 'If Gershon had been a Bearsted or a Montefiore, your father wouldn't have objected to your meeting him on Sundays or going away for weekends with him.' I asked him what he meant, my love, & he said: 'Alec's a bit of a Snob.' That is a bad misreading of Pa's character, you know, darling. He is not a Snob. He has a rather naif love of mixing with the Great Ones & he's not altogether discriminating about Greatness which in his vocabulary is too often synonymous with worldly success – but he's no social snob & I know he had no particular desire for me to marry a Montefiore or a Bearsted or any of that Lot, my love. Do you remember that, just before the War, Sir Robert Waley Cohen asked me to spend a fortnight at Honeymead, darling? The whole thing was cancelled by the outbreak of war but it was clear to me – and to Pa, darling, that the invitation was Tendered because Sir Robert thought I was a Nice Suitable Girl for Matthew to meet. I said as much to Mum & Pa, darling, & Pa said: 'You watch out. Sir Robert is a Purposeful Man when he wants something – but Matthew – well, he may have a Heart of Gold but he's no Adonis – for that matter he's no Einstein.' I remarked, my love, that I'd never seen any signs of the Heart of Gold except in the purely Metallurgic sense & Pa said; 'No, come to think of it you're proba-

bly right – anyway, you watch out for yourself.' Pa certainly had no desire to have Matthew for a son-in-law, darling, in spite of his wealth & so-called Social Position. He was disgusted not very long after the accident when Lord Nathan, thinking that you might come to Mean Something in his Life on the slender Evidence that Joyce had asked you to take her to a dance said in what Pa described as an 'Insufferably Insolent Tone': 'Who is This Ellenbogen?' to which Pa replied with Outraged Dignity on your account though he didn't love you at the time (but must, I imagine have guessed dimly that I did). 'A great friend of my daughter's.' He was as irritated as I was too, darling, at his Lordship's Superior attitude to Aubrey. 'I'd go on my knees for such a husband for my child,' he said. No, darling, if Pa is any kind of Snob he's an intellectual snob – & so am I – & I told Horace so. But I fancy that this is more of Joan's work, darling. To explain my parents' distrust of Robert, she'd be quite capable of saying: 'Oh! he was Nobody in their sense of the world, you understand – so naturally they hadn't a Good Word to say for him.'

TUESDAY 23 NOVEMBER Darling Joan has just telephoned to say that Joan Wilson rang her up during the course of the morning. Do you remember Joan Wilson, my dear love? She spent most of her life having hysterics in one or other of our rooms at Girton. It all started with a Sports Car Addict, my love, lots of Brawn & no Brain (but then Joan had very little Brain) who kept Casting Her out of his Life & then Swooping her Back in again – Very Nerveracking. Then, darling, there was an Embryonic Parson who Cut Across the Fine Upstanding Military Tradition of the Wilsons by being a Conscientious Objector. They went fruit-picking together, my love, but the Glamour of the Raspberry Shade wore off & the Conscientious Objector re-married. However, my darling, she's now married to an Army Doctor & is (Ye Gods!) a Major in the Army Education Corps. She read English, my dear love, and just – but only just, as Miss Lloyd Thomas was at some pains to tell me – got a Third. Joan is lunching with her tomorrow, my darling, & she's going to ring me and Tell Me All. As soon as she gets back from lunch. I shall not spare you the smallest detail, my dear love.

<u>WEDNESDAY 24 NOVEMBER</u> I was Shaken to the Core, darling, when I heard from Joan this afternoon that Joan Wilson was practically running the Army Bureau of Current Affairs. She lectures to lecturers, darling, & teaches them how to instruct the masses in Politics & Sociology. <u>Joan Wilson</u>, my dear love, who, if she lived to be a hundred, could never wake up to the fact that the Poona tradition went out with Singapore. I may not be all that good, darling, but I believe I've got a better brain & a more humanistic outlook than Joan Wilson, but Sir John Brown had no job for me in Army Education when Lord Nathan wrote to him about me. Ah! Well, c'est la vie.

<u>THURSDAY 25 NOVEMBER</u> My darling, I went out with Joan Wilson expecting to be rather amused by the Girls of the Regiment manner but instead, my dear love, I had one of the most harrowing lunch-hours I've ever spent.

Joan told me, darling, that against the pleading & blandishments of her parents, she had married, on a very short acquaintance, a man who had just divorced his wife. He had expressed a desire for children, darling, from the very first as he hadn't had any by his first marriage, & she had agreed. After they'd been married about two months, my love, she started being sick in the morning & not being decadent & he examined her and found that she was going to have a baby. A few days later she told him she was feeling very ill & he gave her some pills & said: 'Take these every two hours' so she did, darling, but felt no better. About a week after this, my dear love, her husband came into her bedroom & said: 'I'm going to live in camp from tonight – and don't try following me about because I won't have it. Those pills I gave you were intended to bring on a miscarriage but as they've failed you'd better go to a London surgeon & have an operation because if you have the child it will be mentally defective & deformed after all the tablets you've taken – & anyway you needn't think I intend to support it.'

She went back to her father who's a doctor, darling, & he arranged for the operation. She was in hospital for 7 months & they thought she was going to die, but when her father wrote to the husband telling him about it he got a letter back from his solicitors saying that any further letters about Joan were to be addressed

to them. Then he went to India, darling, (this was about two years ago) & Joan has heard nothing of or from him since. It will be 3 years in June since he left her, my dear love, & then she'll be able, after going through the usual formula of writing to him & asking him to come back to her, to divorce him for desertion. She knows he's been unfaithful to her, my darling – she says that there were other women even during the three months they were together, but he's being very careful & she hasn't been able to get any evidence. What she's terrified of, darling, is that he'll reply to her letter asking him to come back to him with an abject apology & a promise that he'll be with her again as soon as the war is over – which will set her back for years – & she hates & fears him, my love (and I don't blame her) and wants to be outside his sphere of influence as soon as she possibly can. Oh! darling, I'm so terribly sorry for her that I feel like crying.

MONDAY 29 NOVEMBER You know, my darling, Joan Pearce told me something today which terrified me so much that I could feel the muscles of my mouth tightening & little bubbles of cold sweat breaking out on my upper lip. She said that her Mr Maxwell, being deprived of feminine company during his 3 years in West Africa had built up an idealized picture of her in his mind – & that when he'd met her again he'd discovered that this wasn't the girl he'd Cherished in his mind's eye at all. For God's sake reassure me, my darling, or I shall go screaming mad. I feel very near insanity now. Oh! darling, darling. I try so hard to give you a fair & detailed picture in my letters of myself as I am. I try so desperately not to idealize my motives in my conduct towards Mum & Pa & others. Tell me that I am not misleading you, my very dear love. That you know me as I am, with all my unevenness of mood, my irritability over small things, my intolerance & manifold limitations, my conspicuous lack of physical beauty, and that you still love me. You're not a disembodied ideal for me, my darling, but the difference between us is that I love your limitations as well as your superabundant virtues because they are a part of you & make you into the person that you are. There is no better or briefer way of explaining what I mean, my darling, than Hamlet's way – You are a man, take you for all in all, I shall not look upon your like again.

WEDNESDAY 8 DECEMBER I'm so profoundly sick of the Air Ministry, my darling, that I'm going to take half a day's leave on Tuesday afternoon. Mr Murray's going has crystallized my loathing of the Civil Service, my darling. As long as he was there I felt I had a friend who, like me, looked upon the humanities as the most important things in life after personal relationships & to whom I could always go with my anxieties & intellectual Discoveries & hopes & fears. I'm very fond of Mr Needham & Kitty & Pamela & Mr Ormond is a pleasant soul but it's not the same thing, darling.

SATURDAY 11 DECEMBER Letter 199 was waiting for me when I got home. In it you say: '... when you sink into the depths of depression because Felicity Boon isn't as conscious of the mystical significance of the Double Bed as you are, I feel it very hard to feel or to offer you sympathy, as personally I don't care two hoots what Felicity Boon thinks about anything, particularly anything which is as peculiarly her own business as the choice of a bed.' It's cost me something to write that out, darling, because when I read it I felt as though you'd slapped my face hard & suddenly & now I feel it all over again. I think there's a good deal that you've forgotten about me, darling, as you'd have realized that it was not in my nature to share a small room for 9 hours a day with a person without being affected by what they say & think. Remember, darling, that I was easily hurt even when I was with you & the bloom of happiness & spiritual peace was on me. Now I have a raw & open wound in my breast & the slightest pin-prick hurts me unbearably. In a way I'm glad you don't worry about my despair, my darling, but in a way I'm sorry because it shows that you will never know the depth of my love (and I want you to know that, my darling) because you can't know it unless you can understand precisely what it means to me to have to be separated from you. You see, darling, if you did know you would worry because you'd realize how thin a veil separates me from insanity.

Of course, darling, I've never heard anything so fantastic as your remark that there is nothing you can do about my despair. The Lord giveth – the Lord taketh away – by a single word you can set my heart singing & my eyes shining with joy. Please, please, my love, don't write to me when you're tired. Your letters

never make me happy then & sometimes they cause me unspeakable pain.

<u>MONDAY 13 DECEMBER</u> Darling, Mr Ryman, the Goldsmith, hasn't got any showrooms only offices. He showed unmistakable respect for a Girl who wouldn't wear Utility Gold & refused to be Fobbed Off with Platinum. When I got into his Inner Sanctum, my darling, he opened an enormous safe and got out a lot of little tobacco tins labelled '18 carat gold' '22 carat gold' '15 carat gold' etc. He opened the 22 carat gold tin, my darling, & poured onto the table a wonderful assortment of watch-chain links, bits of pre-historic wedding rings & watch cases & little lumps of twisted metal. He asked me to choose any piece of gold whose colour pleased me, darling, & I chose a reddish lump & he weighed it & said that he could get a wedding ring out of it, he thought. Then darling, he showed me hundreds of drawings – a dazzling display. Finally, I saw one <u>exactly</u> right. Last of all he took my finger measurement, darling, & said the ring would be ready in a fortnight. Then he asked me what I wanted in the way of engraving inside, my darling, & I thought 'Gershon-Eileen' & then I wrote out a cheque for £3. 8/-, my very dear lord, & now please may I have my husband?

<u>WEDNESDAY 15 DECEMBER</u> Darling, I forgot to tell you I came home in a taxi the other night, & when I got out & paid the fare the driver said chattily that last time he'd been to our house was at 11 o'clock at night a couple of years ago when he'd brought a fare who had Knocked & Rung most Positively without achieving any results. Finally he gave it up, darling & asked the taxi driver to go to the nearest call box & ring Primrose 5220 & say that Mr Hore-Belisha wanted to be Let In. 'I knew who you wos, Sir, the moment I set eyes on you,' the driver said. He said, 'and 'e says to me with rather a sad little smile. "Well, what do you think of things, driver?" And I sez: "Ah sir, if they'd let you finish wot you started we'd be doing better than wot we are," and then I telephoned & they let 'im in and 'e stayed for a couple of hours & I sat & waited for him. When he came out, I took 'im 'ome and he asked me in for a drink and we 'ad a long talk. 'E's a fine man & there isn't a working man in the country that doesn't wish 'e was back.'

I saw in this morning's paper, darling, that Deanna Durbin had got her divorce apparently on the grounds that her husband always switched off the wireless when she wanted to listen to concerts! Oh! darling, & we have the temerity to believe that we are living in a civilized age.

SATURDAY 18 DECEMBER Darling, Pan is a Hopeless Case. He telephoned this morning & Mum asked him how he'd got on (meaning that she wondered how he'd done in his end-of-term exams) and he said carelessly: 'Oh! Not too good.' 'What do you mean not too good?' said Mum. 'How did you get on in Spanish?' 'Oh! I was top in Spanish.' 'And what about your other subjects?' 'Well, I was top in all of them too.' 'Well,' said Mum, a little exasperated, 'what on earth do you mean by Not Too Good?' 'Oh!' said Pan, Surprised, 'I wasn't talking about Trials, I was referring to yesterdays Rugger practice.'!!!

SUNDAY 19 DECEMBER On Saturday, darling, Pamela & I were alone in our room for the afternoon & she began very shyly & diffidently to talk about her marriage. She said, my darling, that while she had flu & was whisked away to her mother's flat she suddenly realized with overwhelming panic how utterly dependent on her husband she was – being away from him was like being shut in a room with no sun & no air. She said, my darling, that on her wedding night she'd been a little frightened & she'd suddenly noticed that her husband was frightened too & realized how much a part of one another they were & had felt a wave of happiness & exultation unlike anything she'd ever known before. She realized, darling, that love was stronger than she was and it gave her a tremendous sense of having suddenly taken on a grave & solemn responsibility. That's why she looked anxious & preoccupied in the early months of her marriage, my darling. Oh! I know how she felt because it is an Awe-inspiring discovery to find that you are possessed by something so much more tremendous than yourself – but it's a discovery that I made long before my marriage, my dear love.

MONDAY 20 DECEMBER I am not looking forward to Joyce's wedding tomorrow, my darling. It will be like watching a rather heartless drawing-room comedy – and when I think of it, the words of Blake's sad little lyric hums in my ears. 'My silks and fine array – my smiles and languished air – by love are driven away – and mournful, lean despair – brings me yew to deck my grave – such end true lovers have.' Aubrey described the engagement of Joyce & Bernard as a Merger, my darling. I would rather call it a cool, well-bred Gentleman's Agreement.

TUESDAY 21 DECEMBER My darling, this has been a Gruelling day. Dr Minton having once Got Me into his Lair, my love, Put me Through It. He said that the whole of the back of my nose was blocked with two prongs of broken bone and the result was a formidable accumulation of catarrh. He warned me, my darling, that it would probably mean a small operation which would incapacitate me for a fortnight or so & sooth to say, my love, I'm anxious to have it done as quickly as possible so as to be quite well by the time you come home or I get my job with the British Consul, as the case may be.

I got back very late for lunch, my darling, & only just had time to have a bath and change into silk stockings, my black dress with the tartan collar & my new hat. We were able to get a taxi to the synagogue, my darling, & we arrived early & exchanged conversational gambits with the Salamans, Col. Samuel, Hetty Sebag Montefiore, Neville Laski & others. The service, my darling, was printed with a full translation and I liked the form of it so much that I shall keep it as a model for our own, my very dear love. I didn't have any feelings at all about Joyce & Bernard during the marriage service or afterwards, my darling. I felt absolutely impersonal about the whole thing.

Afterwards, darling we went to the reception in a taxi with Colonel Samuel & he confessed that weddings & military marches always made him cry. The most embarrassing occasion, he told us, my love, was the Victory March after the last war, in which he bestrode a Recalcitrant white horse over which he had no control whatsoever and the tears poured down his face.

Joyce looked extremely beautiful, my darling. She wore

very rich cloth of gold which fell about her more like moulded draperies than a dress & she had a deep border of heavy lace at the bottom of her veil. Ursula was Eclipsed & she knew it. She wore dark red velvet and a little Juliet cap – rather theatrical but pretty – but the most Beautiful Thing of all, my darling, was to see Matthew & his wife together. Fore God! If they stood back to back they'd span the Thames. There they were – their outsized Sam Brown's straining at the buckles – Her vast Bosom jutting outwards like the Prow of a Great Ship – their faces having some of the Spherical Benignity of the Moon. Fascinating, my love. I could hardly take my eyes off them.

WEDNESDAY 22 DECEMBER My darling, I'm lunching with Joan Wilson at the Churchill Club today. I hope she doesn't tell me any more of the Sordid Details of her brief marriage because I feel far too heavily burdened with sorrows of my own to be able to bear hers as well. As one of the people who have the educational future of England in their hands, she's just a jest in rather poor taste – as a living, breathing, sentient human being, she's an emotional mess.

I asked her, by the way, darling, if there were any openings for Civilians in Army Education or adult education generally at the moment & she said that they were simply crying out for people with my sort of interests & aptitudes & that, if you come home & I resigned from the Air Ministry she'd put me in touch with the people concerned. Oh! darling, darling, if only you were able to know with some semblance of precision what is likely to happen to you within the next few months' time there is so much I could be doing in preparation for your return. I was so grateful to Joan for having shown me some beauty that I asked her to dinner tonight.

Later: Joan gave me lots of interesting information during the evening, darling. She's very enthusiastic about me lecturing in the London Area & wants to get things moving at once – but, of course, my darling I must hang on at the Air Ministry until I know where you are likely to be in the course of the next few months.

MONDAY 27 DECEMBER You know, darling, I really don't like Mr Melville. I went into him this afternoon about something and murmured conversationally that I supposed he'd be taking a day's leave instead

of today & he said oh! no he wouldn't. I remarked that I thought he was unwise & pointed out that Mr Murray's policy of unremitting industry over a period of years had brought him a nervous breakdown which had necessitated 6 months' sick leave. He said callously, my darling, that Mr Murray needn't have slaved as he did in the Private Office. He needed only to ask for extra staff to get it. It was clear, darling, that Mr Melville had little use for men who were oblivious of self-interest. He's an unscrupulous careerist.

WEDNESDAY 29 DECEMBER Pan has just telephoned to say that letter 202 is waiting for me at home. Oh! My very dear love, the knowledge that there's something to go home for will carry me through the day on wings.

Oh! darling, I just can't take in the implication of the miraculous possibility of our being together in 2½ months' time at all. I can't believe it. I read the words over and over and over again. I read them out loud in a whisper & in a shout. I read them to Mum & Pa to make sure that they sounded the same in company as they sounded in a room empty of everyone except me. I reminded myself, my very dear love, that there were at least Seven Types of Ambiguity and I asked myself whether this sentence belonged to any of them or to other types not considered by Empson but oh! darling, darling, even after all this the words still seemed to say: 'with any luck I should be home within three months'. Of course, my darling, they meant far more than just that. They meant a Spring wedding with primroses and crisp Scottish air for our honeymoon & release from the bondage of despair & frustration. They meant life, my darling, a new & lovely life for us together with a fresh start as far as work is concerned & death to the weariness, the fever and the fret of separation. 2½ months are nothing, my very dear love. Once I know that at the end of that time I shall be in your arms again they will dissolve like frost on a window pane when you press a warm hand against it. I feel as though I were suspended on a column of air an inch or two above my bed, my darling. I can't, I can't apprehend the idea of so much joy. I feel as I felt the day you asked me to marry you.

Darling, letter 204 arrived this morning. Of course it isn't difficult for me to Obey your Esteemed Instructions and Pull Myself Together when the air is tingling with hope.

Darling, I entirely agree with Mr Walters's assertion that I am not artistically creative but appreciative. I'm sure that my metier is interpretation and not creation.

I do lack scope for self-expression. I think that explains, not my love, of course, because you are the explanation of that, but that complete dependence on you which you find so worrying. You see, my darling, you give me the two things I need more than anything else in the world – emotional security and complete self-expression on all levels – and you give me a third thing too which is the most important of all – the peace & rest which passeth understanding. Oh! darling, I think you can call my lack of emotional balance self-pity without too great injustice. I do from time to time indulge in self-pity and afterwards there's a violent reaction of disgust & humiliation at my own lack of control but on the other hand, my darling, I can see that all this is going to leave no permanent mark because even the very uncertain prospect of your return in March makes all my pain seem unreal & unrealizable.

Ismay sent me another photograph of my Pudding Faced Godchild this morning, darling & wants to know whether Isobel is to be taught to call me 'Godmother' or 'Aunt Eileen'!! I am going to insist on being called 'Eileen'.

All my love for ever & ever, my darling – and I am smiling.

* * *

My wedding ring came by the evening post, my darling. It's beautifully solid & heavy. I've hidden it away, my dear love, in the drawer where I keep your letters and I shan't take it out again until I hand it over into your safe custody.

WEDNESDAY 5 JANUARY My darling, I had a lovely lunch hour. Pamela came with me to supervise the fitting of my suit. On the way, darling, I glanced idly into the windows of a Woman's underwear shop and saw, to my horror, the most obscene sight I ever clapped eyes on – brassieres with the middles cut out so that they make a supporting ring round your bosom leaving most of it naked. Yes, my love, they do look rather like an outsize pair of spectacles. Don't Order me to buy a dozen at once, darling, I couldn't. You do see what I mean, don't you, my love? And in Grosvenor Street too with the place just seething with the rude & licentious American Soldiery. Maybe the idea is to save material, my darling, but it's pretty Horrifying all the same.

FRIDAY 7 JANUARY Darling, I'm going to University College Hospital on the 19th and Mr Mollinson will operate on my nose on the 20th. He says, darling, that I'll be able to breathe perfectly after the oper-ation so you will after all be able to preserve the illusion that Women don't Snore!

SUNDAY 9 JANUARY I had a long letter from Mr Murray telling me that the violets and primroses are coming up in his garden & that they make him feel the Urge to become Permanent Under-Secretary of State to a Ministry of Inspiration with a staff of competent writers. There's no doubt, my dear love, that that and that only would be Mr Murray's Niche. He's running a Counter-Offensive against anti-semitism with his Local MP, my love; I gather that progress on those lines is slow, but not static. Oh! Darling, when I get letters from Mr Murray I realize how much I miss his humane wisdom, his idealism & superb honesty. This mountebank who has taken his place sets me prickling with indignation at every pore – and he dares to imply that Mr Murray was not a Good Civil Servant – perhaps he isn't, my love (though I believe he is) but he's a good man & that is something which High Handed Melville is not.

I had a letter from Basil, darling, Rather an Entertaining letter, my love. He seems in excellent Spirits & as far as I can gather it's due mainly to a brief sojourn in a mental hospital! he seems to thrive on Insanity, darling. I haven't heard him so gay for years.

FRIDAY 14 JANUARY My darling, I enjoyed my lunch with Joan Fisher today. I was telling her about my wedding veil and she said: 'Yes, it would be worth being married in full regalia with a man as handsome as Gershon to set it off.' I was speechless with pleasure, my dear love, & I said: 'Oh! Do you think Gershon is handsome?' 'Oh! yes, I <u>do</u>,' she said. 'I always thought that he was one of the best-looking and most distinguished men in the Union – a man with whom one would be proud to be seen about.' I would have been glad to have had <u>anyone</u> say that of you, my darling, but Joan most of all because she is intensely conscious of masculine good looks – a veritable connoisseur. I can't help being delighted with the opinion of an expert.

Darling, I'm to have my operation next Friday.

SATURDAY 22 JANUARY My darling, I feel scarcely any discomfort today than I should if I had a very bad cold. I slept beautifully last night & my morale couldn't be better.

Dr Minton says I'm to have at least 10 days' holiday, my love, and then I'm to have a day or two at home before I go back to work.

MONDAY 31 JANUARY My darling, I had an exhausting journey. I travelled First Class so as to have a little more comfort & elbow room but in fact the Third Class could hardly have been more crowded. There was one Awful Woman in the Carriage, darling, who had spent the weekend in London flat-hunting – apparently one of a long succession of flat hunts, my love. She had a Crony with her, darling, & she was telling her at the top of her not inconsiderable voice the entire history of all her earlier searches and the result of the last one. 'I found a flat in the City, my dear,' she said, 'In the <u>heart</u> of the Fur District. <u>Everyone</u> says I shall be <u>murdered</u> in my bed if I'm not <u>eaten</u> up by – by <u>creatures</u> out of the Furs first. I had my eye on a much <u>nicer</u> flat where a woman was murdered last month. I thought it might stay empty because of the <u>Mishap</u> – but <u>no</u>, my dear, it was <u>snapped</u> up, so I shall have to make do with the Fur District and the little <u>Animals</u>. So <u>unfortunate</u> but one has to take what one can <u>get</u> these days.'

When I got here, my darling, I was almost crushed by the small forces of arms. I've never had such a lovely welcome in all my

life. I glowed, my love, and in spite of the fact that I was feeling desperately tired & had a pain in my nose from the wind I let Lindy & Margaret & David hang about my neck all the way up the path & into the house because I was so glad to see them.

THURSDAY 4 FEBRUARY My darling, I'm not just stammering – I'm gibber-ring. The whole morning I heard myself chattering in a high-pitched & yet blurred voice to Mrs Turner. The shops spun round me. The spires of King's Chapel against a suddenly blue sky swayed drunkenly. Darling, I think today brought a moment of the purest happiness I've ever known. I was sitting in the nursery waiting to go out, my very dear love, and hemming a handkerchief when the telephone rang. I didn't pay much attention & even when Mrs Turner called out 'Eileen – it's your mother' I brushed aside my instinctive reflex of 'Special news from Gershon' because that's what I always think & walked unhurriedly across the hall. Mum started, my darling, by apologizing for having done something she didn't orter – something she'd never done before, but she said she'd been impelled to do it by a Queer Feeling & that now she couldn't help being glad. What she'd done, my darling, was to read the back of one of your letters, which had made it clear that you were already almost on the first stage of your journey home. Oh! darling, darling, I was nearly sick with joy. I want all the world to be glori-ously intoxicated with joy today, darling. Give me happy faces. I'll have no sorrow about me now. No, never, never, never, never, never.

SUNDAY 6 FEBRUARY Darling, did you know that Mr Turner got the Military Cross in the last war for going back to his deserted dugout under heavy fire to fetch a wounded soldier & carry him to safety? I didn't until Mrs Loewe told me yesterday & today I asked Mrs Turner & she confirmed it – but urged me On Pain of Death never to mention it to Mr Turner. Of course, I wouldn't, my dear love, because I know him well enough to realize that if I did he'd Come Over in a Wave of Embarrassed Gruffness, bless his Inhibited Heart.

THURSDAY 10 FEBRUARY Oh! darling, these last four years have been years of chaos & uncertainty for everyone & not less for me than for other people. Now that there is rest & joy ahead I can feel tremendous reserves of energy & vitality in me. I <u>know</u> you will bring me to life, my darling. I shall skip along by your side in the street and look up at you & ask you what you're laughing at & perhaps it will just be pleasure at being with me again. Do you think it might be that, my very dear love?

SUNDAY 13 FEBRUARY I coughed dreadfully all night, my dear love, & when I told Mum & Pa I hadn't slept Mum said, 'Why?' so crossly and aggressively, my darling, that it led to a full-dress scene. I'm so sick of the clichés 'nerves' and 'smoking' whenever I don't feel well. Pa said he'd known hundreds of engaged girls but none who had behaved as I have while you've been away, and, if you please, he cited Joan after Ian went away as an example! Joan whose love did not survive the strain of the separation from Ian. Yesterday she told me that she hasn't told Ian she's married!

SATURDAY 19 FEBRUARY My darling, my feelings towards the raid last night were very mixed – fear at the horrific noise of the guns and the whistles of rocket shells & bombs – cynical amusement at the thought that we, bungling amateurs as we are, might at any moment be called out to cope with the fires which were so close that we could see the flames – sheer amoral delight at the beauty of the scarlet parachute flares and golden rain from the guns.

WEDNESDAY 23 FEBRUARY My darling, Pan's school room suffered damage from fire-fighting hoses last night. He says everything he possesses is sodden. It was a beastly night & this morning, my darling, there is a story that I'm going to be transferred away from S9. I have to go & talk to Mr Melville. I feel sick with apprehension. I think he's going to be rather nasty to me. Oh! God. He doesn't like me, my dear love, and that's why I'm being transferred. Of course, it <u>may</u> work out for the best, my darling, because it may give me the opening I want from getting away from the AM.

My darling, my interview with Mr Melville wasn't as bad as I expected. The fact that he was Sending Me Away in Disgrace

hardly emerged at all, he simply said, with absolute truth, that there was no doubt that I was not fitted for the Civil Service & that he thought he could persuade SI to get me a job in Adult Education. Oh! darling, I was so delighted at the thought of getting out of the AM that I hardly paid any attention to being in Disgrace.

Bernard told me, darling, of a friend who, though he is neither an atheist nor sufficient of a linguist to be able to read Russian, always gets the Russian equivalent of the 'Freethinker' in order, my love, that his extremely Prim landlady may weekly pick up off the doormat a periodical endorsed with Russian Lettering & the translation 'The Atheist – Published by the Society for the Propagation of Ungodliness'.

THURSDAY 24 FEBRUARY You know, my darling, living at home is going to be even more trying under Air Raid conditions than it would be normally. I have always been all for staying in bed during raids, my love, but now I'm so desperately anxious to be alive for you when you come home. I'm still not in the least afraid of Death, my darling, but I certainly feel that if He were to turn up now or soon after our marriage I couldn't regard him as anything more than an unwelcome Interloper – there being a Time & Place for everything.

SATURDAY 26 FEBRUARY I'm very glad, my dear love, that I went to see Joan Fisher's mother about Birth control. She's gentle-voiced, fine-boned Scotswoman & her attitude is sane, kind & healthy. It seems, darling, that tablets alone are practically no protection at all and she says that you must wear a very thin rubber contraceptive called 'Durex' which you'll be able to get from the Marie Stopes Clinic by saying that you're a patient of Dr Evelyn Fisher. She says, darling, that it's so thin that it can't possibly bother you – especially if you damp it first – but the snag is, my dear love, that it can only be used once and that it has to be put on when you're half excited. That's a sorrow to me, my darling, but she says it's the best she can do for us & that if I go back to her after our honeymoon she'll teach me how to use a rubber semi-permanent attachment. When I have one of those, my darling, you won't have to bother with a sheath anymore. She told me that the most natural way for us to be wanton would be for me to lie on my back. I didn't

ask her for this information, my darling, but she said that it was something we ought to know because such a lot of nonsense had been written about it.

I had an uneventful lunch with Felicity, my love, the only thing of note was that a Man Assaulted her in Fetter Lane last night & she landed him an Uppercut on the jaw which sent him away bellowing with pain! That's the stuff, darling!

SUNDAY 27 FEBRUARY My darling, Nelly Ionides telephoned to ask how we'd been getting on in the raids. 'Well, as a matter of fact dear,' said Mum, 'we had a little trouble the other night – an incendiary in the garden.' Nellie's rejoinder to that, my love, was about as pat a rejoinder could be. 'Did you?' she murmured & added with elaborate casualness, 'Well as a matter of fact we had a crashed German bomber in the garden & there isn't a window or a speck of plaster in its place on the whole estate.' That makes our poor little fire-bomb look pretty silly, doesn't it, my darling.

Mr Melville told me yesterday, darling, that S1 were agreed to offer me to London University for Adult Education, so things should begin to move.

THURSDAY 2 MARCH My darling, I have this morning received Intelligence which indicates almost beyond a peradventure that you are on the last lap, so this is to be my last Air Letter.

Oh! Darling, darling, I love you so terribly that at the thought of seeing you & hearing you & feeling the touch of your mouth against mine and of your hands on my body I feel dizzy & dazzled & bewildered. I'm holding out my arms to you, my darling. Don't be long – please.

All my love, for ever & ever, my darling,
E.

April 1944–March 1946

It was the last letter Eileen would write to Gershon as his fiancée. On 26 March they were married at the St John's Wood Synagogue, Eileen in her long veil and Gershon looking irredeemably 'civvy' in his RAF officer's uniform. As Britain and her allies prepared for D-Day, and Gershon returned to his duties, Eileen settled into her new married life, left the Air Ministry, and began a fresh career as an Adult Education lecturer.

The letters from this last year of the war, with Gershon more frequently at home, are inevitably more patchy, but separation, when it happened, was clearly as much a misery as ever. In the wake of the invasion Gershon would again be overseas, and at the end of the European war in May 1945 was with the British Army of the Rhine, and still there at the time of the Nuremberg war crimes trials, which he attended.

Through these months Eileen's married home remained the Alexanders' rented house in Harley Road. Although Eileen owned a farm in north Wales – and got a paltry rent from it – and Lionel and Dicky would eventually buy their Drumnadrochit Highland retreat, Alec Alexander's lifetime ambition was to own his own house in England, and in September 1945, while he was away in Egypt, Vicky and Eileen moved into 'Baron's Court' in Hampstead's Bishops Avenue – 'a great, empty, echoing house', as Eileen described it, that was distinctly more 'Mosseri' than 'Alexander' in style.

This would remain their home for the early years of their marriage, and it is from there that these last letters were written. Ahead of them, and all their friends – Joan, Joyce, Aubrey, Sheila, Hamish, Ian Nance – lay the post-war world: and with them all the memories, hopes, sorrows, mistakes, losses and wartime dreams so unforgettably caught in her letters.

II

Twin Compasses

My darling, this is my first letter to my husband and I find that I'm so much a part of him – that his voice and his hands and his body are so close to me – that speech – except little breathless whispers in the darkness – seems redundant & out of place. But I want my first letter to be a letter of thanks, my very dear love. It's no good, darling, I can't believe we've only been married a fortnight. The days have been hammered out like gold to aery thinness beat – to the finest, purest, most delicate spun gold.

What I had forgotten, darling, was the amazing complexity and range of happiness you could give me. I had forgotten the deep, indescribable joy of watching your face in repose – the merriment of savouring a comedy situation with you – the intricate pattern of a shared experience & then there were the things which I hadn't forgotten because I had still to learn them – the warmth of your naked body against mine – the irresponsible merriment of wanton playfulness and the solemn sacramental joy of receiving you into my body.

When I think of that, my dear love, I'm sick with shame at my small, niggardly selfishnesses – bothering your leisure with bickering at Dicky, having the fire on when you're sweltering, tidying up after you like an over-industrious crossing sweeper – it is as idiotic really, darling, as Pan following horses in the road to lay in a store of mushroom fertiliser!

This is going to be my first whole day away from you since we got married, darling, and I Can't Take It. On the other hand, I

371

find the familiar drabness of the Ministry, the dreariness of the files, as so remote from the life & joy inside me that they have no longer any power to drive me to irritability and despair. Still no news of a transfer to another Branch.

FRIDAY 14 APRIL Jean came to dinner yesterday evening, darling, and Laid her Intentions in regard to Square before Mum & Pa. Having grown fond of him of recent months, my love, they took it Very Nicely & Pa Applauded Jean's resolve to buy a house in Chelsea. (I wish all my friends wouldn't go spoiling the market for us, my love – it was my idea in the first place.)

FRIDAY 15 SEPTEMBER It looks, darling, as if Providence has decreed that the last meal we ate together is to remain with me and sustain me and Sebastian and/or Kate (herein after known as Sebastian for the sake of convenience) until our second breakfast.

FRIDAY 29 SEPTEMBER My darling, although I have realized that this time our separation was to be a short one, it has still been a time of constant and nagging unhappiness. Whenever I opened a room door and didn't find you sitting in the room I had a sort of cramp in my heart. Whenever I did anything or read anything or wrote anything or had an idea about anything I wanted to talk to you about it & felt hurt & frustrated because I couldn't. I need you, my darling, in the way that one needs one's limbs or one's lungs. I don't just miss you at odd moments as I might miss Aubrey or Victor or Hamish – I'm just incomplete & disintegrated without you.

TUESDAY 16 JANUARY 1945 My darling, as in accordance with a Whispered Word of Motherly Advice from Mum, I have just Anointed my Bubs with surgical spirit by way of putting them through a Toughening Course in preparation for the impact of Sebastian/Kate's gums. I naturally came over All Wistful for my very dear lord whose presence (and assistance) would have turned this rather tedious operation into a joyous mollock.

THURSDAY 18 JANUARY It seems, darling, that yesterday evening while I was out, Alida rang up in great Agitation to ask if the Ambache's had any daughters! It seems that Aubrey has been staying there again & she Scents a Rodent. Victor looked very knowing at this, & revealed that Nachmann had told him that Papa Ambache was Plugging Aubrey like mad & that he appeared to be Getting Somewhere.*

I felt so awful at 4 o'clock today that I collapsed on one of the chairs in the kitchen & wept – whereupon Mrs Clark wagged a Roguish finger at me & said: 'Ah! You'll have to have separate rooms after this, Miss Eileen,' & I felt, my darling, as though some-one had poured rancid slops over me. Even now, darling, I feel I need to wash myself all over with strong disinfectant to get rid of the taint of that remark. There's something so horribly obscene about referring to the joy & peace & contentment of our bed in that way.

TUESDAY 23 JANUARY Jean & Square are getting married on 15th February, my darling. Any chance of your getting away for their wedding? Oh! darling, lay it to thy heart. Jean is moving into her house on the 1st (she has to put in a fortnight's residence in Chelsea before she can qualify to get married in the Town Hall) & Aunt Teddy is moving in with her – very rash, darling. I wonder if she'll ever be able to get her out once she has moved in.

SATURDAY 27 JANUARY My darling, I'm more than a little *surexciteé* this evening & I somehow don't think I'm going to sleep very well.

First of all, my dear love, there were your letters 11 & 12 which came unexpectedly (I was sure the weather was going to Do the Dirty on Me) & went to my head like wine. Then, my dear love, there was a telephone call from Nachman to say that he'd just had a cable from Suzy telling him of her engagement to Aubrey. All roseate & aglow with love as I was, my darling, because of being brought close to you by your letters, it was a particularly piquant

* In March 1945 Aubrey Eban would marry Suzy Ambache, the Egyptian-born daughter of a wealthy pioneering Zionist family, in Cairo. Nachman Ambache, a Cambridge acquaintance, was Suzy's brother.

pleasure to know that Aubrey's Suit had prospered. I rang up Alida, darling, & we were All Girls Together for hours & hours & she read me Aubrey's letter which touched me so much that I nearly cried, my dear love, because he said that, although he had known Suzy for a long time she had, 'for reasons he could not go into', been uncertain of her feelings towards him until recently – & he went on, 'I wish you could be here at this most exciting time,' which, for Aubrey was saying a good deal. They're going to be married in April, darling, & oh! I'm glad.

TUESDAY 6 FEBRUARY Pa lunched at the Bank with Anthony Rothschild yesterday, & Churchill's brother Jack was there. The talk turned on Winston's prodigious memory & Jack said that it was not always reliable & cited a rather recent entertaining episode, love.

Winston let himself into No. 10 a week or two ago &, while he was taking off his coat, he noticed a man waiting quietly in the hall. 'Good evening,' he said. 'Are you waiting to see anyone?' 'Yes,' answered the man. 'I'm waiting to see you.' 'Ah, yes,' said Winston, 'you – er – know who I am?' 'Certainly,' the man replied. Winston got more and more confused. 'D'you know,' he said, 'I'm sure we've met somewhere before – Yes, yes, I have a very good memory for faces – Let me see now – Yes, I'm sure I know you.' The man could Take No More of This, darling. 'Well, you ought to,' he said curtly, 'I've been sitting in your Cabinet for 18 months.'

MONDAY 19 FEBRUARY [Hampstead Nursing Home] My darling li'l Kate* has just left me with a grunt which I interpret as meaning that she considers *la pension bonne et pas chère.* Oh! but it was good to have you, even for so very little time, my dearest love. I wish you could have seen my baby at my breast before you left, my love. She is at her most Engaging then – & it's then that I realize with a little pang, darling, that she really does belong to us & that we made her out of our love – & then I love her, my darling, as I never believed I could ever love any little baby (but I still think she's an ugly little thing all the same).

* Eileen and Gershon's daughter, Katherine Ellenbogen, had been born three days earlier on 16 February.

MONDAY 12 MARCH Darling, I'm too depressed to do anything but brood. Is it very childish of me to feel burdened by all this flesh? This intolerable deal of fat means far more to me than just 3 stones of flesh. It brings back the unhappiest time of my life – when I was a more than podgy child in Cairo & morbidly sensitive about it & pretending not to Give a Damn. Still, darling, Nurse & Sister & Masseuse & Mum & Pa all think I'm getting thinner, whatever the scales may say, though at the moment my bottom billows so. Whenever I move it's as though a breeze were causing a sort of tremor on the sea of flesh that follows me about.

TUESDAY 13 MARCH My darling, do try and be here by Sunday repeat Sunday. You see, love, that's Aubrey's wedding day & Alida is having a Slap-Up Luncheon. Alida is very relieved that I'm coming, dear, because she felt that Aubrey's marriage would be a Hollow Mockery followed by a Long Life of Sin (the idiom, I do confess it, darling, is mine, not hers) unless I went to her party & Blessed his Union.

Kate is being taken to St John's Wood on Sunday morning, darling, to be Spat on by the Beth Din in the person of the Rev. Swift. Now, my dear love, in the general run of things I never feel very near God in St John's Wood Synagogue but I did feel very close to Him when we were married there & so I want you to be with me when I go there for the first time with the li'l soul we have made out of the joy of our bodies & the intimacy of our minds & spirits.

SUNDAY 18 MARCH Oh! darling, how I wished you could have been with us today. Semiramis broke down on the way here, darling, so the day started with a mild flap but Pan sallied forth with a spanner & soon all was well.

In the synagogue there was a white & silver canopy erected on the dais in front of the Ark – for a wedding I suppose – & old Swift led us under that (I was carrying Kate in my arms, darling, & I'm bound to say that in her lace robes, with a peach-bloom on her cheeks from sleep and her little mouth pressed she looked mightily like a rose) and gave me a very lovely prayer to read all about being led out of pain & travail into joy. Then Pan took Kate

375

up to the Ark, darling, & Swift opened it and said an English blessing over her & Mum pressed a fiver into his hand & that was that, except that I promised him another fiver from Us & he Beamed so that I could see that he regarded the ceremony as Cheap at the Price.

Our drive to Harrow was uneventful, darling, & the scenery was alternate rows of plum tress in full blossom, which in the distance looked like a delicate, misty sunrise and houses battered & ruined by Wee Twos. Dicky soon joined us, darling, & I will say for him that he looked swooningly 'andsome – 'like a film star', Nurse, who hadn't seen him before, said.

The party was a terrific success, darling. Mum & Pa gave Alida a 22lb salmon & that with the turkey, provided the centrepiece. There was a wedding cake with the words 'Aubrey-Suzy 18. 3. 45' in peach-coloured mock ice cream. Mrs Halper wasn't there, darling, because she was indisposed with an attack of Acute faribl – the cause, darling, was, In All Innocence, Mum. Mrs. Halper was in a White Heat of Fury because Alida had asked Mum & not her to Lay on the Wedding Feast. However, darling, we all thought that the party was much nicer without her & I said so to Alida who was in a bit of a shock about it & she said: 'Thank you, darling, you're such a comfort. Tell me now, do you think Aubrey is a Virgin?' Well, my love, your guess is as good as mine, so I said stoutly that I was sure he was – you or I would certainly have known if he hadn't been & she said: 'Now isn't that lovely, darling?' and I agreed that it was & that was that.

Pa made a nice, modest little speech, my love, about what a Good Thing Aubrey was and what a Lovesome Thing (Got Wot) Suzy was and it was Clear to All that he was Deeply Moved & so was Alida who wept freely in a Welter of Tchehovian Mother-love. In fact, darling, it was all Very Beautiful & would have embarrassed Aubrey acutely so it's just as well that he was several thousand miles away at the time.

One incongruous little touch, darling, was the snapshots of Aubrey & Suzy mollocking rather primly in front of the camera & Aubrey looking more than mildly discomfited. 'I don't think I like them very much,' Alida confided doubtfully. 'Aubrey is wearing such a foolish expression, don't you think?' and he undeniably

was, darling. The light-hearted mollock is Not for Aubrey, darling. He needs something a good deal ceremonious.

SATURDAY 24 MARCH Darling, it is apparently normal among Academic Women not to Dirty their Nappies as babies. Mum says I never did & Mrs Turner assures me that Jennifer never did – so you may permit yourself to be wholly pleased that Kate never does.

Darling, I don't want to end this letter without telling you that I love you more & more every day, my dearest love, & that our wedding day is the most precious date in my life – it always will be, darling – because on that day I felt (and it was an unforgettable & most wonderful experience) that you and I were standing together in the presence of God & that we were joined together in his sight. On that day & always since I have loved you, my darling, I worshipped you, & the vision of Absolute Good that I somehow have Through our love, with my body & my mind & my spirit – & it will always be so until death us do part & perhaps even after that. Thank you, my paragon of men, for making me so blessed – and I don't think it fanciful to believe that it is because of the deep & wonderful serenity that you have given to me by being my dear & gentle & loving husband that Kate is such a remarkably contented little soul. Oh! my darling, I can never, never show you how much I love you for all This – All I want in life, dear love, is to please you & make you happy. Please let me do that always – always.

VE DAY, TUESDAY 8 MAY My darling, I gave Mum & Pa little Wee presents this morning – nothing much – to mark the end of the war. You shall have more records as your little Wee present, my very dear love &, when you come home, all the love that is in me, which, like the milk in my breasts, increases in direct proportion to the amount that is drawn away from me.

Yesterday Jeanne came to tea & told us that her father & brother had been at that camp where 4,000,000 people have been killed since 1941 – & the vivid picture in my mind of those terrible newsreel pictures of the Concentration Camps rent my heart as she spoke.

Hamish is on his way home, my darling. He may be back by now for all I know. It will be good to see him again.

Today. My dear love, I feel like Verlaine's poem: '*Il pleure dans mon coeur comme il pleut sur la ville, Quelle est cette langueur qui pénètre mon coeur?*'

My darling, I had no stomach for the Victory Celebrations today because you weren't with me. If you had been, love, I'd have set aside all my qualms & war-weariness & the memory of the living skeletons at Belsen & Buchenwald & gone with you into the milling crowds & with your protective arm about me, I'd have felt thankfulness & relief welling up inside me in great bubbles. As it is, my darling, I have ventured no further afield than Finchley Road where there was so little sign of rejoicing that I was reminded of Eliot's:

> Where are the eagles & the trumpets?
> Buried beneath some snow-deep Alps
> Weeping, weeping multitudes
> Droop in a hundred ABCs.

So, my darling, you see I have hovered on the outer fringe of Victory today & I shall not be at peace until you're home with me again.

Now, darling, I can hear the pop of fireworks & distant singing – & Pa & Mrs Wright, with Pan, who arrived home wholly unexpectedly on Under-the-Counter leave, have gone off to See the Town.

SATURDAY 16 JUNE My darling, I've just had a most terrible shock in the form of a telephone message from Joan. She's leaving Robert. I don't know any details – just that she cried most pitifully & kept on repeating that it wasn't her fault. I don't care what she's done, darling, or how unwise she has been. I'm so hurt for her. I'm going to see her in a few minutes – because I can't bear to let her go away without seeing her. She is hoping to get a job at Oxford or somewhere & have Susan with her. I can't write any more, darling. This is such an unspeakable tragedy.

My darling, Joan's is a pitifully sordid little story. After she'd finished feeding Susan, Robert urged her to come back to London & get a job. When she arrived, my love, she found that Robert had struck up an acquaintance with a man called Hughes with whom he

was always going out – mainly to Ivor Novello musicals & other out-of-character plays. (Robert, darling, is nothing if not a high-brow) Robert told her that Hughes got free seats for these plays & that as he was alone in London he felt he couldn't refuse to go to them with him. Joan never met Hughes, my love, but with her Flair for Higher Truth she got to know him quite well in spirit & even psycho-analysed him for Robert – explaining this or that peculiarity or inconsistency in his character – & of course, darling, she made a terrifically Good Story of Hughes to all Robert's friends to their acute embarrassment because they all knew that he was a myth.

Anyway, love, about 6 months ago Robert suddenly told Joan that Hughes was really a Welsh typist at the Ministry of Supply called Blodwyn (characteristically enough, darling, when Joan told Celia Roberts about all this Celia breathed a sigh of relief & said: 'Oh! Blodwyn, well then you have nothing to worry about. If it had been Bronwyn you might have had cause for alarm, but Blodwyn is the traditional Comic Character') & that he was going to take a room in Bloomsbury & live with her & he hoped Joan would wait for him. Joan did wait, darling, for six months, hoping day after day that he'd come back. They met quite frequently & Robert entertained her during lunch or dinner or whatever it might be with marvellous theories about it all. If marriage jogged along in the conventional way, he was wont to say, the fact that it held together didn't matter a fig – on the other hand if it could stand the strain of a thing like this, then it would have real substance. The man really is a Sadist, darling, as I thought origi-nally & I've never known anyone with such a passion for having his cake & eating it too.

Now, my love, Joan has reached the point where she just can't stand the strain any longer. She hopes & believes that Robert will come back to her in the end – (though I think she'd be well rid of him myself, darling, because even if he does come back the whole thing will start all over again with someone else in due course) but meanwhile, darling, she's going away to prepare herself for the possibility that he may never come back & to make a new life for herself & Susan.

Robert hasn't contributed a penny to her support or Susan's during the past 6 months, darling, & she naturally doesn't want

anything from him. Dr Minton has given her a medical certificate saying that she will be unfit for work in the Ministry of WT for 3 months & in that time she hopes to find a job at Oxford or Cambridge & to settle there with Susan. To explain to her parents the fact that Robert never went to see Susan, darling, she told them he was in Antwerp, but now, of course, they know the full story.

You know, darling, I must have blundered miserably last time Joan was in trouble because I'm the only one of her friends who knew nothing of what was going on. She has avoided me consistently ever since she came back to London & yet Sheila, Celia & Horace & Ally & Lennie were fully au courant. Not that that matters, my darling, but I think she would have found, if she'd come to me sooner, that I had learnt my lesson. I wouldn't have Recriminated, my darling, I'd only have tried to understand.

Darling, the breaking up of marriages in our generation leads Victor to the bitter conclusion that there is something wrong with marriage but it leads me to the conclusion that there is something wrong with the general attitude to marriage. So few people seem to realize, my darling, that it's a solemn undertaking & a sacrament. Oh! darling, darling, the more I see of other husbands, the more completely & wonderfully I love my own.

THURSDAY 13 SEPTEMBER My darling, I'm numb & bewildered. Things have happened today through a sort of mist. Mum & Pan & I set off early this morning for London. We went shopping & then to 'Baron's Court' – a great, empty echoing house. We'd only been there a few moments when the telephone rang. It sounded strange and very loud. I answered it. It was Mr Martin who used to be Head of Shell in Cairo. I couldn't understand why he should ring us, my dear love, but I thought it kind of him & said: 'How nice! You're the first person to speak to us on the telephone in our new home – I'm sure it will bring us luck.' God! What Dramatic Irony, my darling. He said unhappily, 'I want you to go back to Twickenham immediately. Uncle Felix is with me. I'm afraid we have bad news for you.' Oh! darling, darling, I suddenly saw the room spinning round me – I thought something must have happened to li'l Kate or to you, my darling. I never thought of Pa

because somehow he was so robust & so full of zest & vitality that I never associated him with sickness or death – but Mr Martin told me that it <u>was</u> Pa, my very dear love. He died of a heart attack last night.

I don't know how I managed to spin a tale to Mum – I told her that Pa had been taken ill & that Uncle Felix wanted her to go back to Riverside to talk about flying back to Cairo. I don't know how Pan got us home, my darling. Mum looked like a ghost & all the way home I was thinking of the pity of it. All his life, my dear love, he has worked & planned to settle in London & now this has happened on the very day that we took over the new house.

When I came into the house, my darling, & looked at li'l Kate dimpling in her pram, I cried because it was so terribly sad that she wouldn't remember Pa who loved her so & was so proud of her. Uncle Felix came soon after we got home, with Dr Minton. (I tried frantically to get Dr Minton on the phone, my love, but no one knew where he was – actually, of course, he was on his way here.) Uncle Felix told Mum, darling, & she set up a wild & desolate keening that it broke my heart to hear: 'My darling Alec – you <u>can't</u> leave me – I need you.' Then, darling, she clutched pathetically at Dr Minton's hand & said: 'You & I will go to Cairo tomorrow, David. We'll save him. He can't die when we're with him can he?' Dr Minton gave her an injection of morphine, my love, & we undressed her & put her to bed. She sobbed & struggled & at last fell asleep. Dr Minton thinks she should sleep for 15 hours – he made it a very strong dose.

Oh! darling, darling, though I have been angered by Pa so many times, though I have even had little hot spurts of hatred for him once or twice, by and large I had a tremendous respect for him and affection too. I'm desolate now to think that I'll never see him On the Scent of the Chocolate ration again – that I'll never again be exasperated by his old, old stories – that I'll never again enjoy the rich humanity of his political & philosophical views. He was a Great man in his way I think, my very dear love, & the world is the poorer for his loss. I rang your parents & spoke to your mother.

My darling, Nellie cabled this morning to say that we could regard Riverside as our home for as long as we liked so we'll be staying on here for a week or two anyway. She's coming here for the night today.

Darling, I read Mum Pa's last letter to her (she had 5 this morning) written on the day he died & I think it brought her comfort. It was so gay & zestful, so full of hopes & plans for the new house – where, he said characteristically, he knew he would be welcomed like a King. It's lovely, darling, that his Superabundant vitality was with him up to the last moment.

David & Sylvia were heartbroken at the news. 'We loved him like a second father,' Sylvia said & I'm sure it's true. Horace said: 'God! It's bloody unfair – Alec of all people. He had Guts enough for 10. I can't believe it.' His friends are pouring in their sorrow & sympathy – if he knows that, my darling, I think he will be happy – like a schoolboy with a 1lb box of assorted chocolates.

Mum is terribly weak & sad, my darling, but she's no longer delirious. She finds comfort in his love & the tenderness of his letters – as I should do if I were her, my sweet Solace. There's no richer thing in life than to be loved by a good man & Mum will always have that.

When we give Kate his last present – (It's very rare, darling, & priceless in value – it's Ptolemaic – perhaps Cleopatra wore it) we must tell her how he loved her & how he longed for his 6 o'clock chat with her each day – & how he was wise & humane & saw in the Labour victory the dawn of a great future for all men.

I was overwhelmed again with the realization of his wonderful capacity for friendship – a unique gift that, my darling. I have never known one man loved so much by so many people. I'm so glad, my darling, that in these last five years I've come to appreciate Pa. I think he knew that the resentment of my childhood & adolescence had been replaced by a feeling of warmth & intellectual ethical kinship. It would have been terrible if he had died before I had learned to know him as he really was. You helped me there, my darling, & that is another tremendous debt of gratitude that I owe my dearest lord. I have never loved you as much as

I do now, my darling, & I think my love for you is helping me to help Mum.

THURSDAY 8 NOVEMBER This evening Joan came to dinner. She seems to have got to the stage of being bored with Robert, darling, I think owing to the fact that he informed her parents that Joan had rushed him into marrying her & now wanted to get her own way as usual by rushing him into leaving. Blod (as Joan calls her) was the Last Straw – anyway, darling, she has hardened considerably towards him since I saw her last & she is now determined that he will not see Susan again until she's grown-up.

TUESDAY 13 NOVEMBER This morning, love, Joan rang me to read me a letter she'd had from Ian. He sounded lonely & much hurt by what had happened to her. He said he hoped she wouldn't mind his writing, darling, 'but I'm never very good at knowing when I'm not wanted'. I think it's not impossible that Joan might marry Ian yet, my dear love, & if she did she'd be her Cambridge self again & all the rest would dissolve like a nightmare.

SUNDAY 25 NOVEMBER Bernard told me on the telephone that Joyce has been deprived of her Appendix with Complications. He also asked me to dinner, an invitation which I accepted, love, mainly out of curiosity – I wanted to see how the Menage worked without Joyce to Keep a Curb on the Cook.

It was a fascinating evening, my dear love. First of all the house, in spite of its extensive dilapidations, is perfectly beautiful although it's semi-furnished in a hotch-potch of styles. Then, darling, there was something exquisitely ironic about the Elizabethan proportions of the meal which their Tatty but Accomplished Cook set before us. A whole sole each followed by a stew garnished with mountains of potatoes & cabbage & a largish Flan – & the soup he had was elephant soup & the fish he had was whole. Finally, my love, over Rare Old Brandy & Coffee (the Brandy being brought up lovingly from the cellar all authentically Cob-webbed) he told me many things with a kind of Gargantuan simplicity.

He told me how his Old Boy had Conned Joyce's Old Boy into Coughing Up at least half of what he (Sir Robert) was propos-

ing to settle on Bernard. He informed me that while Joyce assured him that his bed was the first she had ever shared, he couldn't give her the same assurance but that she didn't seem to mind which he thought was decent of her. He whispered that he thought Ursula was a Phony but that she & Joyce were still 'Very Thick' – he asked me what I thought of the Mosley affair (to which I gave a Diplomatic answer, darling) & wound up by saying that you were a Good Chap. Then, darling, he Wrapped me up in one of his Looted American Army Windjammers with four linings & took me home on his motor cycle – the worst thing about that, darling, was the horrible sense of not being shielded from the tarmac in any way, having to come into quite physical contact with B. by holding onto his coat & having icy spirals of winter draught licking my bottom throughout the journey. However, we got back alright, darling, & I am thanking Heaven fasting for a Good Man's Love.

MONDAY 10 DECEMBER Today, love, I listened to a lecture on Famous English letter writers on the Forces programme. I especially enjoyed Horace Walpole's description of a public execution – but on the Whole, darling, I thought they had Nothing On Me. (I was ashamed of myself, my love, but the thought did cross my mind. Aren't I Orful?)

TUESDAY 11 DECEMBER David rang tonight, darling, with heartening news. He has got the Chair of Philosophy in New Zealand & if Cardiff will release him, he & Sylvia will be on their way in February. I'm so glad for them, darling, although I shall miss them terribly. Five years is a long time – on the other hand it will give us an incentive for going to New Zealand which has always been high on my travelling list.

FRIDAY 14 DECEMBER It's nearly midnight, my dear love. Miss Bradbrook left late & my heart sunk to see her go. It struck me as she went out of the door, my love, in a lumpy old red leather coat with an RAF Scarf with maps of Germany on both sides ('pure silk and NO COUPONS in all the shops,' she said with wicked glee) with her hair all wispy & homespun stockings ridging about her ankles that

it was a strange thing that a woman with a mind as delicate &
graceful as a Dresden shepherdess should bundle herself up in rags
so ungainly.

WEDNESDAY 6 MARCH 1946 My darling, your telegram & letters 36 & 37
arrived in the best possible sequence – the telegram first & then
the letters so that instead of being disappointed at not having you
home as soon as I'd expected (though I'd have been very pleased
that you were going to the Trials, love, anyway) I was enchanted at
the thought of having you home so soon that you felt it necessary
to warn me of a postponement by telegram.

You know, my dear love, though I'm dazed with happiness
at the unbelievable idea of being with you always from now on
without the shadow of separation clouding my delight, I'm a little
afraid, because I think that when we're always together you will
find the little things that irritate you about me more irritating
because you will see more of them. Once, my darling, when you
were crazy with me about something – oh! before we were married
– you said I was like your mother – & I was suddenly terrified
because your mother irritates you so much by & large that you
couldn't live with her for very long possibly.

Oh! darling, darling, I love you so much – it's painful you
know to love anyone as much as that because not only does it hurt
horribly when you anger them but it hurts even more when they
anger you. When I get angry with you over money or over not
being socially attentive to people with whom you haven't much in
common or anything of that sort it's worse than the most acute
form of toothache or wanting to see Duncan so much that you
think you'll die. Because you feel inside: 'Oh! God, I love him more
than life – more than everything that makes life rich & wonderful
& exciting & I'm angry with him as if I hated him. How horrible.
How perfectly horrible.' It's as though someone had taken hold of
my legs & were tearing my body in two.

TUESDAY 26 MARCH This time two years ago, my darling, there was such
a hustle & bustle at Harley Rd – & you came in and kissed me goo'
morning which made the morning reassuringly like other morn-
ings because after all there should be continuity in love – a natural

385

imperceptible progression up a gentle slope so that when you get to the top of the hill & find yourself with your love bestriding the narrow world like a colossus you are not tired or sore-footed or puffed but rested & exhilarated by the warmer, fresher, cleaner air.

I am lonely for you today, my darling, and yet I feel that you're with me. I really have felt since our marriage that we can endure no breach but an expansion like gold to aery thinness beat. Before we were married you were my love but I often lost you for long stretches of time but now if we are two we are so two as stiff twin compasses are two.

Darling, when I think of my love for you I realize what Milton meant by 'He for God only, she for God in him' the essence of the Christian concept of love for God is humility – I am essentially a spiritually proud person though I fight against it – but I love you humbly and with wondering gratitude, my darling, & through my love for you I am brought nearer to God. Thank you! oh! thank you for your love.

Postscript

It was 1947 before Gershon was finally demobbed and could pick up again his plans for civilian life and the law. For three years Eileen had kept herself going with dreams of what their future would hold, and among all the disruptions of war and the emotional turmoil of her friends' lives, there was something deeply touching about her idealism, about her faith in Gershon and their future life together, her determination that they would not repeat the mistakes of others.

Those surviving letters from the early years of her marriage suggest a life of physical and emotional fulfilment, and yet whatever Eileen believed of herself at the time, she was no Natasha Rostova, happy to slide into a dull, matronly domesticity as conventional wife and mother. There were hopes at one point that she might take up her research again but that came to nothing, and though she translated Simenon's novels, wrote scripts for the BBC Education Programme, appeared on *Woman's Hour* to reminisce over the childhood Cairo she had once loathed, and eventually brought out her book on vinaigrettes – she had the best collection in England, one review noted – those arguably, if we did not have the letters, might seem slim pickings from a woman of her dazzling abilities.

The only thing Eileen had ever wanted, she had written in 1939, was to be a 'Cambridge don', but as Gershon's career at the Bar began to prosper, and they could at last set up home together in an Aladdin's cave of a flat on London's stylish Montagu Square

WI, it was another side of her character that flourished. There had always been a taste for what she called the 'willy-nilly' – a quirkiness – about Eileen, and as she grew older this was given an ever freer rein. She would spend most of the mornings in bed – she was not to be phoned before lunch – made jewellery and tapestries (not very well, her sister-in-law remembers), ran a market stall with Gershon on the Portobello Road, and – the old Eileen! – talked. 'She loved to entertain her large circle of friends,' the congregation at her funeral in Golders Green were told in 1986, after she had died from lung cancer: 'an evening at the Ellenbogens was always an immensely stimulating as well as enjoyable experience. Even in her hospital bed during her last illness, Eileen, however weak and tired, not only took pleasure in the visits of her friends, often half a dozen at a time, but regaled them with a conversation which never lost its sparkle.'

It is a shame that we cannot hear that voice – the BBC recording of her *Woman's Hour* appearance has not survived – but the son of an old Girton friend of hers, who knew Eileen in her later years, likened conversation with her to being hit by an 'intellectual tsunami', and that is just how her letters read. Across a gap of eighty years they draw us back into a love story as raw and immediate as if it were happening now. 'I once thought that I had a Genius for writing,' she had written in 1943, 'but I find instead I have a Genius for love.' She was only half right. She had a genius for both.

Dramatis Personae

AARON 'ALEC' ALEXANDER He was married to Victoria 'Vicky' Mosseri, and had three children, Eileen, the oldest; Lionel, at Harrow when the letters open, and Anthony ('Dicky'), at the Dragon School at Oxford, and the bane of his sister's early life. With them was also the children's nurse from Egypt.

THERESA ALEXANDER The widow of Louis Alexander, and the mother of Eileen's cousins Jean and Gerta, 'Aunt Teddy' is one of the great comic creations of these letters. There was scarcely a month when the Alexanders' home was not swelled by one guest or another, but while the likes of Mrs Seidler, an Austrian refugee with a complicated domestic life, or Eileen's naval cousin, Victor Kanter, might come and go, the 'lone, lorn' Dickensian figure of Aunt Teddy would prove an almost immovable object in the overcrowded and long-suffering Alexander household.

JOAN AUBERTIN The clever and engaging descendant of a French prisoner of war from the Napoleonic era, and the daughter of an estate gardener, Joan Aubertin had come up to Girton with a Major County Scholarship and a college exhibition in the same year as Eileen. In the summer of 1939 she took a first in English and after a spell as a teacher came up to London, where she remained at the heart of a circle of Eileen's Girton friends (and enemies) – Joan Pearce, Elizabeth Clark, Joyce Nathan, Joan Friedman, Sheila Falconer, Rosemary Allott – who would be reunited by war.

NORMAN BENTWICH A lifelong Zionist, and an early admirer of Vicky Mosseri, the barrister and academic Norman Bentwich had spent much of his working life in British-controlled Palestine. During the Great War he had served in the Middle East with the Camel Transport, and in 1922 became the first attorney general in the mandatory government, earning the unusual distinction of inspiring Arab demonstrations against him for his Jewish sympathies and Zionist student protests for being too conciliatory to Arabs. Shot by an Arab and called home by his Colonial Office masters as an embarrassment, he returned to hold the chair in International Law at the Hebrew University of Jerusalem.

MURIEL BRADBROOK Muriel Bradbrook was first a student and then a fellow of Girton College and Eileen's tutor. A specialist in Shakespeare and Elizabethan literature, she gave up her teaching in 1941 for the duration of the war, before returning to Cambridge to end her career as the university's first female Professor of English and the Mistress of her old college.

MRS CREWS An intrepid traveller in the Balkans, and a brilliant linguist with 'the best legs in Cambridge', Cynthia Crews provided Eileen with some of her most entertaining copy. Like Muriel Bradbrook she had taken a double first as a student at Girton, and returned as a research fellow before leaving to carry out war work in Turkey and London.

AUBREY EBAN The son of a passionate Zionist mother, Alida Eban, and a figure of almost 'Johnsonian' stature, Aubrey Eban was the indisputable heavyweight among Eileen's friends. It was as 'Abba Eban' that he would make a global reputation as the 'Voice of Israel' in the years after the war, but even as 'Aubrey', he had made national news with a brilliant triple first at Cambridge. A close friend of Gershon Ellenbogen's, he would be a loyal correspondent of Eileen's throughout the war.

BASIL ELLENBOGEN The second of the three sons of Max Katzen Ellenbogen and his wife, Gertrude, Basil Ellenbogen would grow up as a child in the shadow of his older and more charismatic

brother. Educated like Gershon at Liverpool Collegiate School, he studied medicine at Liverpool University, before becoming an army doctor and ended the war in Germany as a deeply committed adherent to all Jewish causes.

HAMISH FALCONER Scottish-born Pilot-Officer J. A. R. 'Hamish' Falconer was the brother of Sheila and perhaps the closest thing among Eileen's friends to the 'Happy Warrior'. On the outbreak of war, he was sent to Salisbury in Southern Africa for training, and returned in the aftermath of the Battle of Britain to marry his fiancée, Charlotte, in St Giles Cathedral and fly Spitfires with 603 ('City of Edinburgh') Squadron from their southern England base.

SIGMUND GESTETNER The son of David Gestetner, the inventor of the first office stencil copying machine and founder of the hugely successful Gestetner Cyclograph Company, Sigmund Gestetner combined the worlds of business, philanthropy and British Zionism.

LESLIE HORE-BELISHA Soldier, barrister, journalist, Liberal politician, and much-loved friend of the Alexanders, the flamboyant Clifton- and Oxford-educated Hore-Belisha first came to the public's attention in the 1930s as an energetic Minister for Transport. In 1937 he was promoted by Chamberlain to the War Office, and in the months before the war pushed through a number of important reforms before being controversially sacked in January 1940, a victim – in just about equal measures – of his generals' hostility, his own love of publicity and establishment anti-Semitism.

HON. NELLIE IONIDES Nellie Ionides was an old friend of the Alexanders, a major benefactor of Britain's museums, and a generous and important figure in Eileen's life. The daughter of the 1st Viscount Bearsted, the founder of Shell, she was living with her husband, the architect Basil Ionides, in their Sussex country home, Buxted Park, surrounded by her art collection, when the house was gutted by fire in 1940.

LORD LLOYD It would be impossible to guess it from Eileen's letters, but behind the figure of the 1st Baron Lloyd, lay a career of remarkable variety. Educated at Eton and Cambridge (where he coxed the Cambridge boat), George Lloyd was a veteran of both the Gallipoli landings and Lawrence of Arabia's desert war, before becoming a deeply imperialist Governor of Bombay (who imprisoned Gandhi), a controversial and reactionary high commissioner in Egpyt (recalled), and head of the British Council, before finally dying in office from German measles – an irony not lost on Eileen – while Secretary of State for the Colonies in Churchill's wartime government.

LORD NATHAN A distinguished First World War soldier, solicitor, Labour politician, tireless public servant, Zionist and Eileen's bête noire, 'Harry Nathan' was an old friend of the Alexander family. In the early days of the war he moved – or was moved – from the House of Commons to the Lords, and it was as the founder of an Army Welfare Department that he and his formidable Girtonian wife, Eleanor, would make their major contribution to the war effort.

DAVID RAFILOVITCH A contemporary of Gershon Ellenbogen's at Liverpool Collegiate School, David Raphael (as he became) and his wife Silvia, the daughter of a famous Edinburgh rabbi and sister of the literary critic, David Daiches, became crucial figures for Eileen at a particularly difficult time of her life. Both husband and wife went on to distinguished academic careers.

HORACE SAMUEL Barrister, writer, financial advisor, and self-appointed scourge of Britain's real and imaginary fifth columnists, Horace Barnett Samuel was one of the most colourful of the Alexander family friends. Educated – like Lord Nathan and Sidney Bentwich – at St Paul's School and then at Cambridge, Samuel effortlessly combined his Soviet sympathies and anti-establishment suspicions with the plutocratic tastes of a member of the family whose musical instrument firm would eventually morph into Decca Gramophone.

ORDE WINGATE Orde Wingate was only a captain in the British Army when Eileen first met him, but clearly destined either for a court-martial or for the top. The son of Plymouth Brethren parents and a committed Zionist, he had made his name as a ruthless, eccentric and insubordinate guerrilla leader during the Arab rebellion in Palestine and went on to lead a brilliant campaign against the Italians in Abyssinia before famously taking the war to Japan in the Burmese jungle. He was killed in a plane crash in 1944 and he remains, now as then, a controversial figure.

MR AND MRS WRIGHT The Alexanders' general handyman and cook. The Alexanders were only renting their house in Swiss Cottage, and Mrs Wright and her disgruntled husband had come with the property, leaving the distinct impression in Eileen's mind that their loyalties were very much to their old employers.

Illustration Credits

Eileen, Lionel and Dicky in Cairo. *(Alexander Family Collection)*
Eileen and Lionel dressed up. *(Alexander Family Collection)*
Portrait of Victoria Mosseri. *(Alexander Family Collection)*
Victoria Mosseri holding Eileen. *(Alexander Family Collection)*
Portrait of Alec Alexander. *(Alexander Family Collection)*
Lionel and Dicky playing in the garden. *(Alexander Family Collection)*
Alec Alexander in a group. *(Alexander Family Collection)*
Portrait of Félix Mosseri. *(Alexander Family Collection)*
Victor Kanter *(Hannah Kanter)*
The Alexander children on camels in Egypt. *(Alexander Family Collection)*
Lord Nathan and Lady Nathan.
Lord George Ambrose Lloyd. *(National Portrait Gallery, London)*
Muriel Clara Bradbrook. *(National Portrait Gallery, London)*
Nellie Ionides.
Aubrey 'Abba' Eban.
Eban with President Nixon. *(Arnold Sachs/Getty Images)*
Orde Wingate with the Emperor of Ethiopia. *(Popperfoto/Getty Images)*
Orde Wingate. *(Popperfoto/Getty Images)*
Eileen outside the post office. *(Alexander Family Collection)*
Eileen's airgraph. *(Alexander Family Collection)*
The first raid of the Blitz. *(Keystone/Hulton Archive/Getty Images)*
St Paul's Cathedral amid bombing damage. *(Keystone/Getty Images)*
Portrait of Eileen Alexander. *(Alexander Family Collection)*

Gershon Ellenbogen. *(Alexander Family Collection)*
London Underground. *(Photo12/Universal Images Group via Getty Images)*
Crowds sleeping on the platform of Elephant and Castle. *(Bill Brandt/Imperial War Museum via Getty Images)*
The twin guns of the anti-aircraft battery at Primrose Hill. *(Photo12/Universal Images Group via Getty Images)*
Eileen and her father. *(Alexander Family Collection)*
Eileen. *(Alexander Family Collection)*
Oswyn Murray's family. *(Murray Family Collection)*
Eileen and Gershon's wedding. *(Alexander Family Collection)*
Katherine 'Kate' Ellenbogen as a child. *(Alexander Family Collection)*
Kate Ellenbogen's wedding. *(Alexander Family Collection)*